The Palace Museum's Essential Collections

CHINESE CERAMIC WARES
with
POLYCHROME GLAZE

The Commercial Press

Chinese Ceramic Wares with Polychrome Glaze

Consultant	Geng Baochang 耿寶昌
Chief Editor	Lü Chenglong 呂成龍
Deputy Chief Editors	Xu Wei 徐巍, Han Qian 韓倩
Editorial Board	Huang Weiwen 黃衛文, Gao Xiaoran 高曉然
Photographers	Hu Chui 胡錘, Liu Zhigang 劉志崗, Zhao Shan 趙山, Feng Hui 馮輝
Translator	Veronique Ng 吳可怡
Editorial Consultant	Hang Kan 杭侃
Project Editors	Xu Xinyu 徐昕宇, Wang Yuechen 王悅晨
Cover Design	Zhang Yi 張毅
Published by	The Commercial Press (Hong Kong) Ltd. 8/F., Eastern Central Plaza, 3 Yiu Hing Rd, Shau Kei Wan, Hong Kong http://www.commercialpress.com.hk
Printed by	C & C Offset Printing Co., Ltd. C & C Building, 36 Ting Lai Road, Tai Po, N.T., Hong Kong
Edition	First Edition in January 2016

© 2016 The Commercial Press (Hong Kong) Ltd.

All rights reserved.

ISBN 978 962 07 5674 0

Printed in Hong Kong

Introducing the Palace Museum to the World

SHAN JIXIANG

Built in 1925, the Palace Museum is a comprehensive collection of treasures from the Ming and Qing Dynasties and the world's largest treasury of ancient Chinese art. To illustrate ancient Chinese art for people home and abroad, the Palace Museum and The Commercial Press (Hong Kong) Ltd. jointly published *The Complete Collection of Treasures of the Palace Museum*. The series contains 60 books, covering the rarest treasures of the Museum's collection. Having taken 14 years to complete, the series has been under the limelight among Sinologists. It has also been cherished by museum and art experts.

After publishing *The Complete Collection of Treasures of the Palace Museum*, it is understood that westerners, when learning about Chinese traditional art and culture, are particularly fond of calligraphy, paintings, ceramics, bronze wares, jade wares, furniture, and handicrafts. That is why The Commercial Press (Hong Kong) Ltd. has discussed with the Palace Museum to further co-operate and publish a new series, *The Palace Museum's Essential Collections*, in English, hoping to overcome language barriers and help more readers to know about traditional Chinese culture. Both parties regard the publishing of the series as an indispensable mission for Chinese history with significance in the following aspects:

First, with more than 3,000 pictures, the series has become the largest picture books ever in the publishing industry in China. The explanations show the very best knowledge from four generations of scholars spanning 90 years since the construction of the Museum.

Second, the English version helps overcome language and cultural barriers between the east and the west, facilitating the general public's knowledge of Chinese culture. By doing so, traditional Chinese art will be given a fresher image, becoming more approachable among international art circles.

Third, the series is going to further people's knowledge about the Palace Museum. According to the latest statistics, the Palace Museum holds more than 1.8 million pieces of artifacts (among which 228,771 pieces have been donated by the general public and purchased or transferred by the government since 1949). The series selects nearly 3,000 pieces of the rare treasures, together with more than 12,000 pieces from *The Complete Collection of Treasures of the Palace Museum*. It is believed that the series will give readers a more comprehensive view of the Palace Museum.

Just as *The Palace Museum's Essential Collections* is going to be published, I cannot help but think of Professor Qi Gong from Beijing Normal University; famous scholars and researchers of the Palace Museum Mr. Xu Bangda, Mr. Zhu Jiajin, and Mr. Liu Jiu'an; and well-known intellectuals Mr. Wu Kong (Deputy Director of Central Research Institute of Culture and History), and Mr. Xu Qixian (Director of Research Office of the Palace Museum). Their knowledge and relentless efforts are much appreciated for showing the treasures of the Palace Museum to the world.

Looking at History through Art

The Palace Museum is a comprehensive collection of the treasures of the Ming and Qing Dynasties. It is also the largest museum of traditional art and culture in China. Located in the urban centre of Beijing, this treasury of ancient Chinese culture covers 720,000 square metres and holds nearly 2 million pieces of artifacts.

In the fourth year of the reign of Yongle (1406 A.D.), Emperor Chengzu of Ming, named Zhu Di, ordered to upgrade the city of Beiping to Beijing. His move led to the relocation of the capital of the country. In the following year, a grand, new palace started to be built at the site of the old palace in Dadu of the Yuan Dynasty. In the 18th year of Yongle (1420 A.D.), the palace was complete and named as the Forbidden City. Since then the capital of the Ming Dynasty moved from Nanjing to Beijing. In 1644 A.D., the Qing Dynasty superceded the Ming empire and continued using Beijing as the capital and the Forbidden City as the palace.

In accordance with the traditional ritual system, the Forbidden City is divided into the front part and the rear part. The front consists of three main halls, namely Hall of Supreme Harmony, Hall of Central Harmony, and Hall of Preserving Harmony, with two auxiliary halls, Hall of Literary Flourishing and Hall of Martial Valour. The rear part comprises three main halls, namely Hall of Heavenly Purity, Hall of Union, Hall of Earthly Tranquillity, and a cluster of six halls divided into the Eastern and Western Palaces, collectively called the Inner Court. From Emperor Chengzu of Ming to Emperor Puyi, the last emperor of Qing, 24 emperors together with their queens and concubines, lived in the palace. The Xinhai Revolution in 1911 overthrew the Qing Dynasty and more than 2,000 years of feudal governance came to an end. However, members of the court such as Emperor Puyi were allowed to stay in the rear part of the Forbidden City. In 1914, Beiyang government of the Republic of China transferred some of the objects from the Imperial Palace in Shenyang and the Summer Palace in Chengde to form the Institute for Exhibiting Antiquities, located in the front part of the Forbidden City. In 1924, Puyi was expelled from the Inner Court. In 1925, the rear part of the Forbidden City was transformed into the Palace Museum.

Emperors across dynasties called themselves "sons of heaven," thinking that "all under the heaven are the emperor's land; all within the border of the seashore are the emperor's servants"("Decade of Northern Hills, Minor Elegance," Book of Poetry). From an emperor's point of view, he owns all people and land within the empire. Therefore, delicate creations of historic and artistic value and bizarre treasures were offered to the palace from all over the country. The palace also gathered the best artists and craftsmen to create novel art pieces exclusively for the court. Although changing of rulers and years of wars caused damage to the country and unimaginable loss of the court collection, art objects to the palace were soon gathered again, thanks to the vastness and long history of the country, and the innovativeness of the people. During the reign of Emperor Qianlong of the Qing Dynasty (1736–1796), the scale of court collection reached its peak. In the final years of the Qing Dynasty, however, the invasion of Anglo-French Alliance and the Eight-Nation Alliance into Beijing led to the loss and damage of many art objects. When Puyi abdicated from his throne, he took away plenty of the objects from the palace under the name of giving them out as presents or entitling them to others. His servants followed suit. Up till 1923, the keepers of treasures of Palace of Established Happinesss in the Inner Court who actually stole the objects, set fire on them and caused serious damage to the Qing Court col-

lection. Numerous art objects were lost within a little more than 60 years. In spite of all these losses, there was still a handsome amount of collection in the Qing Court. During the preparation of construction of the Palace Museum, the "Qing Rehabilitation Committee" checked that there were around 1.17 million items and the Committee published the results in the Palace Items Auditing Report, comprising 28 volumes in 6 editions.

During the Sino-Japanese War, there were 13,427 boxes and 64 packages of treasures, including calligraphy and paintings, picture books, and files, were transferred to Shanghai and Nanjing in five batches in fear of damages and loot. Some of them were scattered to other provinces such as Sichuan and Guizhou. The art objects were returned to Nanjing after the Sino-Japanese War. Owing to the changing political situation, 2,972 pieces of treasures temporarily stored in Nanjing were transferred to Taiwan from 1948 to 1949. In the 1950s, most of the antiques were returned to Beijing, leaving only 2,211 boxes of them still in the storage room in Nanjing built by the Palace of Museum.

Since the establishment of the People's Republic of China, the organization of the Palace Museum has been changed. In line with the requirement of the top management, part of the Qing Court books were transferred to the National Library of China in Beijing. As to files and essays in the Palace Museum, they were gathered and preserved in another unit called "The First Historical Archives of China."

In the 1950s and 1960s, the Palace Museum made a new inventory list for objects kept in the museum in Beijing. Under the new categorization system, objects which were previously labelled as "vessels", such as calligraphy and paintings, were grouped under the name of "Gu treasures." Among them, 711,388 pieces which belonged to old Qing collection and were labelled as "Old", of which more than 1,200 pieces were discovered from artifacts labelled as "objects" which were not registered before. As China's largest national museum, the Palace Museum has taken the responsibility of protecting and collecting scattered treasures in the society. Since 1949, the Museum has been enriching its collection through such methods as purchase, transfer, and acceptance of donation. New objects were given the label "New." At the end of 1994, there were 222,920 pieces of new items. After 2000, the Museum re-organized its collection. This time ancient books were also included in the category of calligraphy. In August 2014, there were a total of 1,823,981 pieces of objects in the museum collection. Among them, 890,729 pieces were "old," 228,771 pieces were "new," 563,990 were "books," and 140,491 pieces were ordinary objects and specimens.

The collection of nearly two million pieces of objects were important historical resources of traditional Chinese art, spanning 5,000 years of history from the primeval period to the dynasties of Shang, Zhou, Qin, Han, Wei, and Jin, Northern and Southern Dynasties, dynasties of Sui, Tang, Northern Song, Southern Song, Yuan, Ming, Qing, and the contemporary period. The best art wares of each of the periods were included in the collection without disconnection. The collection covers a comprehensive set categories, including bronze wares, jade wares, ceramics, inscribed tablets and sculptures, calligraphy and famous paintings, seals, lacquer wares, enamel wares, embroidery, carvings on bamboo, wood, ivory and horn, golden and silvery vessels, tools of the study, clocks and watches, pearl and jadeite jewellery, and furniture among others. Each of these categories has developed into its own system. It can be said that the collection itself is a huge treasury of oriental art and culture. It illustrates the development path of Chinese culture, strengthens the spirit of the Chinese people as a whole, and forms an indispensable part of human civilization.

The Palace Museum's Essential Collections Series features around 3,000 pieces of the most anticipated artifacts with nearly 4,000 pictures covering eight categories, namely ceramics, jade wares, bronze wares, furniture, embroidery, calligraphy, and rare treasures. The Commercial Press (Hong Kong) Ltd. has invited the most qualified translators and academics to translate the Series, striving for the ultimate goal of achieving faithfulness, expressiveness, and elegance in the translation.

We hope that our efforts can help the development of the culture industry in China, the spread of the sparkling culture of the Chinese people, and the facilitation of the cultural interchange between China and the world.

Again, we are grateful to The Commercial Press (Hong Kong) Ltd. for the sincerity and faithfulness in their cooperation. We appreciate everyone who have given us support and encouragement within the culture industry. Thanks also go to all Chinese culture lovers home and abroad.

Yang Xin former Deputy Director of the Palace Museum, Research Fellow of the Palace Museum, Connoisseur of ancient calligraphy and paintings.

Contents

List of Ceramic Wares

COLOUR-GLAZED POTTERY WARES AND PAINTED POTTERY WARES

1 **Painted Pottery Pot with Looped-handles**
and decorated with design of spirals

2 **Painted Pottery Vase**
decorated with painted design of the dragon and phoenix in relief

UNDERGLAZE POLYCHROME WARES FIRED IN HIGH TEMPERATURE

3 **Ewer with a Handle**
and decorated with design of birds and flowers in underglaze brownish-green in celadon glaze, Changsha ware

4 **Pillow in the Shape of *Ruyi* Cloud**
and decorated with design of peony scrolls in black glaze on a white ground, Cizhou Yaoxi ware

5 ***Meiping* Vase**
decorated with design of flowers and foliage patterns in underglaze black in green glaze, Cizhou Yao ware

6 **Jar**
decorated with design of the dragon and phoenix in black glaze on a white ground, Cizhou ware

7 **Octagonal *Meiping* Vase**
decorated with design of dragons reserved in white amidst waves in underglaze blue

8 **Ewer**
decorated with design of phoenixes amidst peonies, rocks, and bamboos in underglaze blue

9 **Jar**
decorated with design of fishes and lotuses in underglaze blue

10 **Plate with a Foliated Broad Everted Rim**
and decorated with design of a pond scene in underglaze blue

11 **Ewer**
decorated with design of flowers in underglaze blue

12 **Plate with a Foliated Broad Everted Rim**
and decorated with design of *lingzhi* funguses, rocks, and bamboos in underglaze blue

13 ***Meiping* Vase**
decorated with design of peach trees in underglaze blue

14 **Celestial Sphere-shaped Vase**
decorated with design of a dragon amidst clouds in underglaze blue

15 **Pear-shaped Vase**
decorated with design of banana trees, rocks, and bamboos in underglaze blue

16 **Flask with Moveable Rings and Two Loops**
and decorated with design geometrical brocade ground, flowers, and waves in underglaze blue

17 **Ewer with a Square-shaped Spout**
and decorated with design of floral sprays in underglaze blue

18 **Flask**
decorated with design of a dragon reserved in white amidst waves in underglaze blue

19 **Flask with *Ruyi* Cloud-shaped Handles**
and decorated with design of camellias in underglaze blue

20 **Garlic-head Flask with *Ruyi* Cloud-shaped Handles**
and decorated with design of geometrical brocade ground and floral designs in underglaze blue

21 **Tubular Jar**
decorated with design of flowers and waves on a geometric brocade ground in underglaze blue

22 **Octagonal Candle-stand**
decorated with design of floral scrolls in underglaze blue

23 **Kendi Ewer**
decorated with design of peony scrolls in underglaze blue

24 **Flower Jar**
decorated with design of lotus scrolls in underglaze blue

25 ***Wudang Zun* Vase**
decorated with design of Arabic scripts and floral scrolls in underglaze blue

26 **Large Incense Burner with Three Legs**
and decorated with design of cliffs and cresting waves in underglaze blue

27 **Large Basin with a Foliated and Everted Rim**
and decorated with design of waves and floral scrolls in underglaze blue

28 **Press-hand Cup**
decorated with design of lotus scrolls and lions playing with a brocade ball in underglaze blue

29 **Press-hand Cup**
decorated with design of lotus scrolls and sunflower patterns in underglaze blue

30 **Bowl**
decorated with design of bamboos, rocks, flowers, and plants in underglaze blue

31 **Plate with a Foliated Everted Mouth Rim**
and decorated with design of paradise flycatcher and floral designs in underglaze blue

262 **Bowl**
decorated with design of two dragons in pursuit of a pearl in iron-red enamel on a yellow ground

263 **Plate**
decorated with design of dragons in pursuit of a flaming pearl in iron-red enamel on a green ground

264 **Bowl**
decorated with design of dragons in green enamel on an underglaze blue ground

265 **Bowl**
decorated with incised design of dragons amidst clouds and cresting waves in aubergine enamel on a green ground

266 **Bowl**
decorated with incised design of dragons amidst clouds and cresting waves in aubergine enamel on a yellow ground

267 **Bowl**
decorated with design of phoenix medallions in iron-red enamel on a *dongqing* celadon ground

268 **Brush Pot**
decorated with design of landscapes in sepia ink enamel on a white ground with simulated wood texture

269 **Plate**
decorated with incised design of floral sprays in yellow enamel on an underglaze blue ground

270 **Plate**
decorated with incised design of two dragons in pursuit of a pearl amidst cresting waves in green enamel on a white ground

271 **Olive-shaped Vase**
with incised design of auspicious clouds, sprays of peonies, and chrysanthemums in green enamel on a yellow ground

272 *Ganlu* **Vase**
decorated with design of lotuses in iron-red enamel on a white ground

273 **Vase with Tubular Handles**
and decorated with incised design of dragons amidst clouds in green enamel on a yellow ground

274 *Meiping* **Vase**
decorated with design of lotus scrolls in green enamel on a black ground

275 **Covered-bowl**
decorated with an imperial poem in iron-red enamel on a white ground

PORCELAIN WARES IN PLAIN THREE-COLOUR ENAMELS

276 **Covered Jar**
in *sancai* glaze (three-colour glazes)

277 **Pillow in the Shape of Waist**
and decorated with carved design of potted flowers in *sancai* glazes

278 **Long Plate in a Floral Shape**
and decorated with design of lotuses and waves in *sancai* glazes

279 **Three-legged Washer**
decorated with incised design of toads in waves in plain three-colour enamels on a green ground

280 **Stem-bowl**
decorated with incised design of lotus scrolls in plain three-colour enamels on a green ground

281 **Stool**
decorated with incised design of dragons in a lotus pond in plain three-colour and red enamels on a white ground

282 **A Pair of Plates**
decorated with incised design of dragons amidst clouds, flowers, and fruits sprays in plain three-colour enamels on an aubergine ground

283 **Plate with a Foliated Everted Rim**
and decorated with incised design of dragons amidst clouds and flowers in plain three-colour enamels on a yellow ground

284 **Octagonal Censer**
decorated with openwork design of *wan* swastikas in plain three-colour enamels on a white ground

285 **Plate**
decorated with incised design of dragons amidst clouds, flowers, and fruits in plain three-colour enamels on a white ground

286 *Duomu* **Pitcher**
decorated with tiger-skin patterns in three-colour enamels

287 **Vase**
decorated with incised design of lotus sprays in plain three-colour enamels on a yellow ground

FAHUA POTTERY AND PORCELAIN WARES

288 **Drum-shaped Stool**
decorated with carved and openwork design of a peacock and peonies in *fahua* enamels

289 **Drum-shaped Stool**
decorated with carved and openwork design of a phoenix in *fahua* enamels

Polychrome Ceramic Wares in the Palace Museum's Collection

LÜ CHENG LONG

Ceramics, which includes pottery and porcelain wares, is the art of "fire and earth" and an important component of the material and spiritual culture of mankind. Chinese ceramics, in particular, has a long and continuous production history which has never suspended in any period and sustainable to the present with a wide repertoire of types and forms. They are produced with superb techniques and are popular merchandises export to various countries and regions with significant influence that command attention and esteem from people in all parts of the world.

Archeological finds reveal that China was the first country which produced and used ceramics in the earliest period of history. A large number of pottery shards were unearthed at the site of Xianrendong, Wannian county, Shangrao, Jiangxi province. The earliest pieces dated to 19,000 years to 20,000 years ago, which are even 2,000 to 3,000 years earlier than the pottery remains found elsewhere and were the earliest pottery shards found in the world. On the foundation of firing pottery wares, the Chinese then produced porcelain wares, the invention of which had gone through a long period of development. As early as the mid-Shang Dynasty (1600–1046 B.C.), Chinese potters had produced wares with porcelain clay pastes, which were covered with transparent lime glaze and fired at a high temperature of over 1,200°C in the kiln. Such type of wares had the basic characteristics of porcelain, but if compared with the firing temperature, texture, and degree of

water absorbance by the pastes of standard porcelain wares, they had not yet reached those standards and thus were called "proto-porcelain wares." With the developments from the Western Zhou Dynasty to the Western Han Dynasty, the quality of this type of proto-porcelain was enhanced, and in the Eastern Han Dynasty (25–220 A.D.), genuine porcelain wares came into being, which marked a new page in the history of human civilization. With the production of various types of red pottery wares, grey pottery wares, painted pottery wares, black pottery wares, white pottery wares to the later proto-porcelain wares, celadon wares, black-glazed wares, white-glazed wares, various colour-glazed wares, underglaze-painted wares, overglaze painted wares to the other wares which are decorated with both overglaze and underglaze colours, the superb creativity and sustainability of Chinese ceramic art were are fully revealed.

The art of Chinese ceramics not only has a long history, but also there are a great number of artifacts still extant, which testify to its progressive development from the historical period to the present day. Nearly every comprehensive or thematic museum of ceramics in the world has collections of Chinese ceramics, however, in terms of quality and quantity, the collection of the Palace Museum, Beijing should be ranked the best.

The Palace Museum is a comprehensive museum with the cores of imperial palace buildings and

imperial collections of artifacts of the Ming and Qing Dynasties. Her ceramic collection has some 360,000 pieces of pottery and porcelain ware, among which around 320,000 pieces are the wares produced by the five major kilns of the Song Dynasty and wares produced by the Imperial Kiln at Jingdezhen in the Ming and Qing Dynasties (commonly known as "*guan wares or imperial wares*"). On the other hand, the museum also collects around 3,800 pieces of intact ceramic ware of the preceding periods, around 30,000 shards collected from over 110 kiln sites in seventeen provinces, cities and autonomous regions all over China since the 1950s of the 20th century, as well as over 10,000 shards left over from the Ming and Qing Dynasties.

Generally speaking, the Palace Museum has collected nearly the most representative types of Chinese ceramic wares from the Neolithic period to the modern era in Chinese history, covering over 8,000 years of the development of Chinese ceramics. The collections have been examined and authenticated by generations of experts with the significances that their history can be traced, the repertoire of types and forms most representative, the number of collections are huge and the qualities are excellent, which should have surpassed those collections in other institutions in the world.

To meet the aspirations of the general readers and members of the academic sector both inland and overseas, the Museum together with The Commercial Press (Hong Kong) Ltd. has published a collection series *Gems of Cultural Relics in the Collection of the Palace Museum* in ten volumes, among which two volumes are on Chinese ceramics, including one volume on "polychrome ceramic wares" and another volume on "colour-glazed monochrome ceramic wares." The compilation of these volumes illustrates a fresh interpretation of the ceramics collection of the Museum, surveys the collection of and researches on Chinese cultural relics and the most recent studies on ancient Chinese ceramics to meet the interest of our readers and target audiences.

The theme of this volume is on the "polychrome ceramic wares."

Painted polychrome ceramic wares refer to all types of ceramic wares with various painted decorations in polychrome colours. In the category of pottery wares, there are colour-glazed pottery and painted pottery wares. In the category of porcelain wares, there are wares in underglaze colours, overglaze colours, combination of both underglaze and overglaze colours, wares in other colour glazes and enamels, plain three-colours, etc. Underglaze coloured wares include wares in underglaze brown, underglaze brown with underglaze green, underglaze black, underglaze cobalt blue (underglaze blue), underglaze copper-red (underglaze red), combination of underglaze cobalt blue and copper-red (underglaze blue and red), combination of cobalt blue, copper-red, and pea-green (wares in three underglaze colours), underglaze five colours, etc. Overglaze coloured wares include wares painted in *wucai* (five-colour) enamels, wares with porcelain paste and painted in opaque enamels, wares in *yangcai* enamels, wares in *fencai* enamels, etc. The combination of both underglaze and overglaze colours include wares in underglaze blue and *wucai* enamels, *doucai* wares, wares in underglaze blue and *fencai* enamels, etc. Wares in other colour glazes and enamels refer to wares with a single colour-glazed ground and painted with decorations in only one single colour glaze or enamel. Wares in plain three-colours are those decorated with three or more low-temperature fired glazes or enamels but without the use of red colour.

In accordance with the above classifications, 290 pieces (sets) of painted polychrome ceramic wares of different dynasties and periods in the collection of the Palace Museum are selected and illustrated in this publication, and this article aims to introduce the development of Chinese ceramic wares with reference to different types of wares discussed below.

COLOUR-GLAZED POTTERY WARES AND PAINTED POTTERY WARES

Polychrome pottery wares can be divided into two main types of "colour-glazed pottery wares" and "painted pottery wares" which are different from each other.

Colour-glazed pottery wares are those with decorative designs painted on the surfaces of wares with pigments made from natural minerals, and then fired in a baking atmosphere in the kiln. Colours include black, red, brown, white, and others. Among them, the black, red, and brown glazes are made by grinding natural minerals with oxidized iron and oxidized manganese mixed in different designated proportions while white wares are made by natural clay. Decorations are painted with Chinese brush and then fired in a baking atmosphere at around 900°C. This type of colour glazed wares was found at the site of the Cishan culture of the Neolithic period, which was around 8,000 years ago, and they developed rapidly in the period of the Yangshao culture , which was around 7,000 to 5,000 years ago. During the period of the Majiayao culture which was around 5,200 to 4,000 years ago, production of colour-glazed wares reached a progressive stage. Common decorative designs on these wares include animals, plants, figures, spirals, geometric patterns, the sun, the moon and other constellations, etc., and they are painted in a naturalistic manner with a primitive favour, reflecting the religious beliefs and ideas of primitive religions and engendering a simple and mysterious appeal.

Experts are of the view that in the history of Chinese ceramics, colour-glazed wares represent an art form that blended both painting with designated wares and marked the first zenith of ancient Chinese art with high historical significance in the history of Chinese art and crafts.

Painted pottery wares refer to the wares with already fired biscuits directly painted with decorative designs rendered with the use natural mineral pigments, and they were not fired in a baking atmosphere for a second time in the kiln. These wares were found in some of the sites of the Neolithic period. In the Warring States period, Qin and Han Dynasties, they had entered a blooming period of production, such as the terra-cotta figures of Qin Shi Huangdi which belong to this type of wares. From the Han Dynasty to the modern era, this type of wares was continuously produced and most of them were burial objects. Usually grey pottery was utilized for this type of wares and their forms include ewer, breakers, *ding* cauldrons, granaries, burial figures, etc. Glazes include red, brownish red, brown, yellow, green, celadon, white, aubergine, etc., and decorative motifs were often derived from the lacquer wares of their respective periods, such as cloud patterns, spirals, dragons and phoenixes, four spirits and others. As the pigments were not fired in a baking atmosphere, they would easily peel off, as shown in many of the extant wares that only remains of the decorative designs could be traced.

UNDERGLAZE POLYCHROME WARES FIRED IN HIGH TEMPERATURE

Porcelain Wares with Underglaze Painted Decorations in Celadon Glaze

The earliest ceramic wares with decorations painted in underglaze colours were produced in the end of the Three Kingdoms period (Wu Kingdom) to the early Western Jin Dynasty, which were high-temperature fired wares painted in underglaze blackish-brown in celadon glaze. In 1983, a ewer with a plated-shaped mouth and cover and decorated with blackish-brown designs in celadon glaze was unearthed at a tomb site of the late Wu and early Jin period at Yuhuatai, Nanjing, Jiangsu. In an

excavation at a work site at Nanjing from 2002 to 2004, several wares with underglaze blackish-brown designs in celadon glaze were unearthed. These wares reflect that potters in the third century had already commanded firing of these wares with underglaze coloured decorations in high temperature.

The emergence of underglaze painted polychrome wares paved a new path in the decorations on ceramics and has great significance in the development history of Chinese ceramics.

The decorative method of painted decorations in underglaze colours was inherited by various kilns such as the Changsha kiln, Yue kiln, Qiong kiln, and others of the Tang Dynasty, and reached a new height. In 1980, archeologists conducted excavations at the tomb of Lady Shuiqiu (the wife of Qian Kuan who was the father of Qian Liu, the first Emperor of the Wuyue Kingdom), at Linan county, Hangzhou, Zhejiang province. This tomb was built in the first year of the Tianfu period, Tang Dynasty (901 A.D.), which was dated to the late Tang period. In the tomb, 42 pieces of ceramic ware were unearthed and among them there were 3 pieces of *mise* (secret colour) celadon ware decorated with *ruyi* cloud designs and others in underglaze brown from the Yue kiln, showing the high standard of producing underglaze painted wares in celadon glaze by the Yue kiln in the late Tang period.

Another important kiln that had made significant contributions to the technique of painting decorations in underglaze colours on celadon wares was the Changsha kiln at Changsha, Hunan, which was the first porcelain kiln to pronounce this technique and marked a new height amongst the various kilns of the Tang Dynasty. From the underglaze painting in brown, the kiln further developed other underglaze painted designs in brown, green, and blue, and much enhanced the expressiveness of the more abundant decorations. There are a wide variety of designs such as flowers, plants, birds, figures, animals, and architecture with the quantity of flower and plant designs numbered the most. The second that numbered the most are designs of birds, including gooses, birds with long tails, phoenixes, egrets, cranes, etc. Examples include a ewer decorated with flowers

and birds in underglaze brown and green in celadon glaze (Plate 3). The decorations are outlined in brown with a small bird lifting its head upwards with two clusters of flowers and plants rendered in underglaze green with simple and swift brush work, reflecting the skillful painting style of potters. The basic colourant of underglaze brown is oxidized iron, which gives a stable and clear effect without blurring in high-temperature firing, and thus potters often used this colour to depict the decorative designs with fluent and clean brush work. The basic colourant of underglaze blue and green is oxidized copper which tends to be blurred and diluted in high-temperature firing. When brown and green or brown and blue colours are used together, the techniques of outlining in brown are applied first, and then washes in green or blue colours would be applied. On the other hand, the potters at the Changsha kiln also employed various text characters such as a single character, adages, advertisement statements, poems and odes to decorate ceramic wares with skillful treatments. Statistics reveal that wares with poetic inscriptions amounted to over 190 pieces, and altogether there are around 60 different poems inscribed. These poems not only came from famous poets such as Gao Shi, Liu Changqing, Jia Dao, Bai Juyi, etc., but also from folk poems with a rich content, reflecting the life and practices of the people at that time.

In addition to catering for the local markets, Changsha wares were also for export purposes, and shipped to Korea, Japan, Philippines, Thailand, Indonesia, Malaysia, Sri Lanka, Pakistan, Oman, Iran, Saudi Arabia, Iraq, Egypt, Kenya, Tanzania, and other countries, and a number of these Changsha wares of the Tang Dynasty had been unearthed there. In 1998, a shipwreck of the Arabian *dhow* was found at the strait near Belitung Island at Sumatra, Indonesia. Investigations reveal that this vessel was a ship of the Tang Dynasty launched from West Asia to carry commercial cargoes but sunk into the sea during an accident. In the salvage of the shipwreck, a number of around 60,000 ceramic wares of the Changsha kiln, Yue kiln, and Xing kiln were found, and Changsha wares amounted to some 50,000 pieces. On a bowl, there is an inscription "The 16th day of the seventh

month of the second year of the Baoli period." The second year of Baoli corresponds to 826 A.D. and this inscription provides evidence of the period when the vessel was in service. These excavated artifacts reflect the large scale and numerous destinations for export of Changsha wares at the time.

Compared with Changsha wares with decorations painted in underglaze colours, products from the Qionglai kiln county were rather coarse and the decorations were usually casually painted and I would not go into details of these wares in this article.

Porcelain Wares with Decorations in Black Glaze on a White Ground

The production of porcelain wares with decorations in black glaze on a white ground started in the late Northern Song Dynasty and was represented by the Cizhou wares produced at the Ci county and Handan city, Hebei province. These wares were popularly produced since the period of Emperor Hailing of the Jin Dynasty (1149–1611) to the Yuan Dynasty (1276–1368), and many kilns were engaged in producing these wares which form a distinctive type of its own.

In producing these wares, mineral stones from the lean iron ore was first grinded and then mixed with water. After the wares were fashioned, potters would paint the decorative designs with a brush on the biscuits dripped with white slip and then covered with transparent glaze. The wares were then fired in high temperature. An eminent aesthetic effect would be produced with the strong contrast of colour tones between the black decorative designs which stood out against the white glazed ground. In accordance with the content of oxidized iron in the pigment and the variations of firing temperatures, the designs would appear in dark black, tea-brownish, paste-like yellow, etc., but they are usually collectively known as "wares with black decorations on a white ground."

Porcelain Wares in Underglaze Blue

Underglaze blue wares are produced with oxidized cobalt as the primary colourant and the decorations are painted on the potted biscuits. Then the wares would be covered with transparent glaze

and fired in a high temperature above 1,250°C to become wares with decorations in underglaze blue on a white ground. The Chinese often mixed the terms "*lan*" *(blue)* and "*qing*" (green) and called these wares as "*qinghuaci*" (literally means porcelain wares with green decorations, which actually refer to "underglaze blue or blue-and-white" wares).

It is known that already in the early ninth century, the kilns at Gong county (nowadays Gongyi city), Henan began to produce wares in underglaze blue. In the shipwreck of the Arabian dhow mentioned above, plates in underglaze blue produced by the Gong county kiln were also found. Since 1975, shards of pillows, plates, bowls, ewers, and vases in underglaze blue of the Tang Dynasty were unearthed at sites at Yangzhou, Jiangsu. Their paste, glaze, decoration, and the colour of underglaze designs share similar features with the plate in underglaze blue found on the dhow and thus prove that underglaze blue were already produced in the late ninth century.

The most representative kiln in producing underglaze blue wares is the Jingdezhen kiln, which started production of these wares in the Yuan Dynasty and up to the present. Underglaze blue wares are the largest scale and best quality wares of the Jingdezhen kiln. Although underglaze blue wares were produced by primarily using cobalt blue in painting decorative designs, differences of aesthetic tastes in various periods and sources of cobalt blue had given underglaze blue wares of different periods their distinctive period styles and characteristics. For instance, on typical underglaze blue wares of the Yuan Dynasty, imported cobalt blue was used. In the Yongle and Xuande period, imported *soleimani* blue was used, and in the Chenghua and Hongzhi periods, *pingdenging* (also known as *beitangqing)* cobalt materials from Leping county, Jiangxi was used. On the Wanli underglaze blue wares, both *shiziqing* cobalt blue from Shanggao county, Jiangxi and imported Mohammedan blue were mixed in designated proportions for painting decorative designs. On the Kangxi underglaze blue wares of the Qing Dynasty, either the *zhe* cobalt blue from Zhejiang or the *zhumingliao* cobalt blue from Yunnan was used. As a result, the Yuan underglaze blue wares are marked

with bright and brilliant colour tones, the Yongle and Xuande underglaze wares are marked with dense and luxuriant colour tones with heaped-and-piled effects, the Chenghua and Hongzhi underglaze blue wares are marked with soft and clear colour tones, the typical Jiajing and Wanli underglaze blue wares are marked with thick and dense colour tones, and the Kangxi underglaze blue wares are marked with transparent and bright colour tones and so on. Conclusively speaking, the best wares in the history of underglaze blue wares produced by Jingdezhen kiln should be those from the Yuan Dynasty, Yongle, Xuande, Chenghua periods of the Ming Dynasty, the transitional period in the late Ming and early Qing periods, as well as the Kangxi period of the Qing Dynasty. The press-hand stem-cups decorated with design of lotus scrolls in underglaze blue of the Yongle period (Plates 28, 29) provide refined examples which are very valuable and rare.

Among the various types of Chinese painted polychrome wares in different glazes and enamels, underglaze blue wares are produced in the largest scale with the most profound impact because they have a number of significant features that other types of wares cannot match.

Firstly, underglaze blue wares are a type of wares with underglaze decorations fired in high temperature. As the decorations are covered with transparent glaze, they would not easily depreciate, lose colours, or possess poisonous lead. Secondly, aesthetically underglaze blue wares give pure, lyrical and subdued appeal. The white is the purest colour and the blue is an unadorned but serene colour. With the decorations in the pure white glaze with a light greenish tint, these wares give a touch of beauty that are reminiscence of a charming scene of green water, blue sky, and white clouds. From an appreciation angle, people favour the calm, brilliant but not extravagant, and serene appeal of these wares. Technically speaking, the firing of underglaze blue wares is easier to handle and a vast scale of production is achievable, making it the most popular type of ceramic wares.

Underglaze blue wares have superb artistic merits for they are art works that incorporate both ceramic production and painting techniques with Chinese brush. Compared with Chinese rice paper, the paste of porcelain is even more water absorbent. In such a regard, it is necessary to command a consummate mastery of the brush in a fluent and skillful manner according to the artists' mind, which require substantial artistic cultivation. Once the state of merging the brush and the mind is attained, then a new artistic realm could be created. These wares create serenity that generates a state simulating the existence of heaven and earth of quietness without sound, movement that expresses a dynamic and vigorous rhythm, a world of spontaneity with unbound mist and waves as well as myriad peaks and mountains, and delicacy that manifests meticulous brush work with every detail rendered. Such an artistic appeal is very different from the flat wash painting on the wares with black decorations on a white ground or wares simply decorated with red and blue decorations as seen on the Cizhou wares of the Jin Dynasty. In particular in the Kangxi period of the Qing Dynasty, potters and ceramic artists had brought the art of underglaze blue wares to its cradle by commanding the "water-dilution" technique. Such a technique is to dilute underglaze blue pigments into various tonal gradations such as "dense richness," "primary richness," "secondary richness," "primary lightness," and "shading lightness." According to the pictorial treatment, potters and ceramic artists would paint the decorative designs in different tonal gradations to create shading effect, sense of dimensionality and perspective. For instance, on the work *Covered-jar decorated with a scene "Farewell at the Tiger Stream" in underglaze blue* (Plate 76), although only one single colour of underglaze blue is used, however, by manipulating water-dilution techniques in rendering the decorations, the pictorial treatment is imbued with rich layers, brilliance, and brightness.

Since the 14th century, underglaze blue wares were not only available on the local market but also extensively exported to other countries and won high esteem. The Tokapi Saray Museum in Turkey and the Ardebil Shrine in Iran have large number of underglaze blue wares of the Yuan and Ming Dynasties in their collections. From the 17th to the 18th century, Augustus II, Monarch of Poland (member of the royal

family of the Kingdom of Saxony and prince-elector of the Holy Roman Empire) and the Kings Louis XIV and Louis XV of the House of Bourbon in France were devotees to Chinese ceramics and intensively collected Chinese ceramic wares, including a large number of underglaze blue wares. Since the 17th century, various countries including Japan, Iran, Holland, Britain, France, Germany, Italy, and others had imitated and copied Chinese underglaze blue wares in their production of ceramics, and this fully reveals the extensive impacts of underglaze blue wares in the world.

Porcelain Wares in Underglaze Red

In comparison with the term "underglaze blue" comes the term "underglaze red," which is the type of wares decorated in copper red glaze or painted in copper red glaze, the colourant of which is oxidized copper. The result aims to create decorations in red on a white glazed ground, and is thus called "underglaze red." Compared with underglaze blue, the atmosphere and firing temperature in the kiln for copper oxide have more rigid requirements. Any deviations would lead to inaccurate colour of pure red. As the front and rear chambers, the left and right parts, and the upper and lower sides of a kiln have different temperatures, it is even more difficult to technically master the successful firing of underglaze red wares than that of the underglaze blue wares.

In accordance with decorative techniques, there are four main types of underglaze red wares. The first is to paint the decorative designs on the biscuit with copper red pigments and cover with transparent glaze. Then it is fired in high temperature reduction atmosphere in the kiln and this type of wares is known as "underglaze red wares with linear decorations." The second type is to carve decorative design on the biscuit covered with transparent glaze, and then fills the designs with copper red pigments and fired in high-temperature reduction atmosphere. Referred to as *baoshao* (precious firing) in historical records, this type of wares is actually partially decorated with copper-red glazed designs fired in high temperature. The third type is to paint patches or splashes of copper red on the surface of the wares and then cover with transparent glaze. Afterwards, these wares are fired in high temperature reduction atmosphere to produce red splashes or patches on a white ground. The fourth type is to apply copper red pigments (sometimes with incised decorative designs) on the spare areas outside the main decorative designs and fire in high-temperature reduction atmosphere to produce designs in white on a red ground, which is known as "lifted white designs in underglaze red."

Underglaze red wares were first produced at the Jingdezhen kiln in the Yuan Dynasty, but only a limited quantity was produced and the colour was not accurate and pure. Excavations at the Imperial Kiln of the Ming Dynasty at Zhushan, Jingdezhen show that a large number of underglaze red wares were produced in the Hongwu, Yongle, and Xuande periods, but owing to the technical difficulties, wares successfully fired were not many and a large number of wastes were left. As a result, the production of underglaze red wares declined since the Xuande period, and was not revived until the Kangxi period of the Qing Dynasty. In the Qing Dynasty, the mastery of firing underglaze red wares significantly surpassed that of the Yuan and Ming Dynasties. In particular in the Kangxi, Yongzheng, and Qianlong periods, the colour of underglaze red was accurately and successfully fired, and even with tonal gradations to enhance the appeal of decorative designs, reflecting that the production of underglaze red wares had reached a new height. For example, the *meiping* vase decorated with design of dragons reserved in white and cresting waves in underglaze red (Plate 104) has an elegant form with pure colour tone, which is a refined representative piece of underglaze red ware.

Porcelain Wares in Underglaze Blue and Red

This type of wares refers to those decorated with designs in both underglaze blue and red, which was first produced in the Jingdezhen kiln in the Yuan Dynasty, yet there are only four pieces extant with one collected by the Palace Museum, Beijing (Plate 110). It is mentioned above that the firing requirements and atmosphere in producing underglaze red wares are more rigid than that of the underglaze blue, and thus it is more difficult to achieve accurate colours of

both underglaze blue and red designs on a same piece which is fired in the same temperature and firing atmosphere at the same time.

As technical requirements for production this type of wares are rigid, there are few wares of the Ming Dynasty extant. Since the 1980s of the 20th century, a number of wasted wares of the Yongle and Xuande periods were unearthed at the Imperial Kiln site of the Ming Dynasty at Jingdezhen, which provides us with reference materials for the study of the production of these wares at the time. Unearthed artifacts include *meiping* vases, stem-bowls, stem-cups, etc., most of which are decorated with cresting waves in underglaze blue and dragons, sea beasts, and fishes in underglaze red, etc. Since the Xuande period, few wares in underglaze blue and red were produced. On the bowl decorated with design of children at play in underglaze blue and red (Plate 111), only the dresses and trousers of some figures are painted in copper red and the colour turns to pale dark, however, it is still regarded as a valuable piece since not many pieces were produced successfully at the time.

In the Kangxi, Yongzheng, and Qianlong periods of the Qing Dynasty, the production of underglaze blue and red wares reached a high standard. Both the combined use of underglaze blue and copper red pigments and the combined use of underglaze blue and copper red glazes were successful with the colours of red and blue accurately achieved in pure colour tones. On the *meiping* vase decorated with dragons amidst clouds and waves in underglaze blue and red, the colour of underglaze blue is dense and brilliant, whereas the colour of underglaze red tends to be light and soft, which is a representative piece of the imperial underglaze blue and red wares of the Qianlong period, Qing Dynasty.

Porcelain Wares in Three Underglaze Colours

This type of wares with designs in three underglaze colours was a new type of wares painted with colours under the glaze and first produced in the Kangxi period, Qing Dynasty based on the production of underglaze blue and red wares. Other than the underglaze blue which has oxidized cobalt as colourant and underglaze red which has oxidized copper as colourant, a new colour of pea-green with oxidized iron as colourant was added, and thus this type of wares in three underglaze colours came into being. Most of these wares produced in the Kangxi period, Qing Dynasty were imperial wares and forms include brush-pots, *zun* vases in the shape of phoenix's tails, *gu* flower vases, various types of vases, jars, basins, boxes, bowls, etc., and they are often decorated with flowers, birds, landscapes, pines, bamboo, plum blossoms, etc. in a refreshing manner with a touch of archaic favour. The exterior base is often written with a six-character mark of Kangxi in three columns in underglaze blue, a six-character mark of Kangxi in three two columns within a double-line medallion in underglaze blue, or an imitated mark of the Xuangde period of the Ming Dynasty.

Porcelain Wares with Designs in High-temperature Five Colour Enamels under the Glaze

This new type of wares with designs in five colour enamels under the glaze was first produced in the 34th year of Guangxu (1908) by the Hunan Ceramics Company founded by Xiong Xiling (1870–1937).

Xiong Xiling, styled Bingsan, was a native of Fenghuang county, Hunan province and a noted politician in modern China. In the 30th year of the Guangxu period (1904), he was sent to Japan by Duan Fang (1861–1911), the Governor of Hunan to inspect industries and business. He found that ceramic industries in Japan were very prosperous and even surpassed that of China. In the 31st year of Guangxu (1905), the Provincial Government established the Hunan Ceramics College with Xiong appointed as managing director who initiated to employ Japanese as tutors for training of ceramic potters and artists. In the 32nd year of Guangxu (1906), he raised funds by selling shares to establish the Hunan Ceramics Company at Liling, Hunan and recruited accomplished potters and artists from Jingdezhen kiln to teach the techniques in producing refined wares. Since then, the ceramics industry at Liling flourished.

The distinctive feature of wares with designs in five colour enamels is that the decorations are painted in various colour enamels under the glaze and fired

in high temperature. Basically five colours are used including deep green, blue (sea-green), tea-brownish colour, agate colour, and bright black, and thus collectively known as "five colour enamels under the glaze." These colours can be matched in different proportions to produce a wider range of colours, as compared with the single or double colours under high-temperature fired glaze produced in the preceding periods. From the first year of Xuantong period to the fourth year of the Republican period (1909–1915), this type of wares had won various awards in Industrial Fairs and Expositions held in China and as a result, ceramic wares produced from Liling also won high esteem in China as well as overseas.

Porcelain Wares in *Wucai* (Five Colours) Enamels

There are two types of wares in *wucai* enamels in the Chinese tradition. One type is known as "wares in overglaze *wucai* enamels," which are produced by painting decorative designs in red, green, yellow, aubergine, and black enamels on the fired body in white glaze and then fired a second time in a baking atmosphere in the kiln. Another type is to paint part of decorative designs in underglaze blue and leave spaces in the pictorial composition for later application of colour enamels. After covered with transparent glaze and fired in high temperature, then decorative designs would be painted within the outlines by filling in colour enamels or painted with designs in colour enamels with boneless washing technique and then fired in a baking atmosphere for a second time in the kiln, which is known as "wares in underglaze blue and *wucai* enamels."

This type of wares in overglaze *wucai* enamels was derived from the five-coloured wares from the Ding kiln and the Cizhou Kiln at the northern part of China in the Northern Song and the Jin Dynasty, and was first produced in the Yuan Dynasty. Most of the *wucai* wares of the Ming Dynasty are wares in underglaze blue and underglaze *wucai* enamels, and only a few belong to the category of overglaze *wucai* enamels. The production of wares in underglaze blue and *wucai* enamels began in the Xuande period

of the Ming Dynasty, and reached its bloom in the Jiajing, Longqing and Wanli periods with new heights attained. On a *gu* vase decorated with designs of dragons amidst clouds, birds and flowers in *wucai* enamels (Plate 128), the decorative designs are rendered in luxuriant pictorial treatment and painted with dense colour tones, representing a refined ware of the *wucai* enamelled wares of the Wanli period. Yet it is noted that in the Ming historical documents, both wares in underglaze blue and *wucai* enamels and wares in *doucai* (competing colours) enamels were collectively known as "*wucai* wares."

Wares in *wucai enamels* of the Qing Dynasty could be divided into two major types: wares in underglaze blue and *wucai* enamals and wares in overglaze *wucai* enamels. Compared with the wares in *wucai* enamels of the Ming Dynasty, wares in *wucai* enamels of the Qing Dynasty had attained progressive developments in terms of porcelain quality, variety of colour enamels, painting styles, and other aspects. From the Shunzi to the Xuantong period of the Qing Dynasty, the production of wares in *wucai* enamels continued without stop, however, it was the wares in *wucai* enamels of the Kangxi period that best represent the high production standard of this type of wares in the Qing Dynasty.

In terms of the wares with *wucai* enamels of the Kangxi period, the enamels were not only confined to the colours of red, yellow, green, brownish-red, aubergine, and others commonly found in the Ming Dynasty, but the most significant breakthrough was the innovative use of blue enamel over the glaze, the application of shiny bright black enamel like the colour of black lacquer, and the sprinkling gilt enamel. The artistic expressiveness was thus much enhanced with high aesthetic appeal. For example, on the *zun* vase decorated with design of egrets in a lotus pond in *wucai* enamels (Plate 135), red, blue, green, gilt, and other colour enamels were employed to depict the elegant scenes of a lotus pond, and in particular the use of large areas of gilt designs added charm and luxuriance to the pictorial rendering which was in vogue in the period. To replace underglaze blue with overglaze blue enamel further facilitated the production of painting and firing of *wucai* wares with

a large number of which produced at the time. The Kangxi *wucai* wares were not only noted for luxuriant colour schemes, but also for exquisite painting skills and naturalistic rendering, which alternated the decorative style of focusing more on enamel colours rather than pictorial representation in the Ming Dynasty. Kangxi *wucai* enamels were mostly thinner than that of the Ming counterparts, and were fired at around 800°C, which was a bit higher than the 700°C firing temperature of *yangcai* (commonly known as *fencai*) enamels. After firing, the enamel would have a transparent glassy quality which gives a sense of hardness and solidity, and thus it was also known as "hard enamel."

Porcelain Wares in Doucai (Competing Colours) Enamels

Doucai wares are produced by combining both underglaze blue and overglaze colour enamels in painting the decorative designs with designated aesthetic appeals and effects. On a potted biscuit, decorative designs would be outlined or partially painted first, and then covered with transparent glaze and fired in high temperature. Afterwards, parts of the decorative designs would be painted, washed, covered, or dotted in various colour enamels. Upon completion of painting the designs, the ware would be fired in a baking atmosphere in low temperature in the kiln. As a result, contrasting and competing colour schemes of underglaze blue and overglaze colour enamels would be created.

The production of *doucai* wares was initiated in the Xuande period, Ming Dynasty, developed in the Chengtong period, and matured in the Chenghua period with the latter most esteemed. Forms include jars, vases, boxes, bowls, plates, cups, stem-cups, dishes, and others which are characterized by thinly potted bodies and refined quality. The transparent glaze is shiny, translucent, and has a jade-like quality, and the decorative designs are painted with soft, charming and subtle colour tones in a delicate and lyrical manner. The pair of chicken cups in *doucai* enamels (Plate 149) is potted with a new form and painted with superb brush work, which won unprecedented esteem. Guo Zizhang of the Ming

Dynasty commented that, "The chicken cups of the Chenghua Imperial kiln were the most superb among all wine vessels." Gao Danren, a connoisseur of the early Qing period, commented that, "There were various types of wine cups of the Chenghua period, and they were painted with exquisite decorations, subtle colour schemes with shading effects, as well as with shiny and refined bodies. In particular, on the chicken-cups decorated with peonies, the chickens were depicted with a touch of vividness and realism."

The colour enamels of the Chenghua *doucai* wares are characterized by luxuriant, transparent, and bright tones. They bear marks written in regular script in underglaze blue. Only one type of reign mark with the six-character mark of Chenghua is found. An alternative mark *tian* is found in the center of the exterior base of wares such as jars decorated with design of dragons in pursuit of pearl above cresting waves in *doucai* enamels, mythical beasts in cresting waves in *doucai* enamels, jars decorated with design of heavenly horse and cresting waves in *doucai* enamels (Plate 144), covered jars decorated with design of lotus scrolls and a mark *tian* (heaven) in *doucai* enamels (Plate 145), jars decorated with Eight Precious Emblems supported by lotus scrolls in *doucai* enamels, etc.

In conclusion, the porcelain quality, typeforms, decorative designs, and painting techniques on Chenghua *doucai* wares are consummately merged and mastered to create an unprecedented type of refined wares, which is a gem in the art of ceramics in China.

It is agreed that *doucai* wares were first produced in the Jingdezhen kiln in the Ming Dynasty, however, this specific term was not found in historical records of the Ming Dynasty. Various writings and publications on ceramic wares of the Ming Dynasty only quoted the term "*wucai*" or "underglaze blue interspersed with five colours" to refer to this type of wares instead of "*doucai*."

Doucai wares of the Qing Dynasty could be classified into two main types. One type imitated those of the Chenghua *doucai* wares whereas another type was wares with distinctive period styles of its own.

Kangxi *doucai* wares in imitation of Chenghua proto-types include imitations of the chicken-cups, cups decorated with design of lotus sprays, cups decorated with design of dragons in pursuit of pearl, cups decorated with design of grapes and melons, jars decorated with design of flowers and butterflies, etc. Although the decorations were not as vivid as that of Chenghua wares, however, they still maintained a high standard of quality and were the best of the imitations in various periods. New creative forms of the *doucai* wares of the Kangxi period are mostly plates, bowls, and cups, but there are also other new types of wares such as jars, Ben Pakistan ewers, flower basins, pear-shaped vases, brush pots, water pots, covered boxes, etc. The most distinctive type of the *doucai* wares of the Kangxi period is represented by a type of large flower pots which are fashioned in various square, hexagonal, oval, begonia, and foliated shapes.

In terms of forms, decorative treatment, combination of colours, and painting technique, the *doucai* wares of the Yongzheng period marked a new zenith. In particular potters and ceramic artists utilized *yangcai* (a style in imitation of western painting) enamels, and painted the decorative designs in colour washes with meticulous brush work and luxuriant palette, bringing a touch of realism to pictorial subjects.

The form, painting style and luxuriant colour scheme of *doucai* wares of the Qianlong period were basically similar to that of the Yongzheng period. Yet there were new features such as more geometric pictorial treatments of decorative designs, complicated compositions and application of more designs painted in gold which generate a most elaborate and sumptuous elegance.

After the Jiajing period and with the decline of power of the court, less *doucai* wares were produced and there were nearly no innovations. Most of the *doucai* wares were merely imitations of wares in the preceding periods.

Porcelain Wares in Opaque Enamels (Falangcai or Cloisonné Enamels)

Wares in opaque enamels are also called "painted opaque enamels on porcelain biscuits." It was a new type of overglaze painted wares with the adoption of decorative style in colour enamels on copper cloisonné wares imported from Europe and then transplanted to decorate porcelain wares. The initiation of this type of wares was closely associated the personal favour of Emperor Kangxi for painting in opaque enamels.

Opaque enamel is a glassy substance in powder form with raw materials of feldspars and quartz. Alkali and sodium borate are used as fluxes with oxidized titanium, oxidized antimony, and fluoride serve as emulsions; and oxidized copper, oxidized cobalt, and oxidized iron as colourants. Then the materials would be grinded, mixed, heated, melted, and put into cold water to produce enamel blocks, and then further grinded into powder. After the enamel powders are mixed and applied on various gold, silver, and copper biscuits and fired, it would become painted opaque enamelled designs on metallic biscuits. If it is applied on glass biscuit, the piece would be called glass ware in opaque enamels. If it is applied on porcelain biscuit, it would be called porcelain ware in opaque enamels.

This type of wares was first produced and still in its initial stage of production in the Kangxi period, thus matching of colours, decorative styles and the format and writing style of reign marks generally followed those copper wares in opaque enamels. The ground was mostly painted in rouge-red, light yellow, blue, or coral-red, and the decorative designs were mostly confined to flowers without any bird. The reign mark is often a four-character mark of Kangxi written in regular script in rouge-red or blue enamel over the glaze, or a mark written in underglaze blue for the wares with a coral-red ground.

Emperor Yongzheng also had a fond favour for this type of wares and gave his personal advice on the production, thus bringing a leap in the production of wares in opaque enamels in the Yongzheng period. With a few exceptions which still have colour-enamelled grounds, a large number of wares are decorated with designs directly painted on a white glazed ground in opaque enamels. In terms of decorative motifs, the monotony of just painting with flowers without bird in the Kangxi period was given up, and various designs in the style of court painting

appeared, such as flowers and birds, flowers, bamboo and rocks, landscapes, etc., and were further enriched by poetic inscriptions with seal marks of literati taste put at the beginning and the end of the poems. The content of the poetic inscriptions fully matches the decorative designs and the fluent and swift brush work also complements the decorative motifs and the forms of the wares. For example, on the bowl decorated with orchids, rocks, and poetic couplet in opaque enamels on a light yellow ground (Plate 171), rocks and orchids are painted on the bowl with a yellow ground, and inscribed with the poetic couplet "On the island with cloudy mist is a path leading to immortality, the fragrance of orchids spread in Spring time," and matched by seal marks "*jiali,*" "*jincheng,*" and "*xuying*" in seal script, representing a refined porcelain ware assimilating the art of poetry, calligraphy, painting, and seal carving harmoniously.

The artistic merits of this type of wares produced in the Qianlong period were left behind that of the Yongzheng period. Archival documents show that the reason might have been the lack of competent potters and ceramic artists and frequent changes of posts at the Imperial Workshop. On the other hand, the different aesthetic tastes of Emperor Yongzheng and Qianlong might also lead to changes in the production. Wares decorated with designs by incorporating the arts of poetry, calligraphy, painting, and seal-carving, which were popular in the Yongzheng period, were continuously produced in the Qianlong period, and the style of poetic inscriptions and choice of seal marks were also similar to that of the Yongzheng period. New decorative motifs such as western ladies and children and a boy herding a buffalo are found on Qianlong wares in opaque enamels. However, it was the porcelain wares decorated with designs in *yangcai* enamels best represent the decorative styles of the Qianlong period, instead of the wares in opaque enamels.

Porcelain Wares in Yangcai (a Style Modelled after Western painting) and Fencai (Powdered) Enamels

There were three main types of wares in opaque enamels in the Qing Dynasty as recorded in the Qing court archive. The first type was "wares with porcelain biscuits painted in opaque enamels." The second type was "wares with porcelain biscuits and painted in *yangcai* enamels," and the third type was "wares in *wucai* enamels." The first type was discussed above and the other two types would be discussed below.

"Porcelain wares in *yangcai* enamels" refers to the wares decorated with designs by following the style of western painting in opaque enamels. In the 13th year of the Yongzheng period (1735), Tang Ying, the Director General of the Imperial kiln, mentioned in his book *Tao Cheng Jishi* that, "the *yangcai* wares were newly produced by following the styles of western painting in opaque enamels. Figures, landscapes, flowers, and birds were all rendered meticulously and delicately." From this record, it is known that the production of wares in *yangcai* enamels came into being in the Yongzheng period, and reached its zenith from the sixth year of the Qianlong period (1741) to the ninth year of the Qianlong period (1744) with fine quality and substantial quantity. After the Qianlong period and up to the Xuantong period, production of these wares by the Imperial Kiln at Jingdezhen still continued without any suspension.

In the Qing court archive, the term "*wucai*" covered a variety of porcelain wares. For example, the famous *doucai* wares of the Chenghua period, Ming Dynasty was also known as "*wucai* wares of the Cheng(hua) kiln." Polychrome ceramic wares with decorative designs rendered in the traditional Chinese painting style in opaque enamels, which are not the standard type porcelain wares painted in opaque enamels, are also sometimes called *wucai* wares. In the Republican period, people were of the view that this type of ceramic wares, together with wares in *yangcai* enamels, should be collectively called "wares in *fencai* (powdered) enamels" due to the soft and subtle aesthetic effects like painting with colour powders, and differentiate these wares from the wares in opaque enamels, and also gave it the term "(wares of) *guyuexian (Studio of the Ancient Moon)*." However, later people gave up this term because it lacks concrete evidence from past records to support this term, and alternatively adopted the term "porcelain wares in opaque enamels" as recorded in the Qing

court archive, which was commonly known as "wares in opaque enamels."

Considering that the *"wucai"* wares referred to in the court archives were decorated with designs painted in the wash and splash techniques with tonal gradations in the style of traditional Chinese painting, which was basically different from the traditional wares in *wucai* wares which were painted with single lines and flat brush work, and that there is not yet the most appropriate term to describe these wares, I still use the term *fencai* to describe these wares in my article.

The colour enamels used for decorating wares in opaque enamels, wares in *yangcai* enamels, and wares in *fencai* enamels were basically the same, however, they represent three different decorative styles on overglaze colour enamelled wares. In additional to the differences in painting style and decorative motifs, the styles in writing reign marks were also different.

Most of the wares in opaque enamels of the Yongzheng period are written with a four-character mark of Yongzheng in the Song regular style with double-line square in blue. The exterior line of the square is thicker whereas the interior line is thinner. There are also wares written with a four-character square mark of Yongzheng in regular script in rouge-red, or a six-character mark of Yongzheng in regular script in two columns in within a double-line medallion in underglaze blue. Wares in *yangcai* enamels are written with a four-character square mark of Yongzheng in seal script within a double-line medallion in underglaze blue.

Wares in opaque enamels of the Qianlong period are usually written with a square four-character mark of Qianlong in Song regular script or just in regular script within a double-line square, with the exterior line thicker and the interior line thinner. There are some examples that the thickness of both the interior and exterior lines is the same. Small pieces such as small cups, small vases, etc. are often written with marks not enclosed by squares or medallions due to the limited size of the base. There are four main types of reign marks on the porcelain wares in *yangcai* enamels of the Qianlong period. The first type is written with a square four-character mark of Qianlong in Song regular script and sometimes within a double-line square in blue. The exterior line of the square is thicker and the interior line is thinner, and there are examples with marks not enclosed within a square. The second type is written with a square four-character mark in seal script within a double-line square in blue. The exterior line of the square is thicker and the interior line is thinner. The third type is written a six-character mark or four-character mark of Qianlong in seal script in underglaze blue or iron-red. The six-character mark either has the six characters written in three columns or in one single horizontal line from the right to the left. The four-character mark either has the four characters written in two columns or in one single horizontal line from the right to the left. The fourth type is a six-character mark of Qianlong in seal script in three columns in relief under the glaze.

Wares in *fencai* enamels of the Kangxi period are written with a six-character mark of Kangxi in regular script in underglaze blue, or imitated six-character mark of Chenghua, Ming Dynasty in two columns, within a double-line medallion in underglaze blue. Some were incised or carved with a four-character mark of Kangxi. Most of the *fencai* wares of the Yongzheng period are written with a six-character mark of Yongzheng in regular script in two columns within double-line medallions or double-line squares in underglaze blue. There are also pieces written with a six-character mark of Yongzheng in regular script in three columns within a double-line medallion in underglaze blue, or a six-character mark of Yongzheng in seal script in three columns in underglaze blue. Wares in *fencai* enamels of the Qianlong period are often written with a six-character mark of Qianlong in regular script in three columns in underglaze blue on a white glazed ground.

Porcelain Wares in Mixed Glazes and Enamels

Porcelain ware in mixed glazes and enamels was another major type of ancient Chinese ceramics with a wide variety of works finely produced. Basically, this type of wares in mixed glazes and enamels can be sub-divided into two types. The first type is to paint a single colour enamel on a ground covered with white

glaze or *dongqing* celadon glaze, such as wares with designs in green enamel on a white ground, wares with designs in yellow enamel on a white ground, wares with designs in iron-red enamel on a white ground, wares with designs in brown enamel on a white ground, wares with designs in iron-red enamel on a *dongqing* celadon ground, etc. Another type is to paint decorations in a single colour enamel on a ground in other colour glazes, such as wares with designs in green enamel on a yellow ground, wares with designs in green enamel on an underglaze blue ground, wares with designs in green enamel on a black ground, wares with designs in yellow enamel on a green ground, wares with designs in yellow enamel on an underglaze blue ground, wares with designs in aubergine enamel on a yellow ground, wares with designs in aubergine enamel on a green ground, wares with designs in iron-red enamel on a green ground, wares with designs in iron-red enamel on a yellow ground, etc. Among these wares, those with designs in green enamel on a white ground, designs in yellow enamel on a white ground, designs in green enamel on a yellow ground, designs in green enamel on a yellow ground, designs in aubergine enamel on a yellow ground, designs in aubergine enamel on a green ground, and designs in yellow enamel on a green ground are closely associated with "wares in plain three-colour enamels," or we can say that the plain three colour glazes are derived from these wares in mixed glazes and enamels.

Porcelain Wares in Plain Three-Colour Enamels

Influenced by the pottery wares in low-temperature fired lead glazes of the Tang Dynasty, this type of wares was developed from the wares in mixed glazes and enamels only without the use of red glaze or enamel. They were first produced in the Chenghua period of the Ming Dynasty, and continuously produced in the Zhengde, Jiajing, and Wanli periods of the Ming Dynasty, and Kangxi period of the Qing Dynasty. In each stage of the development, there were innovations in terms of typeforms, decorative techniques, and choice of colours. Wares in plain three-colour enamels reached its golden period in the Kangxi period, Qing Dynasty.

In general, plain three colour enamels are confined to pouring yellow enamel, pouring green enamel (cucumber green enamel), and pouring aubergine enamel (light aubergine enamel). All these enamels are low temperature fired lead enamels and could be used as the ground colours, and then two other colour enamels are added. Sometimes peacock-green glaze, black glaze, white glaze, and others could also be applied to become three-colour enamels on a yellow ground, three-colour enamels on a green ground, three-colour enamels on an aubergine ground, and three-colour enamels on a peacock-green ground and so on. There are also wares with the above three kinds of low temperature fired enamels applied directly on a white ground of the biscuits. This type of wares first appeared in the Jiajing period, Ming dynasty, but the mass production of which was only materialized in the Kangxi period, Qing Dynasty, and became the most distinctive type of three colour enamelled wares of the Kangxi period. The typical technical rendering was to combine incised designs under the glaze with overglaze colour enamels that the incised designs under the glaze are barely visible and the overglaze designs stood out eminently with bright colour schemes. An example is the plate decorated with dragons amidst clouds, flowers, and fruits in plain three-colour enamels (Plate 286). Incised designs of dragons amidst clouds are visible under the painted design of flowers and fruits with a creative and skillfully designed treatment. Another type was a special type of plain three-colour enamelled wares, which was known as "three colours in tiger skin texture," the decorative style of which is to splash and pour yellow, green aubergine, and white enamels to form patches, which looks like the texture of a tiger's skin.

These two types of wares in mixed enamels and enamels and plain three-colour enamelled wares with similarities in technical production could be used for daily use such as drinking or dining wares, or used as ritual vessels in ceremonies and burial objects.

Fahua Pottery and Porcelain Wares

Fahua has different writings in the Chinese language, and *fahua* wares were first produced in the

southern and southeastern parts of Shanxi province in the Yuan Dynasty. They were also produced at other places such as Xi'an of Shannxi province, Luoyang of Henan province, and others, but the number was quite limited. Most of these wares were for use in temples and monasteries, such as incense-burners, vases, jars, stools, statues of immortals and Buddhist figures, and architectural components. Major colours include yellow, green, blue, and aubergine. Originally only pottery *fahua* wares were produced, and it was not until the mid-Ming Dynasty that potters in Jingdezhen successfully imitated these wares by using porcelain biscuits.

Fahua glaze was developed from the traditional low-temperature fired lead glaze in ancient China. The chemical components of these two types are basically the same, only with the difference in using fluxes. The colours of *fahua* glaze are more abundant, such as greenish-blue, golden colour, peacock-green, etc. which was not found in the low-temperature fired lead glazes. These wares require two stages of firing. The biscuit was fired in a high temperature of 1,200°C and then fired a second time in mid temperature of around 1,000 °C to 1,100°C in the kiln.

The most distinctive technique in producing *fahua* wares is the so called technique "raised slip" or "relief slip" technique. Firstly finely grinded clay slip is injected into a clay bag with a small tube. With the hand compresses the bag, the slip will be pushed out for outlining decorative designs on a ware. After slip cools down and becomes solid, then the biscuit would be fired for the first time in the kiln. When the piece is again cooled down, various colour enamels would be filled into the decorative designs and fired a second time in a baking atmosphere.

This type of wares was very popular in the Ming Dynasty, but declined in the Qing Dynasty.

COLOUR-GLAZED POTTERY WARES AND PAINTED POTTERY WARES

1

Painted Pottery Pot with Looped-handles
and decorated with design of spirals

Neolithic period Majiayao culture – Banshan type (ca. 2600 – 2300 B.C.)

Height 37 cm
Diameter of Mouth 10 cm
Diameter of Base 13 cm

The pot has a small mouth, a bulging belly, and a flat base. On the symmetrical sides of the belly is a pair of looped-handles. The biscuit has a dark-red tint. Two wide borders, one with saw-shaped designs glazed in black and other in red glaze entwined together on the shoulder and the upper belly, forming eminent spiral designs to show the dynamic movement of a forceful running river.

Painted pottery wares are those with decorative designs painted on the surfaces of wares with pigments made from natural minerals, and then fired in a baking atmosphere in the kiln. Majiayao culture is first discovered in Lintao in Gangsu province, and so it is named. It dates back to the late Neolithic period culture developed in the region in the upper stream of the Yellow River. Painted pottery wares attribute to one-third of Majiayao pottery unearthed.

According to the development of forms and designs, they can be categorized into four types: Shilingxia, Majiayao, Banshan, and Machang. The combination of subtle linear form, curves, and round dots in two continuous borders on this pot is typical decorative style of Banshan wares. Use of saw-shaped designs to decorate the decorative border is a distinctive decorative feature of Banshan painted pottery wares.

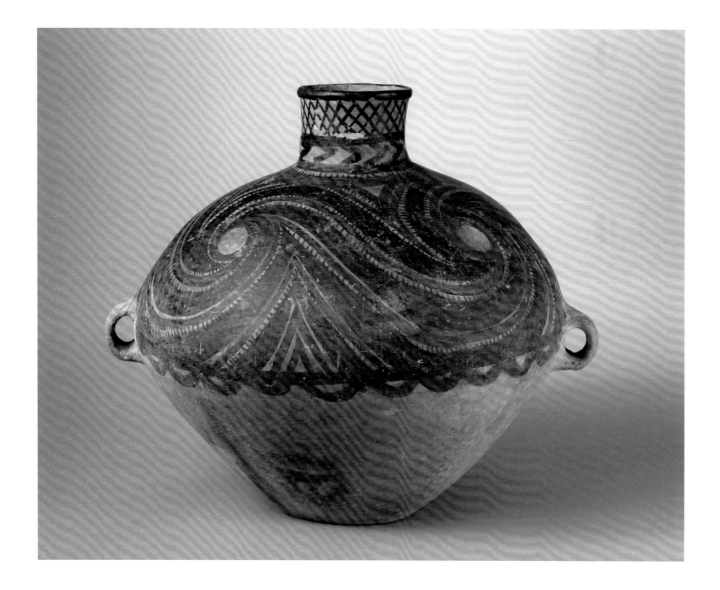

2

Painted Pottery Vase
decorated with painted design of the dragon and phoenix in relief

Western Han Dynasty

Overall Height 64 cm
Diameter of Mouth 21 cm
Diameter of Foot 24 cm

This vase has a plate-shaped mouth, a narrow neck, a round belly flattened on the sides, and a high stem ring foot. On the symmetrical side of the belly is a pair of mythical animal-masked handles. The jar has a matching round and convex cover. The body is painted with designs with a border of triangle designs underneath the mouth rim, design of waves and cloud patterns on the neck. Three borders of string patterns in relief separated the belly into upper and lower parts; with the upper part decorated with a dragon, a tiger, and birds enriched by cloud patterns, and the lower part is painted with floral and foliage scrolls.

The decorative patterns on this jar are modelled after the designs on lacquer wares of the same period. It is finely potted and painted in a fluent and swift manner. The use of red, green, blue, black, white, and yellow glaze is exquisite and elaborate. Though after 2,000 years, the glaze is still dazzling which is a rare piece in the painted pottery wares of the Western Han Dynasty.

Painted pottery wares are those with decorative designs painted on the surfaces of fired wares with pigments made from natural minerals, and not fired again in a baking atmosphere in the kiln. It was first produced in the late Neolithic period, and flourished in the Warring States period and Qin and Han Dynasties. Wares include vases, *dou* containers, basins, *zun* vases, and *ding* cauldrons, etc. Glazes used included red, black, yellow, white, and brownish-red. Patterns are often painted on grey pottery pastes, whereas the rich colour scheme and the sophisticated decorations generate a strong free and romantic aesthetic favour.

UNDERGLAZE POLYCHROME WARES FIRED IN HIGH TEMPERATURE

3

Ewer with a Handle
and decorated with design of birds and flowers in underglaze brownish-green in celadon glaze, Changsha ware

Tang Dynasty

Height 22.7 cm
Diameter of Mouth 11 cm
Diameter of Base 12.2 cm

The ewer has a flared mouth, a wide neck, a slanting shoulder, and a globular belly tapering downwards to a round cake-shaped base. On the belly are four vertical lines in recess to form fashion a melon-shaped ewer with an eight lobed short spout on one side of the shoulder while on the other symmetrical side is a curved spout. Two bushes of flowers and grasses and a bird with its head lifting up in green glaze outlined by brown glaze are painted underneath the spout. The decoration is completed with concise simple lines and brush work in a naturalistic manner, demonstrating the excellent painting skills of the potters in the Changsha kiln.

Changsha Kiln is one of the renowned ceramic kilns in the Tang Dynasty, noted for its innovative production of porcelain wares with underglaze decorations in celadon glaze, which were extensively exported. Green glaze is mostly used for decorative designs with a wide variety of motifs painted in a naturalistic style. The emergence of underglazed painted polychrome wares fired in high temperature paved a new path in the decoration of ceramics and has great significance in the development of history of Chinese ceramics.

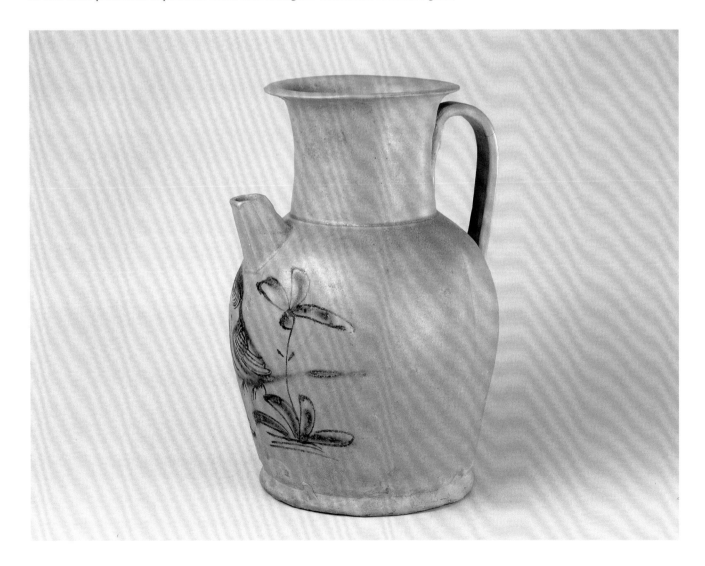

4

Pillow in the Shape of *Ruyi* Cloud
and decorated with design of peony scrolls in black glaze on a white ground, Cizhou Yaoxi ware

Jin Dynasty

Height 11 cm
Length 28.5 cm
Width 19.5 cm

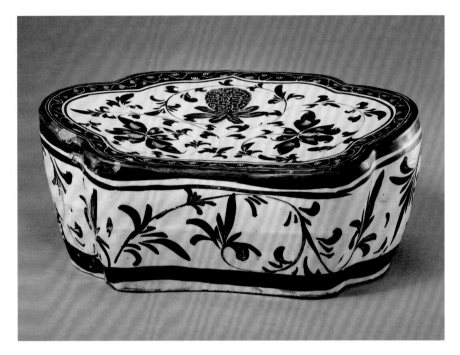

The pillow is in the shape of a *ruyi* cloud. The surface of the pillow is outlined by a black border, in which wave patterns are painted. On the border, a line is drawn along the shape of the pillow to encircle peonies and other floral designs. The vertical surface is painted with floral and foliage sprays. The exterior base exposes the brown glaze with remains of white slip and glaze, and has a round hole for releasing air during firing.

The pillow with decorations painted in black glaze which contrast with the white ground and generate a strong aesthetic effect. The decoration is painted gracefully which represents a refined ware of Cizhou wares in the Jin Dynasty.

The production of porcelain wares with decorations in black glaze on a white ground started in the late Northern Song and Jin Dynasties, and they were first produced at the Ci county in Hebei province. Influenced by it, such wares were in mass production in kilns at Henan, Shanxi, Shandong, and Inner Mongolia, which had become one of the extensive kiln systems and form a distinctive type of its own in the Jin and Yuan Dynasties. The style of this pillow is similar to those made in the Yu kiln and Hebi kiln at Henan, and is possibly a product of either of these two kilns.

5

Meiping Vase
decorated with design of
flowers and foliage patterns
in underglaze black
in green glaze,
Cizhou Yao ware

Jin Dynasty

Height 32 cm
Diameter of Mouth 3 cm
Diameter of Foot 7.6 cm

The vase has a small mouth, a short neck, a slanting shoulder, and a globular belly tapering downwards to a slightly splayed base and ring foot. The shoulder is decorated with three clusters of string patterns interspersed by wave patterns. The belly is decorated with four clusters of floral and foliage scrolls with the lower belly decorated with two clusters of string patterns interspersed by floral patterns.

Meiping vase was first produced in the Tang Dynasty, and then developed into a traditional stylized form of Chinese porcelain wares. *Meiping* vases were produced across all Dynasties with variations in style in different periods. This type of wares was first fired in high temperature to produce the decorative design in black glaze on a white ground, then applied with cucumber-green glaze and fired for a second time in low temperature. Cizhou kilns in the Jin Dynasty also produced decorative designs in black glaze on yellow and peacock green ground, and the production process is similar. Compared with wares decorated in black glaze on a white ground, wares in the above-mentioned categories were produced in low quantities, and extant and unearthed wares are rare and unusual.

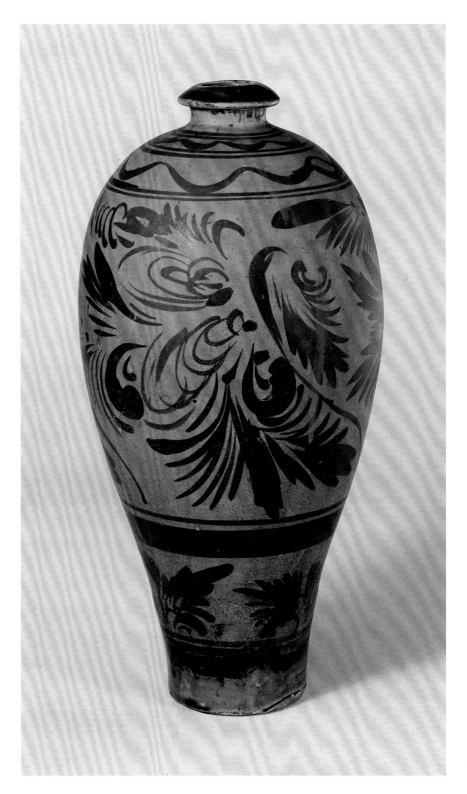

6

Jar
decorated with design of the dragon and phoenix in black glaze on a white ground, Cizhou ware

Yuan Dynasty

Height 28 cm
Diameter of Mouth 16.5 cm
Diameter of Foot 13 cm

The jar has an upright mouth, a short neck, a slanting shoulder tapering downwards to the belly, and a ring foot. The shoulder is decorated with chrysanthemum scrolls that are separated from the belly by three string borders. The belly is painted with dragon-and-phoenix designs.

The craft of decorative design in black glaze on white ground on Cizhou wares was that after the wares were fashioned, potters would paint the decorative designs with a brush on the biscuits dripped with white slip and then covered with transparent glaze. The wares were then fired in high temperature baking atmosphere.

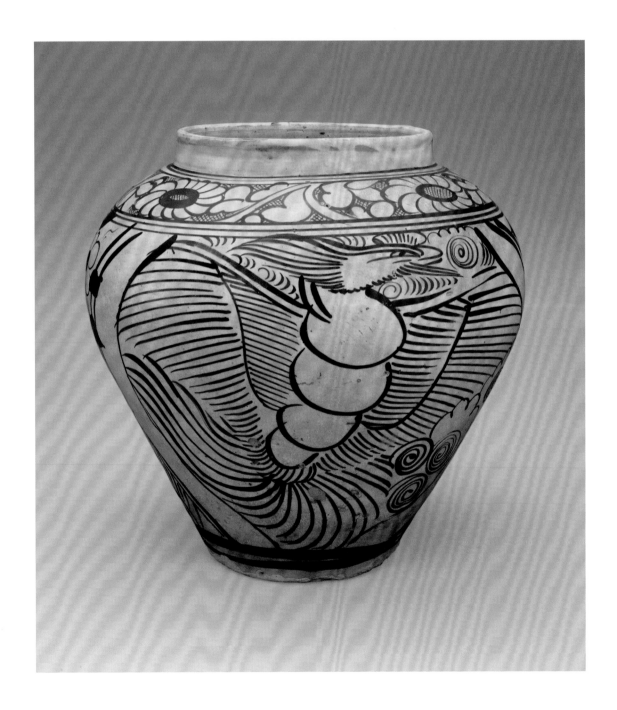

7

Octagonal *Meiping* Vase
decorated with design of
dragons reserved
in white amidst waves
in underglaze blue

Yuan Dynasty

Height 46 cm
Diameter of Mouth 6.6 cm
Diameter of Foot 14.5 cm

Unearthed in a cellar of the Yuan Dynasty at
Baoding, Hebei in 1964.

The vase is in octagonal shape with eight lobes and has a broad everted mouth, a sloped neck, a wide shoulder tapering downwards to the belly, and a ring foot. The mouth and neck are plain. The shoulder is decorated with a brocade border of lozenges, underneath are four symmetrical *ruyi* cloud collars, in each of which is painted with a *qilin* Chinese unicorn and a phoenix amidst lotus flowers. The belly is decorated with dragons amidst cresting waves. Four dragons with two horns, a slim neck, an elongated body and incised with scales in white glaze are depicted in various postures. Near the foot of the vase is decoration of four *ruyi* cloud-collars in which peony design is painted, which echo with the decorations on the shoulder.

Dragon is the most supreme mythical creature which is regarded as an auspicious symbol in the Chinese culture. In the Song and Yuan Dynasties, it is the symbol representing the virtue and power of the emperor, thus only wares used by the emperor are decorated with dragon design. Porcelain wares in underglaze blue in the Yuan Dynasty always borrow decorative designs from embroidery and silk garments, such as hanging *ruyi* cloud patterns and cloud collars are derived from decorations on shawls for decorating ceramics.

This vase is thickly potted and glazed in greenish-white with the decorative designs rendered with painterly quality and delicate brush work. The colour of underglaze is dense and solid, generating a sense of archaism.

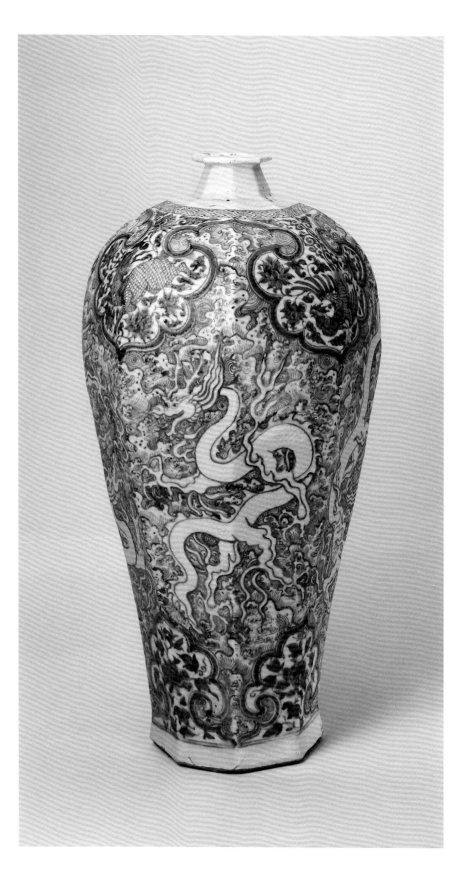

8

Ewer
decorated with design of
phoenixes amidst peonies,
rocks, and bamboos
in underglaze blue

Yuan Dynasty

Overall Height 23.5 cm
Diameter of Mouth 4.7 cm
Diameter of Foot 7.3 cm

The ewer has a small mouth that widens downwards to the hanging belly and a splayed ring foot. On the symmetrical sides of the belly are a narrow and curved handle and a curved spot on which is a round loop. It has a matching round cover with a flat top on which is a tourmaline knob. The body is decorated with phoenixes flying amidst peonies, complemented with bamboos and rocks underneath. The exterior wall of the ring foot is decorated with acanthus patterns. The interior is glazed in white. The top of the cover is painted with chrysanthemum petals design, the spout is decorated with flaming pearls, and the handle with silver ingots, hair-pin design and precious emblems.

Phoenix flying amidst peony is an auspicious decorative motif in Chinese tradition. In ancient mythology, phoenix is the most supreme among all kinds of birds while peony is the most esteemed among all kinds of flowers, which symbolizes wealth. Phoenix and peony as decorative motifs often carry auspicious blessings of wealth and fortune.

The form of the ewer is gracefully fashioned, and the glaze is pure and translucent, whereas the underglaze blue colour is dense and accurate. In the Palace Museum collection, the form and design of a ewer produced in the Longquan Kiln in the Yuan Dynasty is similar to this one. Hence, this type of ewers was likely produced both in the Jingdezhen kiln, Jiangxi province and Longquan kiln in Zhejiang province in accordance with designs issued by the court.

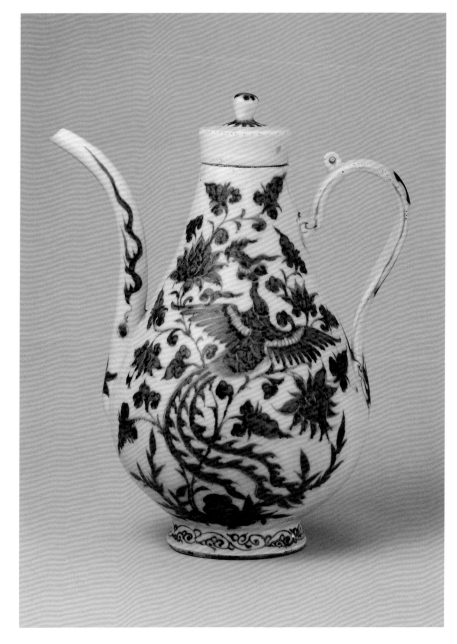

9

Jar
decorated with design of fishes and lotuses in underglaze blue

Yuan Dynasty

Height 31 cm
Diameter of Mouth 21 cm
Diameter of Foot 20.3 cm

The jar has a rimmed mouth, a short neck, a slanting shoulder, a globular belly, and a shallow and wide ring foot. The neck is painted with wave patterns whereas the shoulder is painted with peony scrolls design. The belly is depicted with four swimming fishes including *qing* (mackerel), *bo* (white fish), *li* (carp) and *gui* (mandarin fish) in a realistic style, which are puns for virtues "*qing bai li gui*" (pure, clean, etiquette, and noble) upheld by court officials. The fish designs are enriched by lotus, lotus seeds, and aquatic plants. The lower belly is painted with acanthus patterns and lotus lappets. On the base remains of glaze are found.

The colour of underglaze blue on this jar is dense and brilliant with a charming gracefulness, and the decorative designs are rendered with painterly quality and lofty resonance.

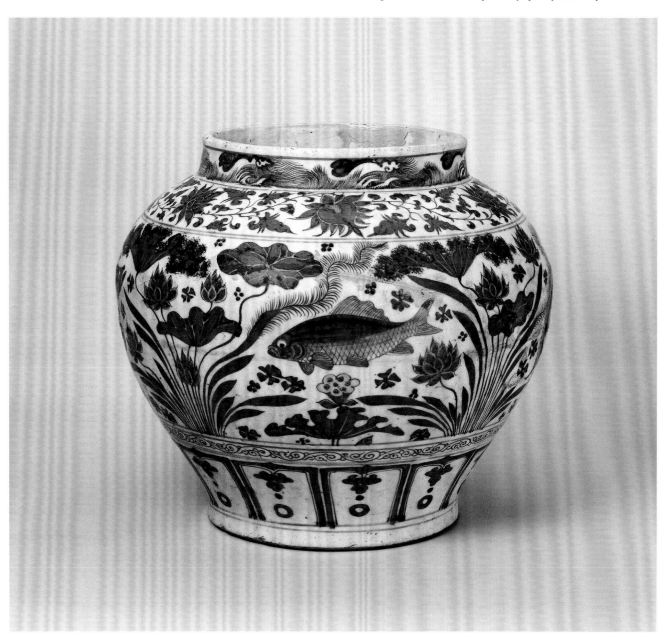

10

Plate with a Foliated Broad Everted Rim
and decorated with design of a pond scene in underglaze blue

Yuan Dynasty

Height 7.3 cm
Diameter of Mouth 46.4 cm
Diameter of Foot 29.8 cm

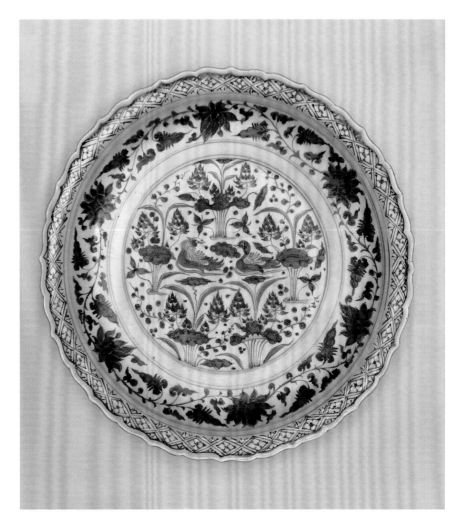

The plate is fashioned in the shape of sixteen petals of a water chestnut flower. It has flared mouth, foliated rim everted to a flange, shallow curved wall, and a ring foot. The centre of the plate is painted with two mandarin ducks swimming in a lotus pond, and looking at each other with affection. Both the interior and exterior wall of the plate is painted with lotus scrolls, with six lotuses in blossom stemmed from the stalk. Water chestnut flowers are painted on the foliated edge. The interior base of the plate is unglazed.

In Chapter 13 "Night Market" in the writing *Meng Liang Lu* written by Wu Zimu of the Southern Song Dynasty, there is a record of the merchandises sold at the night markets at Lin'an in summer and autumn, include a type of vests decorated with gauze patterns of "beauties in a lotus pond." Ke Jiusi, a painter of the Yuan Dynasty wrote in one of his odes collected in *Gongci Shiwu Shou* that, "Contemplating lotus flowers on a boat sailing on the Taiye Pond, there are mandarin ducks swimming amongst lotus flowers. I reminded the young court ladies to remember the robes of the emperor are sewn with embroidered designs of the scene of 'beauties in a lotus pond.'" Ke further remarked that "In the Tianli period, the imperial robes were often sewn with designs known as 'beauties in the lotus pond.'" From this record we can trace the origin of this decorative motif, which comes from the embroidery design as recorded in the above historical documents.

The form of the plate is elegantly potted and covered with pure and translucent glaze. The colour of underglaze blue is dense and brilliant, representing a refined underglaze blue ware of the Yuan Dynasty.

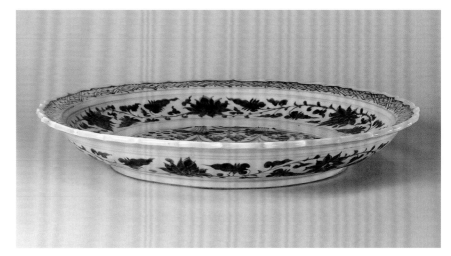

11

Ewer
decorated with design of flowers in underglaze blue

Ming Dynasty Hongwu period

Overall Height 37.8 cm
Diameter of Mouth 7.7 cm
Diameter of Foot 11.7 cm
Qing court collection

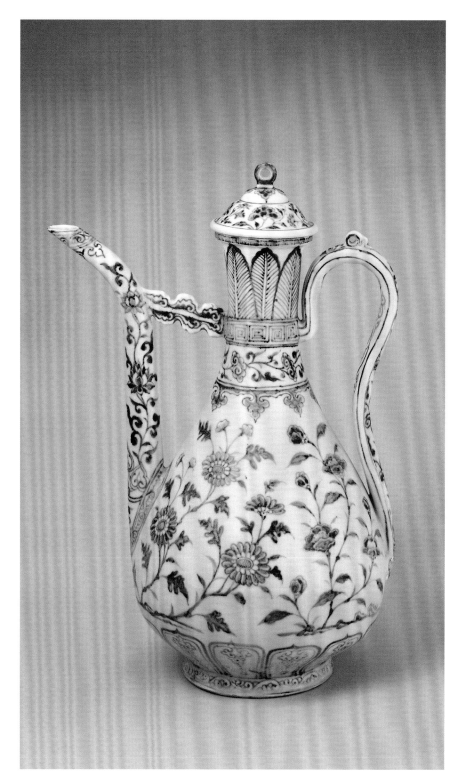

The ewer has a flared-mouth, a small neck, a hanging belly, and a ring foot. On one side of the belly is a long and curved spout which links to the neck by a cloud-shaped flange to support the long spout. On the symmetrical side of the curved spot is a curved handle. It has a matching canopy-shaped cover with a looped-knob. The mouth rim is decorated with key-fret patterns, while from the upper to the lower neck are decorations of banana leaves, key-fret patterns, *lingzhi* fungus scrolls and *ruyi* cloud lappets. The belly is decorated with chrysanthemums and camellias. Near the base, vertical lotus petal design is painted. The exterior of the ring foot is decorated with foliage scrolls; the surface of the cover is decorated with *ruyi* cloud patterns and floral sprays. The spout and the handle are decorated with lotus scrolls and foliage scrolls respectively.

This type of ewers is a variation of pear-shaped vases, by adding spout and handle, thus it is also named "pear-shaped ewer." It is commonly found in the imperial wares of the Hongwu period, including underglaze blue, underglaze red and Longquan celadon wares. Distinctive decorative styles, such as s stems of banana leaf are reserved white, interweaved key-fret patterns, independent lotus petals without linking together, and flattened chrysanthemums, are different from the decorative styles of the Yuan Dynasty, reflecting a prominent period style of its own in the Hongwu period.

12

Plate with a Foliated Broad Everted Rim
and decorated with design of *lingzhi* funguses, rocks, and bamboos
in underglaze blue

Ming Dynasty Hongwu Period

Height 8 cm
Diameter of Mouth 46 cm
Diameter of Foot 26.7 cm
Qing court collection

The plate has a foliated edge everted to a flange, a curved wall, and a ring foot. The centre of the plate is decorated with a lozenge-shaped panel in which there are rocks, bamboos, and *lingzhi* funguses surrounded by a border of acanthus patterns. The exterior wall is decorated with chrysanthemum scrolls, and near the foot are decorations of lotus lappets. The interior of the ring foot is unglazed, exposing the paste with reddish tint.

The plate is in an unusual large size and decorated with designs painted in a consummate and skillful manner with swift and fluent brush work. The designs of bamboos and rocks are in reminiscence of the literati taste. Decorative motifs in the interior and the exterior also carry auspicious blessings of fortune, longevity, and progeny.

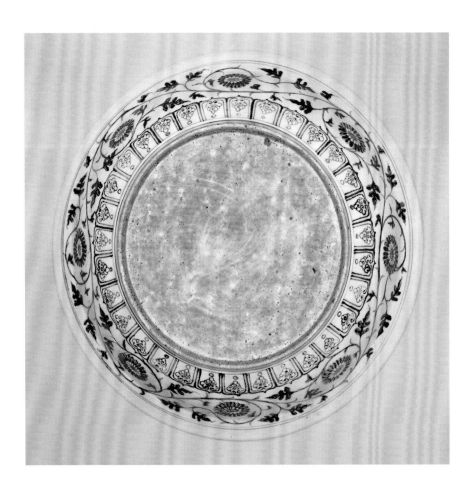

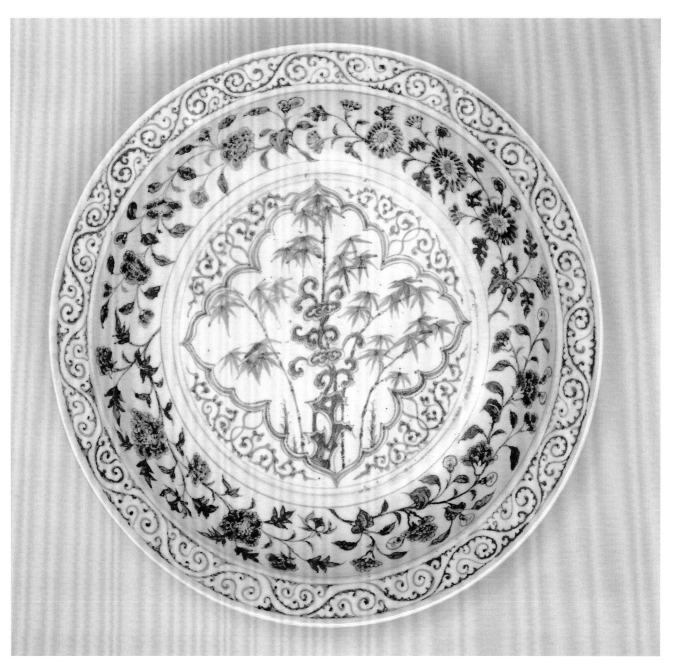

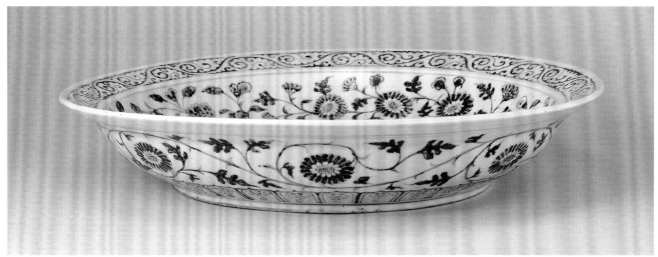

13

Meiping Vase
decorated with design of
peach trees
in underglaze blue

Ming Dynasty Yongle period

Overall Height 41.7 cm
Diameter of Mouth 2.8 cm
Diameter of Foot 4.5 cm

The vase has an everted mouth, a short neck, a slanting shoulder, and a belly tapering downwards to a slightly splayed base and a shallow and wide ring foot. It has a matching bell-shaped cover, on which is a round tourmaline knob. The shoulder is decorated with foliage scrolls whereas the belly is painted with peach trees with ripe peaches on the branches. Chrysanthemum scrolls are painted near the base. The surface of the cover and knob is painted with lotus lappets whereas the exterior wall of the cover is decorated with fruits and floral sprays.

The form of the vase is well fashioned with fine paste and shiny translucent glaze. The decorations are rendered with painterly brush work and delicacy, which carry the auspicious meaning of longevity. The underglaze blue was the imported *soleimani* blue material from West Asia that contained high oxidized iron and low manganese oxidize with a diluted and suffused aesthetic effect, which imbued the decorative designs with tonal gradations and heaped-and-piled effect with the appeal of ink painting on Chinese rice paper.

Yongle and Xuande periods are golden periods in the development of Chinese porcelain wares in underglaze blue. Wares produced in the Jingdezhen Kiln are of impeccable craftsmanship in terms of form, paste, painterly techniques, decorative styles, and writings of reign marks. Typical wares of Yongle and Xuande periods used imported *soleimani* blue material in painting decorative designs, giving a dense and bright colour tone with crystallized heap-and-piled effect which is also known as 'iron-rust" patches.

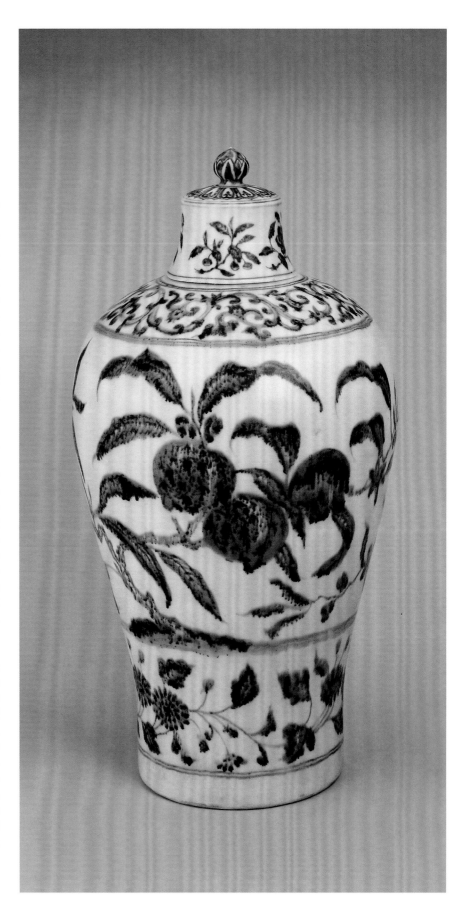

14

Celestial Sphere-shaped Vase
decorated with design of a dragon amidst clouds in underglaze blue

Ming Dynasty Yongle period

Height 43.2 cm
Diameter of Mouth 9.4 cm
Diameter of Base 16.5 cm
Qing court collection

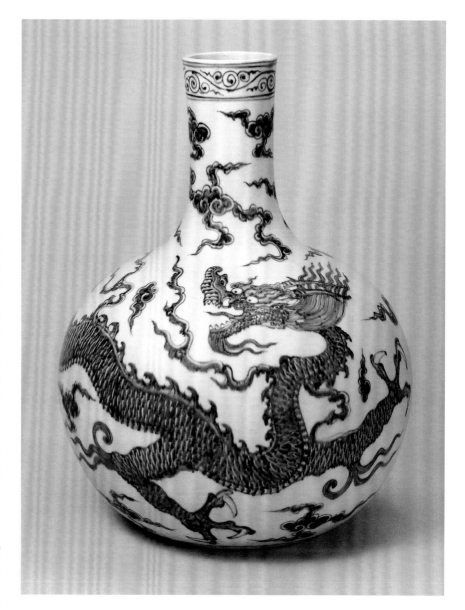

The vase has a slightly flared mouth, a long neck, a slanting shoulder, a globular belly and a flat base. Foliage scrolls are painted near the base whereas the neck is decorated with auspicious clouds. The belly is decorated with a dragon with three claws flying amidst auspicious clouds, with its head turns sideway as if it is looking back. The dragon is depicted in dynamic motion and fierce outlook with its mouth wide open exposing the teeth, hairs flying in the air and sharp claws.

The vase is painted with decorations by using the imported *soleimani* blue material giving dense and brilliant colour tones and diluted effect, with also the crystallized oxidized iron heap-and-piled effect.

Celestial sphere-shaped vase is a new form developed in the Yongle period of the Ming Dynasty. With its large body and globular belly, the form resembles a constellation in the universe and thus gets the name of celestial sphere-shaped vase. Four similar vases with dragon amidst cloud design are in the collection of the Palace Museum. The museum also collects celestial sphere-shaped vases produced in the Xuande period, and the major differences are that the upper lip of the dragon everts more prominently, and a reign mark of Xuande written in regular script is written underneath the mouth rim, whereas most Yongle wares do not have any reign marks.

15

Pear-shaped Vase
decorated with design of banana trees, rocks, and bamboos in underglaze blue

Ming Dynasty Yongle Period

Height 32.8 cm
Diameter of Mouth 8.2 cm
Diameter of Foot 10.8 cm
Qing court collection

The vase has a flared mouth, a small neck, a hanging belly, and a splayed ring foot. The mouth rim is plain, and patterns painted on the upper neck include banana leaves, foliage scrolls grass and *ruyi* cloud lappets. The belly is decorated with green bamboos, rocks, banana leaves, fences, and flowers and grasses on a slope, reflecting the literati aesthetic taste. Near the base is decoration of lotus lappets and on the exterior wall of the base are decorations of floral designs. The interior of the ring foot is covered with greenish-white glaze.

The vase is covered with thick and shiny glaze with dense and brilliant, as well as blurred and suffused, colour tone of the imported *soleimani* underglaze blue. The decorative designs should come from hands of court painters, representing an exquisite piece of the time. Extant pear-shaped vases of the Yongle period are rare. Imitation wares were produced in the Jingdezhen Kiln in the Yongzheng period of the Qing Dynasty. The distinctive feature is the size is smaller and the painterly brush work becomes very meticulous, whereas the underglaze blue does not have the diluted and suffused effects.

Pear-shaped vase was first produced in the Tang Dynasty, and the form was standardized in the Northern Song Dynasty. It was used as a functional wine container but gradually turned into a type of wares for display and appreciation. It gets its name from various sources, such as a poem by Cen Shen of the Tang Dynasty, which describes, "It is known that there are many festive events at Wangchuan, in fact worthy of bringing the *yuhuchun* wine for enjoyment," and a poem by Sikong Tu, which describes, "Bringing a *yuhu* (jade vase) to enjoy the Spring, listening to the sound of rain in a thatched hut. A lofty scholar is sitting inside the studio, with graceful bamboos around him." Or, it is said that *yuhuchun* was a kind of wine in ancient China.

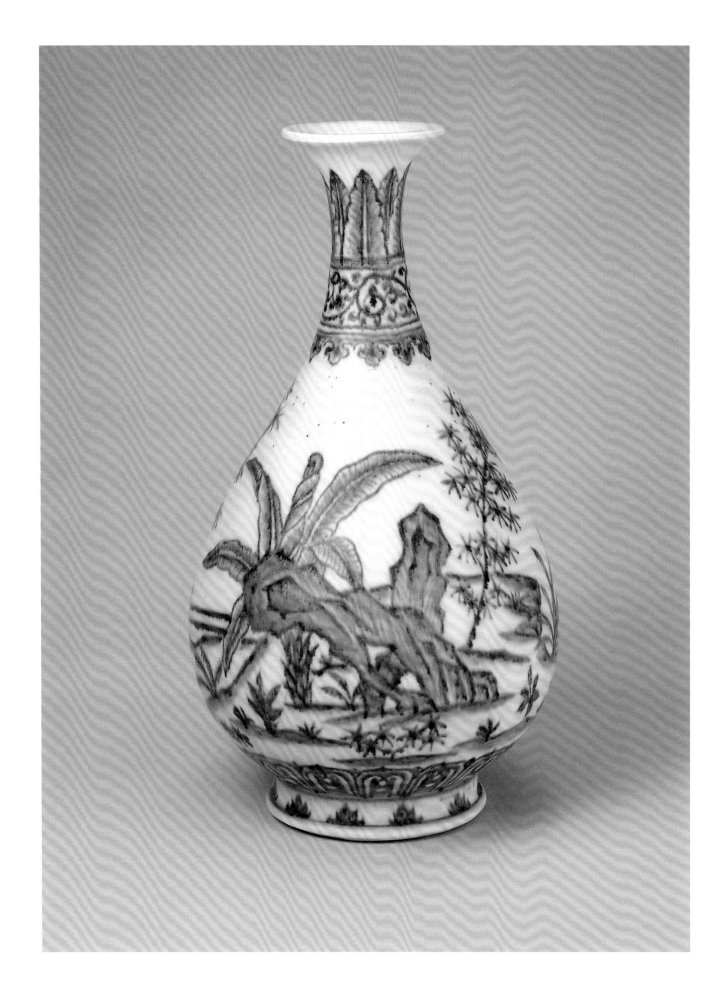

16

Flask with Moveable Rings and Two Loops
and decorated with design geometrical brocade ground, flowers, and waves in underglaze blue

Ming Dynasty Yongle Period

Height 45 cm
Diameter of Mouth 6.3 cm
Diameter of the Back 38 cm
Qing court collection

The flask is in the shape of a reclining tortoise with an everted mouth, a short neck on which is a string border in relief and underneath the border is a small round loop. On each of the symmetrical sides of the shoulder is a round loop in which is a moveable ring. At the centre of bulging surface is a convex navel. The back of the jar is flat and plain without glaze, the centre of which is recessed in the shape of a round cake. The body is covered with greenish-white glaze and decorated with designs in underglaze blue. Above and underneath a string border in relief at the neck are designs of key-fret patterns and foliage scrolls. The centre of the front jar is decorated with navel in convex and wave designs, enclosed by geometrical brocades of floral sprays, waves and floral medallions. The outer ring is painted with floral scrolls whereas on the sides of the flask are decorations of wave design.

The flask is fashioned with a distinctive form, which is also known as "reclining flask." It is modelled after the copper wares of the Islamic countries in West Asia. The colour of underglaze blue is dense and brilliant with the oxidized iron crystallized heap-and-piled effect, showing a feature of the identity of Islamic culture. In particular, the leaves of lotus scrolls are rendered in the shape of spreading saw teeth, which is very different from the traditional Chinese painting style.

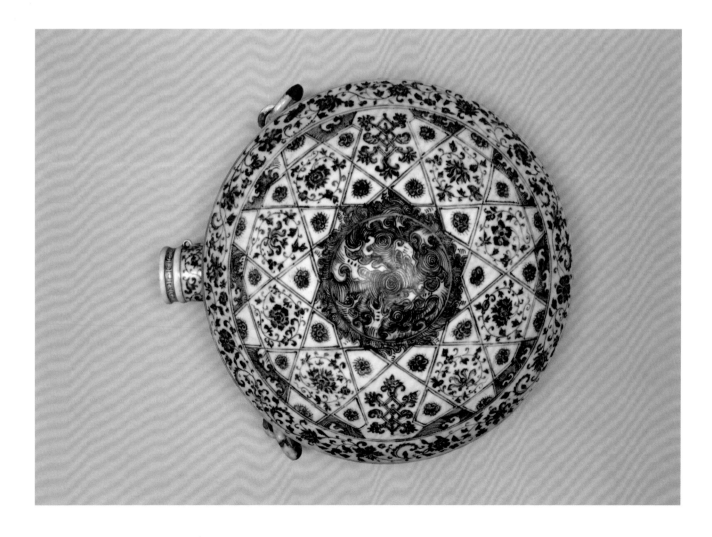

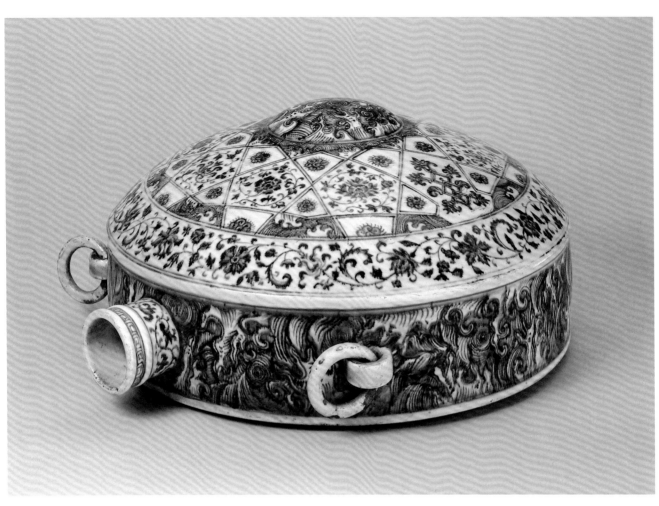

17

Ewer with a Square-shaped Spout
and decorated with design
of floral sprays
in underglaze blue

Ming Dynasty Yongle period

Overall Height 38.8 cm
Diameter of Mouth 7.4 cm
Diameter of Foot 11.5 cm
Qing court collection

The jar has an everted mouth rim, a long neck, a slanting shoulder tapering downwards to the base and a ring foot. On the side of the neck is a square spout with a gourd-shaped mouth gourd-shaped whereas on the other side of the neck is a curved handle. It has a matching canopy-shaped cover on which is a round tourmaline knob. The neck is decorated with peony scrolls. The shoulder is painted with lotus lappets, underneath is a border of floral scrolls. The belly has eight panels in which are painted floral designs. The exterior of the ring foot is decorated with foliage scrolls. The interior of the ring foot is covered with greenish-white glaze. The surface of the cover is painted with lotus lappets and the handle is decorated with floral sprays.

The form of this jar is new and creative, imitating metallic wares of the Islamic countries in West Asia. Such kind of wares in white glaze, underglaze blue and others were produced in the Imperial Kiln at Jingdezhen in the Yongle and Xuande periods. Yongle wares are not written with reign marks whereas Xuande wares are mostly written with reign marks in underglaze blue.

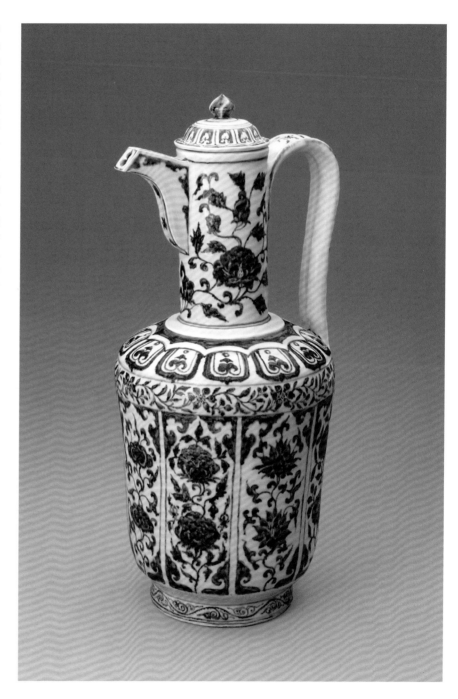

18

Flask
decorated with design of a dragon reserved in white amidst waves in underglaze blue

Ming Dynasty Yongle Period

Height 45.4 cm
Diameter of Mouth 7.8 cm
Diameter of Foot 14.5 × 10 cm
Qing court collection

The flask has a flared mouth, a long neck narrowed in the middle and gradually widened at the upper and lower part. The belly is round and flat and the ring foot is in oval-shape. Near the rim of the mouth are decorations of acanthus patterns and on the neck are lotus scrolls. The belly is decorated with a three-clawed dragon reserved in white amidst cresting waves. The head of the dragon is painted sideway as if it is looking back. The eyes of the dragon are dotted in underglaze blue and the body is incised with scales. The front leg and back of the dragon are in flames. The dragon is rendered in a vigorous manner with dynamism.

This flask is imitated after metallic wares of Islamic countries in West Asia. Imported *soleimani* underglaze blue material was used, giving dense and brilliant colour tone with the diluted and suffused effect like Chinese ink painting.

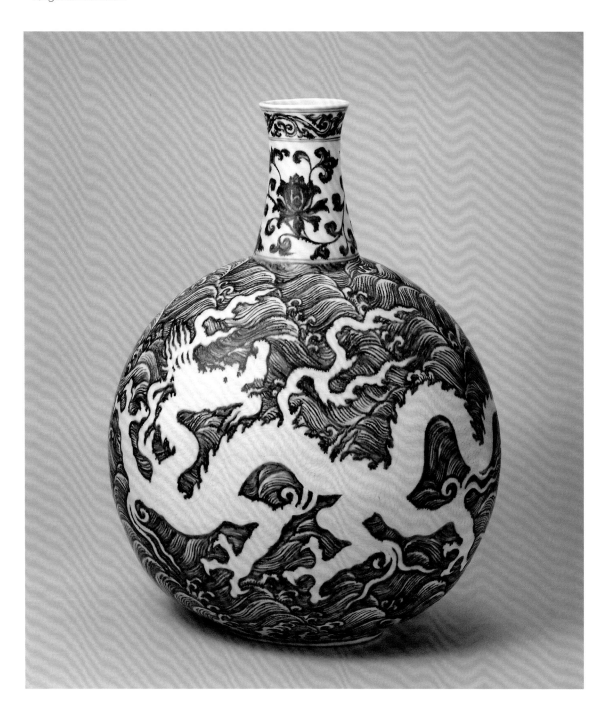

19

Flask with *Ruyi* Cloud-shaped Handles

and decorated with design of camellias in underglaze blue

Ming Dynasty Yongle Period

Height 25 cm
Diameter of Mouth 3 cm
Diameter of Base 10 × 7.6 cm
Qing court collection

The flask has an upright mouth, a small neck, a round and flat belly, and an oval-shaped flat sandy base. A pair of *ruyi*-shaped handles is on the symmetrical side on the neck and shoulder. The neck is painted with floral scrolls whereas the shoulder is painted with banana leaves. Both sides of the belly are decorated with camellia sprays. When the surface of the belly is touched, a horizontal border streak of joint can be found.

This kind of flask was first produced in the Imperial Kiln at Jingdezhen in the Yongle period of the Ming Dynasty. Flasks were also produced in the Xuande period, mainly in celadon and white glaze. The form is an imitation of the metallic wares of Islamic countries in West Asia. In the Kangxi and Yongzheng periods of the Qing Dynasty, the Imperial Kiln at Jingdezhen had produced imitated pieces, but the body of the wares was either too thin or too thick. The distinctive differences between flasks of the Yongle and Xuande periods are that the two sides of the flask have a horizontal border of joint whereas the Yongle and Xuande prototypes do not have such a joint.

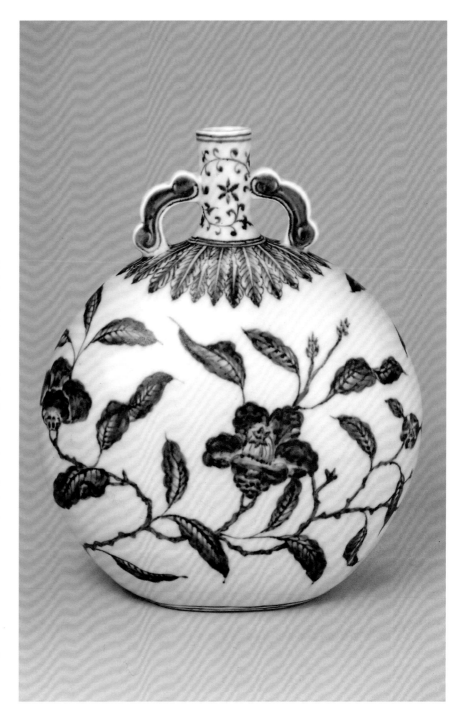

20

Garlic-head Flask with *Ruyi* Cloud-shaped Handles

and decorated with design of geometrical brocade ground and floral designs in underglaze blue

Ming Dynasty Yongle period

Height 27.8 cm
Diameter of Mouth 3.7cm
Diameter of Foot 7.7cm

Qing court collection

The flash has a garlic head shaped mouth, a short neck, a round and flat belly tapering downwards to a splayed foot. On the symmetrical sides of the mouth and shoulder is a pair of *ruyi* cloud-shaped handles. On the left and right side of the belly, there is a nipple design in relief. The mouth is decorated with upright *ruyi* cloud lappets in which are floral designs. The neck is painted with floral designs, and the *ruyi*-shaped handles are outlined in underglaze blue. Patterns on both sides of the belly are the same. At the centre is a hexagonal star, and extending outside are octagonal and hexagonal geometric patterns to form a brocade ground. The interior of the brocade ground are decorated with floral and wave designs. The nipple decorations are painted with chrysanthemum petals, and the sides of the flask are decorated with lotus sprays. The foot is decorated with *ruyi* cloud collars and floral designs. The flat base is unglazed and in the centre is a recessed in round and glazed in greenish-white.

The flask is modelled after the wares from the Islamic countries in the West Asia. This kind of vases were first produced in the Imperial Kiln at Jingdezhen in the Hongwu period, with the number increased in the Yongle and Xuande periods, including white glazed wares and underglazed wares. In the

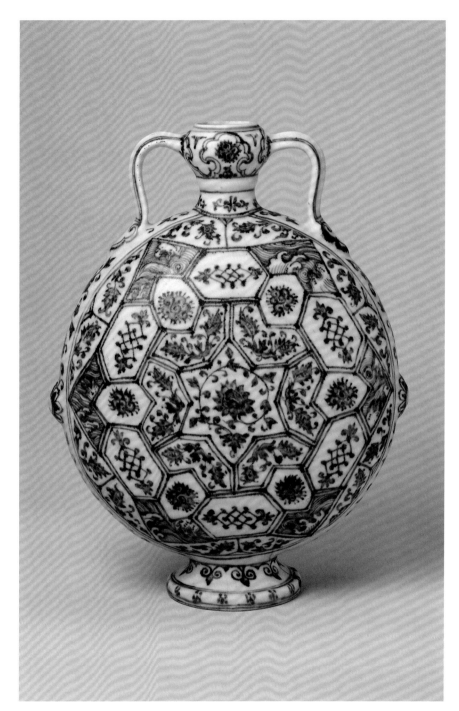

Kangxi and Yongzheng periods of the Qing Dynasty, the Imperial Kiln at Jingdezhen also produced such imitated pieces. Compared with those produced in the Yongle and Xuande periods, those made in the Qing Dynasty were smaller in size with the decorations more precisely and meticulously depicted with the underglaze blue colour has no diluted and suffused effects.

21

Tubular Jar
decorated with design of flowers and waves on a geometric brocade ground in underglaze blue

Ming Dynasty Yongle period

Overall Height 28.5 cm
Diameter of Mouth 12.5 cm
Diameter of Foot 10.8 cm
Qing court collection

The jar has everted mouth rim, short neck, cylindrical belly and ring foot. The neck is painted with wave designs and shoulder with lotus scrolls. The belly is painted with geometrical brocades as the ground in which is painted with floral and wave designs. The lower belly is decorated with lotus scrolls. The exterior of the ring foot is decorated with triangular geometric designs while the interior is covered with white glaze.

The size of the mouth and the base is similar, the belly is thick and bulging so it is named *zhuang* (strong) jar. Its form and design are modelled after the wares produced in the Islamic countries in West Asia. In the Yongle period, the Imperial Kiln in Longquan, Zhejiang province had also produced this kind of jars in celadon glaze. The form shows the creative adoption of influences from other cultures for producing new types of wares at the Imperial Kiln in the period.

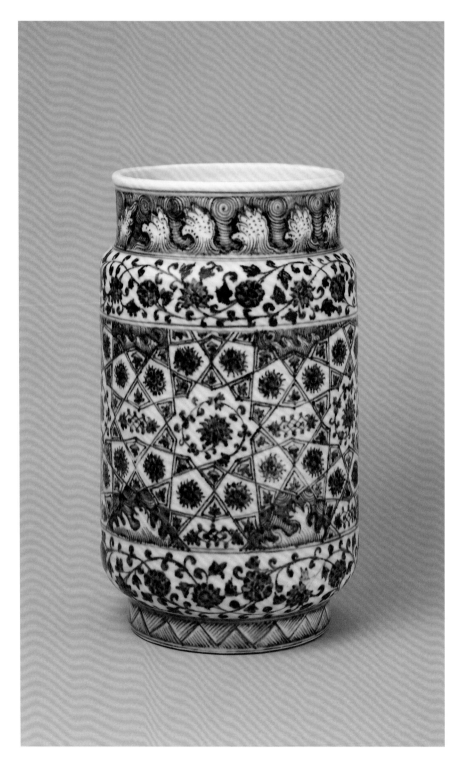

22

Octagonal Candle-stand
decorated with design of floral scrolls in underglaze blue

Ming Dynasty Yongle period

Height 38.5 cm
Diameter of Mouth 9 cm
Diameter of Foot 23.5 cm
Qing court collection

The candle stand is modelled in three tiers: upper, middle and lower. The upper tier with the mouth for inserting a candle and the lower tier with the base are both in the shape of octagonal waisted pedestal. The supporting stand in the middle tier is in cylindrical shape. The base is hollow while the surface of the pedestal has a recessed ring for holding candle drops. The base is glazed, while part of the top is unglazed, which shows that a cylindrical supporting stand was used during firing to avoid the heavy mouth insertion and the supporting stand from collapsing due to their heavy weight.

The mouth from top to the bottom is painted with banana-leaf patterns, spiral patterns and lotus petals. The upper part of the pillar is decorated with a brocade ground, complemented by chrysanthemum scrolls underneath. Wave patterns are painted on the concave ring on the surface of the upper part of the pedestal is decorated with lotus petals design. The exterior wall of the stand is painted with eight panels in which are chrysanthemums and lotus sprays.

The candle stand is modelled after gilt bronze wares of the Islamic countries in West Asia. The structure is rather complicated with decorative designs rendered in a luxuriant manner. The imported *soleimani* underglaze blue material is used to produce a dense and brilliant colour tone with diluted and suffused effect.

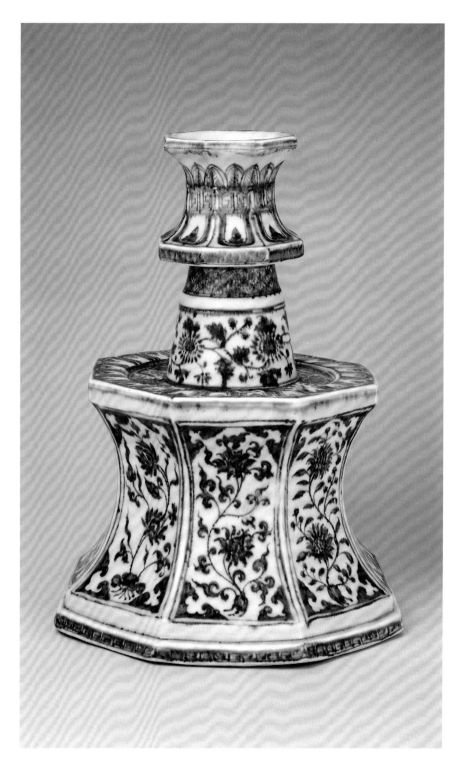

23

Kendi Ewer
decorated with design of peony scrolls in underglaze blue

Ming Dynasty Yongle Period

Height 20.5 cm
Diameter of Mouth 6.5 cm
Diameter of Foot 10 cm
Qing court collection

The ewer has flared-mouth, round mouth rim, small neck and hanging belly supported by a pedestal. The upper part of the body is fashioned in the shape of a pear-shaped vase. The interior of the foot has a tiered inner and outer ring which reveals that a supporting ring was used during firing to support the ware. On one side of the belly is a long spout, but without a handle. The body is decorated with peony scrolls, the spout is painted with floral scrolls and on the pedestal are decorations of lotus petals and key-fret designs.

Kendi ewer is a water container used by the Islamic priest or disciples for drinking water or washing hands during religious ceremonies. The name is originated from Sanskrit script. Kendi ewers have a wide variety of forms, and Kendi wares in the shape of this one were first produced in the Imperial Kiln at Jingdezhen in the Yongle period. They were also produced in the Xuande period in underglaze blue and white glaze. Most of the Yongle wares are not written with reign marks whereas those of the Xuande period are usually written with reign marks.

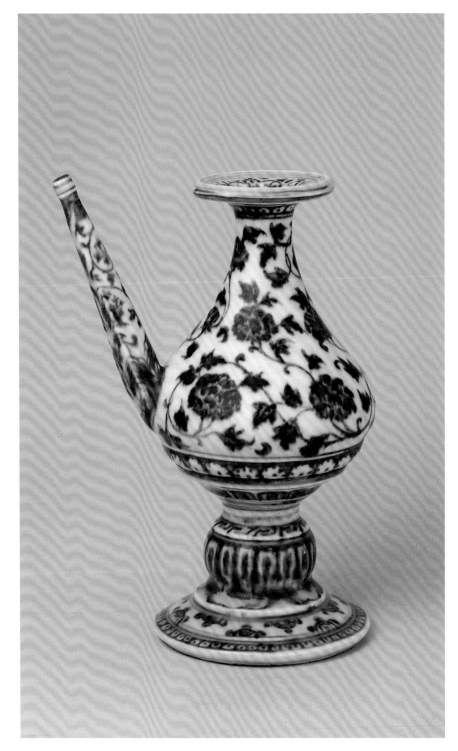

24

Flower Jar
decorated with design of lotus scrolls in underglaze blue

Ming Dynasty Yongle period

Height 14.7 cm
Diameter of Mouth 8 cm
Diameter of Foot 4 cm
Qing court collection

The jar has upright mouth, short neck, globular belly and horizontal foot. On the mouth and shoulder is a dragon-shaped handle. The neck is decorated with wave designs, whereas the belly is painted with lotus scrolls. Near the foot are decorations of lotus lappets.

Floral scrolls design is a traditional auspicious pattern, which is also known as "longevity entwining vine" which is a variegated form evolved from a kind of entwining plant. The entwining design looks as without end and thus it symbolizes "everlasting life." The pattern is rendered in various forms such as lotus and peony scrolls.

This jar is a new form produced in the Imperial Kiln at Jingdezhen in the Yongle period of the Ming Dynasty. It is modelled after jade jars for watering flowers and plants in the Islamic countries in West Asia. The dragon-shaped handle, however, is a motif from the Chinese tradition. Such wares were produced in the Xuande periods, with Xuande wares written with reign mark whereas the Yongle wares are not written with reign marks.

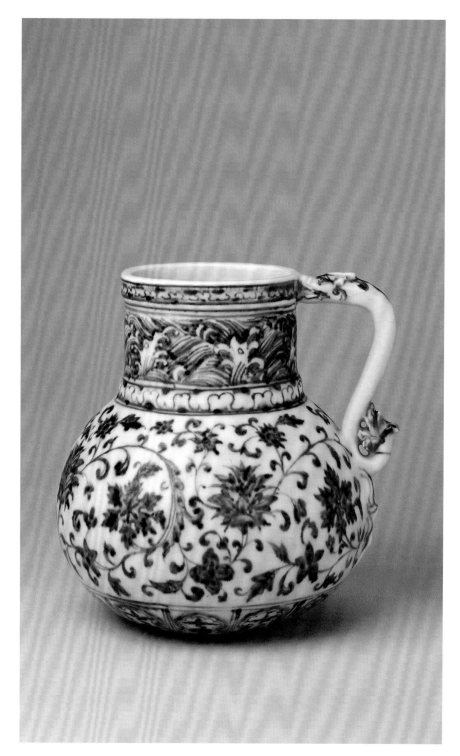

25

Wudang Zun Vase
decorated with design of Arabic scripts and floral scrolls in underglaze blue

Ming Dynasty Yongle period

Height 17.2 cm
Diameter of Mouth 17.2 cm
Diameter of Foot 16.6 cm
Qing court collection

The *zun* vase has a cylindrical-shaped body, contracted waist and without a base. The middle part of the body is convex in shape. The upper and lower mouths are foliated and everted to a flange respectively. The interior flanged rim of the lower mouth has an unglazed ring, showing use of a supporting ring during firing. The interior mouth rim and the exterior foot ring are decorated with chrysanthemums, and the

exterior of the mouth rim is painted with floral designs. Three clusters of design are painted on the cylindrical body with the upper and lower parts decorated with Arabic scripts on a ground with foliage scrolls whereas the middle part is decorated with upright and inverted chrysanthemum petals.

The form of this *zun* vase is unique and it was produced in the Imperial Kiln at Jingdezhen in the Yongle and Xuande periods, which are modelled after copper wares of the Islamic countries in West Asia. There are three possible functions of such type of *zun* vases: i) stand for supporting designated vessels; ii) mortar for grinding herbs in use in West Asia; iii) candle stand for holding big candles used in the courts in West Asia. Emperor Qianlong had mentioned the name "*wudang zun* (vase)" in his imperial poems and in a poem "In praise of the *wudang zun* vase produced in the Imperial Kiln of the Xuande period," he particularly pointed out that, "The shape is rather similar to the bronze *zun* wine-container inscribed with character *Fuyi* of the Shang Dynasty, yet the inner part is hollow and without a base, which is different from that *zun* wine container. In such a case, I quoted the description by Han Fei to describe it." However, as recorded in the book *Han Feizi,* chapter *waichushuo, upper right, item thirty-four,* the original text should be, "Master Tangxi told Lord Zhao that now there is a jade *zhi* container which is worth a thousand gold taels, but the interior is hollow without a *dang* (flange), can it be used for containing water? Lord Zhao replied no." Here the word *dang* actually refers to the base. Yet such a specific term *wudang zun* (vase) is wrongly used, because the word *dang* does not refer to a base, and *wudang* does not mean "without base" in such a case.

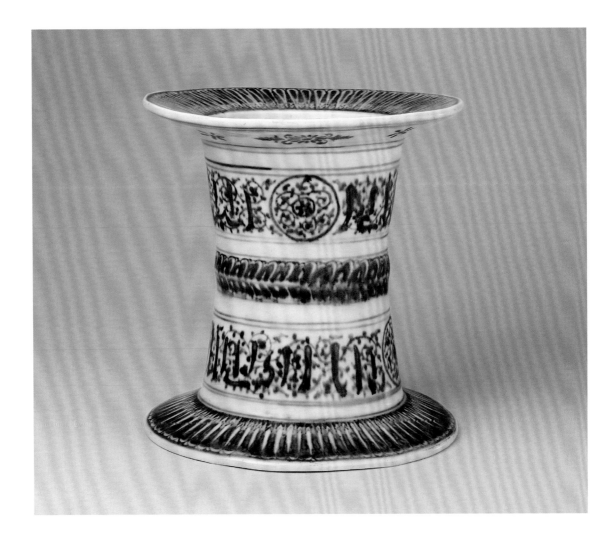

26

Large Incense Burner with Three Legs
and decorated with design of cliffs and cresting waves in underglaze blue

Ming Dynasty Yongle period

Height 57.8 cm
Diameter of Mouth 37.8 cm
Distance between Feet 37.5 cm
Qing court collection

The incense burner has square rim, short neck, globular belly, and slim base, and the belly is supported by three legs in the shape of elephant leg. The neck has a border of nipple designs in relief. On the two symmetrical sides of the shoulder is a pair of upright looped handles. The interior of the incense burner is covered with white glaze. The exterior wall is decorated with cliffs and cresting waves designs in underglaze blue. The cresting waves hit against the mountain rocks vigorously, symbolizing the power of the court is strong and would last forever. The base is slightly recessed but unglazed, and the base of the three legs is also unglazed.

The incense burner is thickly potted and huge in size. Covered with thick and translucent glaze and with dense and brilliant tones of underglaze blue, this incense burner demonstrates the impeccable craftsmanship of porcelain production in the Imperial Kiln at Jingdezhen in the Yongle period, as well as the power of the court at the time. The imported *soleimani* underglaze blue material gave a dense and suffused colour tone and the oxidized-iron crystallized heap-and-piled effect. All these features reveal the characteristics of typical Yongle underglaze blue wares produced in the Imperial Kiln at the time. Its form is also similar to a large bronze incense censer with gilt designs collected by the Qutan Temple at Ledu county, Qinghai province, which bears the mark of the Yongle period, thus providing authentication evidence to this piece.

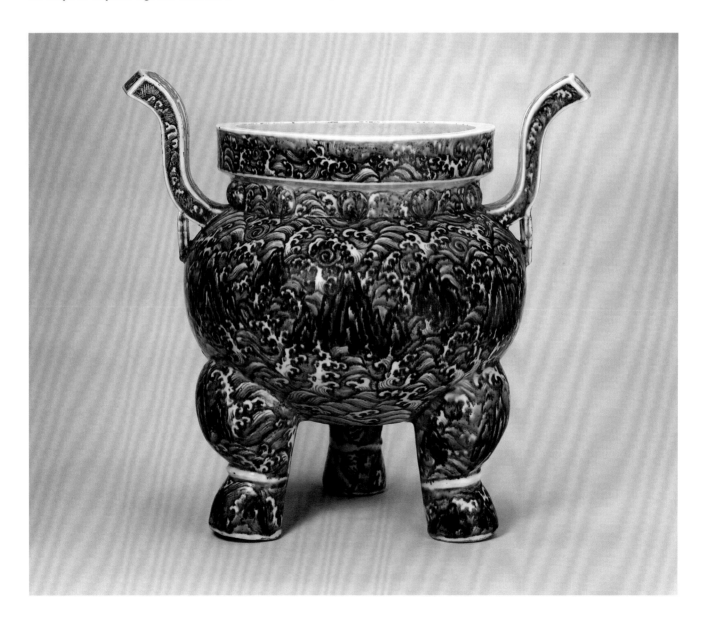

27

Large Basin with a Foliated and Everted Rim
and decorated with design of waves and floral scrolls in underglaze blue

Ming Dynasty Yongle period

Height 12.2 cm
Diameter of Mouth 26.6 cm
Diameter of Base 19 cm
Qing court collection

The plate has a wide mouth, a foliated edge everted to a flange, an upright wall, and a flat base. At the centre of the interior base are decorations of a floral medallion and *ruyi* cloud collars enclosed by a border of wave designs. The exterior and interior walls of the plate are decorated with floral scrolls of the four seasons. The upper surface of the flanged rim is decorated with wave designs whereas the lower side is decorated with floral sprays. The exterior base body is plain and unglazed.

The ware was a new type of wares produced in the Imperial Kiln at Jingdezhen in the Yongle period, and modelled after the silver wares of Islamic countries in West Asia. The decorative designs are sophisticated and skillfully rendered in perspective layers and luxuriant pictorial compositions. The imported *soleimani* underglaze blue material was used with a dense and brilliant colour tone with diluted and suffused effects. In the court archive of the Qing Dynasty, this type of basin is known as "western-hat-washer," and imitated pieces are produced. Also, in the court archive of the Qing Dynasty, it is recorded that Tang Ying was ordered to produce similar pieces for sending to the court.

28

Press-hand Cup
decorated with design of lotus scrolls and lions playing with a brocade ball in underglaze blue

Ming Dynasty Yongle period

Height 5.2 cm
Diameter of Mouth 9.2 cm
Diameter of Foot 3.9 cm
Qing court collection

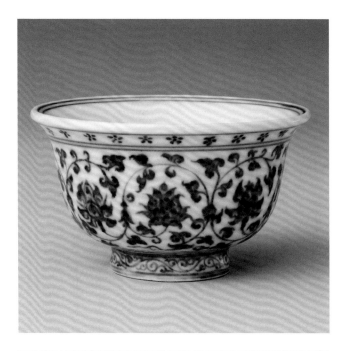

The cup has a flared mouth, a tapering waist, a deep belly, a thick base, and a ring foot. The interior centre of the cup is decorated with two lions playing with a brocade ball within a single-line medallion. The interior of the ball is written with a mark of Yongle in seal script. The interior is plain. The exterior mouth rim is decorated with plum blossom designs and the exterior wall is painted with lotus scrolls. The exterior of the foot is decorated with acanthus patterns.

This cup is documented in the historical records of the Ming Dynasty. The form and designs painted on the exterior wall are the same as the sunflower-shaped press-hand cup illustrated at Plate 29, and the size is similar too. It is known as "press-hand cup" because the size is in good proportion, the body is thinner near the mouth rim and gradually becomes thicker downwards, and with the slightly flared mouth, it fits perfectly for holding by the hand to reach the position of the wrist. Functionally since the cup is thinner near the mouth and becomes thicker downwards, the weight would concentrate on the lower part of the cup and would be more stable for placing.

Press-hand cups in underglaze blue produced in the Yongle period were refined wares which won high esteem and had been repeatedly imitated across different periods. Four such valuable cups of the Yongle period are collected by the Palace Museum. Another prominent feature with high historical significance is that these cups represent the earliest imperial wares in underglaze blue with reign marks of the Yongle period written, and initiated the practice of writing imperial reign marks in underglaze blue on wares in the subsequent periods of the Ming and Qing Dynasties.

29

Press-hand Cup
decorated with design of lotus scrolls and sunflower patterns in underglaze blue

Ming Dynasty Yongle period

Height 5.1 cm
Diameter of Mouth 9.1 cm
Diameter of Foot 3.9 cm
Qing court collection

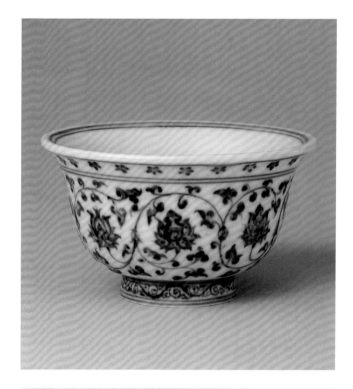

The cup has a flaredmouth, a tapering waist, a deep belly, an ovoid base, and a ring foot. The interior centre of the cup is decorated with sunflower design within a single line medallion. The interior of the sunflower is written with a mark of Yongle in seal script. The interior is plain. The exterior rim is decorated with plum blossom designs and the exterior wall is painted with lotus scrolls. The exterior of the foot is decorated with acanthus patterns.

The form and decorative designs on the exterior wall of this cup is the same as the cup decorated with lions playing with a brocade ball illustrated at Plate 28, and the size is similar as well. Press-hand cup decorated with lotus scrolls in underglaze blue is a type of well-acclaimed porcelain wares of the Yongle period, and also recorded in historical documents of the Ming Dynasty. In the book *Bowu Yaolan* written by Gutai in the late Ming Dynasty, he mentioned that, "Among the press-hand cups produced in our Yongle period, if design of two lions playing with brocade ball is painted in the interior centre of the cup and the ball is written with a four-character or six-character mark of Yongle period in seal script with each character in the size of a rice, such cups are of the most refined and superior quality. If the cup is decorated with design of mandarin ducks, it is ranked the second and if it is decorated just with floral design, it is ranked the third. Based on this record, there are three types of press-hand cups produced in the Imperial Kiln in the Yongle period, either with the interior centre decorated with two lions playing with a brocade ball, mandarin ducks, or floral design; and with a mark of Yongle in six and four characters. From extant and unearthed wares, press-hand cups produced in the Yongle period are similar in shape and in size. Among the four press-hand cups collected by the Palace Museum, three are decorated with sunflowers with five petals in medallions in the interior centre, and written with a four-character mark of Yongle in seal script in two columns in underglaze blue within the flower. Up to the present, press-hand cups decorated with mandarin ducks and written with a six-character mark of Yongle period have not been found.

30

Bowl
decorated with design of bamboos, rocks, flowers, and plants in underglaze blue

Ming Dynasty Yongle period

Height 7.1 cm
Diameter of Mouth 16.4 cm
Diameter of Foot 5.8 cm
Qing court collection

The bowl has a flared mouth, a deep and curved belly, and a ring foot. The interior is plain. The exterior wall is decorated with a continuous garden scene of bamboos, rocks, flowers, and plants in underglaze blue. The exterior wall of ring foot is decorated with key-fret patterns, whereas the interior is covered with greenish-white glaze.

The form of this bowl is gracefully and thinly potted, and covered with shiny translucent glaze. The form is fashioned after the bowls in light-bluish celadon glaze produced in the Ru Kiln in the Northern Song Dynasty. Significant void spaces are left in the pictorial plane, giving a spatial and refreshing charm to this bowl. Such a style marks a departure from the wares with thickly potted bodies and luxuriant decorations in vogue in the Yuan Dynasty and the Hongwu period, Ming Dynasty. It opened a new landmark decorative style on imperial wares of the Yongle period, Ming Dynasty.

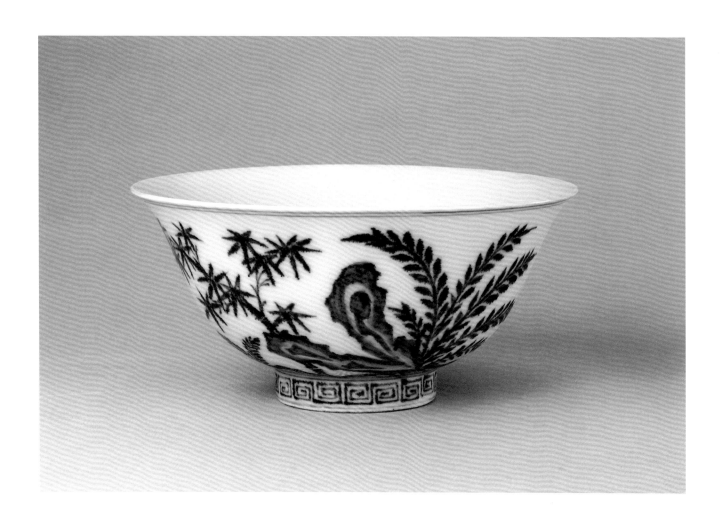

31

Plate with a Foliated Everted Mouth Rim
and decorated with design of paradise flycatcher and floral designs in underglaze blue

Ming Dynasty Yongle period

Height 9.2 cm
Diameter of Mouth 51.2 cm
Diameter of Foot 34.5 cm
Qing court collection

The plate is lobed in the form of sixteen petals of water chestnut flowers. It has a flared-mouth, a foliated rim everted to a flange, and a ring foot. The interior centre is decorated with a paradise flycatcher perching on a loquat branch. The bird is painted with its head turning back to peck the loquat fruit. The interior wall is painted with sprays of pomegranates, peaches, lychees, and loquats. The upper side of the flanged rim is painted with lotus scrolls, and the lower side is painted with wave designs. The exterior wall is painted with chrysanthemum sprays. The sandy base has a reddish tint where the paste is exposed.

Only three large plates of this type are extant, and this piece is the most refined. The paste of wares in underglaze blue produced in the Yongle and Xuande periods of the Ming Dynasty is potted with appropriate thickness, and the decorative designs are enlivened with a refreshing charm and grace, marking a departure from the Hongwu underglaze blue wares which carried on the Yuan legacy with thick paste and luxuriant decorations. On the other hand, most of the plates in underglaze blue of the Yongle period are decorated with floral designs, and wares decorated with birds and flowers like this one are rare and unusual.

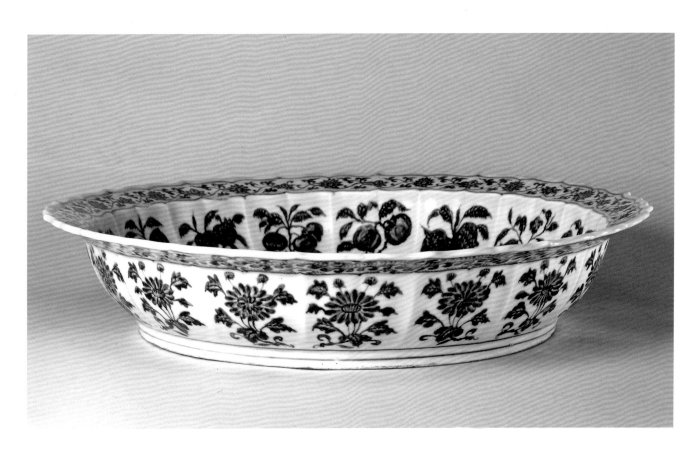

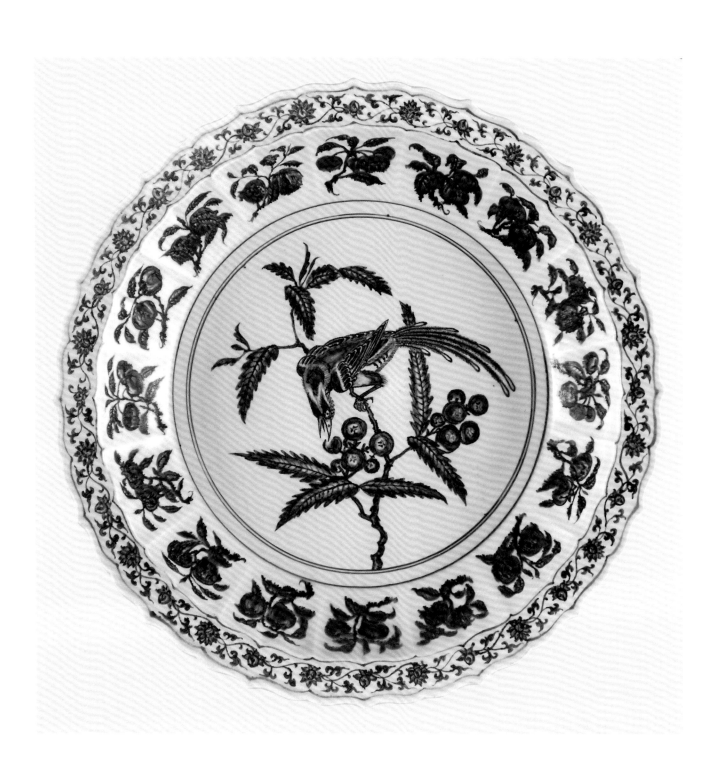

32

Large Plate
decorated with design of a garden scene and floral sprays in underglaze blue

Ming Dynasty Yongle period

Height 8.5 cm
Diameter of Mouth 63.5 cm
Diameter of Foot 49.5 cm
Qing court collection

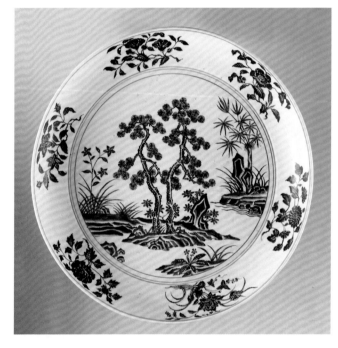

The plate has a flared mouth, a shallow curved wall and a ring foot. The interior centre is decorated with a garden scene with two pine trees, palm tree and rocks, and slope with flowers and plants. The exterior wall is decorated with sprays of chrysanthemums, camellias, pomegranate flowers, gardenias, peonies, lotuses, and others. The interior of foot is unglazed. The exterior base is finely potted and smooth, leaving vertical traces of using supports during firing.

The large plate is finely potted and stable and decorated with designs with a touch of lyricism. The colour of underglaze blue is dense and brilliant. Considering the high technical requirement in production and firing, it was not easy to have such large-sized wares successfully produced at the time.

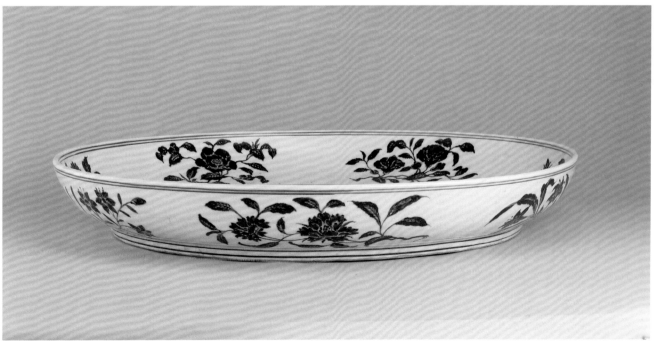

33

Bowl
decorated with design of
burclover scrolls
in underglaze blue and gilt

Ming Dynasty Yongle period

Height 6.4 cm
Diameter of Mouth 14.9 cm
Diameter of Foot 5.4 cm

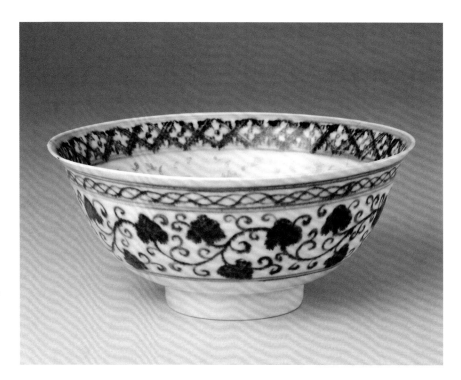

The bowl has flared-mouth, deep and curved belly and ring foot. The decorations are rendered in underglaze blue and gilt. The interior centre is painted with lotus designs, whereas the interior wall is decorated with floral scrolls in gilt. Underneath the interior mouth rim is a brocade border of lozenges. The exterior of the mouth rim is painted with swirling lines and the exterior wall is decorated with burclover scrolls. The interior of the ring foot is covered with white glaze.

Wares with decorations painted in underglaze blue and gilt first appeared in the Yongle period of the Ming Dynasty. The technique is to paint the designs in underglaze blue on the paste and then fired in high temperature. After firing, decorations in gilt would be painted on the fashioned wares and fired a second time in a baking atmosphere in low temperature in the kiln. There are other extant wares with identical decorations, but only painted in underglaze blue without gilt designs, and bear painted marks in the shape of snowflakes.

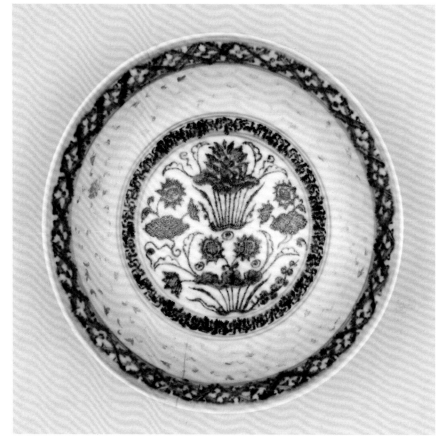

34

Celestial Sphere-shaped Vase
decorated with design of camellia scrolls in underglaze blue

Ming Dynasty Xuande period

Height 46 cm
Diameter of Mouth 8.9 cm
Diameter of Foot 15.2 cm
Qing court collection

The vase has everted mouth rim, upright neck, slanting shoulder, globular belly, and flat base. The upper and lower neck is decorated with lotus scrolls and *ruyi* cloud lappets respectively. In the *ruyi* cloud lappet design, buds of lotus flowers are painted. The belly is fully decorated with camellia designs. The exterior base is plain, and the shoulder is written with a mark of Xuande in regular script in two columns in reserved white.

The form of this vase is potted with well proportion and the decorations are rendered skillfully with excellent brush work. It is covered with thick glaze with a tint of greenish-white. Void spaces are left on the body, giving it a refreshing charm. Celestial-sphere vase was a new typeform first produced in the Imperial Kiln at Jingdezhen in the Yongle period of the Ming Dynasty and production continued in the Xuande period. The differences of the vase produced in these two periods are that Xuande wares are often written with a reign mark, and the form of Yongle wares is more delicate than that of the Xuande wares.

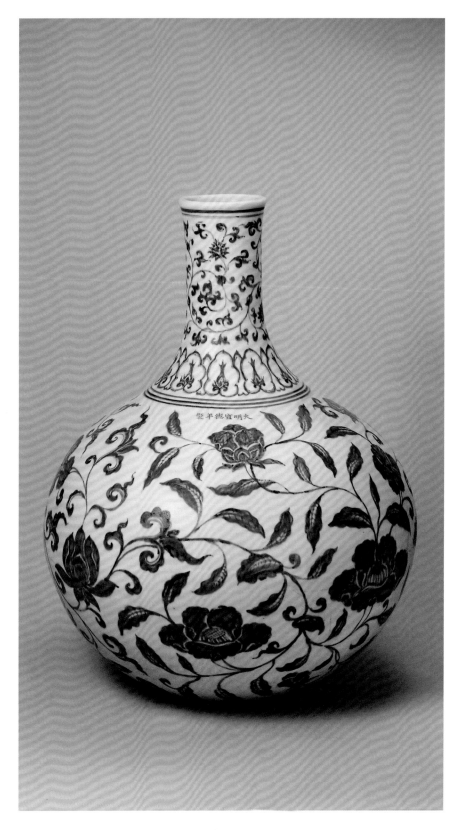

35

Meiping Vase
decorated with design of floral scrolls in underglaze blue

Ming Dynasty Xuande period

Height 53.1 cm
Diameter of Mouth 8 cm
Diameter of Foot 16.5 cm
Qing court collection

The vase has everted mouth rim, short neck, slanting shoulder tapering downwards to the belly, and ring foot. The shoulder and near the foot are decorated with a border of upward and inverted lotus petal lappets respectively. Chrysanthemum and camellia scrolls are painted on the belly. The exterior base is unglazed. The shoulder is written with a mark of Xuande in regular script in reserve white. The vase should have a matching bell-shaped cover, which is lost.

Meiping vases produced in the Jingdezhen Imperial Kiln in the Yongle and Xuande periods are the most graceful and elegant pieces of its kind. There are two types of *meiping* vases in this period: one is bulge and tall, up to more than 50 cm in height without the cover, like this one, whereas the other has a more reasonable size, up to over 30 cm in height without the cover, and with belly supported by a splayed foot to make it more stable, such as the vase illustrated at Plate 13.

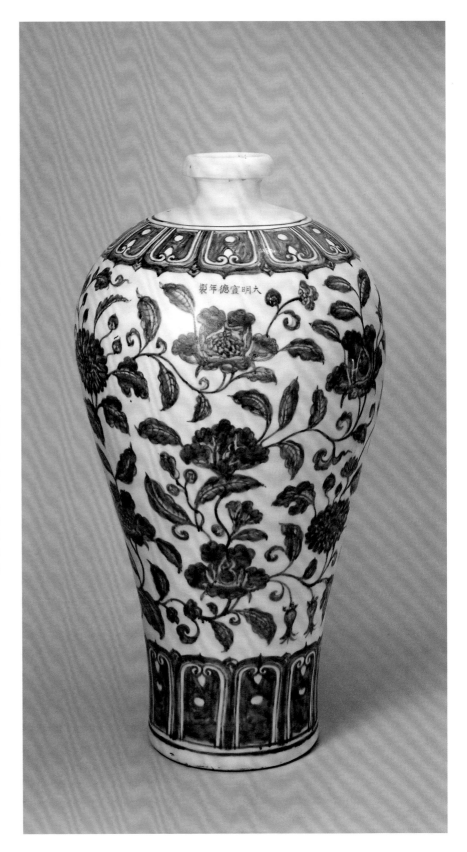

36

Gourd-shaped Flask with Ribbon-shaped Handles

and decorated with arabesque design in underglaze blue

Ming Dynasty Xuande period

Height 29.9 cm
Diameter of Mouth 2.7 cm
Diameter of Foot 7 × 5.21 cm
Qing court collection

The flask is in the shape of a gourd; the mouth and neck are in round shape, while the belly is round and flat resting on a square ring foot. A pair of ribbon-shaped handles is on the symmetrical sides of the neck and shoulder. Chrysanthemums scrolls are painted on the mouth, arabesque design on both sides of the belly, and with floral sprays decorating the handles. The interior of the foot is covered with greenish-white glaze. Underneath the mouth rim is a horizontal mark of Xuande written in regular script.

Arabesque is a kind of repetitive and elaborate design in geometrical form, which is derived from the naturalistic form of plants. It is a prominent decorative motif in Islamic art and is often found on the walls of Mosque.

The form and decorative designs of this flask are modelled after Islamic crafts in Western Asia. It was first produced in the Imperial Kiln at Jingdezhen in the Yongle period, and continued in the Xuande period, represented in both underglaze blue and white glaze wares. Flasks produced in the Yongle period usually were usually not written with reign marks, and Xuande wares generally have reign marks on them.

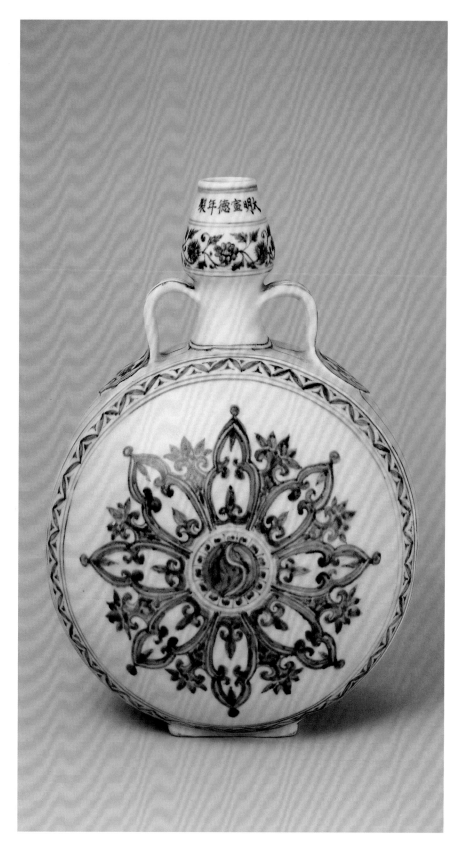

37

Vase with Angular Corners, Elephant-shaped Handles
and decorated with design of morning glory in underglaze blue

Ming Dynasty Xuande period

Height 14 cm
Diameter of Mouth 5.5 cm
Diameter of Foot 7.5 cm

The vase has round mouth rim, upright and cylindrical-shaped neck, and square belly with angular corners and tapering downwards to flared ring foot. On the symmetrical sides of the neck is a pair of elephant-shaped handle, which is painted in underglaze blue. The neck and the belly are decorated with morning glories. The interior of the foot is in two tiers and glazed in white. The exterior base is written with a mark of Xuande in regular script in two columns within a double-line medallion in underglaze blue.

The special form of vases with angular corners was first produced in the Imperial Kiln at Jingdezhen in the Xuande period, Ming Dynasty. Some are glazed in white, some in underglaze blue, and all are fashioned after metallic vessels in the Islamic countries in West Asia. Many imitated pieces in various sizes were produced in Imperial Kiln at Jingdezhen in the late Ming Dynasty. Imitation pieces were also produced in the Yongzheng period, Qing Dynasty, the sizes of which are significantly larger.

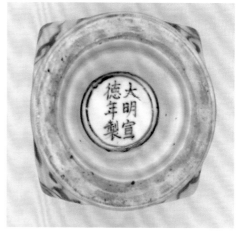

38

Covered Jar with Flanges
and decorated with design of eight Buddhist emblems and Sanskrit script in underglaze blue

Ming Dynasty Xuande period

Overall Height 28.7 cm
Diameter of Mouth 19.1 cm
Diameter of Base 24.7 cm
Qing court collection

The jar has an upright mouth, a slanting shoulder, a globular belly tapering downwards and a flat base. It has a matching round cover with flat top, and the surface centre of the cover is slightly recessed. The shoulder has eight protruding flat flanges, which resemble the composite look of a Buddhist wheel of dharma view from above. The interior wall and the shoulder are painted with wave designs and the eight flanges are painted with lotus scrolls. The belly is decorated with three borders of Sanskrit script characters. The middle border is packed with Sanskrit script characters whereas the upper border is decorated with eight Sanskrit characters interspersed by eight Buddhist emblems supported by lotus sprays, and the lower border is decorated with eight Sanskrit characters interspersed by lotus sprays. The foot is painted with upright lotus lappets. The interior centre is written with five characters "*da de ji xiang chang*" (The realm of great virtue and auspicious blessing) in seal script from left to right, enclosed by nine lotus petals, and on each petal is written a Sanskrit character. The centre of the cover surface is written a Sanskrit script character, surrounded by four Sanskrit characters and interspersed by deformed cloud patterns. The exterior wall of the cover, as well as the interior of the cover, is decorated with wave designs.

Sanskrit is the ancient Indian language, which is also the legitimate language of Buddhism. The jar is decorated with the *nancha* version of Sanskrit, representing the Esoteric Sect and the seed-syllable of the true words of Buddha or Bodhisattva. Disciples of the Esoteric Sect believe that whenever and wherever these characters are written, the Buddha and Bodhisattva represented by these characters would bring blessings. Also by touching a vessel carrying mantra will also bring auspicious blessings and protect one from disasters. Most of the emperors of the Ming and Qing Dynasties believe in Buddhism, thus many of the Ming and Qing wares are decorated with designs that are associated with Buddhism.

The jar is possibly a dharma vessel used during Buddhist ceremonies and rituals in court. It is fashioned in a unique form amongst various types and forms of ceramic jars of different dynasties. It is noteworthy to point out that in a court painting *Hongli* (Emperor Qianlong) *contemplating archaic vessels,* Emperor Qianlong is dressed in the Chinese costume and sits in bed with this jar displayed prominently on a square-shaped side table, reflecting that it is a vessel much favoured by the emperor.

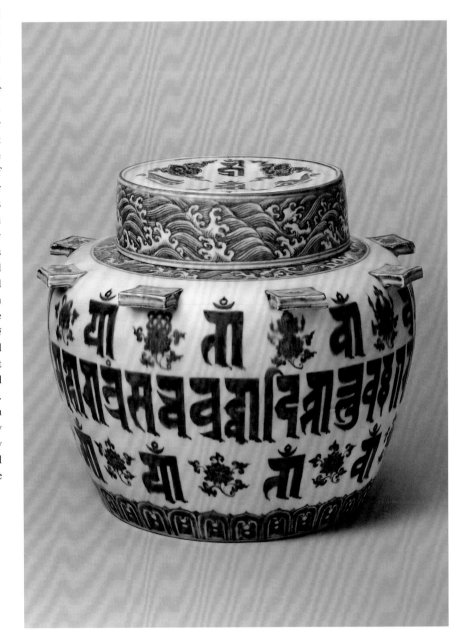

39

Covered-Jar

decorated with design of lotus scrolls in underglaze blue

Ming Dynasty Xuande period

Overall Height 19 cm
Diameter of Mouth 17 cm Diameter of Foot 15.7 cm
Qing court collection

The jar has an everted mouth, a short neck, a slanting shoulder, a globular belly, and a ring foot. It has a matching canopy-shaped cover, on which is a tourmaline knob. The neck is decorated with floral designs. On the shoulder and near the foot are decorations of upright and inverted lotus lappets. The belly is fully decorated with lotus scrolls whereas the exterior of the cover is painted with lotus petals and floral scroll designs. The knob is painted with lotus petal design. The exterior base is written with a mark of Xuande in regular script in two columns within a double-line medallion in underglaze blue.

The jar is fashioned in a full and globular form with the underglaze blue colour accurate and bright, and the decorations are enlivened with a naturalistic favour and vividness.

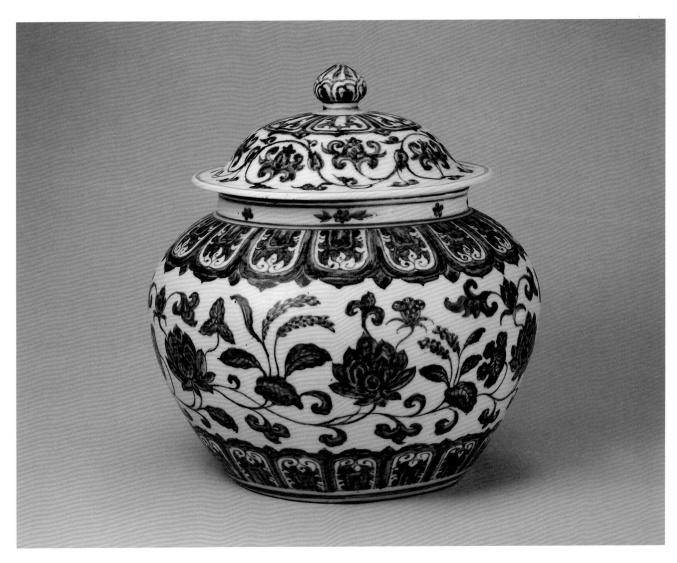

40

Zun Vase in the Shape of Pomegranate with Six Lobes
and decorated with design of *lingzhi* fungus sprays in underglaze blue

Ming Dynasty Xuande period

Height 19 cm
Diameter of Mouth 6.9 cm
Diameter of Foot 9.7 cm
Qing court collection

The jar has six lobed sides, a round mouth, a foliated flanged rim, a short and narrow neck, a slanting shoulder, a globular belly, and a flared ring foot. The flanged rim is decorated with lotus petal designs. The neck is decorated with ring designs with the shoulder painted with lotus collars. *Lingzhi* sprays are painted on the belly, and the lower belly and flared foot are decorated with upright and inverted lotus lappets respectively. The interior of the ring foot is in tiered shape form and glazed in greenish-white. The exterior base is written with a mark of Xuande in regular script in two columns within a double-line medallion in underglaze blue.

The distinctive form of the jar is modelled after the shape of pomegranate, which is a new design of imperial wares produced in the Imperial Kiln at Jingdezhen in the Xuande period. The graceful and charming form complemented by the spacious pictorial composition displays a harmonious and naturalistic resonance.

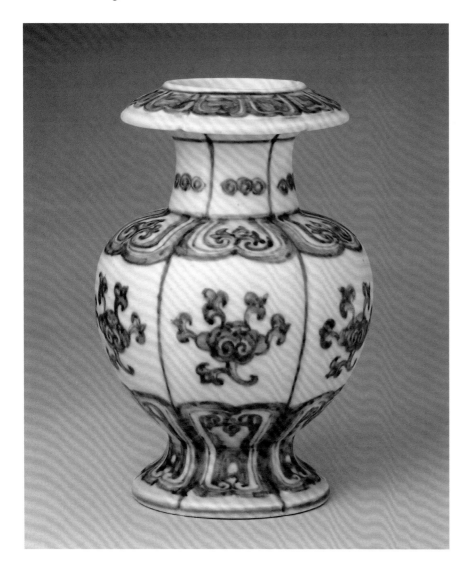

41

Three-legged Incense Burner
decorated with design of pines, bamboos, and plum blossoms in underglaze blue

Ming Dynasty Xuande period

Height 31.7 cm
Diameter of Mouth 20.2 cm
Distance between the Legs 12 cm
Qing court collection

The incense burner has a square mouth rim, a short neck, a flat and multi-angled belly supported by three animal-masked elephant-shaped legs. A pair of upright handles is on the mouth and shoulder. The mouth is decorated with tortoise-shell brocade patterns whereas the belly is decorated with rocks and the composite design of pines, bamboo, and plum blossoms, commonly known as the "three friends of winter." The interior of the handle is painted with *lingzhi* fungus sprays whereas the exterior is painted with foliage scrolls. The three animal-masks on the three elephant legs are also painted in underglaze blue and the exterior base is slightly recessed without glaze.

Pines and bamboo would not wither in the winter whereas plum blossoms endure and bloom in cold weather, thus they are called the "three friends of winter," which is a traditional symbolic decorative motif representing the integrity and loftiness of a literati gentleman.

In 1984, an incense burner with similar size and style in white glaze produced in the Xuande period was unearthed in the site of the Ming Imperial Kiln in Zhushan, Jingdezhen. These wares show the distinctive features of large and vigorous form, as well as a dynamic representation of imperial burners used in the Xuande period. They also provide valuable reference for the research on the copper Xuande incense burners of the Xuande period.

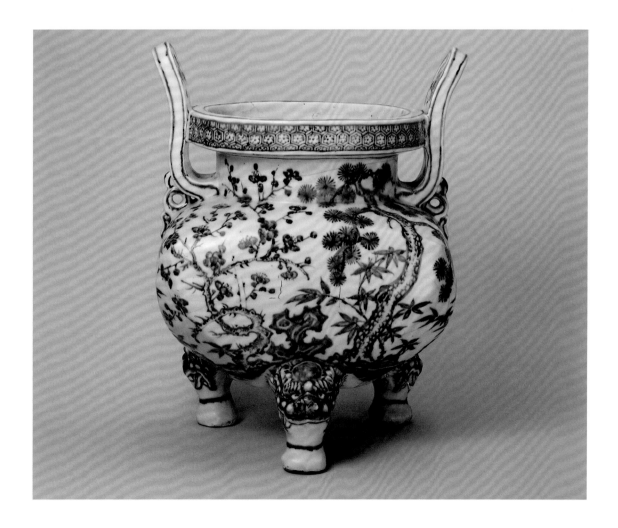

42

Rectangular Incense Burner
decorated with foliated panels and two phoenixes amidst lotus flowers in underglaze blue

Ming Dynasty Xuande period

Height 18 cm
Diameter of Mouth 22 × 14 cm
Diameter of Foot 22 × 14 cm

The incense burner has a rectangular everted mouth, a short neck, a flat belly supported by a rectangular pedestal resting on four legs. The mouth rim is painted with *lingzhi* scrolls, whereas the neck is decorated with chrysanthemum sprays. Each side of the belly is decorated with a lozenge-shaped panel in which two phoenixes flying amidst lotus flowers are painted. The belly and edge of the four feet are decorated with *ruyi* cloud-shaped patterns. The neck is written a horizontal six-character mark of Xuande written in regular script in underglaze blue.

Phoenix is one of the common auspicious designs in China and is also used for decorating porcelain wares produced in the Imperial Kiln in the Xuande period. The phoenix design is often complemented by other decorations such as auspicious clouds, in companion with dragon, or flying amidst lotuses and peonies, and is painted with a touch of gracefulness and delicacy, and carries auspicious meanings.

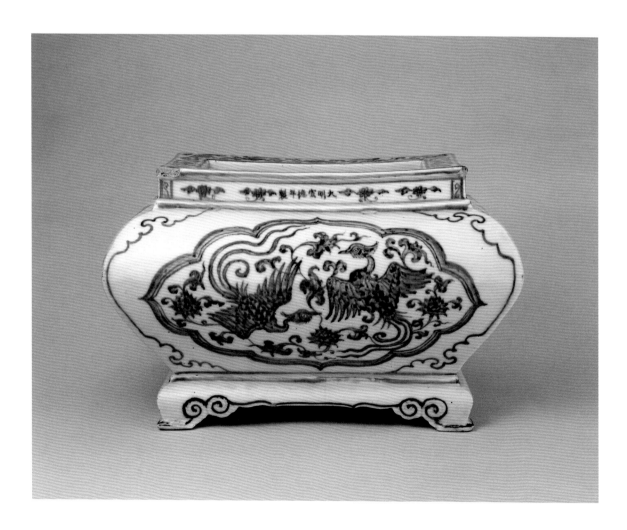

43

Brush-washer in the Shape of a Sunflower
and decorated with design of two phoenixes amidst clouds in medallions in underglaze blue

Ming Dynasty Xuande period

Height 4.5 cm
Diameter of Mouth 17.5 cm
Diameter of Foot 14.2 cm

Qing court collection

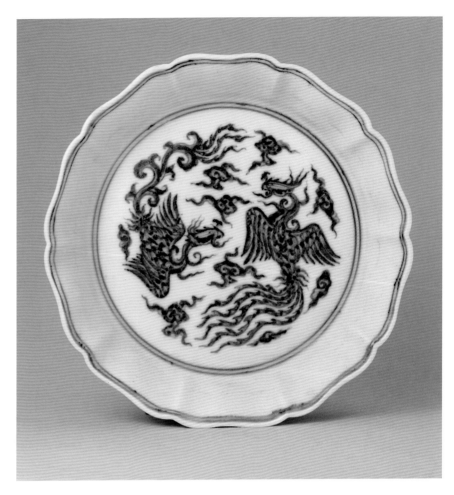

The washer is fashioned in the form of sunflower with ten petals, slightly recessed in the interior centre and the ring foot. On the interior centre and the exterior wall are decorations of medallions of phoenixes flying amidst auspicious clouds. The exterior and the interior sides are further decorated with four string borders in underglaze blue respectively. The interior of the foot is covered with white glaze. The exterior base is written with a six-character mark of Xuande in regular script in two columns within a double-line medallion in underglaze blue.

Washer served various functions in ancient China, such as washing utensil, stationery item, or decorative object. Sunflower-shaped brush washer was first produced in the Ge Kiln in the Song Dynasty. A large number of these wares in white and underglaze blue were produced in the Imperial Kiln, at Jingdezhen in the Yongle and Xuande periods, Ming Dynasty. Fruit-and-flower sprays, dragon amidst clouds, two phoenixes amidst clouds, and dragon-and-phoenix amidst clouds are popular decorative motifs.

44

Bowl

decorated with design of a phoenix singing on a bamboo tree and a scene of ladies in a garden in underglaze blue

Ming Dynasty Xuande period

Height 7.8 cm
Diameter of Mouth 18.7 cm
Diameter of Foot 7.7 cm

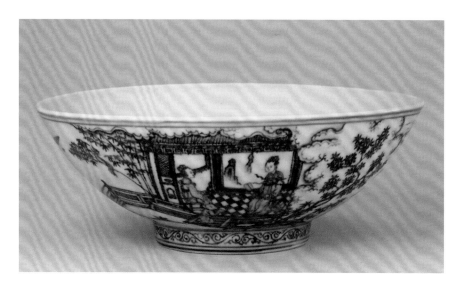

The bowl has a flared mouth, a deep and curved wall, and a ring foot. The interior wall is plain whereas the exterior wall is painted with a continuous garden scene of ladies engaging in leisure activities. On one side of the bowl are two ladies chatting inside a pavilion, with an attendant beside them. On the other side are two ladies strolling near a pavilion. All ladies have their hairs coiled up and dresses with ribbons touching the ground and drifting in the wind. The garden is decorated with rocks and clusters of bamboo, trees, flowers, and grasses, along with these are fences, a stream, and a phoenix singing on a bamboo tree surrounded by auspicious clouds. The exterior wall of the ring foot is painted with acanthus patterns. The exterior base is written with a six-character mark of Xuande in regular script in two columns within a double-line medallion in underglaze blue.

A number of plates, bowls, and stemcups in underglaze blue produced in the Imperial Kiln in Xuande period are decorated with the scene of ladies strolling in a garden, which represents a distinctive decorative motif on the imperial wares of the Ming Dynasty. The ladies are mostly rendered with a slim body and graceful posture with a touch of tranquility and lyricism.

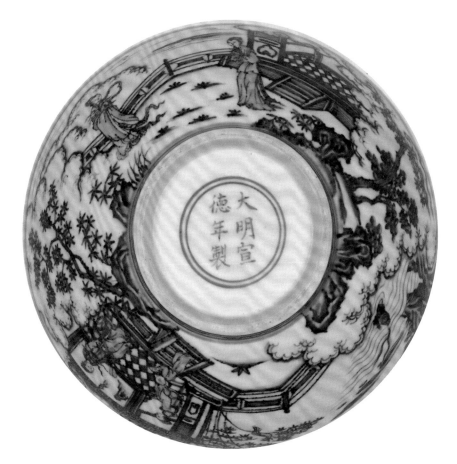

45

Bowl with Cover
and decorated with two dragons and cresting waves in iron-red enamel and underglaze blue

Ming Dynasty Xuande period

Height 7.4 cm
Diameter of Mouth 17.4 cm
Diameter of Foot 9.3 cm

The bowl has a flared mouth, a deep and curved belly, an angular base, and a ring foot. The body has two string borders in relief, above which are two dragons in iron-red enamel amidst cloud patterns in underglaze blue. Underneath the string borders are cresting waves painted in underglaze blue. The interior centre is written with a six-character mark of Xuande in regular script in two columns within a double-line medallion in underglaze blue.

The colours of decorative designs on the bowl are harmoniously matched. The eyes of the dragons in iron-red are dotted with underglaze blue, and further enriched by cloud patterns in underglaze blue around and the cresting waves in underglaze blue below. The major colour scheme of layers of blue and red matched with a touch of elegance. Originally the bowl should have a fitting cover which is now lost.

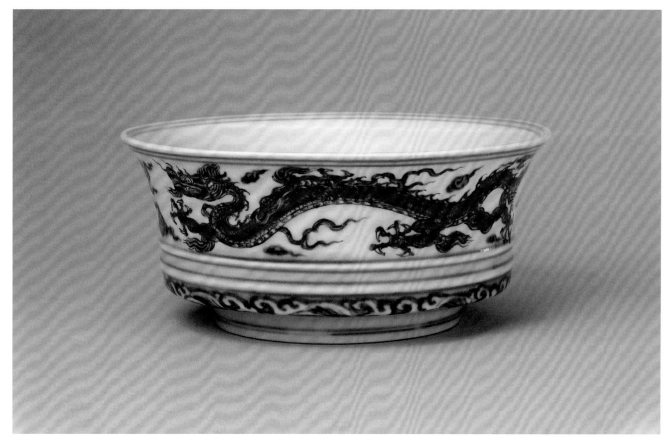

46

Meiping Vase
decorated with design of peacocks and peonies in underglaze blue

Ming Dynasty Zhengtong period

Height 36.5 cm
Diameter of Mouth 5 cm
Diameter of Foot 12.8 cm

The *meiping* vase has a small mouth, a short neck, a slanting shoulder tapering downwards to an elongated belly. The shoulder is painted with lotus and peony scrolls, and the belly is decorated with peacocks and peonies. Banana leaves are painted near the foot.

The decorative theme on the vase is eminently rendered, and the underglaze blue is in dense and brilliant colour tone. The peacock is painted in a graceful manner with feathers meticulously depicted whereas the peonies on the branches are in full bloom. Phoenix is a bird in Chinese mythical legend, which is said to transform into a peacock when it is born on earth. Peony represents wealth and elegance, thus the combined motifs of phoenix and peony symbolizes wealth and auspicious blessing.

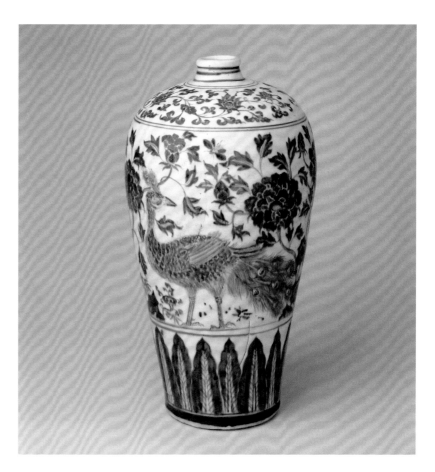

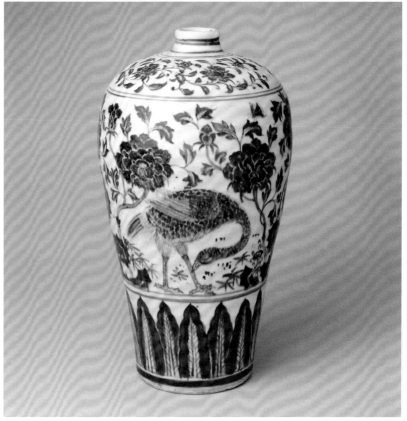

47

Jar
decorated with design of the eight immortals celebrating birthday in underglaze blue

Ming Dynasty Jingtai period

Height 35.3 cm
Diameter of Mouth 21.5 cm Diameter of Foot 20 cm

The jar has a mouth slightly curved inside, a short neck, a slanting shoulder, and a globular belly tapering downwards to a ring foot. The neck is painted with brocades of lozenges, and the shoulder is decorated with cranes amidst clouds and various precious emblems. The belly is decorated with a continuous scene of the eight immortals celebrating birthday, and complemented by prominent cloud patterns. Cresting waves and cliffs design is painted near the foot and the interior of the foot is unglazed.

The eight immortals are legendary deities of Daoism, including Tieguai Li, Han Zhongli, Lü Dongbin, Zhang Guolao, Cao Guojiu, Han Xiangzi, Lan Caihe, and He Xiangu. As the legend tells, they are invited by the Queen Mother of the West to attend a peach banquet to celebrate her birthday. Given this, the eight immortals in birthday celebration is a popular motif with the auspicious meaning of longevity.

The colour of underglaze blue has a greyish tine and the glaze has a greenish-white tint, as well as crackles on the glaze surface.

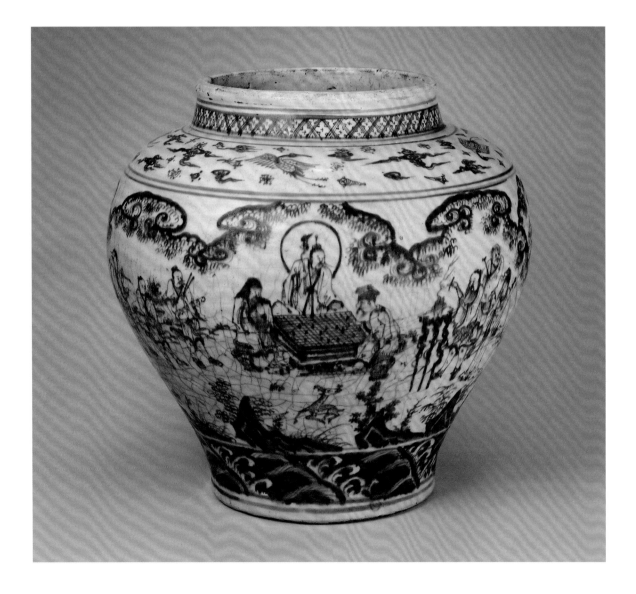

48

Cylindrical Incense Burner
with Three Legs
and decorated with design of Persian script
in underglaze blue

Ming Dynasty Tianshun period

Height 11.5 cm
Diameter of Mouth 15.3 cm
Distance between feet 14 cm

The burner is in cylindrical shape. It has an everted mouth rim, a straight wall, and a flat base supported on three legs. The interior of the burner is plain, whereas the exterior wall is decorated with underglaze blue designs. A border of key-fret patterns is painted near the mouth rim, and the belly is decorated with three rows of Persian script in underglaze blue. The Persian scripts is a poem of the Persian poet Sa'di Moshlefoddin Mosaleh (1208—1291), quoted from the collection of poems *Garden of Fruits*. The poem encourages people to be humble, respectful to God, and care for the poor. Two string borders in underglaze blue are painted near the base. On the right side of the interior base is a three-character mark of Tianshun written in regular script in underglaze blue.

The form of the burner is well proportioned with the paste finely fashioned, generating a sense of elegance and stability. The glaze has a greenish-white tint. The Persian scripts are written in a fluent and swift manner that is both decorative and demonstrates the spiritual state of the ceramic artist. The three-character mark of Tianshun in regular script carries on the vigorous style of the Xuande period, as well as reflecting the delicate writing style of the Chenghua period. In particular, the character *tian* is written in a similar style of the character *tian* written on the jars with a mark *tian* of the Chenghua period.

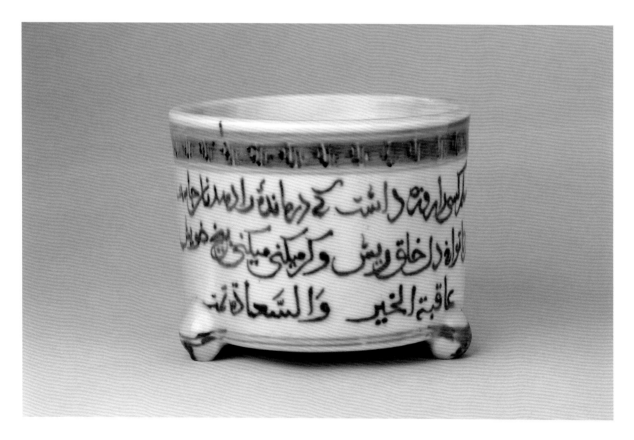

49

Incense Burner with Three Legs
and decorated with design of lotus scrolls, eight Buddhist Emblems, and drum-nails in underglaze blue

Ming Dynasty Chenghua period

Height 9 cm
Diameter of Mouth 10 cm Diameter of Base 9.5 cm
Qing court collection

The incense burner is in cylindrical shape. It has a flat base supported by three animal-shaped legs. Near the mouth on the exterior wall and the base are decorations of nipple patterns in relief. The belly is decorated with eight auspicious Buddhist Emblems, including the wheel, the conch shell, the umbrella, the canopy, the lotus, the twin-fish, the jar, and the endless knot, supported by lotus scrolls, and the foot is painted with lotus flowers in underglaze blue. The exterior base is written with a six-character mark of Chenghua in regular script in two columns within a double-line medallion in underglaze blue.

The eight emblems are the eight dharma tools used in Buddhist ritual ceremonies, including the dharma wheel, the white conch shell, the precious umbrella, the white canopy, the lotus flower, the water bottle, the twin-fish, and the endless knot; each embodying different meaning in Buddhism respectively. The decorative motif of eight emblems is collectively known as "eight emblems bring brightness and brilliance."

The form of the incense burner is finely potted and covered with shiny and translucent glaze. The colour of underglaze blue is soft and pure. It represents a typical and rare imperial underglaze blue ware of the Chenghua period. Ceramic art of the Ming Dynasty had reached a new height in the Chenghua period with a new fashion of delicate forms, translucent thin glaze, and meticulous painterly brush work with a touch of gracefulness and subtleness. Plates, bowls, cups, and stem-cups written with a mark of Chenghua are more often seen, but not for burners, vases, and jars.

50

Covered Jar
decorated with design of auspicious rocks and flowers in underglaze blue

Ming Dynasty Chenghua period

Overall Height 11.3 cm
Diameter of Mouth 7.9 cm
Diameter of Foot 10.3 cm
Qing court collection

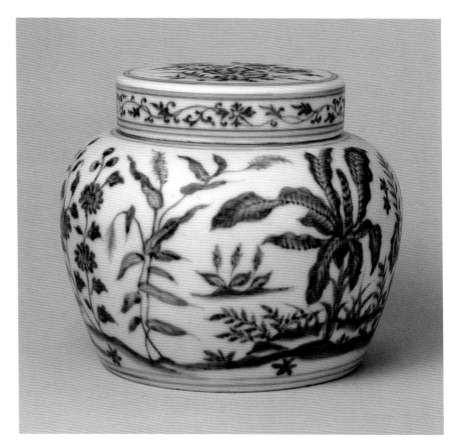

The jar has an upright mouth, a short neck, a slanting shoulder, a globular belly tapering downwards, and a ring foot. It has a matching round cover with an upright mouth rim. The belly is decorated with auspicious rocks, chrysanthemums, reeds, banana leaves, and various flowers, setting on a slope with flowers and grasses. The cover is decorated with auspicious rocks, flowers and plants, and its exterior wall is decorated with foliage scrolls.

The paste of the jar is thinly potted and light, and covered with pure white glaze and underglaze blue decorations with a soft and pure colour tone. The decorations are painted in a vivid and naturalistic manner with refreshing charm, representing a refined piece of the underglaze blue wares of the Chenghua period.

The style of Chenghua imperial underglaze blue wares can be classified into two types, the early style and the standard style. The earlier Chenghua style was rather close to that of the Xuande imperial wares, which used the imported *soleimani* blue material containing high iron and low magnesium, and gave a dense colour tone and oxidized iron crystallized heap-and-piled effect. Since the production period was rather short, extant wares are rare. The typical Chenghua imperial wares of the period used the *pingdenging* local underglaze material from Leping, Jiangxi, which contains low iron and high magnesium, for painting decorations, and thus the colour tone was purer and soft without the crystallized heap-and-piled effect, and the decorations were rendered in a more vivid and swift style.

51

Bowl
decorated with design of nine dragons in the sea in underglaze blue

Ming Dynasty Chenghua period

Height 7.8 cm
Diameter of Mouth 17.2 cm
Diameter of Foot 7 cm
Qing court collection

The bowl has flared mouth rim, deep and curved belly, and ring foot. The interior centre is decorated with a dragon rising from the sea within a double-line medallion. Near the mouth rim are decorations of coin patterns. The belly is decorated with nine dragons, rising and chasing in the cresting sea waves. The exterior base is written with a six-character mark of Chenghua in regular script in two columns within a double-line medallion in underglaze blue.

The decorative designs on this bowl are skillfully treated by using underglaze blue in a softer tone to depict waves for highlighting nine dragons painted in dense underglaze blue colour. The fierce postures of the nine dragons generate a vigorous and heroic appeal. Nine dragons playing in the sea was a common motif on Ming imperial wares, and usually cresting waves form the background so that the nine dragons would stand out prominently. Also there are examples that underglaze blue was used for painting the cresting waves, and iron-red colour was used to paint the dragons so to produce a contrasting colour effect. Underglaze blue wares of the Chenghua period are esteemed for their designs painted in soft colour tone. The decorative designs on this bowl is noted for the tonal gradations of underglaze blue from dense to soft, which give a lustrous appeal and further enliven the spirit of dragons, thus representing a rare refine piece of Chenghua imperial wares in underglaze blue.

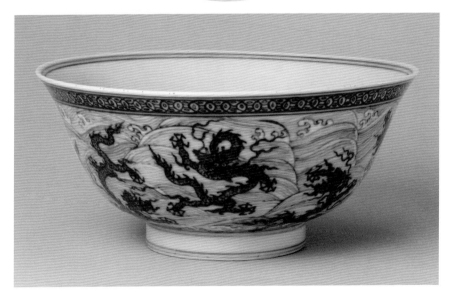

52

Bowl
decorated with design of auspicious rocks and camellias in underglaze blue

Ming Dynasty Chenghua period

Height 6.7 cm
Diameter of Mouth 15.3 cm
Diameter of Foot 5.2 cm
Qing court collection

The bowl has flared mouth, deep curved wall, and ring foot. The interior is plain. The exterior wall is decorated with three clusters of camellias, interspersed by slopes with grasses and flowers, as well as flying bees. The interior of the right foot is covered with greenish white glaze, and the exterior base is written with a six-character mark of Chenghua in regular script in two columns within a double-line medallion in underglaze blue.

The paste and body of this bowl is light and thinly potted, and covered with shiny translucent glaze. Its decorations are characterized by delicate painterly brushwork and soft underglaze blue tone of the *pingdengqing* local underglaze blue material produced from Leping, Jiangxi. The imperial underglaze blue wares of the Chenghua period marked a new aesthetic taste of Chinese underglaze blue wares, as represented by this bowl which is a representative piece of the Chenghua imperial underglaze blue wares.

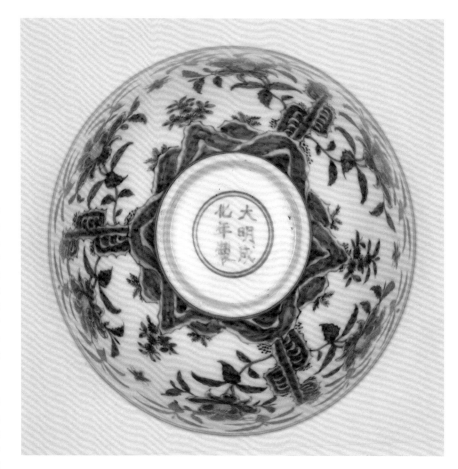

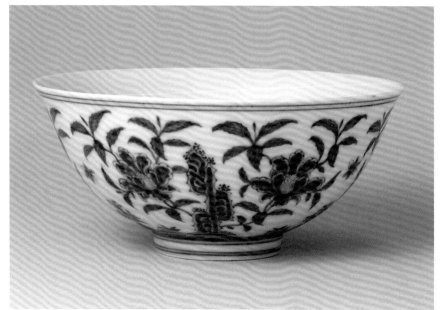

53

Bowl
decorated with design
of a lotus pond
in underglaze blue

Ming Dynasty Chenghua period

Height 4.9 cm
Diameter of Mouth 8.8 cm
Diameter of Foot 3.6 cm
Qing court collection

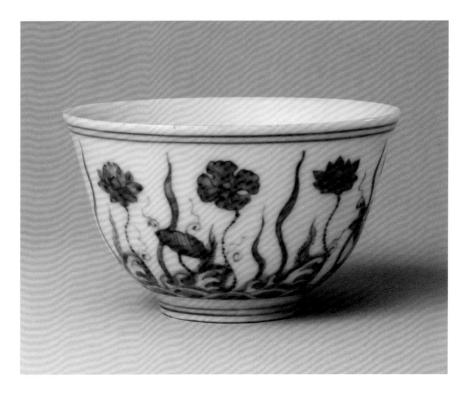

The bowl has slightly flared mouth, deep curved wall, and ring foot. The interior is plain. The exterior wall is decorated with a lotus pond in underglaze blue. Several lotus stems with flowers are depicted in a naturalistic and refreshing manner, which look like swinging in the breeze. Other water plants are painted in between the lotuses and near the base are decorations of water spirals. The interior of the right foot is covered with white glaze. The exterior base is written with a six-character mark of Chenghua in regular script in two columns within a double-line medallion in underglaze blue.

Lotus pond is a popular design in Chinese traditional motifs, and it was designated with the tribute "beauties in water pond" in the Yuan and Ming Dynasties. Underglaze blue wares with this design first appeared in of the Yuan Dynasty, and were continuously produced in the Ming Dynasty.

54

Bowl with a Recessed Foot
and decorated with design of fruits, trees, and birds in underglaze blue

Ming Dynasty Chenghua period

Height 4.1 cm
Diameter of Mouth 9.6 cm
Diameter of Foot 5.3 cm
Qing court collection

The bowl has a flared mouth, a shallow curved wall, and a recessed foot. The interior is decorated with five Sanskrit characters in the *nancha* style, representing the five Dhyani-Buddhas, within *ruyi* cloud collars and painted in underglaze blue. The exterior wall is decorated with fruits, trees, and three birds resting on branches, raising its head or eating fruits. Another bird is depicted flying in the sky. The interior of the ring foot is covered with white glaze. The exterior base is written with a six-character mark of Chenghua in regular script in two columns within a double-line square.

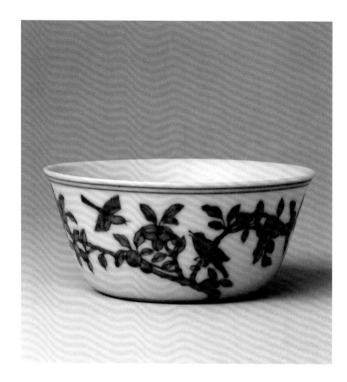

The Tibetan Buddhism pronounced that in order to cultivate the layman, Mahavairocana manifested himself into the five Dhyani-Buddhas, symbolizing the five wisdoms, and thus also known as the five Dhyani Buddhas of the Vjradhatu and Garbhadhatu: Vairocana of the Centre, Ratna-sambhava of the South, Akshobhya of the East, Amitabha of the West, and Amogha-siddha of the North.

The painted decorations on the exterior wall of the bowl is depicted like a handscroll of Chinese painting with soft underglaze colour tone, making it resemble a classic scroll of Chinese painting of flowers and birds in ink.

55

Plate
decorated with design of *qilin* Chinese
unicorns and auspicious clouds
in underglaze blue

Ming Dynasty Chenghua period

Height 6.5 cm
Diameter of Mouth 34.2 cm
Diameter of Foot 22.2 cm
Qing court collection

The plate has a flared mouth, a curved wall, and a ring foot. The interior centre is decorated with two *qilin* Chinese unicorns chasing each other and interspersed by cloud patterns within a double-line medallion. The exterior wall is decorated also two *qilin* Chinese unicorns chasing each other and interspersed by cloud patterns as well. Near the mouth rim on the exterior wall is a horizontal six-character mark of Chenghua written in regular script in underglaze blue. The base is unglazed, showing brownish spots which is commonly known as "sticky rice base."

Qilin Chinese unicorn is an auspicious fabulous beast in ancient Chinese mythology, which has a composite outlook of deer, horse and dragon. It has a single horn on the head, scaly body, and is born by itself with a tame character. The fabulous beast can live up to 3,000 years and is regarded as the supreme head of the four "spiritual animals" and all beasts. It is also a symbol of a peaceful regime governed by the sacred emperor, and thus has become a popular motif in ancient Chinese art.

Most of the typical Chenghua wares include plates, bowls, cups, dishes and covered jars with smaller sizes rather than large pieces. This plate has a larger size with a refined paste. The decorations are finely painted in a fluent and vigorous style, representing a fine piece of extant Chenghua wares.

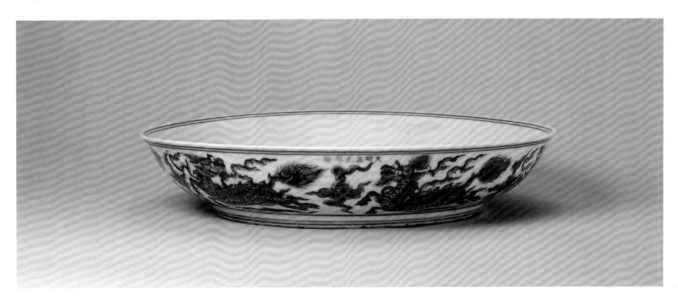

56

Bowl
decorated with design of
dragons amidst clouds
in iron-red and
underglaze blue

Ming Dynasty Chenghua period

Height 9.6 cm
Diameter of Mouth 21.6 cm
Diameter of Foot 8.7 cm

The bowl has a flared mouth, a deep
curved belly, and a ring foot. The interior
centre and the exterior wall are decorated
with design of dragons in iron-red, and en-
riched by tortoise-shell brocade border and
lingzhi cloud patterns in underglaze blue.
The interior of the ring foot is covered with
greenish-white glaze.

The paste of the bowl is delicately pot-
ted and refined, and the shiny glaze is trans-
lucent and pure. It is a representative refined
piece of imperial Chenghua wares with sub-
tle form, delicate and painterly quality, and
soft colour tone.

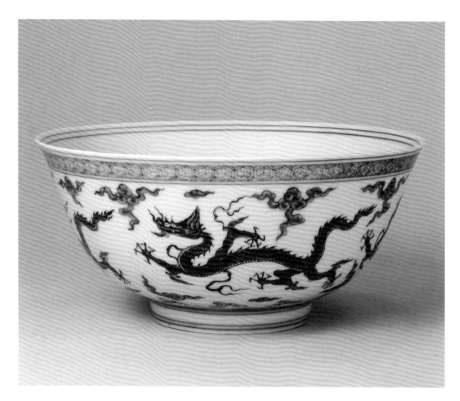

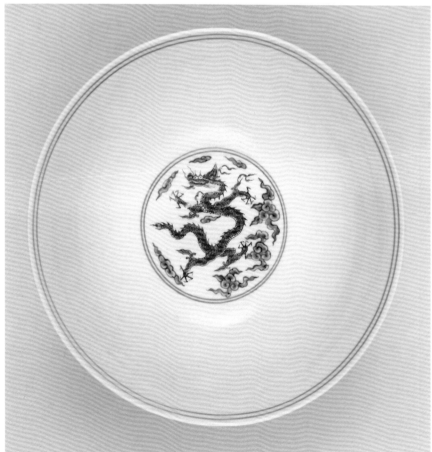

57

Plate
decorated with design of floral and fruit sprays in underglaze blue on a yellow ground

Ming Dynasty Chenghua period

Height 5.2 cm
Diameter of Mouth 29.5 cm
Diameter of Foot 21 cm
Qing court collection

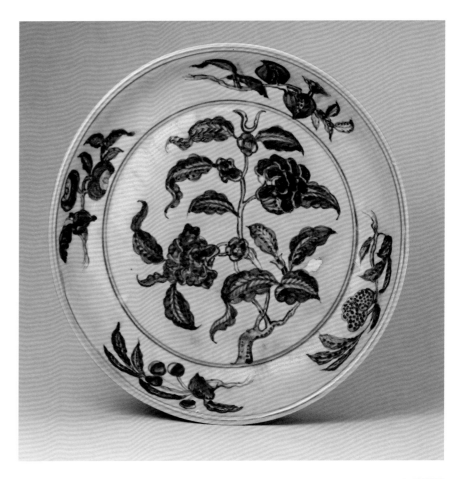

The plate has a flared mouth, a shallow curved wall, and a ring foot. The ground is glazed in yellow with underglaze blue decorations. The interior centre is decorated with sprays of pomegranate flowers, whereas the interior wall is decorated with auspicious fruits such as peaches, lychees, and others. The exterior wall is decorated with lotus sprays. The exterior base is unglazed, showing the so-called "sticky rice base." Underneath the mouth rim is a horizontal six-character mark of Chenghua written in regular script in underglaze blue and reserved in white.

Wares with underglaze blue decorations on a yellow ground was a new type of porcelain wares first produced by combining the use of high-temperature and low- temperature fired glazes in the Xuande period of the Ming Dynasty. In the Chenghua period, the colour tone became softer and lighter. The production technique was to fire the underglaze blue decorations first, and then applied yellow glaze on the white glazed paste, and fired a second time in the kiln.

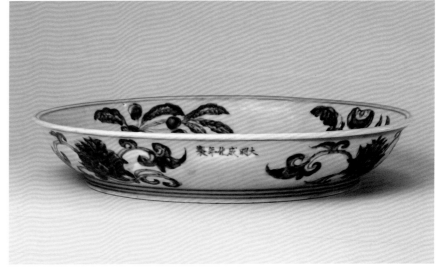

58

Three-legged Incense Burner
decorated with design of Daoist priests in underglaze blue

Ming Dynasty Hongzhi period

Height 12.2 cm
Diameter of Mouth 19.4 cm
Distance between legs 12.4 cm

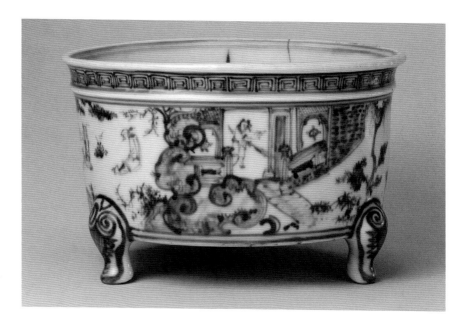

The tubular-shaped incense burner has a round mouth, a straight belly, and a flat base underneath with three legs. Underneath the mouth rim are key-fret patterns and the principal decorations on the belly is a legendary scene depicting Daoist priests, which tells the story that after the priest Mao Ying brought his brothers to cultivate the way of Daoism, they subsequently became immortals, who then often rode on cranes and flying in the sky, with distorted banana-leaf patterns on its feet.

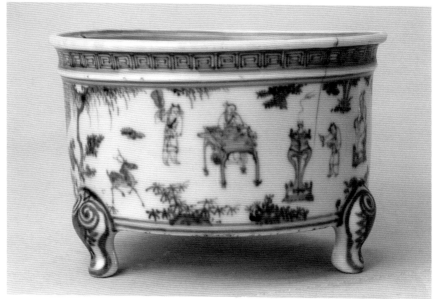

The Daoist priests depicted are the commonly known "True Masters of Three Maos." They were Mao Ying, Mao Gu, and Mao Zhong who cultivated the way and practices of Daoism and had become immortals in the Han Dynasty and founded the Maoshan Sect of Daoism.

The decorations on this incense censer are blurred and suffused. Judging from its form and painting style, this piece should have been produced in local kilns. The figures are painted in a vivid manner with fluent and spontaneous brushwork, and the landscapes are depicted in a realistic manner with a touch of naturalism, revealing the matured techniques of potters of the local kilns in the Hongzhi period.

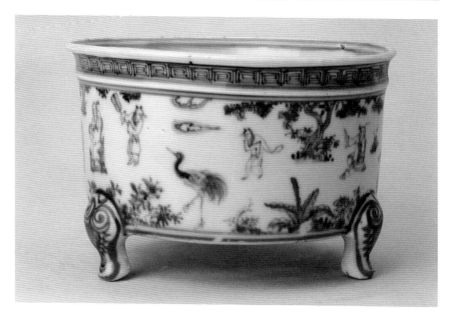

59

Bowl
decorated with design of dragons in a lotus pond in underglaze blue

Ming Dynasty Hongzhi period

Height 7 cm
Diameter of Mouth 16 cm
Diameter of Foot 6 cm
Qing court collection

The bowl has a flared mouth, a deep curved wall, and a ring foot. Underneath the mouth on the interior wall is a border of cresting waves. Both the interior centre and the exterior wall are decorated with design of dragons swimming in a lotus pond. The interior of the ring foot is covered with white glaze. The exterior base is written with a six-character mark of Hongzhi in regular script in two columns within a double-line medallion in underglaze blue.

The decoration of dragons swimming in a lotus pond first appeared in the Xuande period and became more popular in the Hongzhi period. One of the features of dragons of such a design in the Hongzhi period is the slim body of the dragon with a peaceful resonance in pursuit of the essence of subtleness.

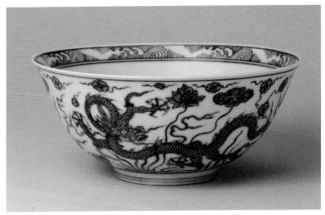

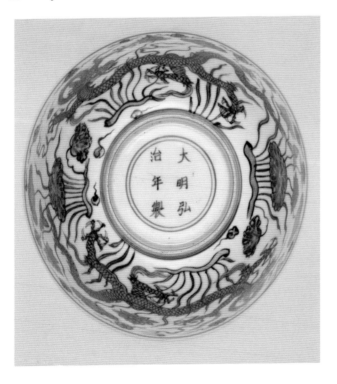

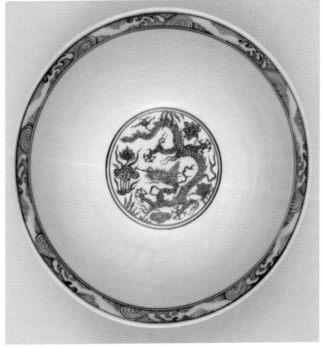

60

Stem-cup
decorated with design of five
fish and auspicious clouds
in iron-red
and underglaze blue

Ming Dynasty Hongzhi period

Height 11.9 cm
Diameter of Mouth 16.1 cm
Diameter of Foot 4.4 cm

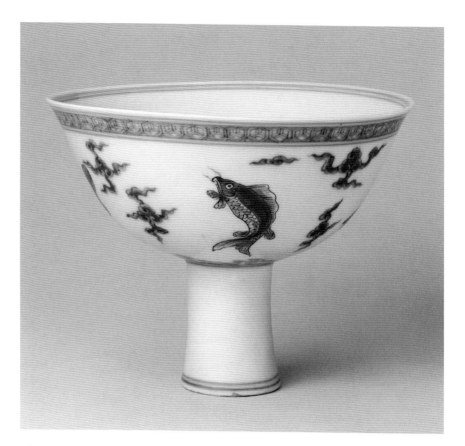

The bowl has a flared mouth, a deep curved wall, and a hollow stem-cup. The interior centre and the exterior wall are decorated with "carps leaping the Dragon Gate" in iron-red and auspicious clouds in underglaze blue, and further enriched a border of tortoise-shell brocade patterns in underglaze blue.

"Carps leaping the Dragon Gate" is a well-known legend in ancient Chinese mythology. It tells that after a carp successfully leaped the Dragon Gate (the gorge located at the section of the Yellow River at the junction of the Shanxi and Shaanxi provinces, which is now known as the "Yumen Gate"), then fire from heaven would burn its tail and it would transform into a dragon. Later the legend became a symbol of success in civil services examinations, promotion in official career, etc. It also symbolizes that all beings should face and counter all difficulties in order to achieve success.

The form of this bowl is elegantly fashioned and covered with translucent and pure glaze. The spatial pictorial treatment creates void spaces, making the design of iron-red carps vivid and stands out prominently. The decorative composition and the painterly brushwork reveal superb painterly brush work and generate a transcended aesthetic appeal.

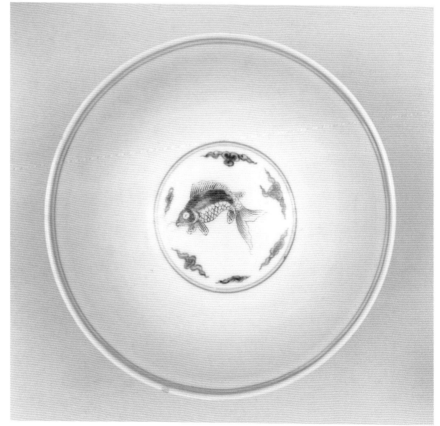

61

Candle-stand
decorated with design of Arabic scripts
in underglaze blue

Ming Dynasty Zhengde period

Height 24.6 cm
Diameter of Mouth 6.7 cm
Diameter of Foot: 13 cm
Qing court collection

The mouth of the candle-stand is in the shape of a shallow bowl, which links to a slim and long supporting tube and underneath the tube is a shallow basin with flared mouth for collecting candle drops. Underneath the basin is a trumpet-shaped flaring high stem. The exterior wall of the mouth is decorated with design of *ruyi* cloud collars and the exterior wall of the basin is decorated with foliage scrolls interspersed by lozenges. The supporting tube and the middle section of the high stem foot are decorated with round panels, in which Arabic scripts are written. On top and underneath the panels are designs of foliage scrolls and lozenges with *ruyi* clouds lappets painted near the base. The interior of the ring foot is covered with greenish-white glaze. The exterior base is written with a six-character mark of Zhengde in regular script in two columns within a double-line medallion in underglaze blue.

This candle-stand was a new typeform of Zhengde imperial wares, which was for functional use with high aesthetic appeal. The use of Arabic scripts and Persian scripts for decorating imperial wares was a distinctive feature in the Zhengde period. The content of the scripts were often quotations from the Koran Classic of Islam, and such a decorative practice was closely associated with Emperor Zhengde who was devoted to the Islamic religion.

62

Boxes Set
decorated with design of ladies in a garden in underglaze blue

Ming Dynasty Zhengde period

Overall Height 23.9 cm
Diameter of Mouth 16.1 cm
Diameter of Foot 10.6 cm

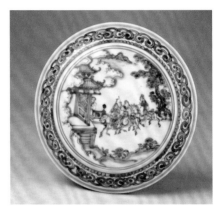

The boxes set is in the shape of a round tube and composed of four sections. The sizes and shapes of the base and the cover are similar, and the boxes in the middle two tiers are also similar, and have ring feet. The cover is decorated with a scene of "success in the Imperial Civil Services Examination," depicting the first top graduates including the *zhuangyuan* first-rank graduate, the *bangyan* second-rank graduate, and *tanhua* third-rank graduate of the Imperial Civil Services Examination who proudly ride on horses and stroll on street for the admiration and praises by the laymen for their success. The bulged area is decorated with *ruyi* cloud collars, and the sides are decorated with tortoise-shell brocade patterns. The boxes in two tiers in the middle are decorated with ladies in amusement in a garden, such as appreciating flowers, burning incense, tasting tea, or strolling with a *qin* Chinese zither and served by their attendants. On the slope are flowers and plants and in the sky are floating auspicious clouds, which generate a graceful and amusing ambience. The side of the base is decorated with tortoise-shell brocade patterns that echo the design on the cover. Near the base are decorations of lotus petals. The interior of the ring foot is covered with greenish-white glaze.

Although the boxes set does not have any reign mark, the quality of the paste and glaze, as well as the colour of underglaze blue and decorative style, show the typical features of Zhengde imperial wares and should belong to the Zhengde period.

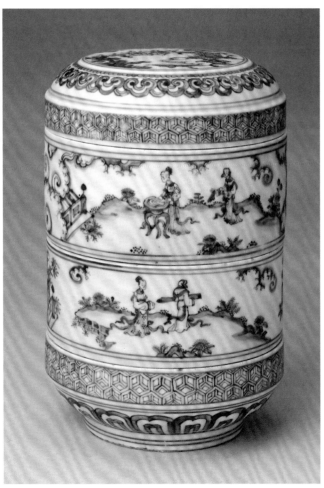

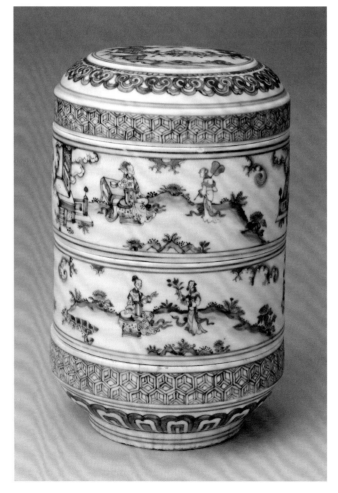

63

Plate
decorated with design of
fishes and aquatic plants
in underglaze blue
on a peacock-green ground

Ming Dynasty Zhengde period

Height 3.4 cm
Diameter of Mouth 17.7 cm
Diameter of Foot 10.4 cm
Qing court collection

The plate has a flared mouth, a shallow curved wall and a ring foot. The interior of the plate is covered with white glaze and plain. The exterior wall is decorated with four fishes: mackerel, white fish, carp and mandarin fish with the homonymic meanings (*qingbailigui*), representing "pure, clean, etiquette and noble." The interior of the ring foot is covered with greenish-white glaze. The exterior base is written with a four-character mark of Zhengde in regular script within a double-line medallion in underglaze blue.

Such type of plates decorated with design of fishes and aquatic plants in underglaze blue on a peacock-green ground was first produced in the Imperial Kiln in the Xuande period, and were continuously produced in the Chenghua and Zhengde periods, but the decorative designs became more simple and concise subsequently.

Wares with underglaze blue and peacock-green glaze were first produced in the Jingdezhen Kiln in the Yuan Dynasty. The production technique was to paint the decorative designs in underglaze blue on the potted wares, and then use the brush to cover the designs with a thin layer of white glaze. Afterwards the wares would be fired for the first time in high temperature, and applied with peacock green glaze for second firing in mid-temperature. Under the shading of peacock green, the underglaze blue decorations would appear in a dark blue colour tone.

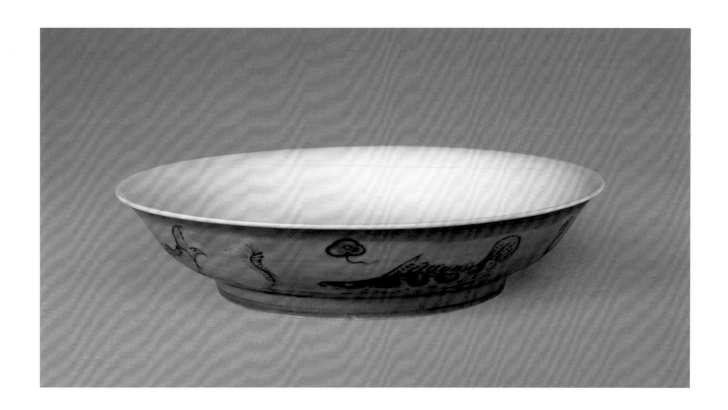

64

Large Covered Jar
decorated with design of a dragon amidst waves and clouds in underglaze blue

Ming Dynasty Jiajing period

Height 54.2 cm
Diameter of Mouth 25.2 cm
Diameter of Base 30 cm
Qing court collection

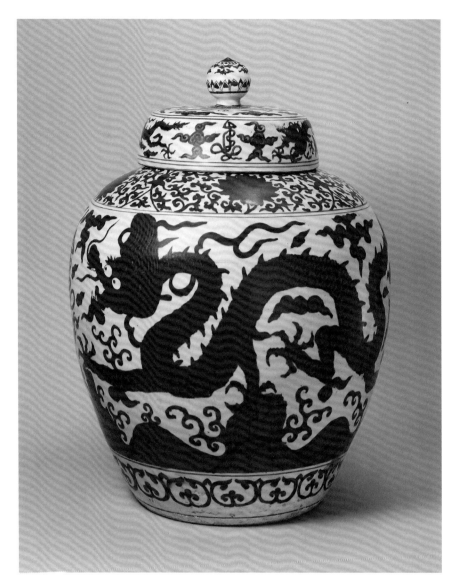

The covered jar has an everted rim, a short neck, a slanting shoulder, and a globular belly tapering downwards towards the flat base. It has a matching canopy-shaped cover topped with a tourmaline knob. The shoulder is decorated with lotus scrolls, and the belly is decorated with a dragon flying amidst clouds and cresting waves, and interspersed by *lingzhi* funguses supporting the characters *shou* (longevity). Near the base are decorations of cloud scrolls. The surface of the cover is also decorated with dragon amidst clouds and interspersed by the character *shou* (longevity). On the neck is a horizontal six-character mark of Jiajing written in regular script in underglaze blue.

This jar has a large size, and although the decorative designs are quite sophisticated, the treatment has clear perspectives to highlight the major pictorial themes. The colour of underglaze blue is accurate and pure. According to *Jiangxisheng Dazhi: Taoshu,* the underglaze blue material used on Jiajing imperial underglaze blue wares was a mixture of imported "Mohammedan" blue with local *shiziqing* (*shizi* blue) in designated proportions. Such mixture of underglaze blue with around 500 grams of "Mohammedan" blue and 5 grams of *shiziqing* was regarded as "superior blue" and its colour tone would be bright, thick, and dense with a slight purplish-red tint in the blue colour, showing a distinctive feature of undrglaze blue materials of the period.

65

Plate
decorated with design of
lingzhi funguses, cranes,
and Daoist spell
in underglaze blue

Ming Dynasty Jiajing period

Height 8.1 cm
Diameter of Mouth 57.5 cm
Diameter of Foot 41.7 cm
Qing court collection

The plate has an everted mouth, a curved wall and a ring foot. The interior base is slightly recessed. The interior centre is decorated with a Daoist spell within a double-line medallion in underglaze blue, and surrounded by designs of cranes, peaches, and *lingzhi* funguses. The exterior wall is also decorated with designs of cranes, peaches, and *lingzhi* funguses. Underneath the mouth rim is a horizontal six-character mark of Jiajing written in regular script in underglaze blue.

This plate with a large size is finely potted, representing a refined piece of imperial Jiajing wares. The underglaze blue colour has a purplish tint, which is the effect of using the "superior blue" material. Emperor Jiajing was a devoted disciple of Daoism and as a result, a wide repertoire of decorative motifs from Daoism, such as the eight Immortals, eight trigrams, bead chains, *lingzhi* funguses, cranes amidst clouds, etc., which symbolize longevity and eternal life, were employed to decorate the art and crafts of the Jiajing period.

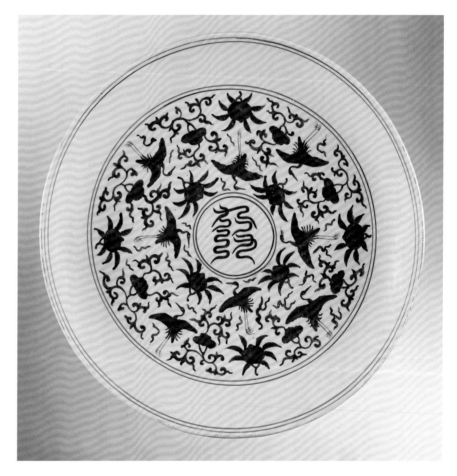

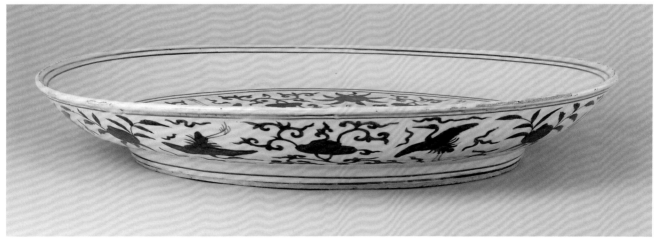

66

Covered Jar
decorated with design of
fishes and aquatic plants
in iron-red and
underglaze blue

Ming Dynasty Jiajing period

Overall Height 41.2 cm
Diameter of Mouth 21.8 cm
Diameter of Foot 21.5 cm

The jar has an upright mouth, a wide shoulder, a globular belly, and a wide ring foot. It has a matching canopy-shaped cover with a pearl-shaped knob. The surface of the cover and the belly of the jar are decorated with a scene of fishes in iron-red swimming in a lotus pond in underglaze blue. Twelve fishes with different postures are swimming leisurely in the lotus pond and amidst aquatic plants. The fishes are painted in light yellow with scales and gills outlined in iron-red, whereas the eyes are painted in black. The interior of the ring foot is covered with greenish-white glaze. The exterior base is written with a six-character mark of Jiajing in regular script in two columns within a double-line medallion in underglaze blue.

The form of this jar has an archaic favour and the decorations are painted with refreshing charm and harmonious colour tones, representing an exquisite imperial ware of the Jiajing period. Imperial wares with iron-red decorations reached its zenith in the Jiajing period, and the colour tone is characterized by a pure and bright red tint. The decorative designs are often outlined in iron-red and complemented with a yellow glazed ground. Such a technique was known as "red on the yellow."

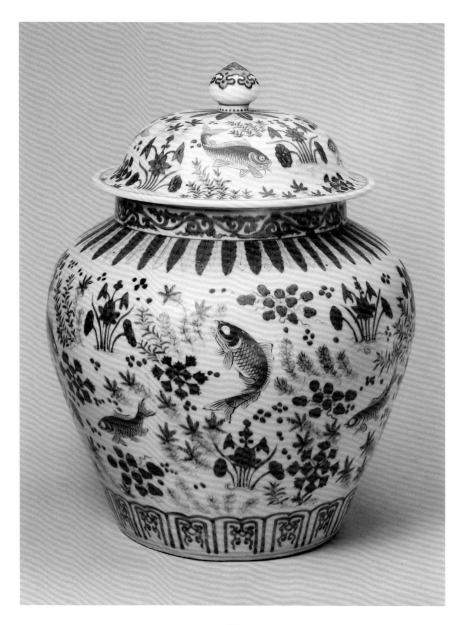

67

Large Plate
decorated with design of dragons and interweaving lotus scrolls in underglaze blue on a yellow ground

Ming Dynasty Jiajing period

Height 11.8 cm
Diameter of Mouth 80.7 cm
Diameter of Foot 54 cm
Qing court collection

The plate has a flared mouth, a shallow curved wall, a concave base, and a ring foot. The plate is glazed in yellow and decorated with underglaze blue designs. The interior centre is decorated with a dragon in the front view and surrounded by interweaving lotus scrolls. The exterior wall is also decorated with interweaving lotus scrolls. Underneath the mouth rim is a horizontal six-character mark of Jiajing written in regular script within a double-line square in underglaze blue.

This type of large plate has an alternative type which is only decorated in underglaze blue, and they should be ritual wares ordered by the imperial court for production by the Imperial Kiln with the purpose to pay tribute at sacrificial ceremonies to the heaven and earth. The dragon with a frontal view is depicted with the dragon head facing to the front, and the body is depicted with symmetrical composition, which looks like a dragon in sitting posture, and thus it is also known as "sitting dragon," and represents the most noble type of dragon designs.

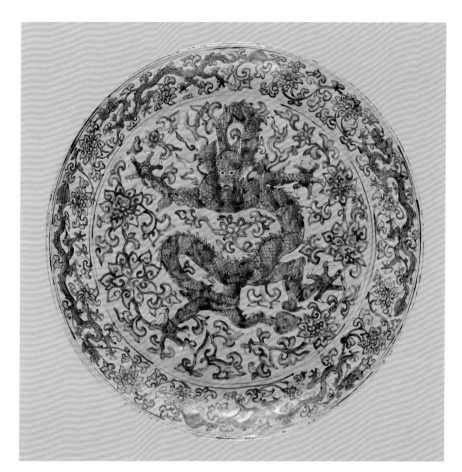

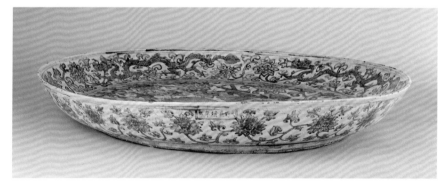

68

Teapot with Overhead Handle
decorated with design of dragon medallions and clouds in underglaze blue

Ming Dynasty Longqing period

Height 30 cm
Diameter of Mouth 10.5 cm
Diameter of Foot 15.3 cm

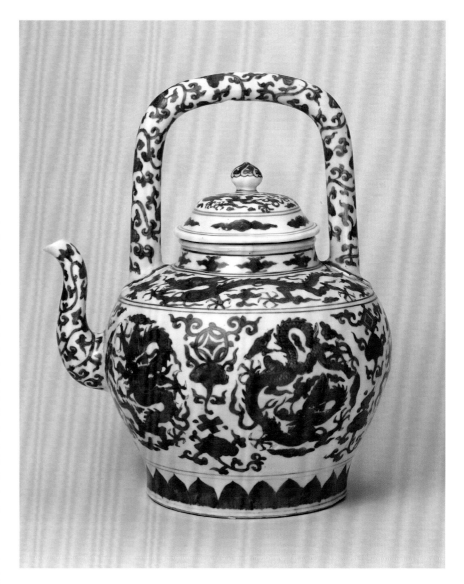

The teapot has an everted mouth, a short neck, a round shoulder, a globular belly, and a ring foot. On one side of the belly is a curved spout and on the shoulder is an overhead handle. It has a matching canopy-shaped cover with a tourmaline knob. The neck is decorated with cloud patterns, and the belly is decorated with five dragon medallions, interspersed by *lingzhi* fungus sprays supporting various precious emblems. Near the foot are decorations of lotus petals. The spout and handle are decorated with floral scrolls. The knob on the cover is decorated with deformed lotus petals. The top of the cover is decorated with dragon amidst clouds while the side is decorated with cloud patterns. The exterior base is written with a six-character mark of Longqing in regular script in two columns within a double-line medallion in underglaze blue.

The shape of the teapot is finely potted in thick and globular form, and covered with lustrous translucent glaze. The sophisticated decorative designs are skillfully treated with clear layers and perspectives in a well-arranged composition. The "superior blue" material was used and thus the underglaze blue colour has a purplish-red tint, representing a refined piece of the Longqing imperial underglaze blue wares. It is the only extant Longqing ware of its type in Mainland China, which is very rare and valuable.

The Longqing period only lasted for six years and thus extant imperial underglaze blue wares are very rare. Other than the decorations of dragon medallions, there are also designs of crane medallions, *chi*-dragon medallions, phoenix medallions, floral medallions, landscapes and rocks, fish and aquatic plants, bird and flowers, etc.

69

Round Box
decorated with dragons and phoenixes in underglaze blue

Ming Dynasty Longqing period

Overall Height 15.3 cm
Diameter of Mouth 20.9 cm
Diameter of Foot 19.2 cm

The flat and round box has interlocking upper and lower parts. The body is decorated with dragons and phoenixes amidst flowers and borders of acanthus patterns. The interior of the ring foot is covered with white glaze. The exterior base is written with a six-character mark of Longqing in regular script in two columns within a double-line medallion in underglaze blue.

"Superior blue" material was used for producing imperial underglaze blue wares in the Jiajing, Longqing, and Wanli periods. The underglaze blue material of the Longqing period was the best and the colour tone was pure and the most accurate, which was highly esteemed.

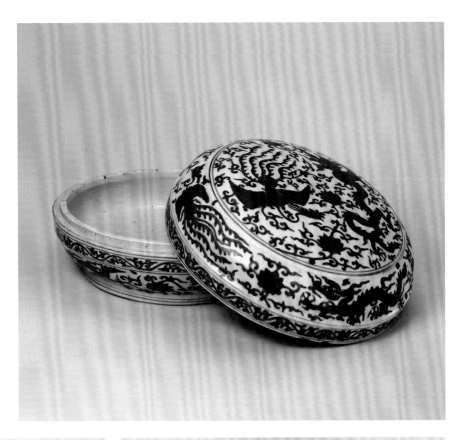

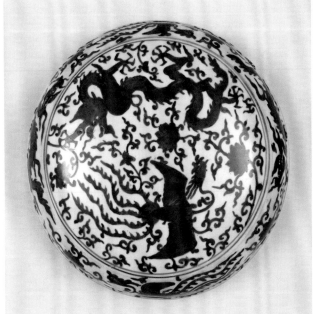

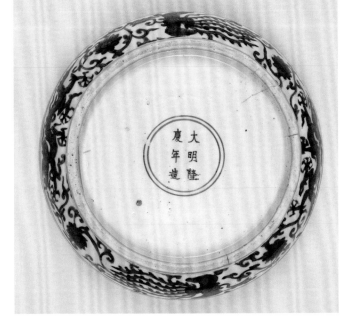

70

Garlic-head Vase
decorated with design of fishes and aquatic plants in underglaze blue

Ming Dynasty Wanli period

Height 37.5 cm
Diameter of Mouth 7.7 cm
Diameter of Foot 18 cm

The vase has a garlic-head shaped mouth, a long neck, a hanging belly, and a ring foot. The mouth rim is decorated with lotus lappets, the neck decorated with a spray of plum blossoms under moonlight, and the belly decorated with fishes, aquatic plants and acanthus patterns. Underneath the exterior rim is a horizontal six-character mark of Wanli written in regular script in underglaze blue.

Such type of large garlic-head vases was commonly produced in the Imperial Kiln in the Wanli period. The upright garlic-head shaped mouth became wider, and the neck became longer if compared with those produced in the Jiajing period, showing the different stylistic treatment of this form in different periods.

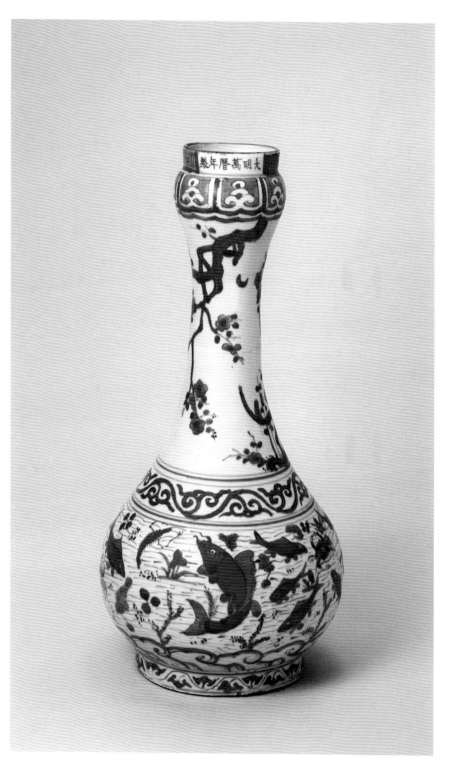

71

Rectangular Box
decorated with openwork design of dragons
in pursuit of a pearl amidst floral patterns
in underglaze blue

Ming Dynasty Wanli period

Overall Height 11.1 cm
Diameter of Mouth 29 × 18.2 cm
Diameter of Base 25 × 18.2 cm

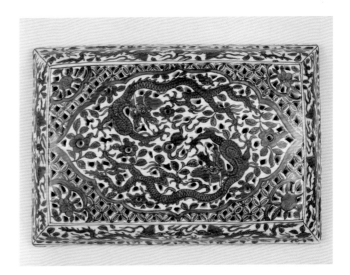

The rectangular box has an openwork cover, and is decorated with two dragons in pursuit of a pearl in a lozenge-shaped panel, surrounded by floral patterns on four sides. The body of the box and the exterior wall of the cover are decorated with two dragons in pursuit of pearl amidst floral patterns. The exterior base is written with a six-character mark of Wanli in regular script within a double-line medallion in underglaze blue.

The colour of this underglaze blue rectangular box is pure and accurate, and the decorative designs are skillfully treated with rich pictorial composition, revealing the high production standard of the Imperial Kiln in the Wanli period. In the Ming Dynasty, the type-forms of underglaze blue wares had reached a most versatile scale, and in term of the types of boxes, there were round-shaped, rectangular-shaped, peach-shaped, rectangular-shaped with round corners, boxes with drawers, silver-tael shaped, lozenge-shaped, ox-eye shaped, heaven covering earth-shaped, etc.

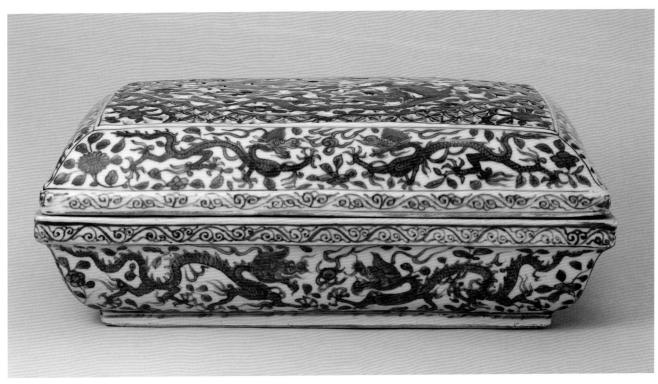

72

Basin with a Foliated Everted Rim in the Shape of a Sunflower
and decorated with design of legendary figures in underglaze blue

Ming Dynasty Wanli period

Height 9.3 cm
Diameter of Mouth 35.5 cm
Diameter of Base 25 cm
Qing court collection

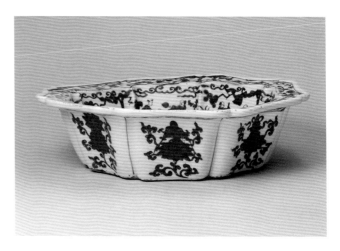

The basin is in the shape of a sunflower with eight petals and has a rim everted to a flange, a straight wall, and a flat base. The mouth rim, the interior wall, and the interior centre are decorated with figures from various legends and stories. The exterior wall is decorated with eight auspicious emblems supported by lotus scrolls. The exterior base is written with a six-character mark of Wanli in regular script in two columns within a double-line medallion in underglaze blue.

This type of foliated basin with the rim everted to a flange was first produced in the Imperial Kiln in the Wanli period, and was used by imperial family members for washing purpose.

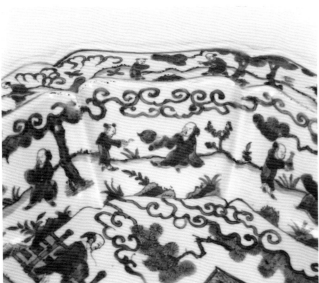

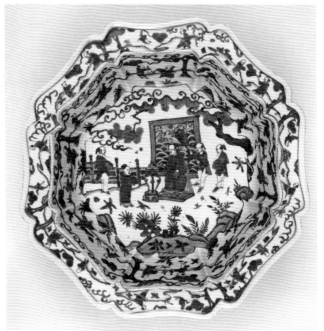

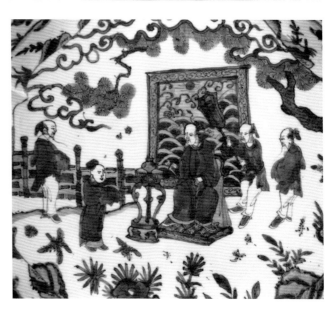

73

Square *Gu* Vase
with Flanges
and decorated with design
of rocks and flowers
in underglaze blue

Ming Dynasty Wanli period

Height 31.8 cm
Diameter of Mouth 14.3 cm
Diameter of Mouth 10.2 cm
Qing court collection

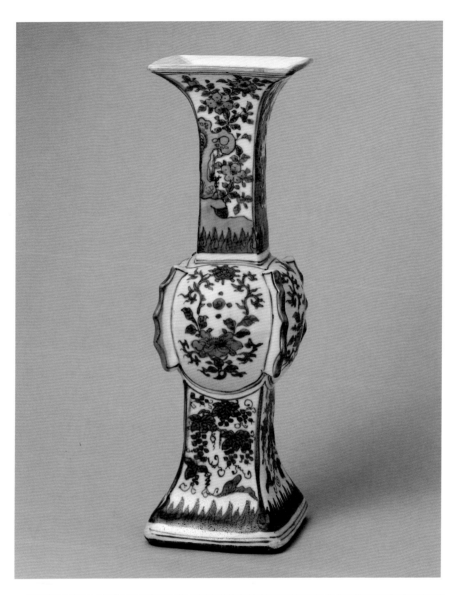

The *gu* vase has a flared mouth, a long neck, a slightly curved bulging belly, flanges at the four corners, and a high splayed foot. The neck is decorated with rock and floral sprays. The four sides of the belly are respectively decorated with the four Buddhist emblems of the wheel, the conch shell, the umbrella, and the canopy, supported by floral sprays. The high foot is decorated with sprays of grapes, and a border of flame respectively decorates the area underneath the neck and near the belly, as well as the foot rim. Underneath the mouth rim is a horizontal mark "*Tianqinian Mi Shiyin zhi*" (commissioned by Mi Shiyin in the Tianqi period) written in regular script in underglaze blue.

Mi Shiyin (1570-1628), original name Mi Wanzhong, styled Zhongzhao, also known as Shiyou and Shiyinan jushi, attained a *jinshi* degree graduate of the Civil Service Examination in the 23rd year of the Wanli period (1595), and was later posted as the Commissioner of Justice of the Jiangxi province. He was a descendent of the famous calligrapher Mi Fu of the Song Dynasty, and a well-known poet, calligrapher, painter, garden architect, and the owner of the famous Shao Garden at the West of Beijing (located in the present Peking University). This *gu* vase should be commissioned by Mi for personal use.

74

Jar

decorated with design of a story scene from
the *Legends of the Three Kingdoms*
in underglaze blue

Ming Dynasty Chongzhen period

Height 14.5 cm
Diameter of Mouth 19 cm
Diameter of Foot 9.5 cm

The jar has an upright mouth, a flat mouth rim, a deep belly, and a flat and slightly concave base covered with white glaze. The exterior wall is decorated with a continuous scene of a story from the Novel *Legends of the Three Kingdoms*. In front of a military camp with flags hoisted amidst landscapes and rocks, the general Lu Bu who wears a headdress holding his hairs in a bun and a embroidered robe is accompanied by soldiers who are holding different weapons. Li Su, accompanied by several attendants carrying various gifts, is about to offer these treasures to Lu. The scene is further enriched by the decorations of flags, military camps, a walled city, landscapes, trees and plants. The colour tone of underglaze blue is dense and bright, and the figures are depicted in a vivid and realistic manner.

This scene is derived from the story "Li Su tries to convince Lu Bu to surrender by offering gold beads" in the novel *Legends of the Three Kingdom*, which tells that when Dong Zhuo was in war with Ding Yuan, all his generals were not able to fight against Lu Bu who was serving Ding Yuan. Dong Zhuo then sent his messenger Li Su, who brought along with a horse "Red Rabbit," gold, jewels and treasures and jewelries, and a jade belt, to visit the military camp of Lu at Luoyang and try to convince him to surrender. The potter and ceramic artist skillfully transformed this story scene to decorate the jar with an amusing and charming style.

This jar is a refined representative underglaze blue ware of the Chongzhen period.

75

Covered Jar
decorated with design of flowers and birds in underglaze blue

Qing Dynasty Shunzhi period

Overall Height 47 cm
Diameter of Mouth 20.6 cm
Diameter of Base 20.4 cm
Qing court collection

The jar has an upright mouth, a short neck, and a wide shoulder tapering down-wards to the flat sandy base. It has a match-ing canopy-shaped cover with a round tourmaline knob. One side of the exterior wall is decorated with a pheasant raising its head and standing on a rock amidst peonies, which has the auspicious meaning of wealth and fortune. The other side is decorated with a magpie resting on a branch, which has the auspicious meaning of great happi-ness. The pictorial plane is further enriched with decorations of bamboo, flowers, and plants. The surface of the cover is decorated with bamboo, rocks, and Chinese roses.

The covered jar has a round and glob-ular body, and colour tone of underglaze blue is dense and bright, with decorations painted in a subtle and delicate manner. The decorative designs carry auspicious mean-ings of fortune, wealth, and happiness. The petals of the peonies spread to the two sides, which belong to the specie of "double-bud peony" and such a design first appeared on late Ming ceramic wares, and had become more popular in the Shunzhi and Kangxi period, representing a distinctive decorative motif of these periods.

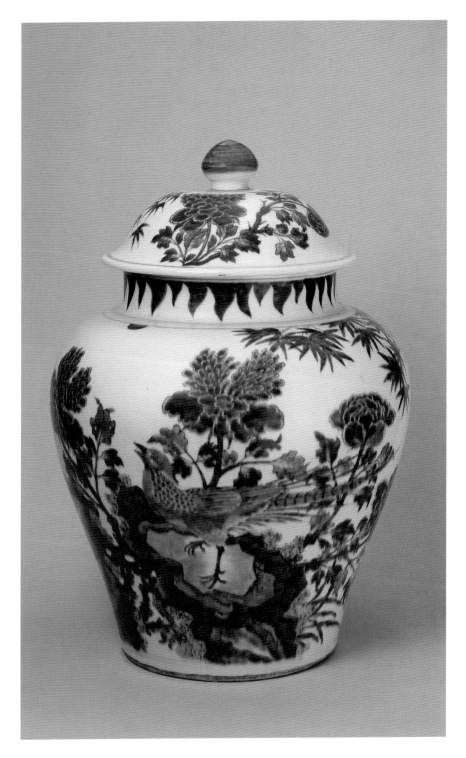

76

Covered Jar
decorated with a scene *Farewell at the Tiger Stream* in underglaze blue

Qing Dynasty Kangxi period

Overall Height 23.7 cm
Diameter of Mouth 23.1 cm Diameter of Foot 14.2 cm

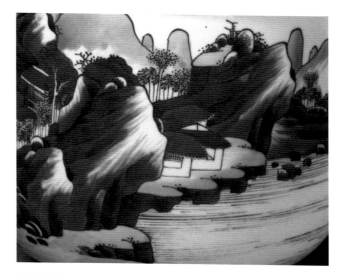

The jar has an upright mouth, a steep belly and a ring foot, and a matching canopy-shaped cover with everted rim and ring-shaped knob. The jar is decorated with a continuous scene depicting the legend *Farewell at the Tiger Stream* which was derived from the writing *Lianshe Gaoxian Zhuan* of the Jin Dynasty. The story tells that the virtuous monk Huiyuan retreated to Mount Lu and resided at the Donglin Monastery for Buddhist cultivation, who was known as Master Yuan. In front of the monastery is a brook known as "Tiger stream," and as Huiyuan was fully committed to cultivation, he never saw off his visitors and walk across the stream, or otherwise a roar of tiger would warn him. One day, the lofty scholar Tao Qian and the Doaist priest Lu Xiujing from the Daoist Shrine of Simplicity and Silence came to visit him. When the gathering ended, Huiyuan wished to see them off and as they were fully engaged in talking to each other, they then crossed the Tiger Stream without alert. Suddenly they heard the roar of a tiger and were then aware that they had accidentally crossed the stream. They smiled and finally bid farewell to each other. Although this was regarded as a legendary story, it embodied the meaning that "Confucianism, Buddhism and Daoism are in one family" as represented by the three friends, could come under the same umbrella and harmoniously accommodate each other without conflict.

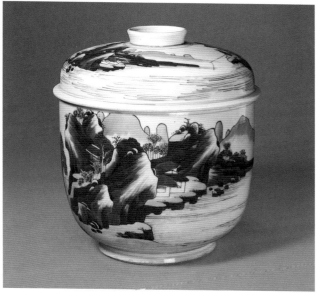

With its thick and stable form, this jar with bright colour tone and decorations depicted with the diluted painting brush style showing clear perspectives and dimensionality represents a refined underglaze blue ware of the Kangxi period.

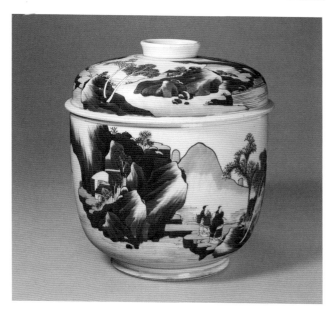

77

Teapot
decorated with design of pines, bamboos, and plum blossoms in underglaze blue

Qing Dynasty Kangxi period

Overall Height 8.8 cm
Diameter of Mouth 7 cm
Diameter of Foot 6.8 cm
Qing court collection

The teapot has a flattened round belly and a ring foot. On the two symmetrical sides of the belly are a spout and a handle respectively. It has a matching round cover with flat top, on which is a knob in the shape of plum blossom branch. The body is decorated with the "three friends of winter": pines, bamboo, and plum blossoms, and complemented by the applique spout in the shape of bamboo trunk, handle in the shape of pine trunk and the knob in the shape of plum blossom branch, with bamboo leaves, pine needles, and plum blossoms rendered in a naturalistic manner. The exterior base is written with the six-character mark of Kangxi in regular script in two columns in underglaze blue.

The form and decorations of this teapot is skillfully fashioned with bright and brilliant colour tone of underglaze blue. With its shiny and translucent glaze as well as thinly potted light body, the teapot generates a lyrical charm.

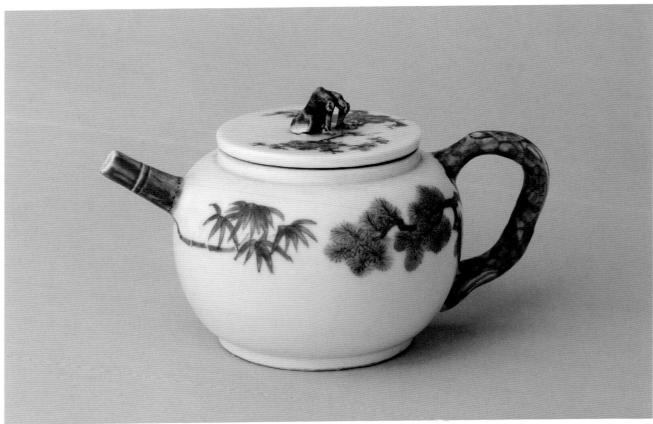

78

Large Flower Pot
decorated with design of the mountain of longevity and sea of fortune in underglaze blue

Qing Dynasty Kangxi period

Height 38 cm
Diameter of Mouth 61 cm
Diameter of Foot 36 cm

The flower pot has a flared mouth, a mouth rim everted to a flange and a deep belly tapering downwards to a recessed groove near the foot. The interior and the exterior of the base is unglazed and in the centre of the flower pot, there is a round hole. The everted mouth rim is decorated with lotus scrolls and the character *shou* (longevity). The exterior wall is decorated with pines, landscapes and rocks, cresting waves, rising sun, auspicious clouds, bats, etc. to compose a continuous scene of the sun rising in the heaven and above the sea, representing the mountain of longevity and sea of fortune. Near the foot is a border of lotus scrolls. Underneath the mouth rim is the horizontal six-character mark of Kangxi written in regular script in underglaze blue.

With its large size, soft colour tone of underglaze blue, and the decorations symbolizing longevity, this flower pot should be produced in the Imperial Kiln of the late Kangxi period for the celebration of the birthday of Emperor Kangxi.

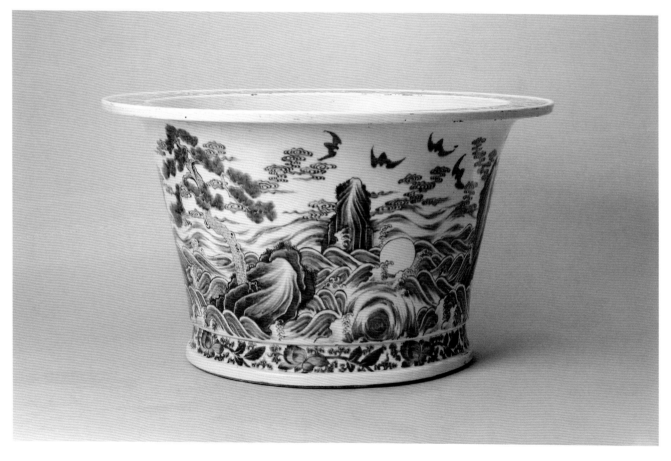

79

Zun Vase
decorated with design of
ten thousand *shou* (longevity) characters
in underglaze blue

Qing Dynasty Kangxi period

Height 76.5 cm
Diameter of Mouth 37.5 cm
Diameter of Foot 28 cm
Qing court collection

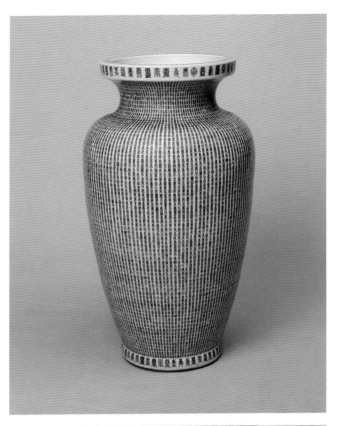

The *zun* vase has a flared mouth, a short neck, and a wide shoulder, a tapering belly, and a ring foot. The rather coarse interior of the foot is unglazed. The body is fully written with 10,000 *shou* (longevity) characters in different scripts and styles. Among them, a total of 154 characters are written in two rows, each row with seventy-seven characters on the mouth rim. On the side of the mouth rim are forty-eight characters, whereas seventy-five rows, each row with 130 characters are written on the belly, and forty-eight characters are written on the side of the foot. Totally there are 10,000 *shou* characters symbolizing everlasting longevity.

The *zun* vase is high and large, and although it is decorated with 10,000 *shou* characters, they are carefully arranged in a balanced style without repeating each other and are fluently written, showing that the whole composition was carefully planned in advance. During the time of writing, as the paste would absorb the colour materials fast, thus each character must be written immediately without any hesitation and halt.

This vase was commissioned and produced by Lang Tingji, the Governor of the Jiangxi province as a tribute to celebrate the 60th birthday of Emperor Kangxi on the 18th day of the third month in the 52nd year of the Kangxi period (1713), and only four pieces of its type are extant. In ancient China, only the Emperor could have the honorary title "*wansui*" (age of 10,000 years old), and his birthday was known as the "Festive Day of Ten Thousand Years." In ancient Chinese calendar, each year was made up with the combination of a chronicle system of the heavenly stems and earthly branches, which started with the year *jiazi*, and ended up with a cycle of every sixty years, which was known as *huajia* or *jiazi*, and the 60th birthday is the most important birthday in one's life.

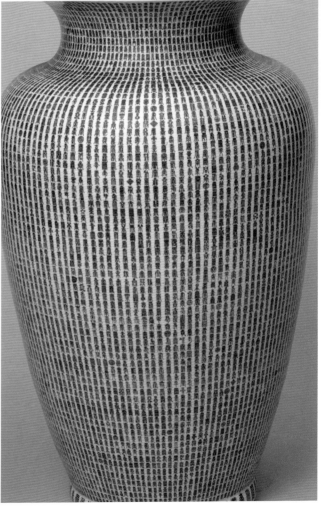

80

Brush-pot
decorated with design of *Wanshou Zun Fu* in underglaze blue

Qing Dynasty Kangxi period

Height 15.6 cm
Diameter of Mouth 18.5 cm
Diameter of Foot 18.2 cm

The brush-pot has a tabular body with narrow waist and glazed in white in the interior and on the exterior. The exterior wall is written with the ode *Wanshou Zun Fu*. The whole essay has over 600 words to describe the origin and merits in producing this *zun* vase with 10,000 *shou* characters, as well as to pay homage to the virtues and accomplishments of Emperor Kangxi. At the end is a square seal mark "*xichao chuanggu.*" The interior of the base is concave in shape and written with the six-character mark of Kangxi in regular script in three columns in underglaze blue.

From the contents of the ode, it is known that the brush-pot was specifically produced to match the *zun* vase with 10,000 *shou* (longevity) characters in underglaze blue (Plate 79). This is one of the two extant pieces of its type.

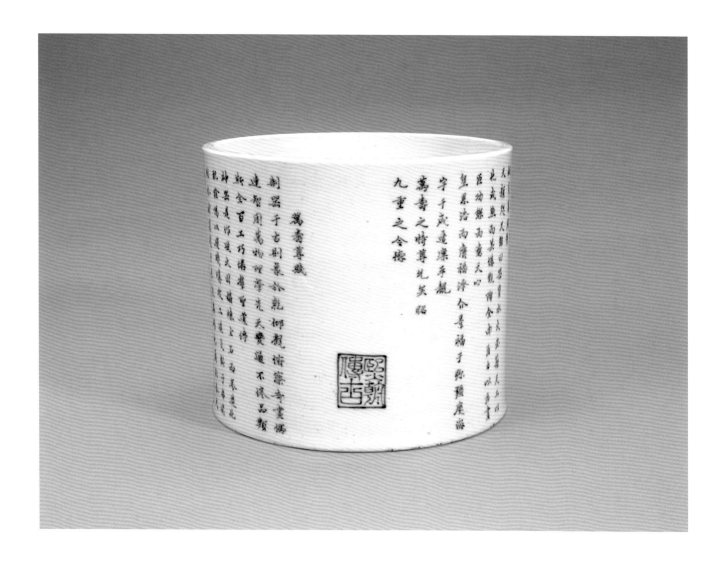

81

A Set of Twelve-month Cups

decorated with design of flowers of the twelve months and poems in underglaze blue

Qing Dynasty Kangxi period

Height 5.5 cm
Diameter of Mouth 6.6 cm
Diameter of Foot 2.7 cm
Qing court collection

Each of the cups has a flared mouth, a deep curved wall, and a ring foot. Twelve cups form a set with identical shapes and sizes. The small cups have unusual delicate forms and are thinly fashioned and covered with shiny translucent glaze. The exterior walls are decorated with flowers representing the twelve months, and inscribed with matching poems, most of which are quoted from *A Complete Collection of Poems of the Tang Dynasty*. At the end of each poem is a square-mark "*shang*" written in seal script in underglaze blue. The exterior base of each cup is written with a six-character mark of Kangxi in regular script within a double-line medallion in underglaze blue.

1st month: Winter jasmine

Inscribed "About the golden blossom and green calyx clings the chill of spring, rare among the flowers is its yellow colour," quoted from the poem *Contemplating Winter Jasmine with a Poem Written for Officer Yang* by Bai Juyi

2nd month: Apricot blossom

Inscribed "Its fragrance blends with the scent of nocturnal rain, the beautiful colour stands out in sunshine or in mist" quoted from the poem *In Return for a Poem on Apricot Blossoms from Lanxi by Zhangsun Yi* by Qian Qi

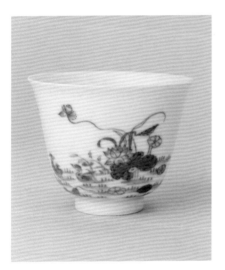
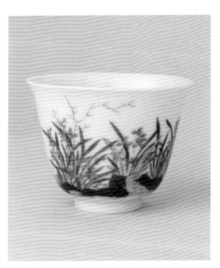
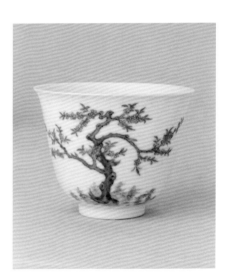

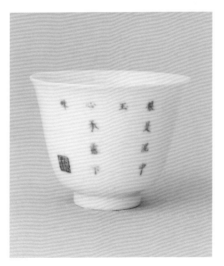
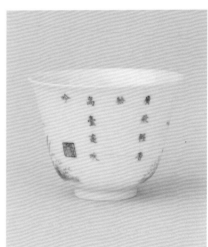

3rd month: Peach blossom

Inscribed "The blossom sways in the wind when the swallow returns from the south, it is the season in late spring when farmers return to their fields" quoted from the poem *Peach Blossoms* by Xue Neng

4th month: Peony

Inscribed "At dawn its ravishing beauty claims the jin zhang's share of the dew, at dusk, its fragrance entices the wind to blow through the Jade Hall" quoted from the poem *Peonies* by Han Cong

5th month: Pomegranate blossom

Inscribed "Its colour dampened with dew is reflected on the beaded curtain, the breeze scented with its fragrance is shielded by the powdered wall" quoted from the poem *Two Poems to Describe the Pomegranate Blossoms in Front of the Mansion* by Sun Ti

6th month: Lotus

Inscribed "Its roots are like jade, unsullied by mud, like pearls are the dewdrops caught on its heart-shaped leaves" quoted from the poem *Lotus leaf* by Li Qunyu

7th month: Orchid

Inscribed "Its delicate fragrance pervades the spacious palace, stirring thoughts of the far capital" quoted from the poem *Orchid* by Li Jiao

8th month: Osmanthus

Inscribed "Its branches are nurtured over endless months, when they are laden with flowers" quoted from the poem *Osmanthus* by Li Jiao

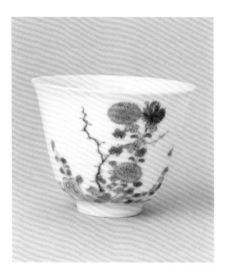
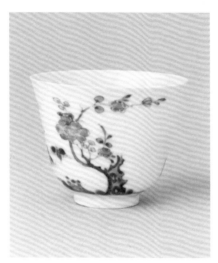
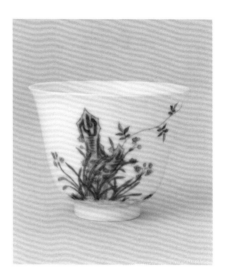

9th month: Chrysanthemum

Inscribed "A thousand years ago, a white-garbed attendant brought wine (to Tao Yuanming), throughout his life (he treasured) the fragrance of the chrysanthemum" quoted from the poem *Chrysanthemum* by Luo Yin

10th month: Chinese rose

Inscribed "Unlike a thousand other flowers that bloom and perish, it alone blazes red throughout the year" (from where the poem was quoted needs further study)

11th month: Plum blossoms

Inscribed "Its white beauty is held by the snow on the tree, its fragrance wafts through the branches" quoted from the poem *A Poem Written by Hearing that the Elder Xue Accompanies the Master to Contemplate Plum Blossoms in Early Spring* by Xu Hun

12th month: Narcissus

Inscribed "The spring breeze blows playfully over the rose, heralding a clear day, in the light of the moon the narcissus are massed on an embankment" (from where the poem was quoted needs further study)

This set of month cups is amongst the most esteemed imperial wares of the Kangxi period, and extant wares are only confined to two types of cups with designs in underglaze blue or *wucai* enamels.

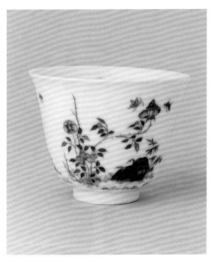

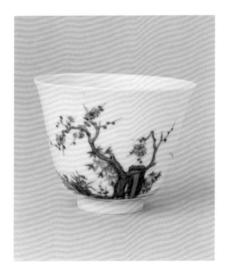

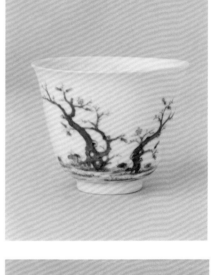

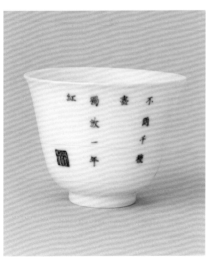

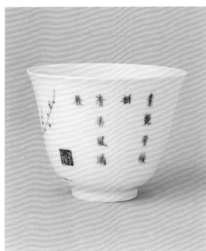

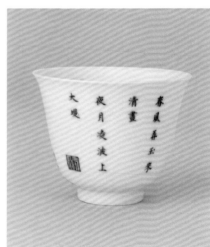

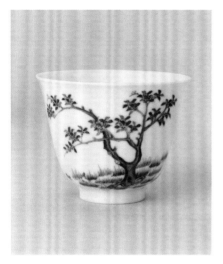
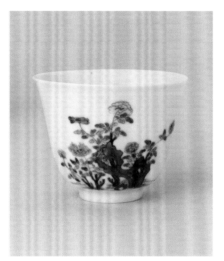
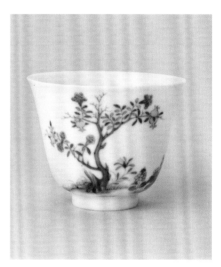
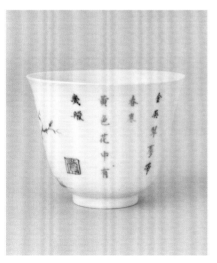
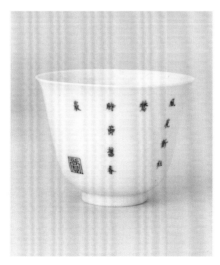
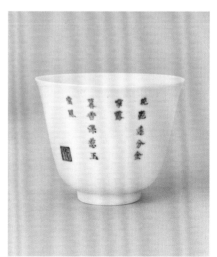

107

82

Olive-shaped Vase
decorated with design of bamboos, peaches and bats in underglaze blue

Qing Dynasty Yongzheng period

Height 39.3 cm
Diameter of Mouth 10 cm
Diameter of Foot 12.3 cm

The olive-shaped vase has a flared mouth, a narrow neck, a globular belly tapering downwards to the splayed foot, and a ring foot. The body is decorated with a peach tree with bloomed peach flowers and ripe peaches. Underneath the tree are designs of *lingzhi* funguses, bamboos, and rocks. In the sky, there are five bats in flight. The mouth rim and the foot are decorated with double string borders in underglaze blue. The exterior base is written with a six-character mark of Yongzheng in regular script in two columns within a double-line medallion in underglaze blue.

Among the decorative designs, *zhu* (bamboo) is a pun for celebration, whereas *lingzhi* funguses and peaches symbolize longevity. The combination of these designs thus represents the celebration of birthday with blessing of long life. *Fu* (bat) is a pun for fortune, and the combination of peaches and bats symbolizes for five bats bringing everlasting fortune and longevity. The term "five fortunes" was originated from the Classic *Shangshu*, which mentioned that there are five supreme blessings (*fu*), including longevity, wealth, peace, virtue, and long life.

The imperial wares of the Yongzheng period are highly esteemed for its delicate and subtle form, and meticulous painterly decorations. This piece, together with other similar typeform and decorations in *fencai* enamels of the Yongzheng period, represents a refined imperial ware of the period.

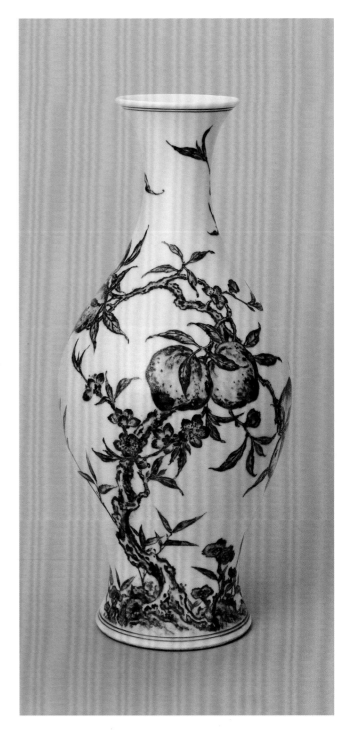

83

Flask with a Garlic-head Mouth

and decorated with *ruyi* handles and floral patterns on a geometric brocade ground in underglaze blue

Qing Dynasty Yongzheng period

Height 25.1 cm
Diameter of Mouth 3.5 cm
Diameter of Foot 6.5 cm
Qing court collection

The flask has a garlic head-shaped mouth, a short and narrow neck, a flat and round belly, and a splayed ring foot. On the symmetrical sides of the mouth and the shoulder is a pair of *ruyi* cloud-shaped handles. Underneath the mouth rim are decorations of *ruyi* cloud collars, whereas the neck is decorated with floral patterns. The centre of the belly is decorated with lotus spray and surrounded by different layers of *qing* chime designs and hexagonal geometric brocade patterns. Inside the brocade ground are decorations of waves, lozenges, and floral designs. The two sides of the belly are decorated with floral scrolls and the wall of the foot is decorated with floral patterns.

There were two main types of imperial underglaze blue wares in the Yongzheng period. The first type is characterized by typical Yongzheng features of its own, while the second type is in imitation of the imperial underglaze blue wares of the Yongle and Xuande periods of the Ming Dynasty. This flask is a typical piece of the second type with its production techniques, form, decorative designs, and underglaze blue colour in imitation of its prototype of flasks with *ruyi* handles of imperial underglaze blue of the Yongle period, Ming Dynasty (Plate 20) and is very similar to the original.

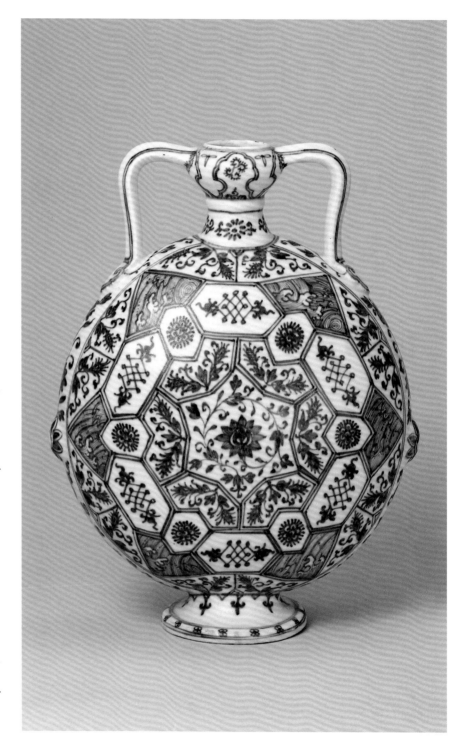

84

Flask with Two Ears
and decorated with design
of lotus scrolls in underglaze
blue on a yellow ground

Qing Dynasty Yongzheng period

Height 51 cm
Diameter of Mouth 8 cm
Diameter of Foot 15.5 × 10 cm
Qing court collection

The flask has a garlic head-shaped
mouth, a short neck, a flat and round bel-
ly, and an oval-shaped ring foot. On the
shoulder are two symmetrical handles in the
shape of ribbons. The whole body is glazed
in yellow as the ground, and decorated with
lotus scrolls, chrysanthemums, peonies,
and Indian lotus, complemented by foliat-
ed scrolls and floral patterns as the border
decorations. Underneath the mouth rim is a
horizontal six-character mark of Yongzheng
written in regular script in underglaze blue.

The form and decorative designs were
imitated from those of the Xuande wares,
Ming Dynasty, but written with the mark
of Yongzheng. Underglaze blue wares with
a yellow ground was first produced in the
Imperial Kiln in the Xuande period, and
were popularly produced in the Kangxi,
Yongzheng and Qianlong periods with the
Yongzheng wares most refined.

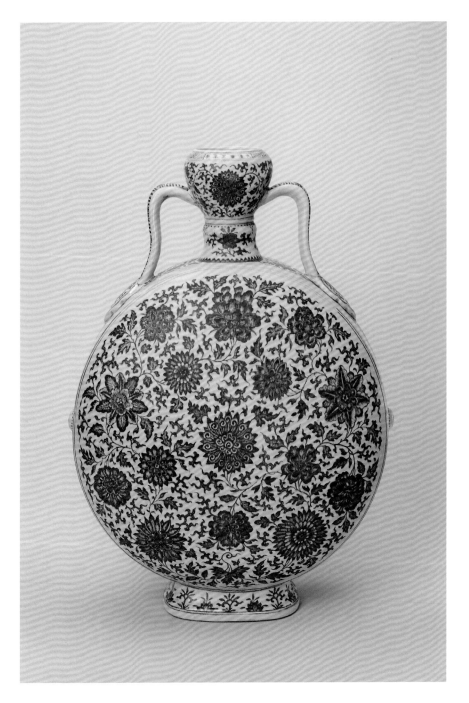

85

Vase with Tubular Ears
and decorated with scenes of a lotus pond in underglaze blue

Qing Dynasty Qianlong period

Height 55 cm
Diameter of Mouth 11 cm
Diameter of Foot 18 cm
Qing court collection

The vase has an everted mouth, a long neck, an angular shoulder, a curved belly slimming downwards, and a ring foot. Two symmetrical tubular ears are modelled on the two sides of the neck. The neck, shoulder, and belly are decorated with lotus flowers in a pond, bordered by a band of cresting waves. The interior of the ring foot is covered with greenish-white glaze and the exterior base is written with a horizontal six-character mark of Qianlong in seal script in three columns in underglaze blue.

The typeform of this vase was first produced in the Qianlong period. The wider shoulder gives the vase a sense of stability. The lotuses with flowers and leaves are painted in different angles with fluent and delicate brush work. As different ingredients of the underglaze blue were employed, there are various tonal gradations and shading effects to make the decorative designs more realistic and enlivened. The pictorial treatments should come from the hands of court painters with superb artistic cultivation.

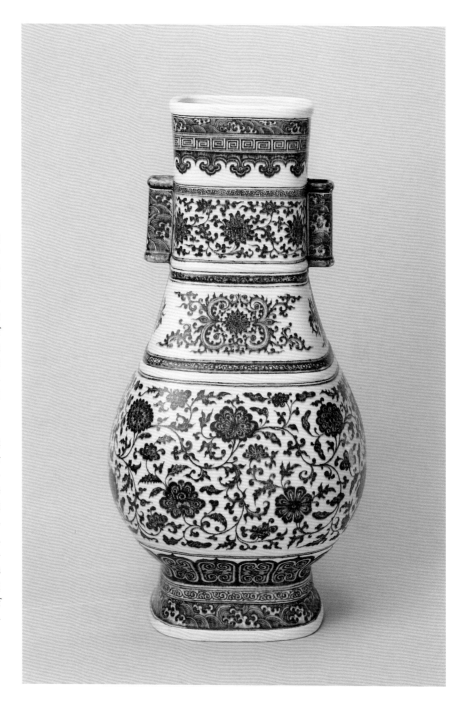

86

Vase with the Reticulating Interior
and decorated with lotus scrolls in underglaze blue on a yellow ground

Qing Dynasty　Qianlong period

Height 19.8 cm
Diameter of Mouth 9.2 cm
Diameter of Foot 11.3 cm
Qing court collection

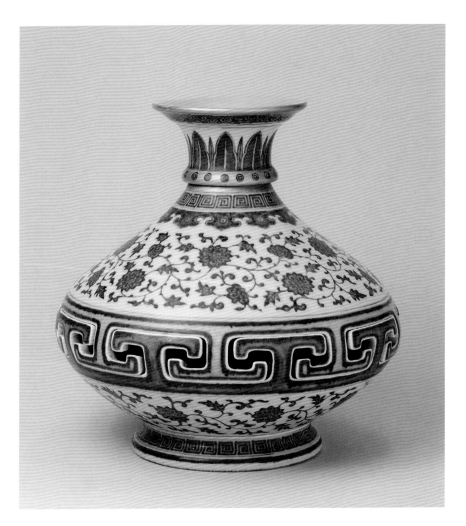

The vase has a flared mouth, a narrow neck, a flat and round belly, and a ring foot. It has interior and exterior double layers. The interior and the exterior vase is interlocked at the mouth but can be revolved. The exterior vase was interlocked by "T" shaped-locks on the upper and lower belly but without fixed, thus facilitating slight revolving but cannot be totally removed from each other. The vase is glazed in yellow as the ground and decorated with underglaze blue designs. The main designs are lotus scrolls in underglaze blue. Underneath the mouth rim are foliated scrolls, and the neck is decorated with banana leaves, round dots, key-fret patterns, and *ruyi* cloud collars from the top to the bottom. The exterior wall of the ring foot is decorated with key-fret patterns. The interior vase is glazed in purplish-red as the ground, and decorated with plum tree trunks. The interior base and the exterior base are covered with turquoise-green glaze, and the centre of the exterior base is reserved in white and written with a six-character mark of Qianlong in seal script in three columns in underglaze blue.

The form of this vase is known as *ji-aotai* vase. The term *jiaotai* was quoted from Chapter *Yi Tai* in *I Ching*, which literally means the harmony of *yinyang*, or heaven and earth. Later the term refers to a blessing for a peaceful and prosperous nation.

This typeform was first designed and produced by Tang Ying, the Director General of the Imperial Kiln in the eighth year of the Qianlong period. In his memorial "Tribute of Commissioned and Newly Designed Wares," he mentioned that "humbly may I design nine new forms of vases with reticulating structures and send them to the capital as tributary wares."

87

Vase with a Flared Mouth

and decorated with design of dragons in pursuit of a pearl amidst clouds in underglaze blue

Qing Dynasty Jiaqing period

Height 17.4 cm
Diameter of Mouth 5.2 cm
Diameter of Foot 6.5 cm
Qing court collection

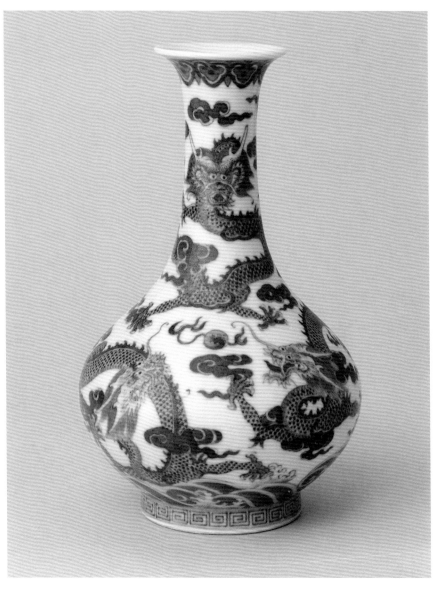

The vase has a flared mouth, a long neck, a round belly, and a ring foot. Underneath the mouth rim are decorations of *ruyi* cloud lappets. The neck is decorated with three dragons in pursuit of a pearl, surrounded by cloud patterns and cresting waves below. The exterior wall of the ring foot is decorated with key-fret patterns. The exterior base is written with a six-character mark of Jiaqing in seal script in three columns in underglaze blue.

The vase is finely potted with fluent linear shape. The biscuit and paste is pure white, and the colour of underglaze is bright and dense, which carried on the legacy of Qianlong imperial underglaze blue wares. In terms of the forms and decorative designs, the Jiaqing imperial underglaze blue wares still followed that of the Qianlong period, and thus there comes the connotation of "Qian and Jia Kilns."

88

Covered Jar
decorated with design of phoenixes amidst peonies in underglaze blue

Qing Dynasty Daoguang period

Overall Height 37.5 cm
Diameter of Mouth 15.6 cm
Diameter of Foot 15.4 cm
Qing court collection

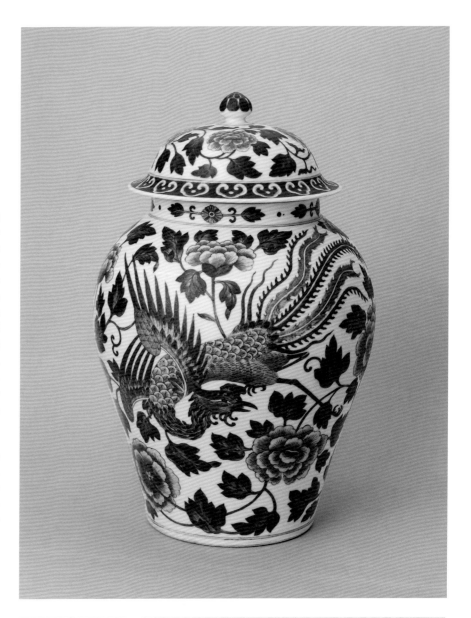

The jar has an upright mouth, a short neck, a slanting shoulder, a curved belly tapering downwards, and a ring foot. The helmet-shaped cover has a round tourmaline knob. The main decorative designs are phoenixes flying amidst peonies. Each side of the belly is respectively decorated with two phoenixes, one flying upwards and one flying downwards amidst peonies, and complemented by border design of floral patterns and deformed *ruyi* cloud patterns. The exterior base is written with the six-character mark of Daoguang in seal script in underglaze blue.

The colour of underglaze blue on this jar is dense and brilliant and the pictorial composition is well treated with meticulous brush work. The decorative designs carry the auspicious meaning for fortune and wealth. The motif is copied from the decorative design of the "jar with design of phoenixes in underglaze blue on a white ground" (please refer to diagram) and fired for production.

Diagram: design drawing of covered jar with painted colour design of phoenixes amidst peonies in underglaze blue on a white ground issued by the Department of Imperial Household in the Qing Dynasty

Inscriptions on a yellow slip: a piece of paper drawing of jar decorated with design of phoenixes on a white ground. The height of the cover is two Chinese *cuns* and six *fens*. The height of the interlocking mouth is five *fens*. The diameter of the mouth is over four *cuns* and nine *fens*. The diameter of the base is over four *cuns* and nine *fens*. The height of the body is nine *cuns* and two *fens*.

89

Pear-shaped Vase
decorated with design of bamboos, rocks, and banana leaves in underglaze blue

Qing Dynasty Xianfeng period

Height 28.5 cm
Diameter of Mouth 8.6 cm
Diameter of Foot 11.6 cm

The vase has a flared mouth, a long neck, a hanging belly, and a ring foot. The upper part of the neck is decorated with banana leaves, whereas the lower part is decorated with foliage scrolls and deformed *ruyi* cloud patterns. The belly is decorated with bamboos, banana leaves, rocks, flowers, plants, and fences. Near the base are decorations of deformed lotus lappets and the exterior wall of the ring foot is decorated with floral patterns. The exterior base is written with a six-character mark of Xianfeng in regular script in two columns in underglaze blue.

Compared with the pear-shaped vases of the early Qing period, this vase has a thicker and shorter neck, and a larger belly. It has somewhat lost the charm and elegance of pear-shaped vases produced in the early Qing period and preceding dynasties, and represents a typical form of pear-shaped vases of the late Qing period.

The basic features of pear-shaped vases are a flared mouth, a narrow neck, a hanging belly, and a ring foot. However, with the change of aesthetic tastes and artistic developments in various dynasties, there are pear-shaped vases with different features characterized by different periods. In general, the later wares often had a thicker and shorter neck, as well as a more globular belly.

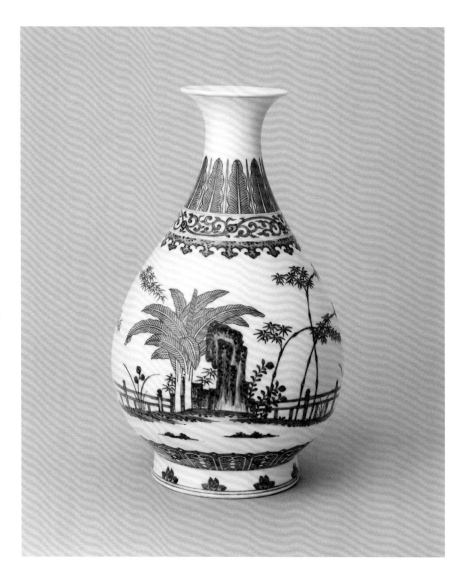

90

Square Vase
decorated with design of flowers and birds in panels in underglaze blue

Qing Dynasty Tongzhi period

Height 37.2 cm
Diameter of Mouth 9.5 cm
Diameter of Foot 14 cm

The rectangular tube-shaped vase has a flared mouth, a short neck, an angular shoulder, a square belly, and a splayed ring foot. The principal designs are four panels on the four sides, in which various scenes of flowers and birds are painted, such as magpies on branches, egrets in a lotus pond, two swallows amidst peonies, etc., which carry the auspicious meanings of "happiness shown on the eyebrows," "prosperity and wealth come all along," etc. Outside the panels are decorations of lotus scrolls.

The form of the vase is stable and elegant. The colour of underglaze has tonal gradations, and the decorative designs are depicted in a charming manner with auspicious attributes. It represents a rare refined underglaze blue ware of the Tongzhi period.

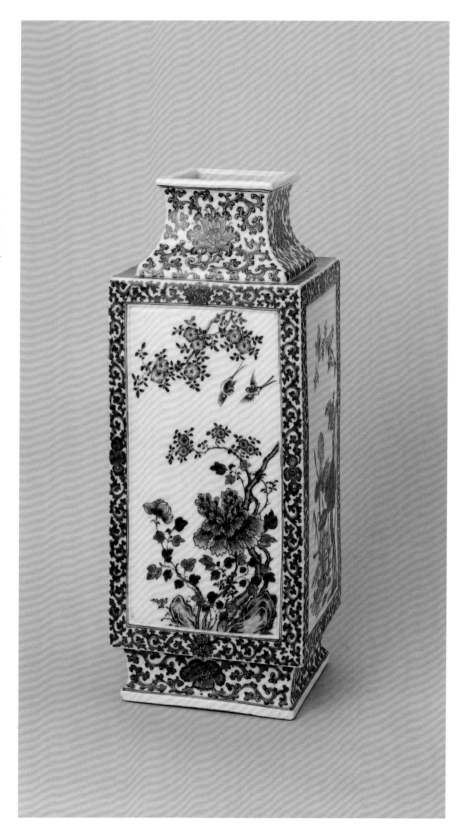

91

Vase
decorated with design of lotus scrolls in underglaze blue

Qing Dynasty Guangxu period

Height 38 cm
Diameter of Mouth 7 cm
Diameter of Foot 13 cm
Qing court collection

The vase has a flared mouth, a long neck, a slanting shoulder on which there are four string borders in relief, a round belly, and a ring foot. The principal designs are lotus scrolls, complemented by cresting waves, *ruyi* cloud collars, banana leaves, key-frct patterns, deformed lotus lappets, etc. in different borders. The exterior base is written with a six-character mark of Guangxu in regular script in two columns in underglaze blue.

This type of vase is known as *shang-ping*, which was a new type of vase specially produced for the Emperor to bestow as gifts to his officials, and they had designated forms. At the beginning, such vases were often decorated with lotus scrolls in underglaze blue, as the motif has a symbolic meaning of honest official disciplines. Extant wares of its type of the Yongzheng period are very rare but from the Qianlong period to the Xuantong period, such vases were commonly produced. After the Tongzhi period, there were new types with designs in *fencai* enamels, in *fencai* enamels with gilt designs, and monochrome wares.

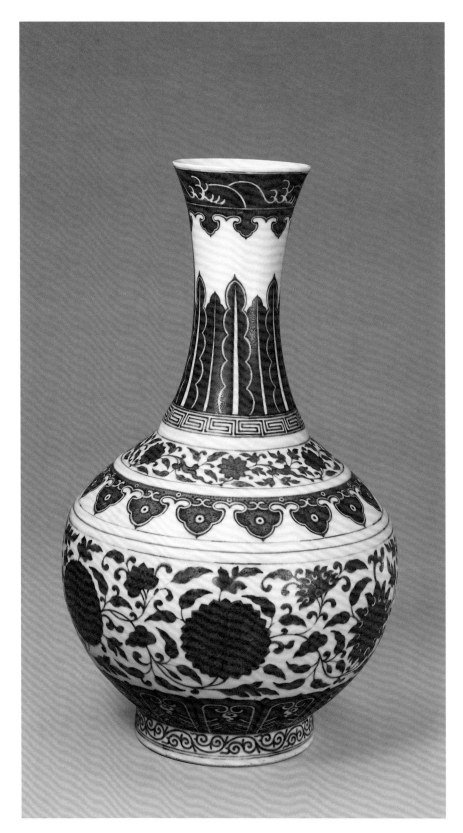

92

Covered Jar
decorated with design of
lotus scrolls
in underglaze blue

Qing Dynasty Guangxu period

Overall Height 53.5 cm
Diameter of Mouth 16.9 cm
Diameter of Foot 23 cm
Qing court collection

The jar has an upright mouth, a short neck, a slanting shoulder, a globular belly tapering downwards, and a ring foot. It has a matching canopy-shaped cover with interlocking mouth and a tourmaline knob. The neck is decorated with banana leaves, whereas the shoulder is decorated with lotus scrolls and deformed geometric patterns, and the belly is decorated with lotus scrolls. The knob is decorated with lotus lappets and the surface of which is decorated with lotus scrolls. The exterior base is written with a six-character mark of Guangxu in regular script in two columns in underglaze blue.

The Imperial Kiln of the Guangxu period followed the design manual issued by the Court. When compared with the design (please refer to the attached diagram), it is found that the form, decorative design, and mark strictly followed the design manual issued by the court, and best illustrated the production mechanism of the Imperial Kiln of the Qing Dynasty.

Diagram: design drawing of the covered jar decorated with design of lotus scrolls painted in colours issued by the Department of Imperial Household in the Qing Dynasty.

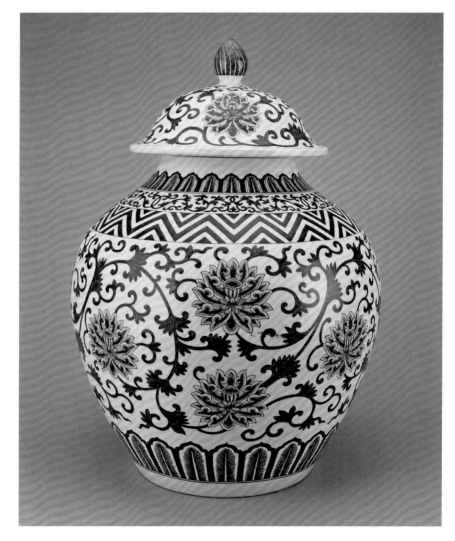

93

Vase with a Straight Neck

and decorated with bats amidst clouds in iron-red and underglaze blue

Qing Dynasty Guangxu period

Height 34 cm
Diameter of Mouth 7.7 cm
Diameter of Foot 23 cm
Qing court collection

The vase has an upright mouth, a long neck, a hanging belly, and a ring foot. The exterior wall is decorated with auspicious clouds in underglaze blue and bats painted in iron-red and gilt. Near the foot are decorations of cliffs and cresting waves. Other decorative designs such as key-fret patterns, deformed *ruyi* cloud collars, and foliage scrolls further decorate the vase. The exterior base is written with a six-character mark of Guangxu in regular script in two columns in underglaze blue.

Other than designs of dragons and phoenixes, various auspicious motifs symbolizing happiness and longevity became more popular in the Guangxu period. The decorations on this vase are composed of auspicious clouds in underglaze blue and flying bats painted in iron-red, which symbolize "great fortune would reach as high as the sky." The combination of iron-red and gilt painting represents the technique of "enamel-on-enamel" painting, which further enhances the exquisiteness and luxurious appeal of this vase.

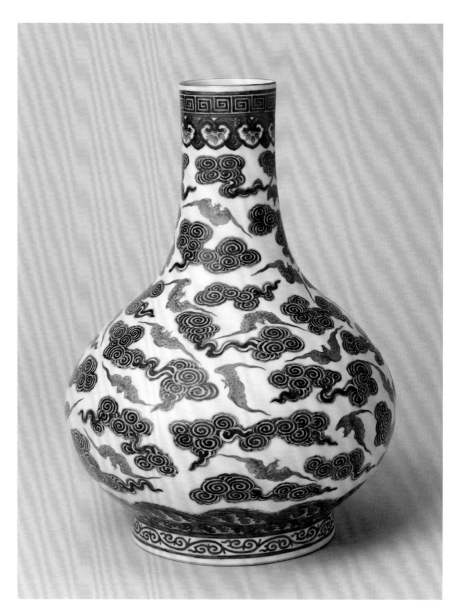

94

Pear-shaped Vase
decorated with carved
design of lotus scrolls
lifted in white
on an underglaze red
ground

Yuan Dynasty

Height 28.6 cm
Diameter of Mouth 7.8 cm
Diameter of Foot 9.8 cm
Qing court collection

The pear-shaped vase has a flared mouth, a narrow neck, a hanging belly, and a ring foot. The whole body is covered with greenish-white glaze. Inside the mouth are washes of underglaze red. On the shoulder and the middle part of the belly are four carved string borders and the belly is decorated with carved lotus scrolls lifted in white on an underglaze red ground.

Pear-shaped vase was a common type-form of Jingdezhen ceramic wares. Other than underglaze red, there are vases in underglaze blue, celadon glaze, and underglaze blue with a peacock green ground. Technically it was very difficult to command the firing of underglaze red wares, and thus extant wares are very rare and valuable. Vases of this type with decorations lifted in white on an underglaze red ground are even rarer and unusual.

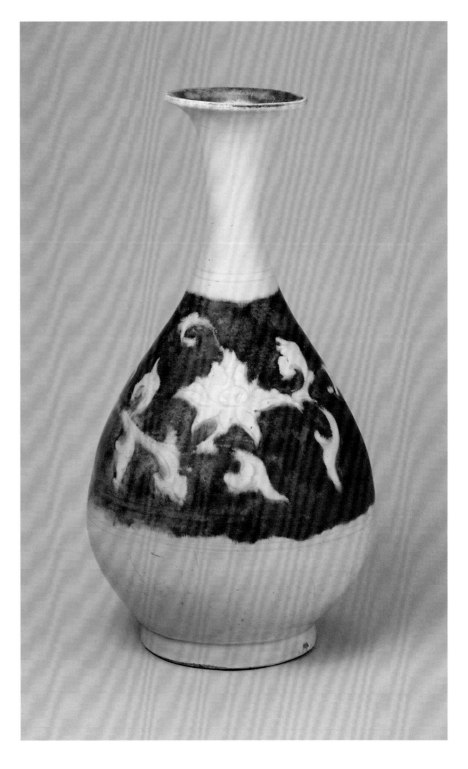

95

Stem-cup with a Movable Base
and decorated with underglaze red splashes

Yuan Dynasty

Height 10 cm
Diameter of Mouth 7.7 cm
Diameter of Foot 3.8 cm

The stem-cup has a flared mouth, a deep curved belly, a slim base, and supported by a hollow stem in the shape of a bamboo trunk. The base and the stem-foot are locked with a tendon, and are movable but not detachable from each other. The body is covered with greenish-white glaze and the interior of the stem-foot is unglazed. The exterior wall is decorated with three splashes of underglaze red and a small round loop.

The colour of copper red splashes on this stem-cup is bright and brilliant just like the colour of ruby. As it was difficult to command the firing of underglaze red wares, this stem-cup is a very rare and a refined underglaze red ware. The moveable stem-foot further enhances its aesthetic appeal and playfulness. A stem-cup with applique design of *panchi*-dragon in underglaze red and moveable stem foot was unearthed from a cellar of the Yuan Dynasty at Gao'an county, Jiangxi in 1980, which reveals that such stem-cup was a typical typeform of the stem-cups of the Yuan Dynasty.

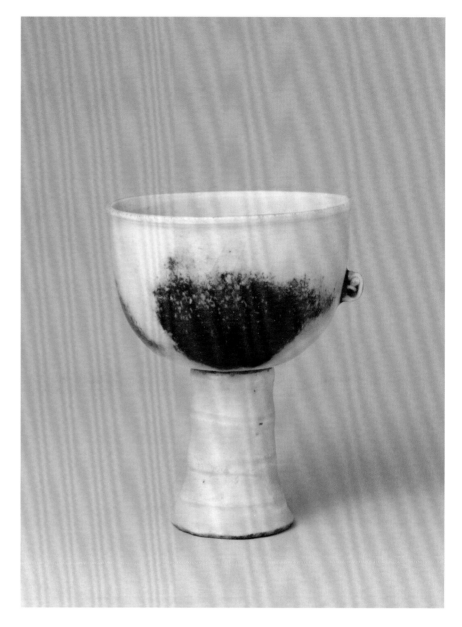

96

Pear-shaped Vase
decorated with peony scrolls in underglaze red

Ming Dynasty Hongwu period

Overall Height 33 cm
Diameter of Mouth 8.4 cm
Diameter of Foot 11 cm
Qing court collection

The vase has a flared mouth, a narrow neck, a hanging belly and a ring foot. It has a matching canopy-shaped cover with a tourmaline knob. Underneath the mouth are decorations of peonies. The neck is decorated with key-fret patterns and floral scrolls. The principal design on the belly peony scrolls, and enriched by *ruyi* cloud collar above and deformed lotus lappets below. The exterior wall of the ring foot is decorated with acanthus patterns. The surface of the cover and knob are decorated with lotus petals, and the rim of cover is decorated with acanthus patterns.

The vase is decorated with various layers of designs with concise and spacious treatment. The colour of underglaze red is subtle and soft. Compared with similar type of wares of the Yongle and Xuande periods, the mouth is flared to a rather large extent similar to that of a flanged mouth. The neck is elongated with the weight of the belly rests on the lower part, thus making this vase stable and elegantly shaped. Another distinctive feature is that the cover is still kept, and is a very rare extant piece of its type in perfect condition.

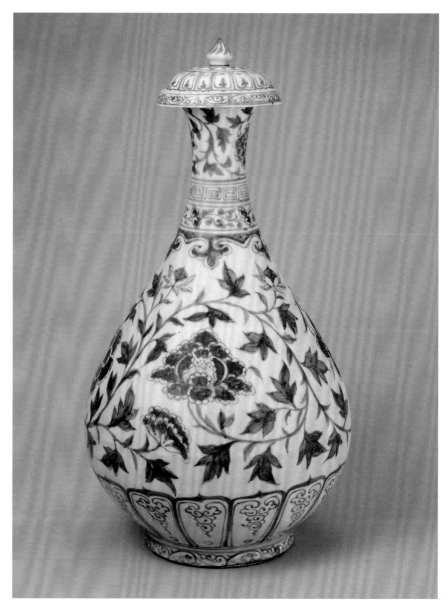

97

Pomegranate-shaped *Zun* Vase with a Lobed Body

and decorated with flowers of four seasons in underglaze red

Ming Dynasty Hongwu period

Overall Height 53 cm
Diameter of Mouth 26.5 cm
Diameter of Foot 23.2 cm

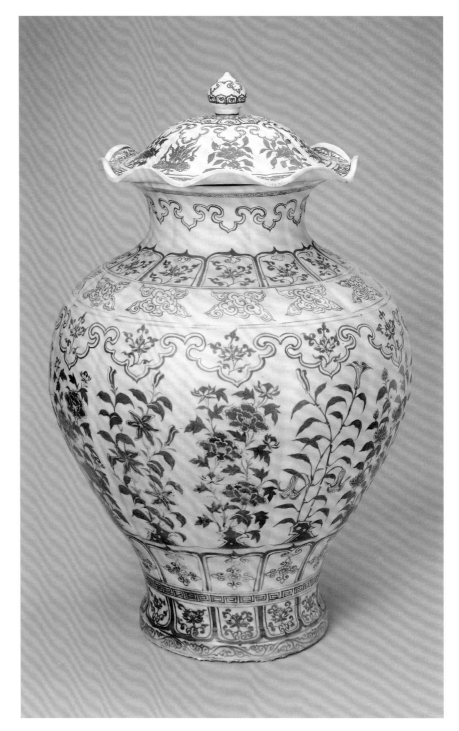

The *zun* vase has a flared mouth, a short neck, a slanting shoulder, a tapering belly, and a splay-foot. The body has twelve lobes in the shape of pomegranate and thus is known as "pomegranate-shaped *zun* vase." It has a matching cover in the shape of lotus leave, and on top is a tourmaline knob. Underneath the mouth rim are decorations of key-fret patterns and the neck is decorated with *ruyi* cloud lappets. The shoulder is decorated with upright lotus lappets in which there are lotus sprays, and underneath are cloud patterns. The upper part of the belly is decorated with continuous *ruyi* cloud lappets in which there are lotus sprays, and below are decorations of twelve scenes of flowers of the four seasons amidst rocks. The lower part of the belly is decorated with upright lotus lappets in which there are floral patterns. The upper part near the foot is decorated with key-fret patterns, and the lower part is decorated with inverted lotus lappets in which there are lotus sprays. The foot rim is decorated with foliated scrolls. The exterior is unglazed. The surface of the cover is decorated with *ruyi* cloud lappets, lotus petals, floral sprays and foliated scrolls, etc.

98

Ewer
decorated with design of peonies in underglaze red

Ming Dynasty Hongwu period

Height 32 cm
Diameter of Mouth 7.3 cm
Diameter of Foot 11 cm
Qing court collection

The ewer has an everted mouth, a narrow neck, a slanting shoulder, a hanging belly, and a ring foot. On one side of the belly is a long and narrow curved spout, and the spout and the neck is linked up with a cloud-shaped flange. On the other side is a curved handle on which there is a small loop. Outside the mouth rim are decorations of key-fret patterns. The neck is decorated with banana leaves, key-fret patterns, *ling-zhi* fungus scrolls, and *ruyi* cloud lappets from the top to the bottom. The belly is decorated with peony scrolls, and underneath near the foot are decorations of upright lotus petals. The exterior wall of the ring foot is decorated with foliated scrolls.

Underglaze red wares of the Hongwu period with well-potted forms and accurate and pure colour are rare. This ewer is potted with a graceful form and the colour of underglaze red is pure and accurate, representing a rare piece of its type.

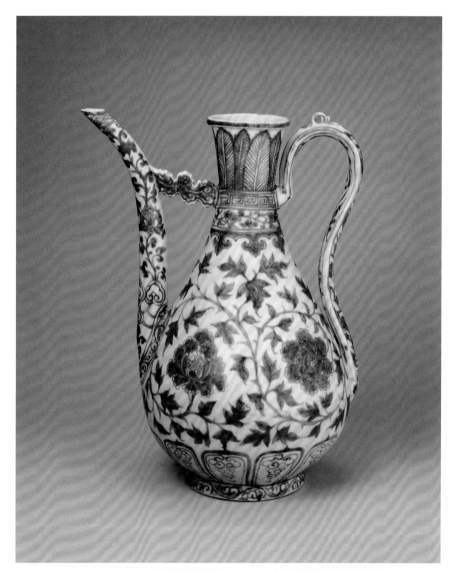

99

Kendi Ewer
decorated with design of peony scrolls in underglaze red
Ming Dynasty Hongwu period

Height 14 cm
Diameter of Mouth 2.3 cm
Diameter of Foot 7.1 cm
Qing court collection

The small kendi ewer has a small mouth with a rim underneath, a short neck, a round belly, and a ring foot. On one side of the shoulder is an awl-shaped spout. The neck is decorated with foliated scrolls, whereas the belly is decorated with peony scrolls and on the shoulder and near the base are decorations of deformed lotus petals.

Such a new typeform was first and only produced in the Imperial Kiln in the Hongwu period of the Ming Dynasty. There are only a few pieces extant, each with a rather identical form, representing a distinctive typeform of its period. According to the record *Mingshi: Yufuzhi,* "In the first year of the Hongwu period, the court commissioned making of official costumes and apparels for bestowing to officials....Now the nation succeeded the Yuan court and by taking reference from the official costumes and apparels of the Zhou, Han, Tang, Song Dynasties, the colour of red should be the legitimate noble colour." From this record, it is known that red was a noble colour of the Ming Dynasty and as a result, underglaze red imperial wares were popular at the time. As the production techniques had not reached a matured stage in the Hongwu period, the colour of underglaze red often turned pale and dark without a bright tone. Yet this kendi ewer has a bright colour and represents a rare piece of its type.

After this distinctive form of kendi ewer was imported into China, it was influenced by the Chinese culture and customs that the function, name and form had changed. In terms of its original form with double mouth rims, later there was a new type of ewer with a single mouth rim produced, and there were variations of both types in different times. The vases with double mouth rims from the Tang to the Northern Song Dynasty were known as *jingping* (pure water vase), while the ewers with double mouth rims produced after the Southern Song Dynasty was known as *kendi* ewers (with the exception of the Benba ewer of the Qing Dynasty which is similar in form).

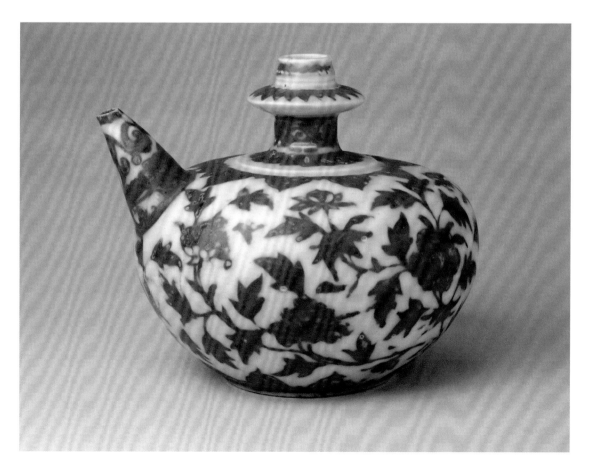

100

Large Dish with a Foliated Everted Rim

and decorated with design of peonies in underglaze red

Ming Dynasty Hongwu period

Height 9.8 cm
Diameter of Mouth 56.3 cm
Diameter of Foot 34.5 cm
Qing court collection

The dish is foliated in the shape of water-chestnut flower and the centre is decorated with floral sprays and enclosed by a border of key-fret patterns. Both the interior and the exterior walls are decorated with the flowers of the four seasons, including peonies, Chinese roses, pomegranate flowers, and chrysanthemums. The foliated rim is decorated with acanthus patterns.

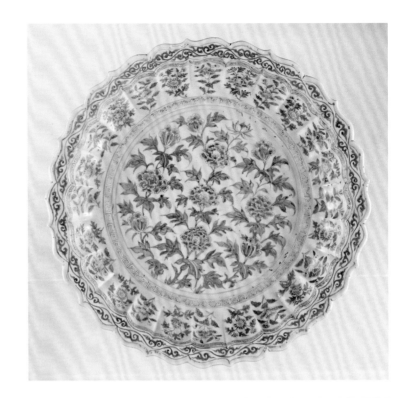

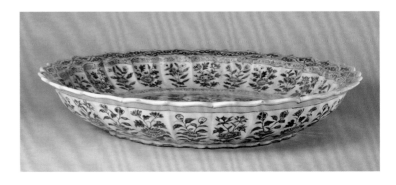

101

Throne
decorated with floral designs in underglaze brown

Ming Dynasty Hongwu period

Height 24 cm
Length 29.3 cm
Width 15.3 cm

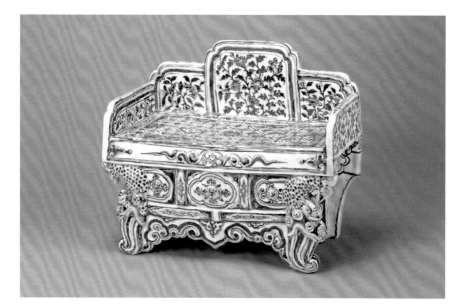

The throne is modelled after the imperial wooden throne of the emperor. The throne is decorated with designs in underglaze pigment with a brownish tint. The top of the throne is decorated with brocade lozenges, in which there are decorations of floral patterns and *wan* swastika patterns (卍). The interior and the exterior sides are decorated with floral sprays of peonies, chrysanthemums, Chinese crab apples, and others. The front legs are modelled in fish-shaped dragons spitting water whereas the rear legs are modelled in the shape of square pillars. In between the four legs are panels with a vase-shaped openings, and underneath the throne, a vertical separation flange is added.

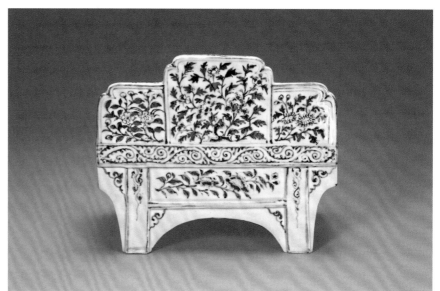

The throne is exquisitely modelled with sophisticated structure that provides valuable reference information on the structure of imperial throne of the Hongwu period. It was difficult to identity whether the underglaze pigments should be oxidized copper or oxidized iron just by judging from eyes. After scientific test without damaging the piece by the laboratory of the Palace Museum, it is identified that the pigment is basically oxidized iron.

102

Stem-bowl
decorated with design of three fish in underglaze red

Ming Dynasty Xuande period

Height 8.8 cm
Diameter of Mouth 9.9 cm
Diameter of Foot 4.4 cm

The bowl has a flared mouth, a deep curved belly, and a splayed hollow high stem. The body is covered with white glaze with mandarin orange-peel marks on the surface. The exterior wall is decorated with three mandarin fish in underglaze red. With the harmonious contrast of red and white colours, the whole piece generates a graceful and elegant resonance. The interior centre is written with a six-character mark of Xuande in regular script in two columns within a double-line medallion in underglaze blue.

The production technique of this type of decorations was first employed by the Imperial Kiln of the Xuande period, which was known as *baoshao* (precious firing technique) and referred to the technique to decorate designated parts on white glazed wares with bright red glaze. Wares with decoration of three fish were recorded as "the fish was fired and lifted from the biscuit with a precious shiny tint" in historical documents.

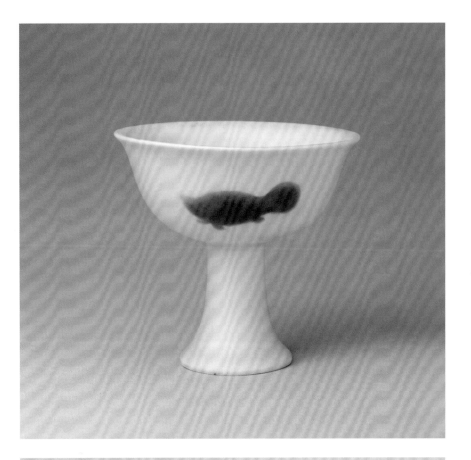

103

Meiping Vase
decorated with design of peaches and bats in underglaze red

Qing Dynasty Kangxi period

Height 45.4 cm
Diameter of Mouth 11.2 cm
Diameter of Foot: 15.2 cm
Qing court collection

The vase has an everted mouth, a short neck, a wide shoulder, a tapering belly and a wide ring foot. On the shoulder and near the foot are decorations of matching lotus scrolls. The belly is decorated with an old and thick peach tree amidst rocks, bamboos, and pines, on which the peach flowers bloom and peaches ripe. Five bats in flight among the branches are depicted with the auspicious meaning of five bats bringing longevity.

This vase is modelled in an elegant form and the colour of underglaze red is bright and pure, representing a refined piece of underglaze red wares of the Kangxi Dynasty. Extant wares show that underglaze red wares with bright and accurate colours, as well as with a variety of forms and decorative designs began to emerge in the Kangxi period.

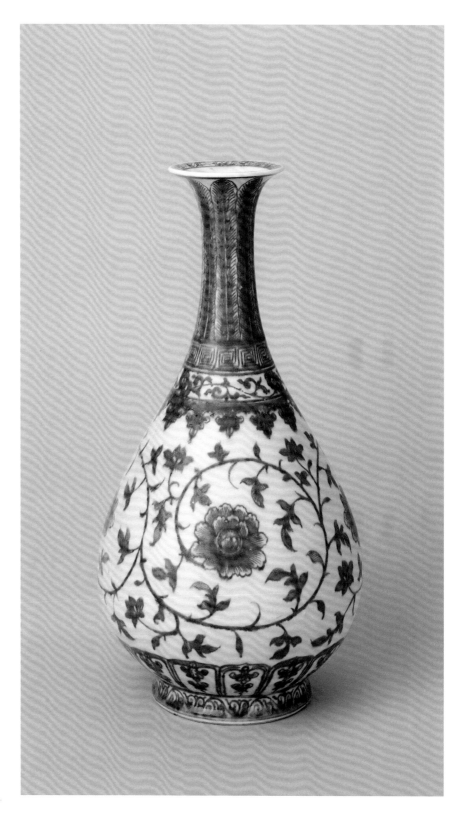

104

Meiping Vase
decorated with design of
dragons reserved
in white and cresting waves
in underglaze red

Qing Dynasty Yongzheng period

Height 35.5 cm
Diameter of Mouth 7.2 cm
Diameter of Foot 13.5 cm

The vase has a small mouth, a short neck, a wide shoulder, a tapering belly, and a ring foot. The exterior wall is decorated with cresting waves in underglaze red and engraved with two swimming dragons, one big and one small, reserved in white. The decorative design has the meaning that the dragon is giving guidance to its offspring. The exterior base is written with a six-character mark of Yongzheng in regular script in two columns within a double-line medallion in underglaze blue.

The vase is modelled after similar wares of the Yongle period of the Ming Dynasty with an elegant form and graceful decorative designs reserved in white on a red ground. After the revival of firing underglaze red wares in the Kanxi period, the production of which had reached a zenith in the Yongzheng period. There were a wide variety of underglaze red wares with bright and accurate colour produced in the period, which often bear the six-character mark of Yongzheng in regular script in underglaze blue.

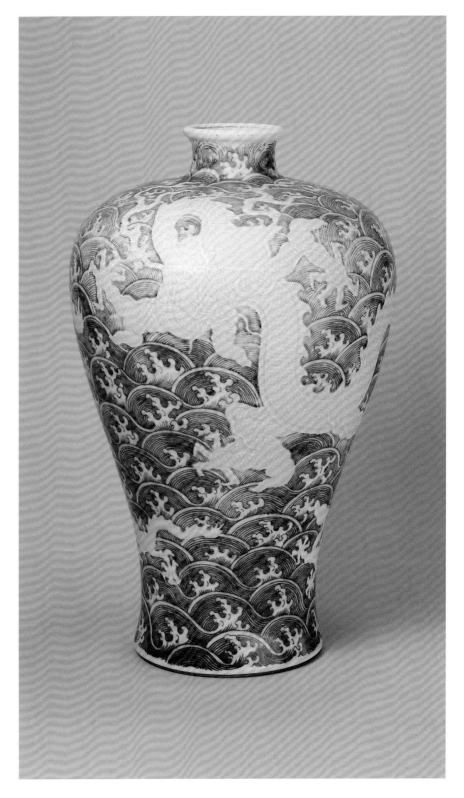

105

Pear-shaped Vase
decorated with sprays of
auspicious fruits
in underglaze red

Qing Dynasty Yongzheng period

Height 37 cm
Diameter of Mouth 8 cm
Diameter of Foot 13 cm
Qing court collection

The vase has a flared mouth, a narrow neck, a hanging belly and a ring foot. The belly is decorated with sprays of pomegranates, peaches, lychees, and others, which carry the auspicious meanings of progeny, longevity, etc. and enriched by other border designs including banana leaves, *ruyi* cloud lappets, lotus petals, acanthus patterns, and others. The exterior base is written with a six-character mark of Yongzheng in regular script in two columns within a double-line medallion in underglaze blue.

The colour of underglaze red on this vase is bright and accurate, and the decorative design of three kinds of fruits of peaches, lychees, and peaches was a very popular auspicious design on the imperial wares of the Qing Dynasty.

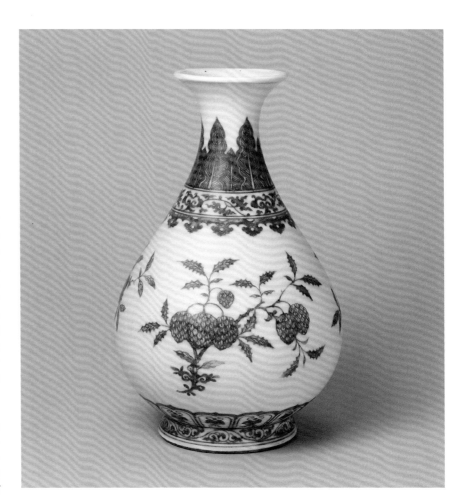

106

Vase
decorated with design of dragons amidst clouds in underglaze red

Qing Dynasty Qianlong period

Height 21.9 cm
Diameter of Mouth 6.4 cm
Diameter of Foot 6.2 cm
Qing court collection

The vase has a flared mouth, a narrow neck, a curved belly tapering downwards, and a ring foot. Underneath the mouth rim are decorations of *ruyi* cloud lappets. The neck and belly are decorated with dragons amidst cresting waves. The exterior wall of the ring foot is decorated with key-fret patterns. The exterior base is written with a six-character mark of Qianlong in seal script in three columns in underglaze blue.

This piece is an imperial ware of the mid-Qianlong period. Other than underglaze red wares, there are also similar underglaze blue wares, wares in imitation of imperial wares, and wares in imitation of Ru wares, etc.

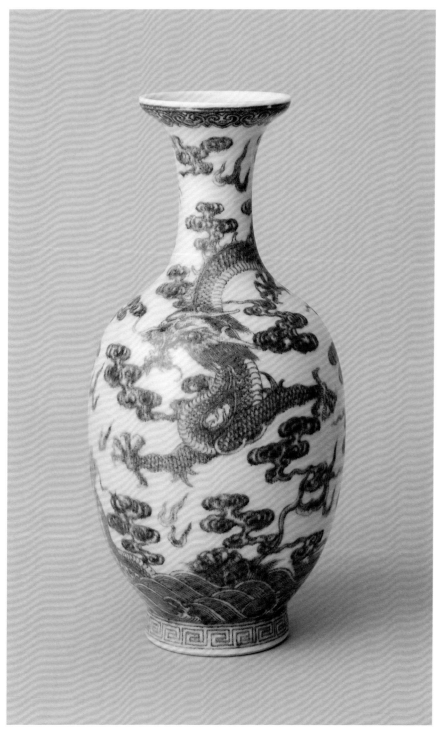

107

Square Flask with Elephant-shaped Ears Holding Rings

and decorated with phoenixes amidst peonies in underglaze red

Qing Dynasty Qianlong period

Height 22 cm
Diameter of Mouth 11.8 × 7.2 cm
Diameter of Foot 11 × 7.9 cm
Qing court collection

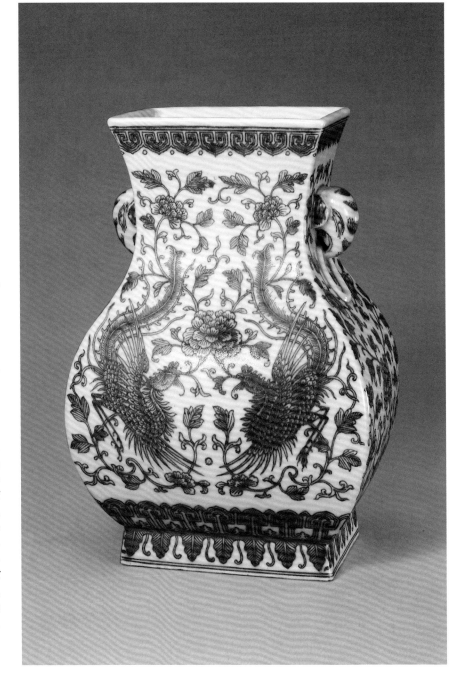

The rectangular-shaped flask has a flared mouth, a narrow neck, a globular belly, and a square ring foot. On the two sides of the neck is a pair of ears in the shape of elephant heads holding rings. The principal decorations are phoenixes in flight amidst peonies, which are further enriched by *ruyi* cloud lappets and banana leaves. The exterior base is written with a six-character mark of Qianlong in seal script in three columns in underglaze blue.

Phoenix was regarded as an auspicious bird in ancient Chinese mythology, and it had appeared as early as in the Shang Dynasty as a symbolic creature of totemic beliefs. Later it has become a symbol of feminism. In the Qing decorative designs, there were often the combination of one dragon and one phoenix to suggest the auspicious meaning of "the dragon and phoenix bringing harmony," or compositions of phoenixes with sprays of peonies, lotuses, etc. to suggest "phoenixes in flight amidst peonies," "phoenixes holding peonies," etc.

108

Flask
decorated with design of plum blossoms and bamboos in spring in underglaze red

Qing Dynasty Qianlong period

Height 26.2 cm
Diameter of Mouth 3.6 cm
Diameter of Foot 8.2 × 4.7 cm
Qing court collection

The flask has a small mouth, a short neck, a flattened round belly, and a oval-shaped ring foot. On the symmetrical sides of the neck and shoulder is a pair of ears in the shape of *ruyi* clouds. Both sides of the belly are decorated with a scene of a white-headed bird standing and singing on a fully bloomed plum tree, and besides the tree are bamboo leaves. The composition of plum blossoms and bamboos has the auspicious meaning of signifying coming of the spring, whereas the white-headed bird is a symbol of longevity.

This typeform of vases was known as *magua* vase in the documents of the Qing court, and the form was imitated from the imperial wares of the Yongle and Xuande periods of the Ming Dynasty. In accordance with the document *No. 62 of Tang Ying* in *Qing Dang*, "The eunuch Hu Shijie sent in a piece of *magua* vase in underglaze red and a design drawing. The imperial court issued an order that by taking reference from the glaze colours of the Ming Dynasty, produce a few pieces in accordance with the design drawing, and assure that the decorative designs are finely painted and clear." This vase matches the archival records, and should be a piece produced in the Imperial Kiln in accordance with the decorative design drawings issued by the court.

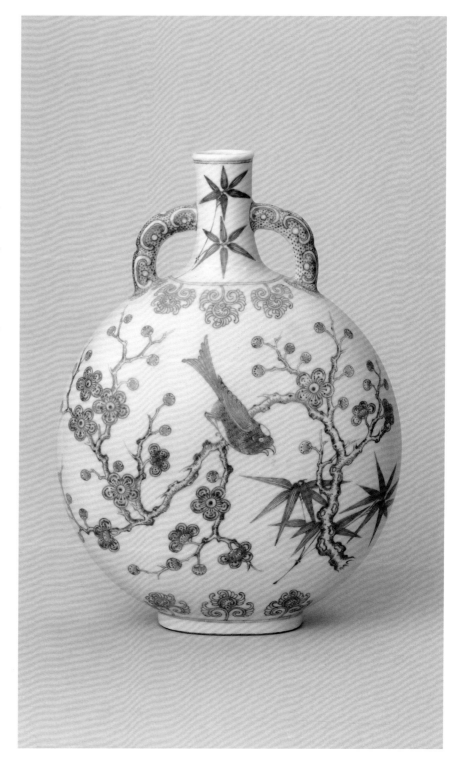

109

Pear-shaped Vase
decorated with day-lilies in underglaze red on a yellow ground

Qing Dynasty Qianlong period

Height 34 cm
Diameter of Mouth 8.6 cm
Diameter of Foot 11.5 cm
Qing court collection

The vase has a flared mouth, a narrow neck, a hanging belly, and a ring foot. It is decorated with underglaze red on a yellow ground. The neck is decorated with banana leaves and floral sprays whereas the shoulder is decorated with deformed *ruyi* cloud patterns. Both sides of the belly are decorated with day-lilies and butterflies, and near the foot are decorations of deformed lotus lappets.

Day-lily was regarded as plant that would bring the birth of boys, and people believed with this flower as ornament, the pregnant woman would give birth to boys. Later it became an auspicious symbol for giving birth of boys.

This vase represented a new typeform of wares with underglaze red decorations on colour glazed grounds. The colour of yellow glaze is brilliant and the colour of underglaze red is accurate and bright, giving the pieces a wonderful grace. Based on the production of underglaze red wares with a white ground in the Kangxi, Yongzheng and Qianlong periods, new typeforms with underglaze red decorations on a pea-green ground, sky-clear blue ground, *dongqing* celadon ground, sky-blue ground, and others were produced.

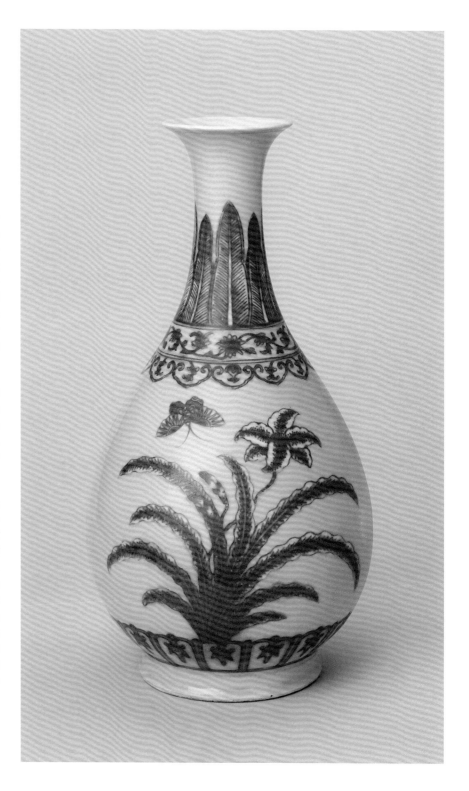

110

Covered Jar
decorated with openwork design of landscapes, rocks, and flowers in underglaze blue and red

Yuan Dynasty

Overall Height 42.3 cm
Diameter of Mouth 15.2 cm
Diameter of Foot 18.5 cm

Unearthed at a cellar at Baoding, Hebei in 1964

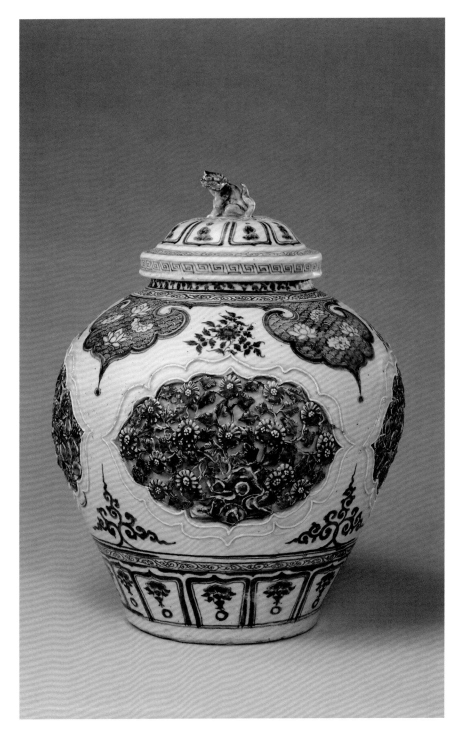

The jar has an upright mouth, a slanting shoulder, a globular belly tapering downwards, and a shallow and wide ring foot. It has a matching canopy-shaped cover with a lion-shaped knob. The whole body is glazed in greenish-white and the base is unglazed. On the four sides of the belly are lozenge-shaped panels outlined with double-bead borders. Inside the panels are designs of flowers of the four seasons, rocks and landscapes carved in openwork. The flowers are painted in copper-red while the leaves are painted in cobalt-blue with sharp contrasting effect. Other parts of the piece are also decorated including chrysanthemum scrolls on the neck, four *ruyi* cloud collars on the shoulder, and interspersed by four sprays of chrysanthemums. Inside the collars are decorations of white lotuses in water in underglaze blue. Underneath the belly are decorations of floral sprays, and near the foot are designs of acanthus patterns and lotus lappets. The surface of the cover is decorated with lotus lappets.

This jar was fabulously potted with exquisitely carved openwork designs. Compared with the firing of underglaze blue, the requirements for firing copper red were even more difficult to command. When the two kinds of glazes are employed at the same time to decorate a piece and to assure that the accurate colours are achieved, high difficult technical requirements are anticipated. The successful firing of this large jar reveals the superb technical competence of production at the time.

111

Bowl
decorated with design of children at play in underglaze blue and red

Ming Dynasty Wanli period

Diameter 10.2 cm
Diameter of Mouth 22.4 cm
Diameter of Foot 8.8 cm

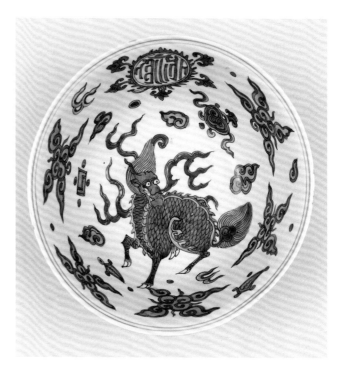

The bowl has a flared mouth, a deep curved wall, and a ring foot. The interior centre is decorated with a *qilin* Chinese unicorn turning its head backwards, and surrounded by auspicious clouds and precious emblems. The exterior wall is decorated with a couple sitting in front of a screen and children at play, holding auspicious flowers and plants such as *lingzhi* funguses, lotus leaves, gourds, etc. The interior of the ring foot is covered with greenish-white glaze. The exterior base is written with a six-character mark of Wanli in regular script in two columns within a double-line medallion in underglaze blue.

The decorative design of lovely and naughty children at play is skillfully depicted. It is a valuable piece although the colour of underglaze red is not so bright and accurate. The technique of firing both underglaze blue and red decorations at the same time first appeared in the late Yuan Dynasty, and was continued in the Yongle and Xuande periods of the Ming Dynasty, although successfully produced wares were quite rare. Such type of wares became less in the later periods as the production techniques were gradually lost.

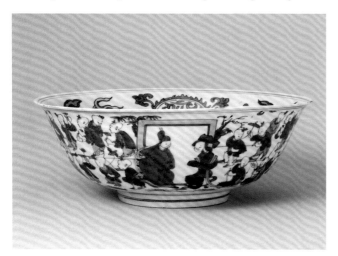

112

Ewer with a
Peach-shaped Knob
and decorated with design of interlocked rings
in underglaze blue and red

Qing Dynasty Kangxi period

Overall Height 13 cm
Diameter of Mouth 8.5 cm
Diameter of Foot 7.7 cm
Qing court collection

The ewer has an everted rim, a slanting shoulder, a globular belly, and a splayed high ring foot. On the symmetrical sides of the belly is a curved spout and handle. It has a matching cover in the shape of a plate with a shallow everted rim. On the cover is a knob with applique design of four peaches in underglaze red and leaves in underglaze blue. The wall of the belly and foot are decorated with design of interlocking rings in white in relief, resembling weaved vines.

This piece was a new typeform of Jingdezhen imperial wares of the Kangxi period with skillful and distinctive modeling, and represents a refined Kangxi imperial ware.

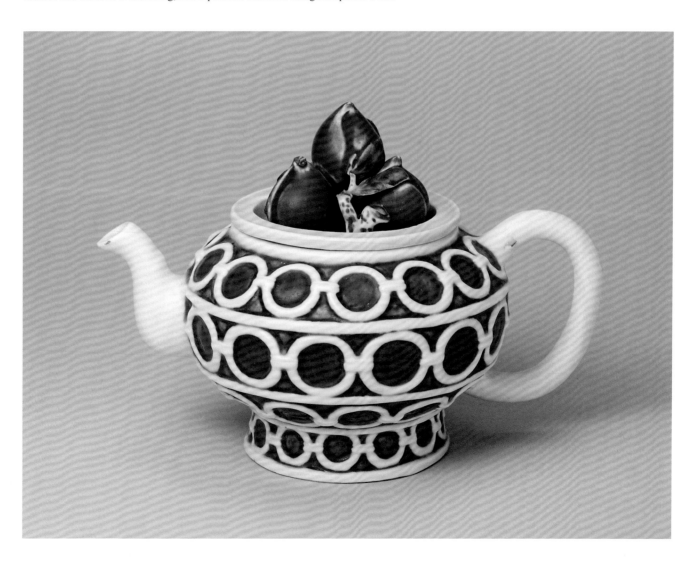

113

Meiping Vase
decorated with design of pines, bamboos, and plum blossoms in underglaze blue and red

Qing Dynasty Yongzheng period

Height 26.7cm
Diameter of Mouth 8.9 cm
Diameter of Foot 11 cm

The vase has a flat mouth, a short neck, a wide shoulder, a tapering belly, a splayed base, and a ring foot. The body is decorated with the design of "three friends of winter – pines, bamboos, and plum blossoms" which are symbols of literati virtues. The plum blossoms, pine branches and trunks, as well as the sun in the sky are painted in copper-red, and other decorative designs are painted in underglaze blue. A distinctive feature is that the bamboo leaves are actually written with four sentences of a poem, "bamboos rise to the sky, pines endure the cold winter, plum blossoms are the most esteemed among all flowers, and these three friends reveal the harmony of the four seasons" to match the pictorial elements on the vase. The exterior base is written with a six-character mark of Yongzheng in regular script in three columns within a single-line medallion in underglaze blue.

The form of this vase was derived from its traditional prototype by enlarging the mouth to produce a new form. With a charming form, pure glaze, delicate and meticulous brushwork, accurate colours of underglaze blue and red and the skillful treatment of both the pictorial composition with poem inscriptions, it represents a profound example of its type.

114

Stem-bowl
decorated with design of sprays of three fruits in underglaze blue and red

Qing Dynasty Yongzheng period

Height 11.8 cm
Diameter of Mouth 16.6 cm
Diameter of Foot 4.7 cm
Qing court collection

The bowl has a flared mouth, a curved wall, and a high ring foot. The exterior wall is decorated with sprays of peaches, pomegranates, and citrons, which are symbols of longevity, progeny, and fortune respectively. Such type of design is known as an auspicious tribute of "three abundances." The interior of the foot is written with a six-character mark of Yongzheng in regular script in underglaze blue.

This bowl represents a new form by imitating similar imperial wares of the Xuangde period of the Ming Dynasty. The imperial stem-bowls decorated with design of three fruits of the Xuande period were only painted in pure red glaze. On this piece with the basic design of three fruits in underglaze red, leaves and branches in underglaze blue are added. These two types were mentioned in the book *Tao Cheng Jishi* written by Tang Ying in the 13th year of Yongzheng (1735) that "Among underglaze red wares, there were those only painted with red glaze or with designs in underglaze red and accompanied by branches and leaves in underglaze blue."

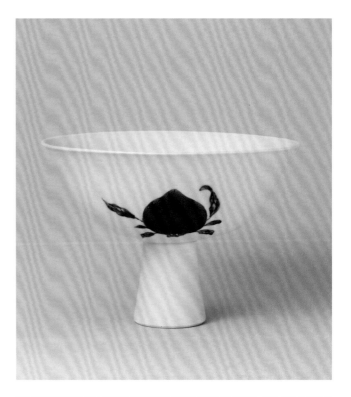

115

Meiping Vase
decorated with design of dragons amidst clouds and cresting waves in underglaze blue and red

Qing Dynasty Qianlong period

Height 35 cm
Diameter of Mouth 7.3 cm
Diameter of Foot 13.3 cm
Qing court collection

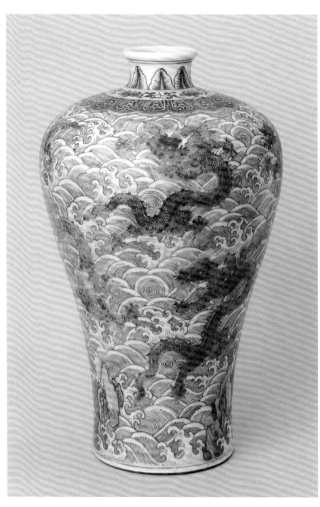

The vase has a small mouth, a short neck, a wide shoulder, a curved belly tapering downwards, and a ring foot. The neck and the shoulder are decorated with borders of banana leaves, *lingzhi* fungus scrolls, and deformed lotus petals. The belly is decorated with cliffs, landscape and cresting waves in underglaze blue, and with nine dragons flying or swimming in between. The exterior base is written with a six-character mark of Qianlong in seal script in three columns in underglaze blue.

This vase was a typical decorative ware of the Qing court, and represents the typical colour tone of underglaze blue and red of the Qianlong imperial wares. The imperial underglaze blue and red wares of the Qianlong period carried on the tradition of the Yongzheng period, showing a dense and brilliant colour tone of underglaze blue and light colour tone of underglaze red. Defects of copper-green dots are usually found in the red colour. Popular type-forms include decorative utensils such as different types of vases, and decorated with designs of lotus scrolls, dragons amidst clouds, phoenix medallions, three fruits, etc.

116

Celestial Sphere-shaped Vase
decorated with design of dragons amidst clouds and waves in underglaze blue and red

Qing Dynasty Qianlong period

Height 47 cm
Diameter of Mouth 10.7 cm
Diameter of Foot 15.5 cm
Qing court collection

The vase has an upright mouth, a long neck, a globular belly in the shape of a celestial sphere, and a ring foot. Both the interior and the exterior are covered with white glaze. The principal design is a dragon in red taking flight amidst clouds with head protruding from and body hidden in the clouds. Near the mouth rim and the foot are decorations of cresting waves. The exterior base is written a six-character mark of Qianlong in seal script in three columns in underglaze blue.

The production of underglaze blue and red wares reached its cradle in the Yongzheng and Qianlong periods. The colour of underglaze red was accurate, clear and bright, as represented by this piece.

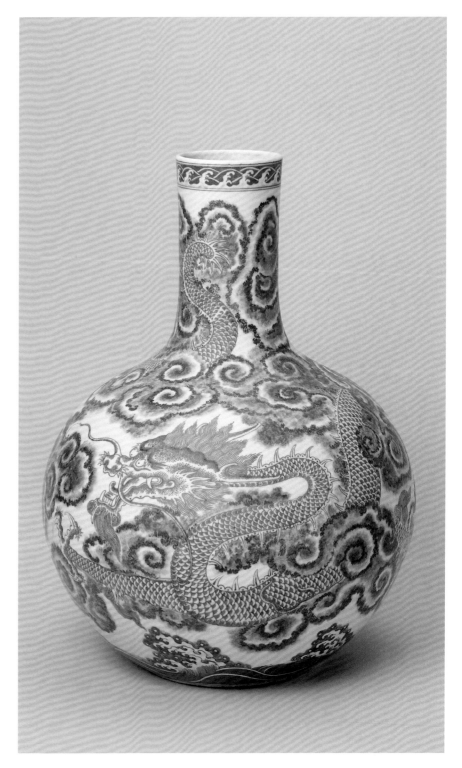

117

Fengwei Vase in the Shape of Phoenix's Tail
and decorated with design of eight horses in three underglaze colours

Qing Dynasty Kangxi period

Height 43.2 cm
Diameter of Mouth 23.2 cm
Diameter of Foot 18.3 cm

The *zun* vase has a trumpet-shaped mouth, a long neck, an angular shoulder, a globular belly slightly splayed near the base, and a ring foot. The exterior wall is covered with pea-green glaze as the ground, on which eight horses in underglaze blue and red are depicted. In ancient Chinese legend, King Mu of the Zhou Kingdom had kept eight horses for patrolling in the country and the decorative design of eight horses on Kangxi wares was derived from it.

This type of vase with its trumpet -shaped mouth like a phoenix's tail was known as "*zun* vase in the shape of phoenix's tail." With their large and tall bodies, these vases were often displayed at the palace halls for decorative purpose or during sacrificial ceremonies. They were produced in both the Imperial Kiln and local kilns and types in underglaze blue, *wucai* enamels, three colours, sepia ink, splashed blue, *dongqing* celadon, pea-green with underglaze blue, and red decorations were produced. The forms of which slightly differed in its early, middle, or later years of production in various periods. This piece should be a work of the late Kangxi period.

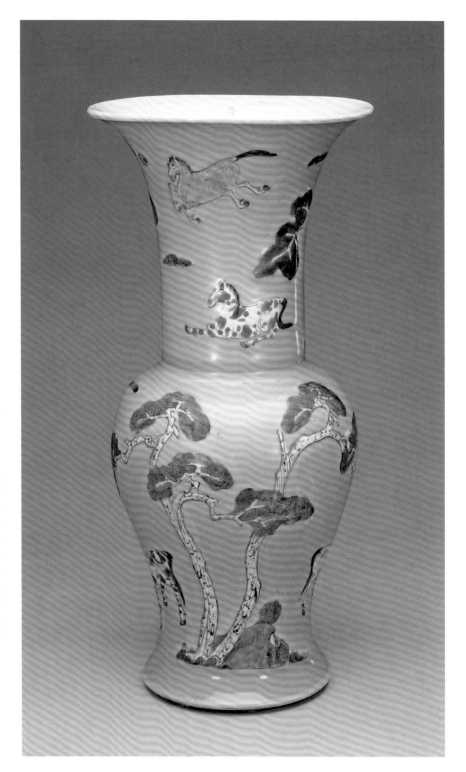

118

Vase
decorated with design of flowers and birds in five underglaze colours

Qing Dynasty Xuantong period

Height 30.3 cm
Diameter of Mouth 6.3 cm
Diameter of Foot 6.3 cm

The vase has a flared mouth, a narrow neck, a slanting shoulder, a long belly, and a ring foot. With a light and thin paste, the vase is covered with white glaze. The exterior wall of the belly is decorated with design of flowers and birds in five underglaze colours in a simple manner with soft colour tones. The exterior base is written with a mark *daqing xuantong sannian Hunan ciye gongsi* (produced by the Hunan Ceramics Company in the third year of the Xuantong period) in regular script in three columns in underglaze blue within a green glazed double-line medallion.

In the history of modern Chinese ceramics, wares in five underglaze colours produced in the Liling Kiln, Hunan in the late Qing to the early Republican period had reached a high standard in terms of production techniques and decorative styles. With its refined paste, beautiful glaze colours, excellent mastery of technical production, and potting, as well as decorations with artistic merits, these wares have become a distinctive type of wares in the world's ceramic industry.

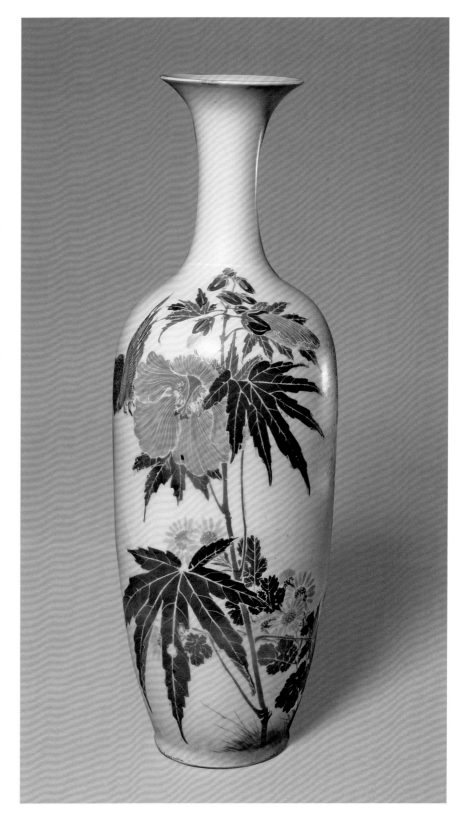

PORCELAIN WARES IN WUCAI
(FIVE COLOURS) ENAMELS

119

Covered Jar
decorated with designs in *wucai* enamels

Northern Song Dynasty

Overall Height 10.2 cm
Diameter of Mouth 11 cm
Diameter of Foot 5.6 cm

The jar is in tubular shape and has a slightly inverted mouth, a deep curved belly tapering downwards, and a ring foot. It has a matching cover with convex surface and flat sides. The paste is in greyish-brown colour and the exterior is covered with white glaze dripping but it stops above the foot. The decorative designs are painted in three colours of red, green, and yellow. The body is decorated with four rectangular panels in which four characters "*yuan*", "*feng*", "*si*", "*nian*" (collectively means the fourth year of the Yuanfeng period) are written and interspersed by swirl patterns. The centre of the cover is decorated with a peony bordered by string patterns.

Yuanfeng was the reign of Emperor Shenzong (1068–1085) of the Song Dynasty. The fourth year of Yuanfeng period was 1081.

This type of wares in *wucai* enamels is known as "ceramic wares in red and green colours" as red and green enamels are employed to paint the decorations. Usually the decorative designs are painted in red, green, yellow, and black enamels on the fired wares, and then fired a second time in low temperature. Kiln sites for producing such type of wares in the Song and Jin Dynasties were located in Henan, Hebei, Shaanxi, Shandong, and other provinces. Most of the wares are bowls and plates.

120

Sitting Statue
of a lady in *wucai* enamels

Jin Dynasty

Height 11 cm
Width. 4.2 cm

The statue is modelled in a sitting posture with her hair bound up into a bun. She wears a long robe outside and a long skirt with diagonal collar inside. The whole body is covered with white glaze, on which are painted designs in red and green enamels whereas the face and hair are outlined in ink.

Such small statues were commonly produced in the Song Dynasty by various kilns in the north and the south. Typeforms include a variety of forms in different colours. They might have been produced from the remaining materials left over during the production of large-sized wares, and the quality was usually coarser.

Professionals in the ceramic industry have different views on the production period of this type of *wucai* wares with principal designs painted in red and green enamels, which have different names such as "added colours of the Song Dynasty," "added colours of the Jin Dynasty" etc. Yet it was certain that production of this type of wares had reached a matured stage after the mid and late Jin Dynasty. A number of unearthed pieces with the mark "*taihe*" (1201–1208, reign of Emperor Zhangzong of the Jin Dynasty), "*zhengda*" (1224–1231, reign of Emperor Aizong), etc. prove that the production of *wucai* wares had reached a rather high standard in the early 13th century.

121

Bowl
decorated with design of peony spray in red and green enamels

Jin Dynasty

Height 5 cm
Diameter of Mouth 15.2 cm
Diameter of Foot 4.6 cm

The bowl has an everted mouth, a deep curved belly, and a ring foot. The rather coarse paste is in yellowish-brown colour and covered with white slip, half of which is covered with transparent glaze. The interior wall is decorated with a spray of peony within four borders of string patterns painted in red. The flower is painted in red with the leaves and branches painted in green. The colours harmoniously match, with the simple brush style and fluent linear rendering with a refreshing grace.

The interior centre and the base have five spur marks, which show that these wares were probably piled up for firing. The method was to use supporting nails to support and separate various pieces and pile them up for kiln setting and firing. The supporting nails were made of clay for separating different wares so that they would not stick together during firing. Since marks would appear after firing and affect the aesthetic appeal of the ware, small nails would be preferred for use.

Most of the wares in red and green enamels in Song and Jin Dynasties were produced in local kilns. The products were usually simple with coarse paste and spontaneous decorations. However, these wares painted in colour enamels and fired for two times opened a new path for the development of painted enamel wares in the later dynasties with profound historical significance.

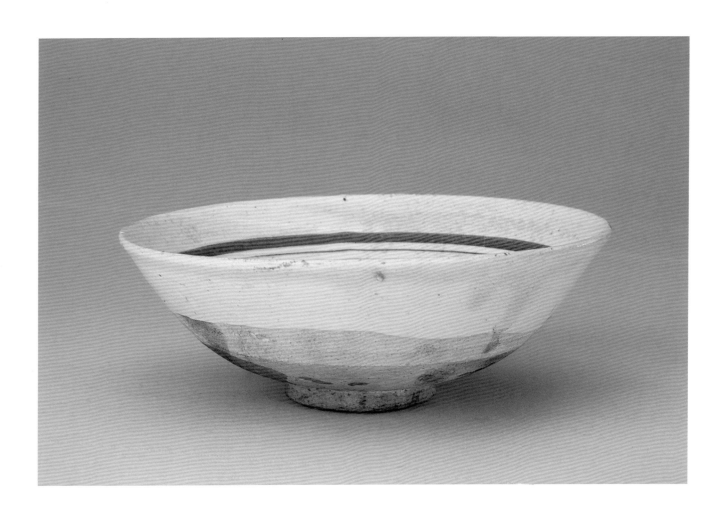

122

Jar
decorated with design of
ducks swimming in a lotus
pond in *wucai* enamels
on a black glazed ground

Jin Dynasty

Height 8.6 cm
Diameter of Mouth 6 cm
Diameter of Foot 6.2 cm

The jar is in the shape of a pear with a narrow mouth, a deep belly which is narrow on the upper part and wider on the lower part and ring foot. The body is covered with black glaze. The exterior wall is decorated with a pair of ducks swimming in a lotus pond in brown enamel. The pictorial treatment is simple and naturalistic, and the designs are painted in a swift and free manner, reflecting the style of literati painting in the Song Dynasty.

The decorative technique of black glazed ware with brown enamel was to grind the mineral with oxidized iron content into powder as colour enamel, and then painted the designs with this enamel pigment on the wares with black glazed ground. Brown enamel designs could be classified into two styles, the first was to use a brush to paint the designs directly and the second is to use techniques of dotting, splashing, or flipping with fingers, so that the colour pigments would stick to the glazed body. As the pigment contains oxidized iron, it would give a shiny iron-rust metallic appearance on the black glaze after high temperature firing. As a result, such as a decorative effect of brown enamel on black glaze are also known as "iron-rust designs", "embroidered designs", or "rusted designs" in historical records.

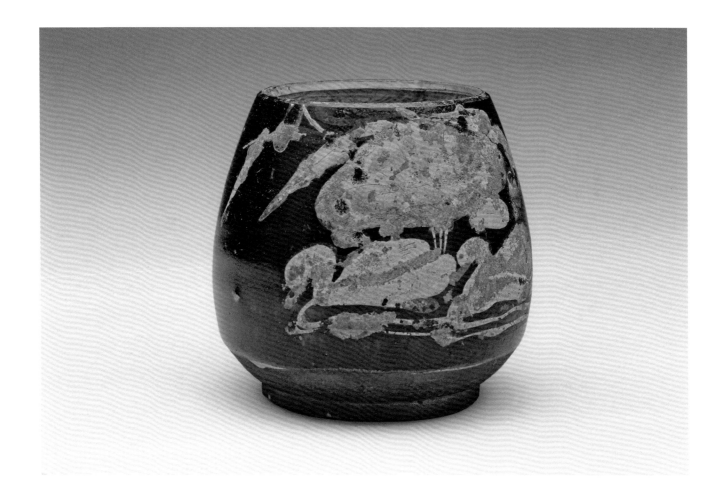

123

Plate
decorated with design of two birds and peach blossoms in *wucai* enamels

Ming Dynasty Zhengde period

Height 2.9 cm
Diameter of Mouth 14.3 cm
Diameter of Foot 8.9 cm

The plate has an everted mouth, a shallow curved wall, and a ring foot. The principal designs are painted in iron-red enamel and enriched by yellow and peacock green enamels. The centre of the plate is decorated with floral sprays in iron-red within a double-line medallion. The exterior wall is decorated with two units of two birds and peach blossoms, on top and below of which are double string borders painted in iron-red. The interior of the ring foot is covered with white glaze. The exterior base is written with a four-character mark of Zhengde in regular script in two columns within a double-line medallion in iron-red.

There are only few *wucai* enamelled wares of the Zhengde period extant and this plate is an important piece for the study of wares in *wucai* enamels of the Zhengde period, Ming Dynasty.

124

Jar
decorated with design of cranes amidst clouds and precious emblems in *wucai* enamels

Ming Dynasty Jiajing period

Height 19.3 cm
Diameter of Mouth 13.2 cm
Diameter of Foot 11 cm
Qing court collection

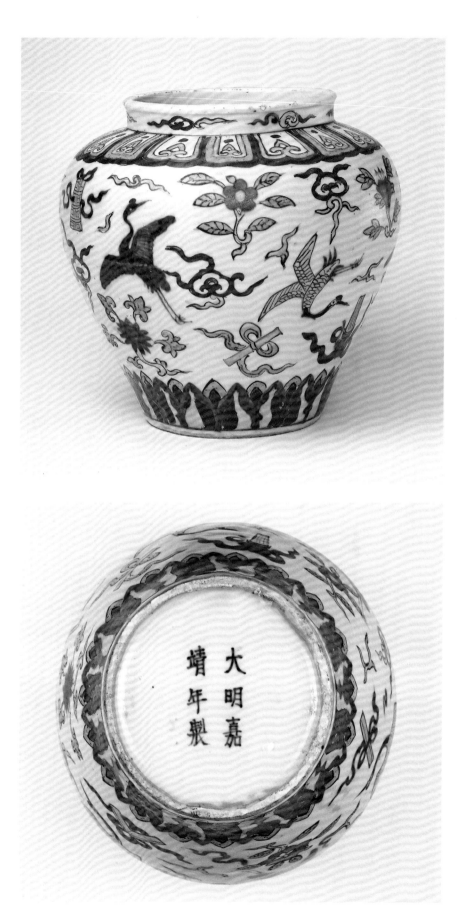

The jar has an upright mouth, a short neck, a wide shoulder, a slim base, and a ring foot. The body is decorated with designs in underglaze blue, red, green, and yellow enamels. The neck is decorated with coloured cloud patterns whereas the shoulder is decorated with deformed lotus lappets. The belly is decorated with three blue and three yellow cranes flying amidst coloured clouds, precious emblems, and floral patterns. The yellow crane design is outlined in iron-red first, and then filled with yellow enamel. Near the base are decorations of deformed banana leaves. The interior of the ring foot is covered with white glaze. The exterior base is written with a six-character mark of Jiajing in regular script in two columns in underglaze blue.

In ancient legend, the directions of east, west, south, north, the heaven and the earth are known as the "six *he* (harmonies)." "Crane (*he*)" is a pun for "harmony." The composite decorative design of six cranes in the Ming Dynasty carried the auspicious meaning of "six harmonies for sharing prosperity," which suggested coming of a peaceful world and everlasting prosperity.

This jar is potted with round and fabulous form with the decorative designs depicted in a vigorous and spontaneous manner. The designs are mostly treated with underglaze blue and yellow enamel with a refreshing grace and delicacy, revealing the distinctive style of Jiajing wares in *wucai* enamels.

125

Large Covered Jar
decorated with design of fishes and aquatic plants in *wucai* enamels

Ming Dynasty Jiajing period

Overall Height 33.2 cm
Diameter of Mouth 19.5 cm
Diameter of Foot 24.1 cm

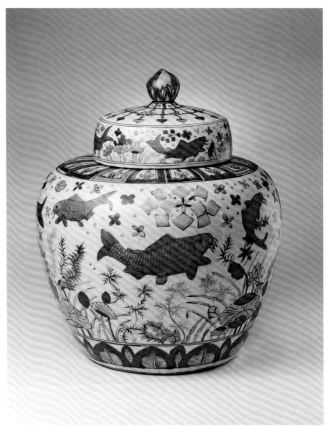

The jar has an upright mouth, a short neck, a wide shoulder, a round belly tapering downwards, and a ring foot. It has a matching cover with a sloped round cover and a tourmaline knob. The shoulder is decorated with deformed lotus lappets and the belly is fully depicted with fishes and aquatic plants in a lotus pond. Eight red carps are swimming leisurely amidst lotuses and aquatic plants. Near the base are decorations of banana leaves. The surface of the cover is decorated with bead chains and the knob is decorated with flames. The exterior base is written with a six-character mark of Jiajing in regular script in two columns in underglaze blue.

This large jar is potted with a thick and fabulous body, decorated with luxuriant colours and skillful pictorial treatment. The scales and fins of the carps are meticulously depicted and they turn their tails for swimming leisurely amidst lotuses and aquatic plants with a touch of naturalistic favour.

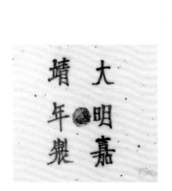

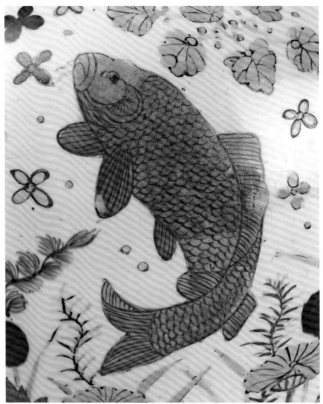

126

Garlic-head Vase
decorated with design of mandarin ducks in a lotus pond in *wucai* enamels

Ming Dynasty Wanli period

Height 44.5 cm
Diameter of Mouth 7.5 cm
Diameter of Foot 14.5 cm
Qing court collection

The vase has a garlic head-shaped mouth, a long neck, a round belly, and a ring foot. The mouth is inlaid with a copper ring. Underneath the mouth rim are deformed banana leaf patterns. The neck is decorated with rocks, Chinese roses, dragonflies, and bees. The belly is decorated with mandarin ducks, lotuses, egrets, water birds, willows, and other charming scenes of a lotus pond, which is known as "beauties in the lotus pond" design. The decorative designs on the neck and belly are interspersed by *lingzhi* funguses. Near the foot are decorations of lotus petals and the wall of the foot is decorated with floral patterns. The interior of the ring foot is unglazed.

Garlic-head vases were very popular in the Wanli period. Most of the decorative designs on this vase are outlined in black enamel and filled with red, green, yellow and light purple enamels with a lofty pictorial treatment, naturalistic favour and aesthetic appeal. As the designs are flatly painted, they are only depicted with shading effects but without dimensional perspectives and tonal gradations.

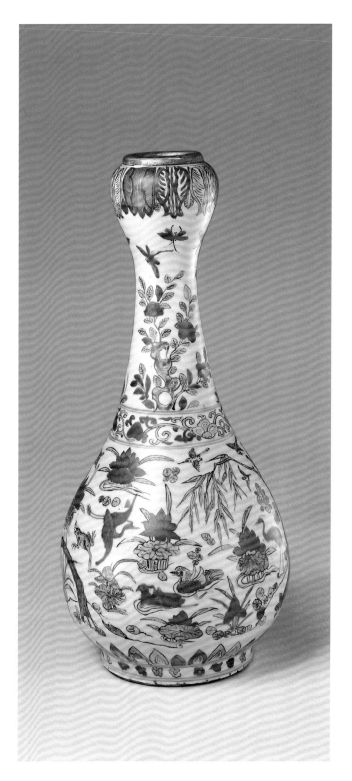

127

Gu Vase
decorated with designs of dragons amidst clouds, birds and flowers in *wucai* enamels

Ming Dynasty Wanli period

Height 58 cm
Diameter of Mouth 17.8 cm
Diameter of Foot 18 cm
Qing court collection

The vase in the shape of ancient *gu* wine-container has a flared mouth, a long and narrow neck, a round belly, a splayed base, and a ring foot. There are three layers of decorative designs. The upper and lower parts of the neck are decorated with dragons in pursuit of pearl. The belly is decorated with a peacock, rocks, and flowers. Under the belly are decorations of cresting waves and *lingzhi* funguses. The decorations are separated by ten layers of banana leaves, *ruyi* cloud patterns, floral scrolls, and key-fret patterns from the top to the bottom. Underneath the exterior mouth rim is a horizontal six-character mark of Wanli in regular script in underglaze blue.

This vase is fashioned in the form of ancient bronze wares and decorated with sophisticated decorative designs with bright and luxuriant colours, which shows the typical style of Wanli *wucai* wares and is a refined piece of its type.

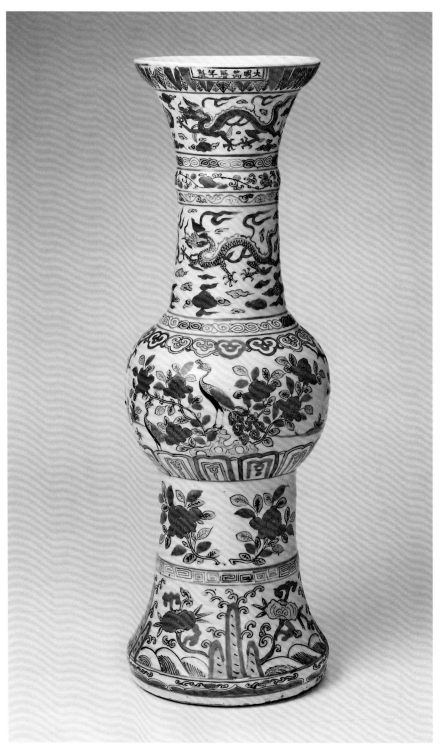

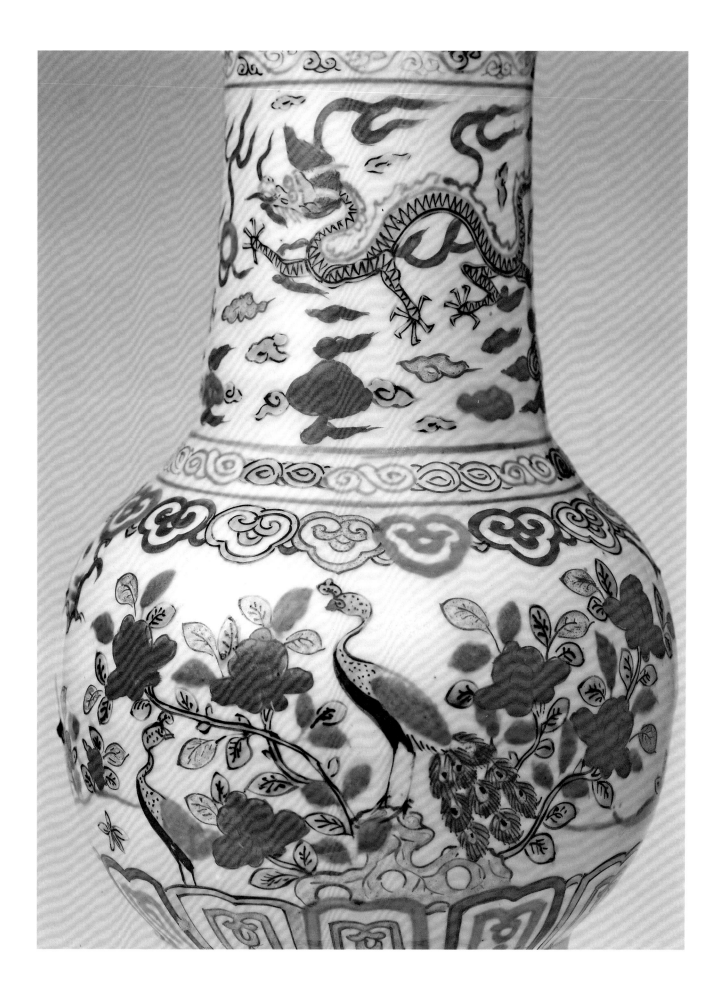

128

Vase

decorated with design of phoenixes amidst clouds in openwork in *wucai* enamels

Ming Dynasty Wanli period

Height 49.5 cm
Diameter of Mouth 15 cm
Diameter of Foot 17.2 cm
Qing court collection

The vase has a washer-shaped mouth, a long neck, a slanting shoulder, a globular belly, a thick base, and a ring foot. On the two sides of the neck is a pair of lion face-shaped ears. Inside the vase is an interior gall. The mouth is decorated with *ruyi* cloud patterns in openwork. The upper part of the neck is decorated interspersed large and small banana leaves, and on top of small banana leaves are openwork design of flowers and butterflies. The middle part of the neck is decorated with brocade ground in between the ears and panels in which there are the characters *shou* (longevity) in seal script in medallions. The lower part of the neck is decorated with openwork design of cloud patterns and flowers. The shoulder is decorated with wide brocade borders, on top of which are lozenge-shaped panels with decorations of sprays of flowers and fruits and birds. The principal designs are the phoenixes in flight amidst auspicious clouds on the belly. A large phoenix is accompanied by eight small phoenixes and flying amidst clouds. Near the foot is a brocade border with openwork design of panels in the shape of Chinese flowering crab apples and further enriched with designs of floral patterns and precious emblems. The exterior wall of the ring foot is decorated with string borders in iron-red enamel.

The vase is exquisitely decorated with massive layers of decorative designs, and the pictorial treatment carries an ambience of happiness and auspicious tributes. The colour enamels include underglaze blue, overglaze red, yellow, green, peacock green, and aubergine. The sophisticated and luxuriant depiction of phoenixes amidst clouds by employing openwork designs and enamelled painting fully reveal the superb production standard at the time.

The decorative styles of *wucai* wares became more luxuriant and the colour of enamels became more dense and thick instead of the subtle and spacious style of the *doucai* wares of the Chenghua period. Such a change came from the rise of popular culture and changes of social customs in the mid and late Ming period.

129

Rectangular Covered Box

decorated with design of
figures and flowers
in *wucai* enamels

Ming Dynasty Wanli period

Overall Height 8.9 cm
Length 17.5 cm
Width 9.7 cm
Qing court collection

The rectangular box has an everted rim at the base and inside the box are eight compartments. The surface of the cover is decorated with a bridge, a stream, and rocks. Two figures wearing black gauze caps and green and red robes are riding on a horse and a cart, and they look like officials. They are accompanied by four attendants who are either leading the way or holding canopies. The four sides of the cover are decorated with figures in stories, and with a background decorated with rocks, landscapes, flowers, grass, trees, streams, etc. The interior of the cover is decorated with a spray of plum blossoms. The exterior walls of the eight compartments are decorated with floral sprays. The interior of the base is decorated with acanthus and surrounded by banana leaves and cloud patterns. The exterior base is written with a horizontal six-character mark of Wanli in regular script within a double-line rectangle in underglaze blue.

The box is a stationary item, which can be used for containing and mixing various pigments. The figures are outlined concisely with a sense of vividness. The decorative designs are painted with red, green, yellow, underglaze blue, reddish-brown, black, and other enamels in a luxuriant manner.

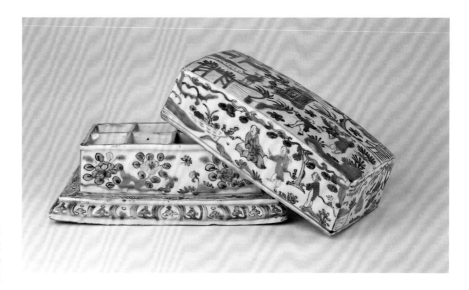

130

Zun Vase
decorated with design of
peony scrolls
in *wucai* enamels

Qing Dynasty Shunzhi period

Height 58 cm
Diameter of Mouth 19.5 cm
Diameter of Base 18 cm

The *zun* vase has a flared mouth, a short neck, a wide shoulder, a tubular belly, and a splayed flat base which is unglazed. The body is fully covered with white glaze. The exterior wall is decorated with peony scrolls with interweaving flowers and leaves in underglaze blue, and red, yellow, green, aubergine, and other colour enamels. The branches are outlined in black and filled with green enamel, interspersed by leaves in underglaze blue. The shoulder is decorated with a brocade border in underglaze blue.

The *wucai* wares of the Shunzhi period basically inherited the archaic style of the late Ming period, which were decorated in underglaze and *wucai* enamels, or just painted with *wucai* enamels. Mostly red and green enamel with strong colour tones were used. The peonies on this vase belong to the species of peony with double buds, and were popularly used to decorate early Qing ceramic wares with a distinctive period style.

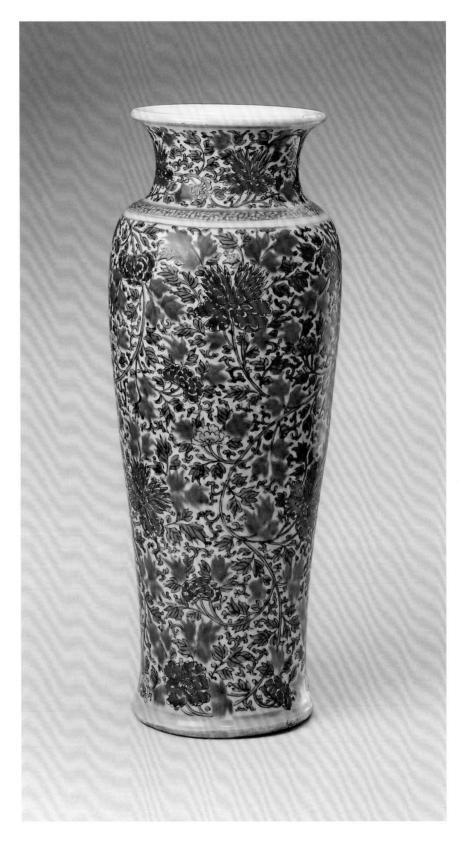

131

Meiping Vase
decorated with design of butterflies in *wucai* enamels

Qing Dynasty Kangxi period

Height 36 cm
Diameter of Mouth 7.1 cm
Diameter of Foot 12.2 cm
Qing court collection

The *meiping* vase has an everted small mouth, a short neck, a wide shoulder tapering downwards, and a splay-base with a shallow ring foot. The neck and the lower part of the belly are respectively decorated with banana leaves and deformed cloud patterns and floral petals. The shoulder is decorated with four round panels in which there are floral sprays. Outside the panels are decorations of brocade coin patterns. The belly is decorated with flying butterflies on a ground with crackled plum blossom patterns.

The crackled plum blossom pattern was also known as "ice-crackle plum blossom pattern" which first appeared in the Kangxi period of the Qing Dynasty and was imitated after the ice-crackles on the Guan wares of the Song Dynasty, on which plum blossoms or plum blossom sprays are painted.

This *meiping* vase is fashioned in an elegant and graceful form and is decorated with a touch of delicacy and bright colours in a luxuriant manner.

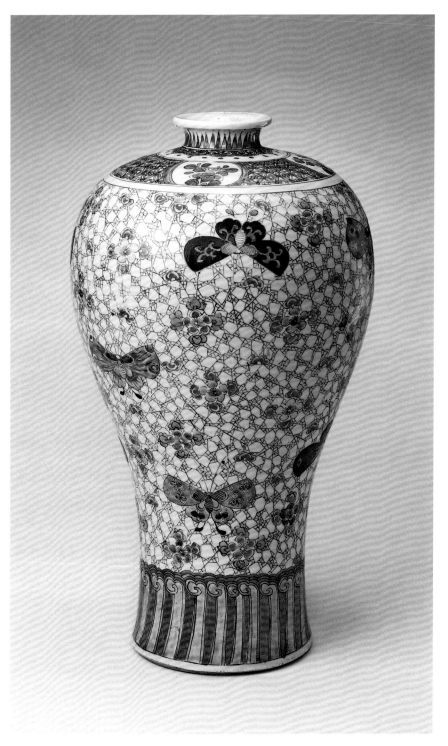

132

Mallet-shaped Vase
decorated with design of scenes of farm-work and weaving in *wucai* enamels

Qing Dynasty Kangxi period

Height 46.5 cm
Diameter of Mouth 13.6 cm
Diameter of Foot 15.1 cm

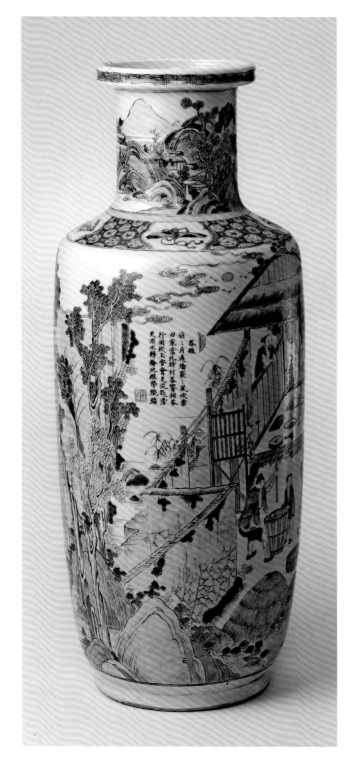

The vase has a mouth in the shape of a washer and has a long neck, an angular shoulder, a deep straight belly slimming near the foot, and a ring foot. The neck is decorated with two scenes of figures and landscapes. The first scene depicts a figure riding on a boat and fishing under the sun, and the second scene depicts a thatched hut in mountains with an old man holding a stick and looking at the far distance. The shoulder is decorated with a brocade ground and plum blossoms in panels. The body is decorated with two scenes of farm-work and weaving, and inscribed with two imperial poems *chongdui* and *fenbo*. The scene of *chongdui* depicts farmers pestle rice and the scene of *fenbo* depicts breeding of silkworms.

The facial expressions, postures of the figures and the landscapes, trees and rocks are depicted in a delicate and meticulous manner in overglaze black, green, aubergine, red, brown, and light green enamels. Emperor Kangxi had much concern about agriculture, and he had ordered Jiao Bingjing, a court painter, to paint a handscroll *Farm-work and Weaving*. Altogether there were 23 pictures respectively depicting the whole process and scenes of farming and weaving, and each picture was accompanied by an imperial poem by Emperor Kangxi. This decorative motif began to appear after the 51st year of the Kangxi period, and this vase is only decorated with two selected scenes. The poem *chongdui* was originally inscribed on the work *Works of the Farmers* by the painter Han Huang of the Tang Dynasty, while the poem *fenbo* was originally inscribed on the work *Scene of Breeding Silkworms* by the painter Liu Songnian of the Song Dynasty.

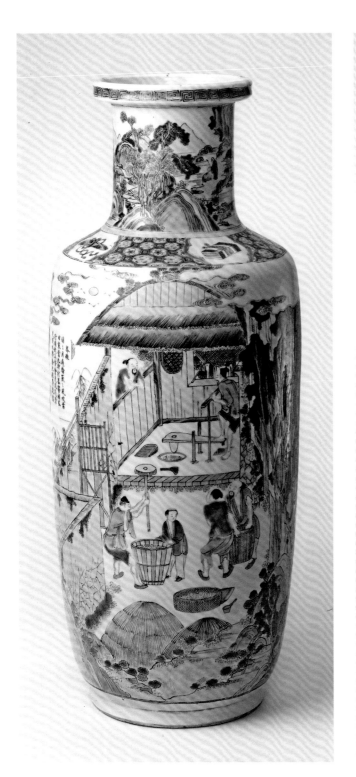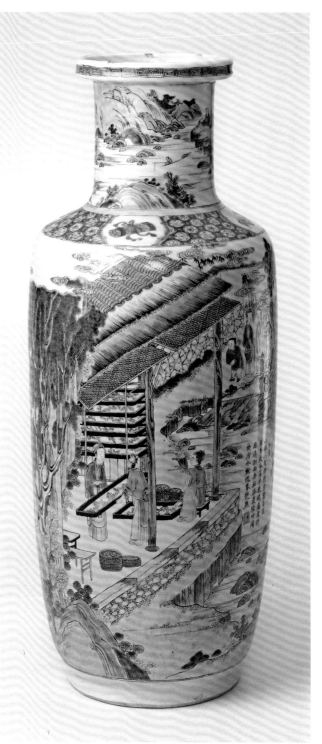

133

Vase with a Flared Mouth

and decorated with design
of butterflies
in *wucai* enamels

Qing Dynasty Kangxi period

Height 44 cm
Diameter of Mouth 12 cm
Diameter of Foot 13 cm
Qing court collection

The vase has a flared mouth, a narrow neck, a slanting shoulder tapering downwards, and a ring foot. The middle section of the neck and the joint area of the neck and shoulder are respectively decorated with brocade border. Below the neck are decorations of butterflies, dragonflies, and other insects painted in different colours and sizes. The exterior base is written a *lingzhi* fungus within a double-line medallion in underglaze blue.

The vase is decorated with butterflies in groups and flying leisurely with delicate brushwork, bright and luxuriant colours with a vivid, and naturalistic resonance. The character *die* (butterfly) is a pun of *die* (old age from around eighty to ninety), and thus the decorative motif of butterflies is closely associated with longevity and celebration of birthdays.

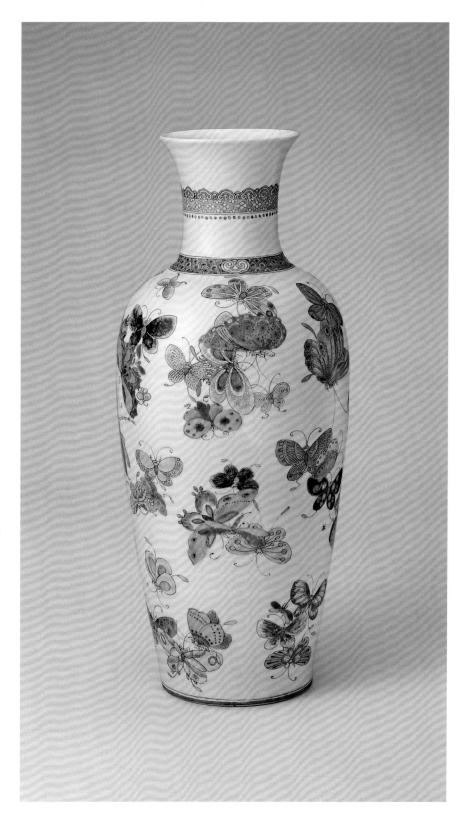

134

Guanyin Vase
decorated with design of
pheasants and peonies
in *wucai* enamels

Qing Dynasty Kangxi period

Height 45 cm
Diameter of Mouth 12.3 cm
Diameter of Foot 14 cm
Qing court collection

The vase has a flared mouth, a long neck on which is a border of string patterns in relief, a slanting shoulder tapering downwards and splayed near the foot, and a ring foot. The neck is decorated with flowers, bamboos, and rocks, and underneath the relief border are inverted cloud lappets. The belly is decorated with seven sprays of peonies with bees and butterflies flying around. A pair of pheasants is resting on a rock. The exterior base is written with an imitated six-character mark of Chenghua in regular script within a double-line medallion in underglaze blue.

The vase is fashioned with an elegant and stable form. The spacious arrangement of decorations is skillfully treated and painted in luxuriant colours with a touch of delicacy and lyricism, representing a refined piece of Kangxi *wucai* wares.

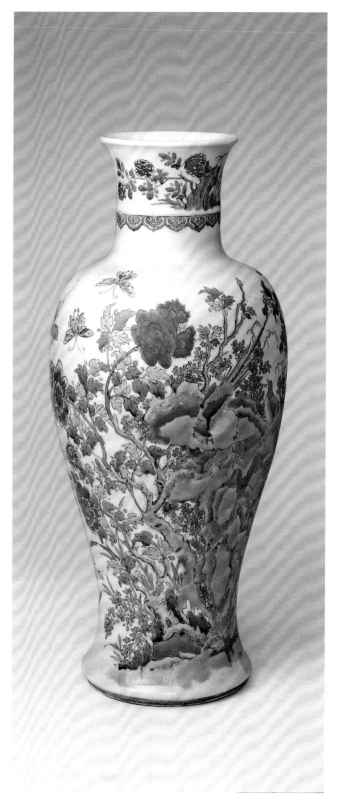

135

Fengwei Vase
decorated with design of egrets in a lotus pond in *wucai* enamels

Qing Dynasty Kangxi period

Height 44 cm
Diameter of Mouth 22.5 cm
Diameter of Foot 13.5 cm

The vase has a flared mouth, a long and straight neck, a slanting body, a globular belly slimming downwards and splayed near the foot, and a ring foot. The body is decorated with scenes of birds, flowers, and a lotus pond respectively on the neck and the belly. The neck is decorated with a lotus pond, lotus buds, lotus leaves, green birds, and bees. The belly is decorated with a lotus pond, egrets, butterflies, and bees. The lotus flower is also known as the water hibiscus. When combined with the design of egrets, it has the auspicious meaning of "prosperity all along," suggesting wealth and fortune.

Although the decorations on Kangxi *wucai* wares are painted in a flat manner, however, they were skillfully treated in a creative manner with various colour schemes by taking reference from different decorative motifs. This vase is decorated with the beautiful scenes of a lotus pond in red, blue, green, and gold enamels, and in particular with the use of gilt enamel and as a result, a charm with luxuriance and elegance is successfully created.

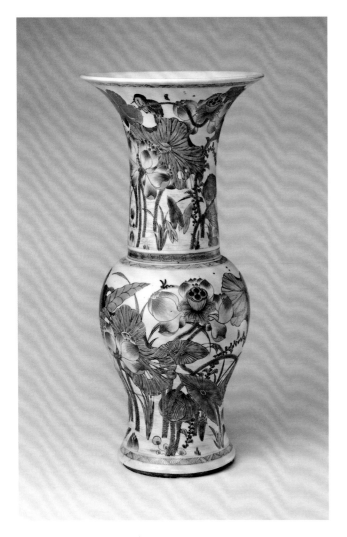
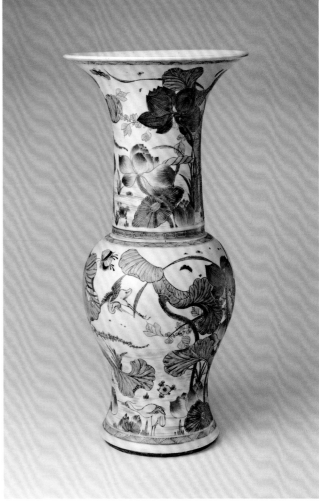

136

Teapot
decorated with design of
bamboos and magpies
in *wucai* enamels

Qing Dynasty Kangxi period

Overall Height 18.7 cm
Diameter of Mouth 8.2 cm
Diameter of Foot 10.8 cm
Qing court collection

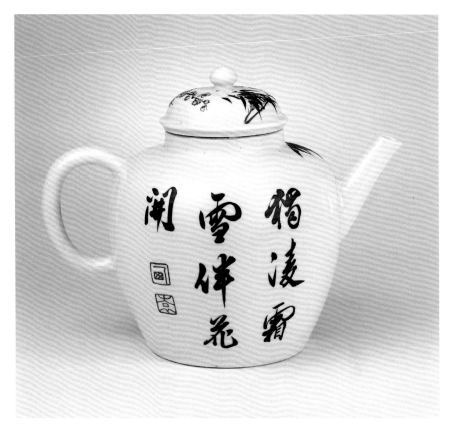

The teapot has an upright mouth,
a round shoulder, a curved belly taper-
ing downwards, and a shallow ring foot.
On the symmetrical sides of the belly is a
straight spout and a curved handle. It has
a matching canopy-shaped cover with a
tourmaline knob. One side of the body is
decorated with plum blossoms, bamboos,
and a magpie. The bird is depicted with its
beak and claws in red, chest in yellow and
black, and hairs at the back in black and
red. The other side is inscribed with a poem
sentence which literally means "transcends
the snowy weather and waiting flowers to
bloom," and written with relief-style seal
marks *xi* and *yuan* in seal script in iron-red
at the end of the inscription.

The teapot is fashioned in a charming
form with the pictorial elements treated in a
lyrical manner. The decorations are outlined
in black or red enamels, and filled with red,
green, yellow, brown, and black enamels
with the black enamel as a highlight colour.
"Xiyuan" was the styled name of Gao Feng-
han (1683–1749), also named Han, styled
Xiyuan, pseudonyms Nancun and Nanfu,
who was an accomplished painter, calligra-
pher, and seal-carver of the Qing Dynasty.

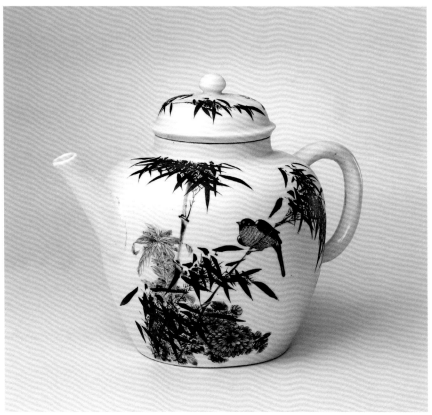

137

Bowl
decorated with design of the eight immortals celebrating birthday in *wucai* enamels

Qing Dynasty Kangxi period

Height 8.3 cm
Diameter of Mouth 18.7 cm
Diameter of Foot 8.1 cm
Qing court collection

The bowl has a flared mouth, a deep curved wall, and a ring foot. The interior centre is decorated with large peaches. The exterior wall is painted with the eight immortals. The combination of these decorative designs has the auspicious tribute of "eight immortals celebrating birthday".

The bowl is glazed in pure white and the figures are outlined in red enamel, in which various colour enamels are applied, including iron-red as the major colour and complemented by green, aubergine, black, deep red and others. With a soft and lyrical colour scheme, the eight immortals are depicted in different postures with their facial expressions rendered in a delicate manner, generating a sense of vividness.

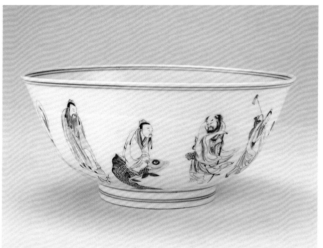

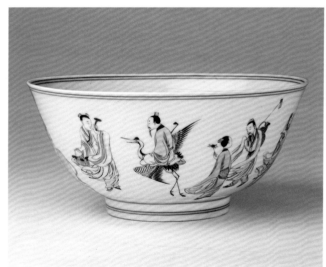

138

A Set of Twelve-month Cups
decorated with flowers of the twelve months in *wucai* enamels

Qing Dynasty Kangxi period

Height 4.9 cm
Diameter of Mouth 6.7 cm
Diameter of Foot 2.6 cm
Qing court collection

Each of the cups has a flared mouth, a deep curved wall and a ring foot. Twelve cups form a set with identical shapes and sizes. The small cups have unusual delicate forms and are thinly fashioned and covered with shiny translucent glaze. The exterior walls are decorated with flowers representing the twelve months and inscribed with matching poems, most of which are quoted from *A Complete Collection of Poems of the Tang Dynasty*. At the end of each poem is a square mark "*shang*" written in seal script in underglaze blue. The exterior base of each cup is written with a six-character mark of Kangxi in regular script within a double-line medallion in underglaze blue.

1st month: Winter jasmine

Inscribed "About the golden blossom and green calyx clings the chill of spring, rare among the flowers is its yellow colour," quoted from the poem *Contemplating Winter Jasmine with a Poem Written for Officer Yang* by Bai Juyi

2nd month: Apricot blossom

Inscribed "Its fragrance blends with the scent of nocturnal rain, the beautiful colour stands out in sunshine or in mist" quoted from the poem *In Return for a Poem on Apricot Blossoms from Lanxi by Zhangsun Yi* by Qian Qi

3rd month: Peach blossom

Inscribed "The blossom sways in the wind when the swallow returns from the south, it is the season in late spring when farmers return to their fields" quoted from the poem *Peach Blossoms* by Xue Neng

4th month: Peony

Inscribed "At dawn its ravishing beauty claims the jin zhang's share of the dew, at dusk, its fragrance entices the wind to blow through the Jade Hall" quoted from the poem *Peonies* by Han Cong

5th month: Pomegranate blossom

Inscribed "Its colour dampened with dew is reflected on the beaded curtain, the breeze scented with its fragrance is shielded by the powdered wall" quoted from the poem *Two Poems to Describe the Pomegranate Blossoms in front of the Mansion* by Sun Ti

6th month: Lotus

Inscribed "Its roots are like jade, unsullied by mud, like pearls are the dewdrops caught on its heart-shaped leaves" quoted from the poem *Lotus Leaf* by Li Qunyu

7th month: Orchid

Inscribed "Its delicate fragrance pervades the spacious palace, stirring thoughts of the far capital" quoted from the poem *Orchid* by Li Jiao

8th month: Osmanthus

Inscribed "Its branches are nurtured over endless months, when they are laden with flowers" quoted from the poem *Osmanthus* by Li Jiao

9th month: Chrysanthemum

Inscribed "A thousand years ago, a white-garbed attendant brought wine (to Tao Yuanming), throughout his life (he treasured) the fragrance of the chrysanthemum" quoted from the poem *Chrysanthemum* by Luo Yin

10th month: Chinese rose

Inscribed "Unlike a thousand other flowers that bloom and perish, it alone blazes red throughout the year" (from where the poem was quoted needs further study)

11th month: Plum blossoms

Inscribed "Its white beauty is held by the snow on the tree, its fragrance wafts through the branches" quoted from the poem *A Poem Written by Hearing that the Elder Xue Accompanies the Master to Contemplate Plum Blossoms in Early Spring* by Xu Hun

12th month: Narcissus

Inscribed "The spring breeze blows playfully over the rose, heralding a clear day, in the light of the moon the narcissus are massed on an embankment" (from where the poem was quoted needs further study)

This set of month cups in *wucai* enamels is a type of imperial wine cups, with another type represented in underglaze blue wares with the form, size, decorative designs and poems identical (Plate 81).

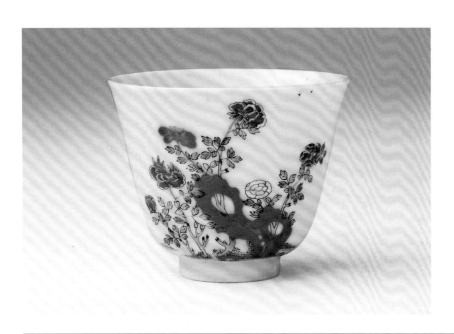

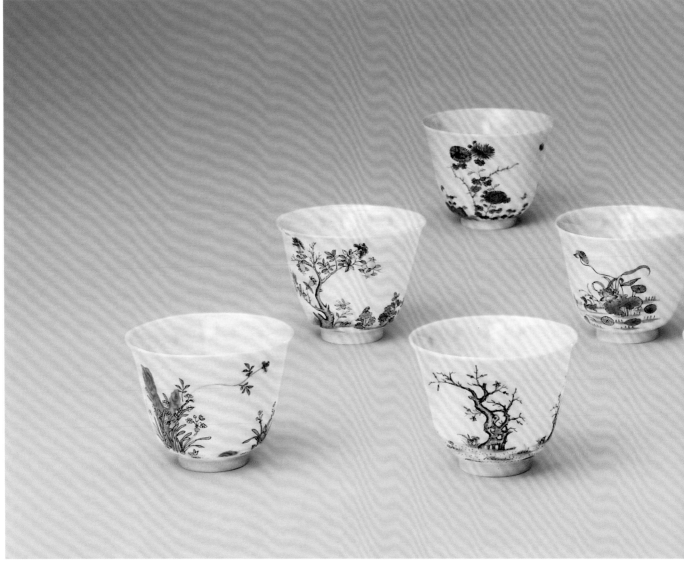

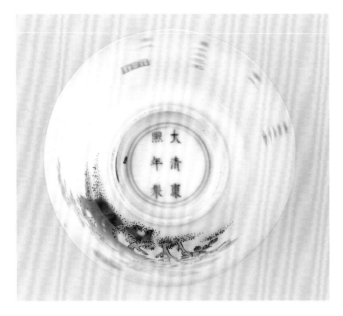

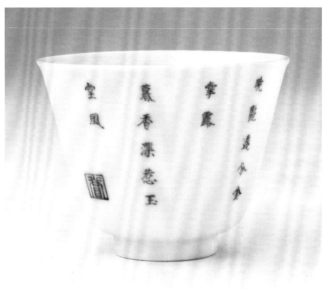

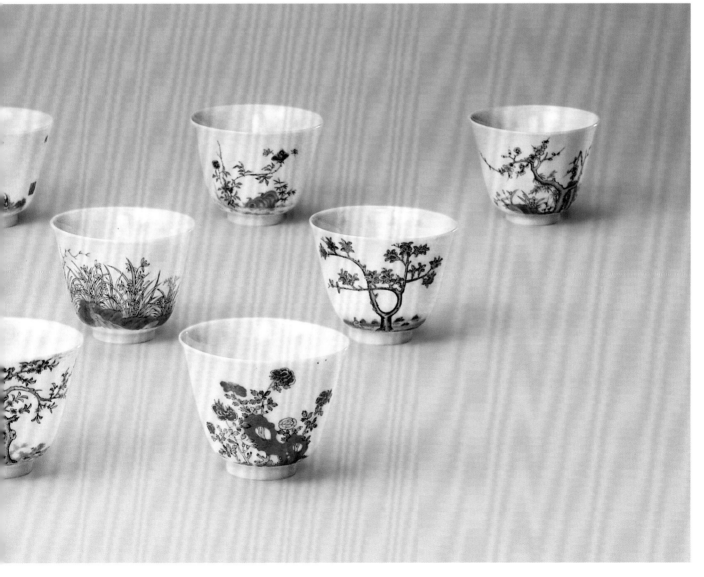

139

Bowl
decorated with design of dragons in pursuit of pearls in *wucai* enamels on a yellow ground

Qing Dynasty Kangxi period

Height 6 cm
Diameter of Mouth 12 cm
Diameter of Foot 4 cm
Qing court collection

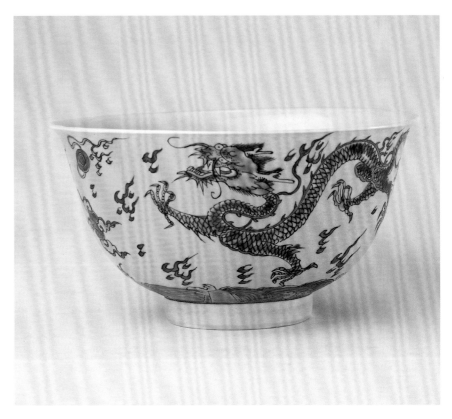

The bowl has a slight flared mouth, a deep curved belly, and a ring foot. The exterior is glazed in yellow as the ground, on which are decorations of two green dragons in pursuit of a flaming pearl. Underneath the flaming pearl is a *lingzhi* cloud pattern in the shape of *wan* swastika, and surrounded by flames painted in iron-red. Near the foot are decorations of cliffs and cresting waves painted in green. The exterior base is written with a six-character mark of Kangxi in regular script in three columns within a double-line medallion in underglaze blue.

Wan (卍) swastika design was derived from Sanskrit and a Buddhist symbol with the meaning "ten thousand auspicious virtues." In the reign of Empress Wu Zetian of the Tang Dynasty, the court gave it the pronunciation *wan,* which became an auspicious emblem and was popularly used to decorate art objects and crafts.

The bowl is fashioned in a graceful shape and the decorations are painted with fluent brush work and skillfully treated colours, representing a refined imperial ware of the Kangxi period. Most of the Kangxi *wucai* wares were glazed with a white ground and decorated with designs in *wucai* enamels. Other typeforms include wucai enamels on a pea-green ground, *wucai* enamels on a red ground, *wucai* enamels on a splashed-blue ground, *wucai* enamels on a black ground, etc. Among them, extant *wucai* wares with a yellow ground are the rarest.

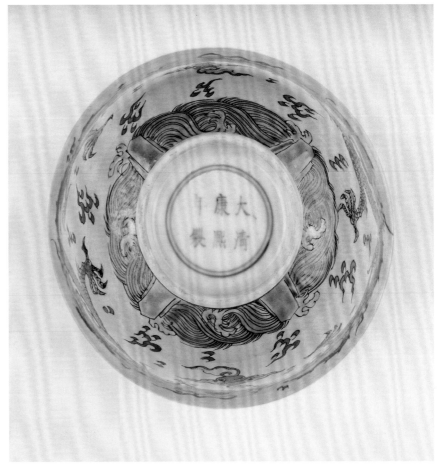

140

Jar
decorated with design of ladies and children at play in *wucai* enamels

Qing Dynasty Yongzheng period

Height 34.1 cm
Diameter of Mouth 14.6 cm
Diameter of Foot 15.3 cm

The jar has a plate-shaped mouth, a short neck, a slanting shoulder, a round belly tapering downwards, and a splayed ring foot. The shoulder is decorated with chrysanthemum scrolls on a brocade ground. The belly is decorated with a scene of ladies and children at play. On one side, two ladies are standing together with a child behind, and a maiden holding a flower basket is walking towards them. On the other side, there is an openwork carved table placed under a Chinese parasol tree. A lady is sitting beside it and looking at two children, and with another child playing behind her. The exterior base is written a six-character mark of Yongzheng in regular script in three columns within a double-line medallion in underglaze blue.

The jar is finely modelled with figures and other designs painted in a fluent, delicate, and naturalistic manner. The clouds are outlined in red and filled with colours. Other decorative designs are outlined in black and applied with appropriate colours to match the designs. The major colour scheme is light and deep green, and complemented by other colours such as red, yellow, brown, black, blue, etc. It is a fine piece for the study of *wucai* wares of the Yongzheng period.

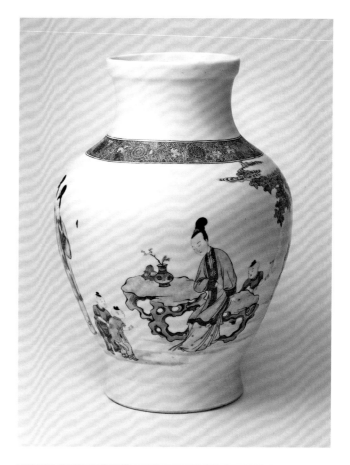

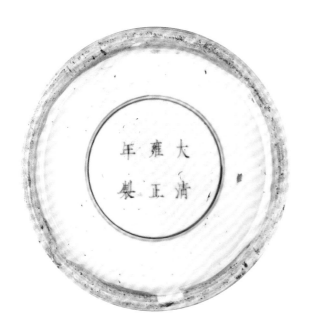

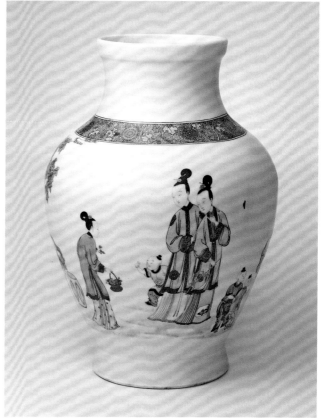

141

Bowl
decorated with design of dragons and phoenixes amidst flowers in *wucai* enamels

Qing Dynasty Yongzheng period

Height 5.8 cm
Diameter of Mouth 15 cm
Diameter of Foot 5 cm

The bowl has a flared mouth, a deep curved wall, a narrow base and a ring foot. The finely potted biscuit is covered with translucent white glaze. The interior centre is decorated with dragons in pursuit of pearl. The exterior wall is decorated with two dragons and two phoenixes flying amidst flowers. Underneath the mouth rim are decorations of the eight Buddhist Emblems and *ruyi* cloud patterns. The exterior base is written with a six-character mark of Yongzheng in regular script in two columns within a double-line medallion in underglaze blue.

The combination of dragon and phoenix designs has the meaning of "the dragon and phoenix bringing auspicious blessings," and is a popular decorative motif on Chinese ceramics. The dragon is the supreme representation of serpents whereas the phoenix is the supreme representation of birds, both of which are symbols of auspicious blessings. As their statuses echo the relation between the emperor and his subordinates, this decorative motif has become an imperial symbol with the dragon representing the male and the phoenix representing the female. The dragon-and-phoenix design began to appear on the ceramic wares in celadon glaze, white glaze and wares with molded designs from the Five Dynasties to the Northern Song Dynasty, and was widely employed to decorate the underglaze blue, underglaze red, *wucai, doucai,* and other imperial wares of the Ming and Qing Dynasties.

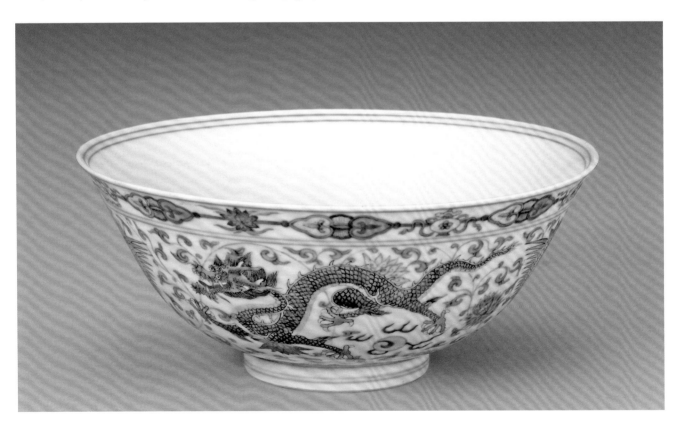

142

Bowl
decorated with design of children at play in *wucai* enamels and gilt on an iron-red ground

Qing Dynasty Jiaqing period

Height 9.7 cm
Diameter of Mouth 21 cm
Diameter of Foot 7.5 cm

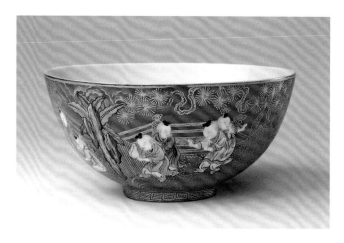

The bowl has a flared mouth, a deep curved wall and a ring foot. The exterior wall is decorated with a scene of children at play in *wucai* enamels and gilt on an iron-red ground. The decorative background composes of pines and fences painted in gilt, in which there are four groups of children playing with water, fireworks, squirrels, or competition game with plants around the rocks and palm trees. The children are depicted vividly with their dresses in different colours. Even for the same child, the colours of his coat and trousers are painted in different colours. The exterior wall of the ring foot is decorated with key-fret patterns in gilt whereas the interior of the ring foot is glazed in white. The exterior base is written with a six-character mark of Jiaqing in seal script in three columns in underglaze blue.

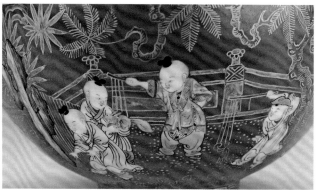

This bowl was modelled after the type of large bowl decorated with sixteen children at play in *wucai* enamels and gold on an oil-red ground produced in the Lang Kiln in the Kangxi period. In addition to the wares with gilt designs on an oil-red ground, the Lang Kiln also produced such large bowls with *wucai* decorations on a white ground. The proto-type of the decorative motif appeared as early as on the imperial underglaze blue wares of Chenghua period, Ming Dynasty.

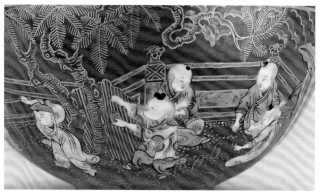

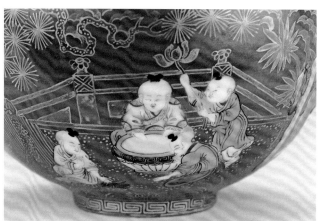

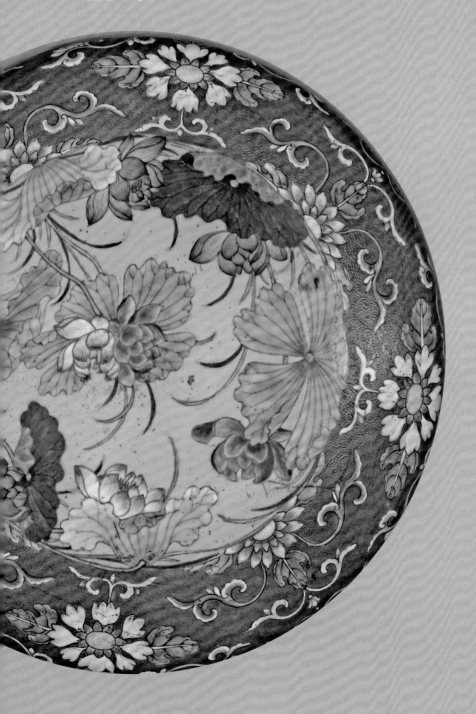

PORCELAIN WARES IN DOUCAI
(COMPETING COLOURS) ENAMELS

143

Vase with a Straight Neck
and decorated with design of creeping reeds in *doucai* enamels

Ming Dynasty Chenghua period

Height 18.7 cm
Diameter of Mouth 4 cm
Diameter of Foot 8.5 cm
Qing court collection

The vase has an everted rim, a straight neck, a flat and round belly, and a ring foot. The interior and the exterior are glazed in white with a greyish tint. Under the glaze are decorations of creeping reeds outlined in underglaze blue, and filled with light green enamel over the glaze. The exterior base is written with a six-character mark of Chenghua in regular script in two columns within a double-line square in underglaze blue.

In terms of extant or unearthed *doucai* wares of the Chenghua period, there are few vases found. This vase is decorated with creeping reeds, which are often used as border designs, also representing a new form at the time. The combination of outlined designs in light underglaze blue and light green enamel gives a refreshing grace to this piece.

The marks of imperial Chenghua wares were often written in a casual and spontaneous manner, which look like written by children, and thus this writing style is known as "children's style." It was said that these marks were written by Emperor Chenghua personally.

144

Jar
decorated with design of heavenly horses and cresting waves in *doucai* enamels and inscribed with the mark *tian* (heaven)

Ming Dynasty Chenghua period

Height 10.5 cm
Diameter of Mouth 5.5 cm
Diameter of Foot 7.3 cm
Qing court collection

The jar has a straight short neck, a wide shoulder, a slim belly splaying slightly near the foot, and a ring foot. The belly is decorated with four majestic horses running amidst waves, which is known as "design of sea and horses." On the shoulders of the horses are flames. The four horses are painted in underglaze blue (two of them), red and yellow. The cresting waves are painted in green. On the shoulder and near the foot are decorations of upright and inverted banana leave patterns. The mouth and the exterior wall of the foot are further decorated with border designs in yellow. The exterior base is written with a mark *tian* (heaven) in regular script in underglaze blue.

In addition to the cresting waves which are outlined in underglaze blue, shading with tonal gradations in green enamel is further added, which is known as the technique "tinted colour." The decoration of "design of cresting waves and horses," which was borrowed from flags with horse designs used in ritual ceremonies, had appeared on Jingdezhen underglaze blue wares as early as the Yuan Dynasty. The cresting waves and horse designs found on the jars of the Chenghua period generally followed the flag designs as illustrated in historical records.

This type of jar was much favoured by Emperor Yongzheng and Qianlong. In the imperial court archive, they were known as "Jar with the mark *tian* (heaven) and *wucai* enamels of the Chenghua." This jar was originally displayed the Chonghua Palace and as the cover had lost, Emperor Qianlong ordered Tang Ying to replace a cover for it.

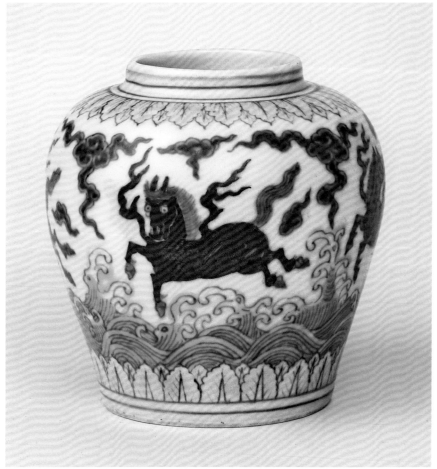

145

Covered Jar
decorated with design of lotus scrolls and the mark *tian* (heaven) in *doucai* enamels

Ming Dynasty Chenghua period

Overall Height 8.3 cm
Diameter of Mouth 4.3 cm
Diameter of Foot 6.5 cm
Qing court collection

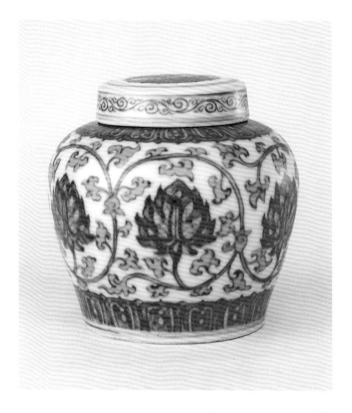

The jar has an upright mouth, a wide shoulder, a slightly taper-ing belly, and a ring foot. It has a matching flat round cover which is slightly convex. The belly is decorated with lotus scrolls, on which six fully bloomed lotus flowers are outlined in underglaze blue with-out applying overglaze enamels. The stems and the leaves are out-lined in underglaze blue, and then filled with green enamel. On the shoulder and near the foot are borders of inverted and upright lotus petals. The centre of the cover surface is decorated with a lotus flow-er outlined in underglaze blue and painted in overglaze iron-red. The wall of the cover is decorated with acanthus in underglaze blue. The interior of the ring foot is glazed in white. The exterior base is writ-ten with a mark *tian* (heaven) in regular script in underglaze blue.

The Chenghua period was over 500 years from now. Extant Chenghua wares which still keep the original covers are extremely rare. This piece with the original cover in perfect condition is there-fore extremely rare and valuable.

146

Covered Jar
decorated with design of composite *baoxiang* flower in *doucai* enamels

Ming Dynasty Chenghua period

Overall Height 19.7 cm
Diameter of Mouth 7.9 cm
Diameter of Foot 8.4 cm

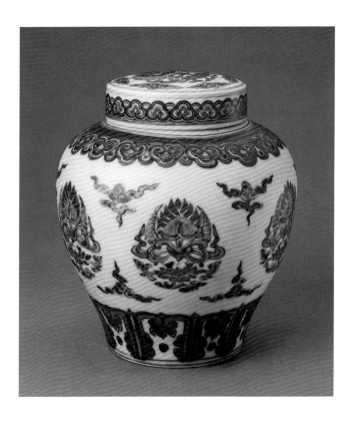

The jar has an upright mouth, a short neck, a wide shoulder, a slim belly, and a shallow ring foot. It has a matching flat round cover. The shoulder is decorated with *ruyi* cloud lappets. The belly is decorated with medallions of *baoxiang* flowers (flower rosettes) supported by sprays of lotus stems, and interspersed by symmetrical cloud patterns. Near the foot are decorations of upright lotus petals. The interior of the ring foot is covered with white glaze. The surface is decorated with Buddhist club designs which are surrounded by floral and cloud patterns. The side of the cover is decorated with *ruyi* cloud patterns. The exterior base is written with a six-character mark of Chenghua in regular script in two columns within a double-line medallion in underglaze blue.

The *baoxiang* flower was a traditional auspicious decorative motif symbolizing "treasure" and "immortality." Its form is derived from designated flower species (such as lotus or peony) and combined with leaves of other flowers. The stamen is often depicted in the shape of bead chains (*baozhu*) which resembles pearls, and thus the decorative motif got its name.

This jar is an unusual large piece of *doucai* jars of the Chenghua period. With the principal colours of red and green, and complemented by yellow colour, the jar generates an elegant and lyrical resonance. Historical archival documents revealed that the jar was produced by Tang Ying, Director General of the Imperial Kiln, at the order of the court issued on the second day of the leap seventh month of the 13th year of the Qianlong period.

147

Stem-cup
decorated with design of grapes in *doucai* enamels

Ming Dynasty Chenghua period

Height 6.8 cm
Diameter of Mouth 8 cm
Diameter of Foot 3.5 cm
Qing court collection

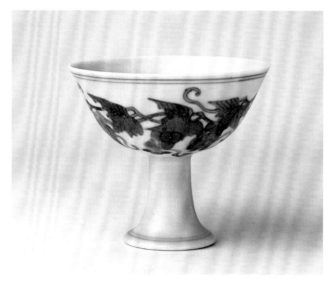

The cup has a slightly flared mouth, and a shallow curved belly supported by a small trumpet-shaped hollow stem-foot. The exterior wall is decorated with sprays of grapes in *doucai* enamels with the stem and vines painted in yellow enamel with light greenish tint. The leaves are painted in reddish-aubergine, whereas the grapes are painted in thick blackish-aubergine with a layer of interspersed shiny blue and aubergine colours, which fully illustrate the texture and appearance of ripe grapes. The mouth rim and the exterior wall near the foot of the stem-cup are decorations of two borders of string patterns in blue respectively. The base of the foot, where it is glazed, is written with a horizontal six-character mark of Chenghua in underglaze blue.

This type of stem-cup was first produced in the Imperial Kiln of the Chenghua period, and was known as "stem-cup with flared mouth and flat belly decorated with design of grapes in *wucai* enamels." Before the production of this type of stem-cups, it was thought that the imperial stem-cups of the Xuande period were the most refined. However, with the emergence of this type of stem-cups, people generally esteemed that they should surpass the aesthetic merits of the Xuande prototypes. In his book *Bowu Yaolan* by Gu Tai of the late Ming Dynasty, he commented that "the most superb imperial wares of the Chenghua period should be the stem-cup with a flared mouth and a flat belly decorated with design of grapes in *wucai* enamels, which even surpassed its proto-types of the Xuande period."

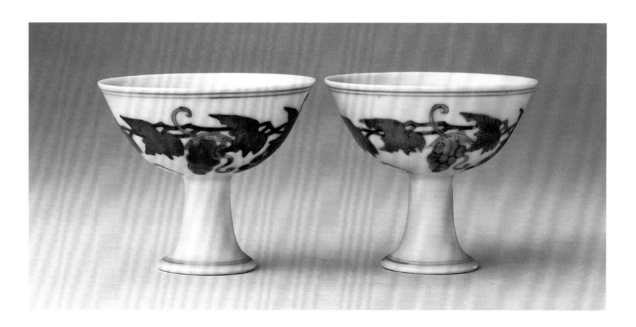

148

Cup
decorated with design of
lofty scholars
in *doucai* enamels

Ming Dynasty Chenghua period

Height 3.4 cm
Diameter of Mouth 6.1 cm
Diameter of Foot 2.6 cm
Qing court collection

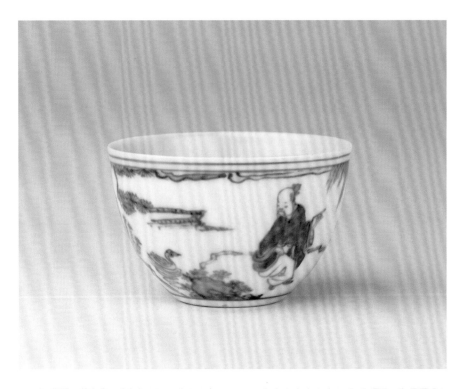

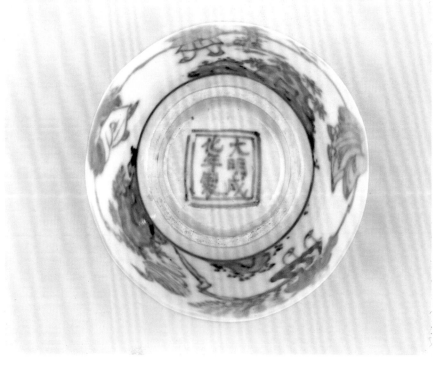

The cup has an everted mouth, a slightly flared rim, a deep curved wall and a shallow ring foot. It is fully covered with shiny and pure white glaze. The exterior wall is decorated with two scenes. One scene depicts the story "Wang Xizhi loves the goose." In the scene, Wang Xizhi, who is wearing a red robe, is sitting beside a pond, watching a swimming goose. An attendant wearing green coat is holding book scrolls and standing beside him with willows, flowers and colour clouds around. Another scene depicts the story "bring the *qin* zither to visit a friend," in which Yu Boya is visiting his friend Zhong Ziqi. Yu Boya with his hairs tied up in two buns is walking steadily with an attendant wearing red coat and carrying a *qin* zither following him in a setting with pines, cypresses and clusters of wild chrysanthemums. Both scenes are painted with the principal colours of underglaze blue, overglaze red, and green, complemented by yellow and reddish-brown colour, and the decorations are rendered with swift brush work and a bright colour scheme. The interior of the ring foot is covered with white glaze. The exterior base is written with a six-character mark of Chenghua in regular script in two columns within a double-line square in underglaze blue.

This cup is a new typeform of the imperial wares of the Chenghua period with a graceful round shape. The decorations are treated ingeniously with spacious perspective, showing the influence of the painters of the time, such as Shen Zhou and Wu Wei.

149

A Pair of Cups
decorated with design of children at play
in *doucai* enamels

Ming Dynasty Chenghua period

Height 4.8 cm
Diameter of Mouth 6 cm Diameter of Foot 2.7 cm
Height 4.8 cm
Diameter of Mouth 5.9 cm Diameter of Foot 2.6 cm
Qing court collection

Each of the cups has an everted mouth, a deep curved wall, and a ring foot. It is thinly potted and covered with translucent glaze with a charming and lyrical shape. The exterior wall is decorated with two scenes of children at play. One scene depicts two children playing with kites. The other scene depicts three children playing competition game with plants. The dresses of the children are painted in red, green, light aubergine, other colour enamels, and underglaze blue. The scenes are further enriched with other decorative elements such as rocks, palm trees, banana leaves and clouds. The interior of the foot is covered with white glaze. The exterior base is written a six-character mark of Chenghua in regular script in two columns within a double-lined square in underglaze blue.

The competition game of playing with plants was a common folk game in the past, and was often played during the Dragon Boat festival. Various plants were picked for the competition. Winning scores sometimes came from whether the names of the flowers and plants could match each other, the quantity or rarity of the plants picked, or hooking the plants and the broken one would lose the game.

This pair of cups was originally in the collection of the Qianqing Palace and a favoured treasure of the Emperor Qianlong. The cups decorated with children at play are most esteemed for their delicate forms, subtle colour schemes, and vivid decorations. The Imperial Kiln of the Jiajing period, Ming Dynasty had imitated these cups which carry the mark of the Jiajing period instead.

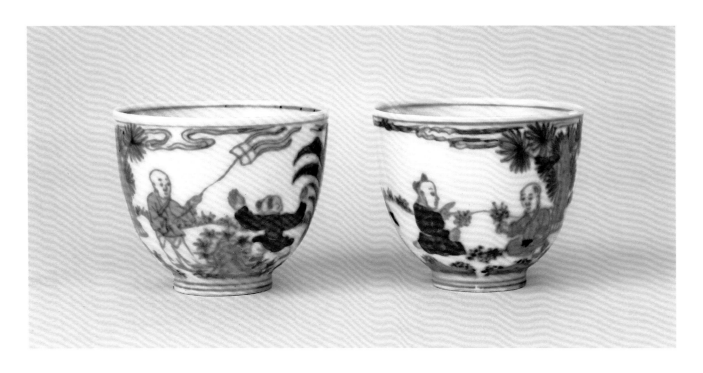

150

A Pair of Cups
decorated with design of grapes in *doucai* enamels

Ming Dynasty Chenghua period

Height 4.8 cm
Diameter of Mouth 5.5 cm Diameter of Foot 2.5 cm
Height 4.8 cm
Diameter of Mouth 5.5 cm Diameter of Foot 2.4 cm
Qing court collection

Each of the cups has an everted mouth, a deep curved wall, and a ring foot. The exterior wall is decorated with sprays of grapes which have intertwined vines and abundant fruits. In between the leaves, fruits, and vines, the void and solid spaces are skillfully treated to creative perspectives. The stems are painted in reddish-brown, the vines painted in yellow and the leaves painted in green enlivened with a touch of realism. The ripe fruits painted in aubergine are treated with round and fully matured forms. The interior of the ring foot is covered with white glaze. The exterior base is written a six-character mark of Chenghua in regular script within a double-line square in underglaze blue.

The form of this pair of cups is fashioned in the shape of a lotus bud with a touch of delicacy and gracefulness. Other than these two pieces, the Palace Museum has more of these refined cups in her collection.

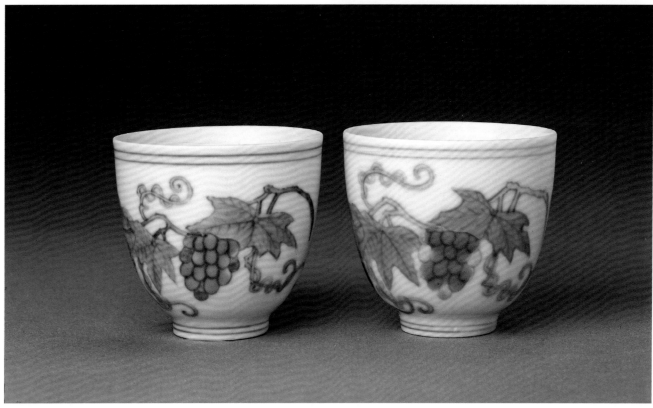

151

A Pair of Cups
decorated with design of autumn scenes
in *doucai* enamels

Ming Dynasty Chenghua period

Height 3.9 cm
Diameter of Mouth 6.9 cm Diameter of Foot 2.6 cm
Height 3.9 cm
Diameter of Mouth 6.9 cm Diameter of Foot 2.6 cm

Each of the cups has a slightly flared mouth, a deep curved wall, and a ring foot. The paste is thinly potted and the greenish glaze has a greyish tint. The exterior wall is decorated with landscapes, rocks, flowers, plants, and flying butterflies in underglaze blue and *doucai* enamels. Techniques of filling in colours, dotting and added colours are employed in rendering decorations. The butterflies are layered with green or aubergine enamel, with the aubergine colour turns dense without glare. The floral sprays and the tail of a small butterfly are decorated with red dots in a naturalistic manner. The interior of the ring foot is covered with white glaze. The exterior base is written with a six-character mark of Chenghua in regular script in two columns within a double-line square in underglaze blue.

The form of the cup is fashioned with a touch of delicacy and gracefulness. The paste is so thinly potted and semi-transparent that the decorations outside are also visible in the inside. The decorations depict the autumn scenes in the wilderness, and the decorative elements are skillfully depicted with spacious treatment and refreshing charm, reflecting the style of literati painting. The autumn which lasts for three months is known as *sanqiu* (autumn of three months) and thus this pair of cups is named after this connotation.

The aubergine colour on this ware was actually a minor defect appeared accidentally during firing with the colour, which turns dense without glare and brightness. Such a colour was rarely found on Chenghua *doucai* wares, and was unique of its period, which could hardly be imitated in the subsequent periods.

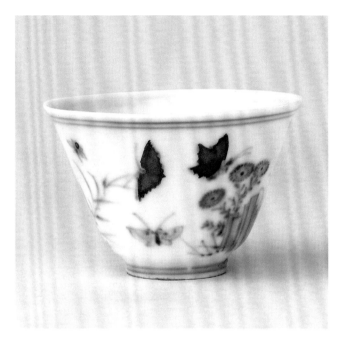

152

Plate
decorated with design of
lotus scrolls
in *doucai* enamels

Ming Dynasty Jiajing period

Height 5.3 cm
Diameter of Mouth 22.4 cm
Diameter of Foot 13.5 cm

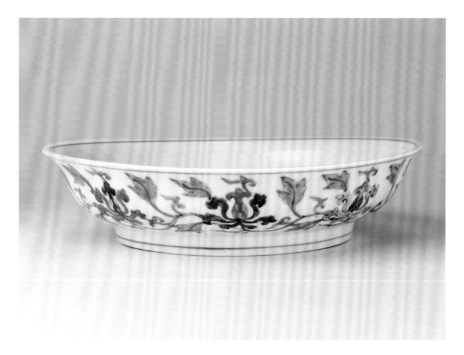

The plate has a flared mouth, a deep curved wall, and a deep recessed ring foot which curved inwards on the exterior wall and splayed in the interior wall. The base is slightly recessed. The exterior wall is decorated with lotus scrolls with eight lotus flowers fully bloom amidst the stems and vines. The stem, vines, and leaves are painted in green whereas the flowers are painted in different colours. Two of them are depicted with petals in underglaze blue and stamens in red and yellow. Four of them are depicted with petals in red and stamens in underglaze blue and green. Another two are depicted with petals in yellow and one stamen in underglaze blue and yellow, and another in underglaze blue and red. The exterior base is decorated with sprays of peonies with ginger-yellow petals and green stems and leaves, with the veins further outlined in black. At the decoration of the stamen of the peony is a six-character mark of Jiajing written in regular script in two columns within a double-line square in underglaze blue.

Reign mark in the shape of a flower appeared as early as on the Yongle and Xuande wares of the Ming Dynasty. They were continuously in use in the periods of Jiajing and Wanli, but became less and less.

153

Bowl
decorated with design of eight Buddhist Emblems and lotus sprays in *doucai* enamels

Ming Dynasty Wanli period

Height 8.7 cm
Diameter of Mouth 16.5 cm
Diameter of Foot 7.1 cm

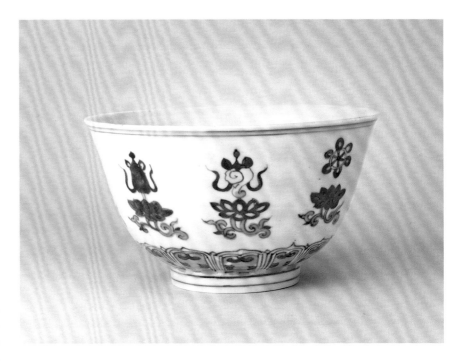

The bowl has a flared mouth, a deep curved belly, and a ring foot. The belly is decorated with the eight Buddhism Emblems, including the wheel, the conch shell, the umbrella, the canopy, the lotus flower, the jar, the twin-fish, and the endless knot, supported by lotus sprays in *doucai* enamels. Near the foot are decorations of deformed lotus lappets. The exterior base is written with a six-character mark of Wanli in regular script in two columns within a double-line square in underglaze blue.

As a Buddhist offering vessel, this bowl was imitated from the bowl decorated with design of eight Buddhist Emblems and lotus sprays in *doucai* enamels of the Chenghua period, Ming Dynasty. However, the colours of the decorations became brighter and more brilliant. Eight auspicious emblems were popular decorative motifs for Ming ceramic wares. In addition to colour enamels, there were the eight auspicious emblems painted in underglaze blue, *anhua* incising in white glaze, *wucai* enamels, and others. They were either used as principal decorative designs or complementary designs.

154

Benba Ewer
decorated with design of bead chains in *doucai* enamels

Qing Dynasty Kangxi period

Overall Height 23.2 cm
Diameter of Mouth 5 cm
Diameter of Foot 9.1 cm
Qing court collection

The ewer is in the shape of a pagoda with a round mouth, a straight neck, and a globular belly supported on a hollow stem foot in the shape of a Buddhist throne. On the belly is a curved spout, and the spout as well as the mouth has matching canopy-shaped lids. From the top to the bottom, the body is decorated with seven borders of bead chains in relief. The ewer is further painted with lotus petals, bead chains, flaming clouds, etc. in *doucai* enamels.

The Benba ewer is also known as the "Tibetan Ewer" which is a ceremonial vessel of Tibetan Buddhism. The ewer is decorated with various motifs with precisely filled-in enamels in contrasting and bright red, deep green, and yellow colour tones. The lids and the mouth rim are further decorated in gilt, enriching the luxuriance of the ewer. This typeform was produced in the Ming Dynasty and various periods of Qianlong and Jiaqing periods in the Qing Dynasty, but without lids for the mouth and spout.

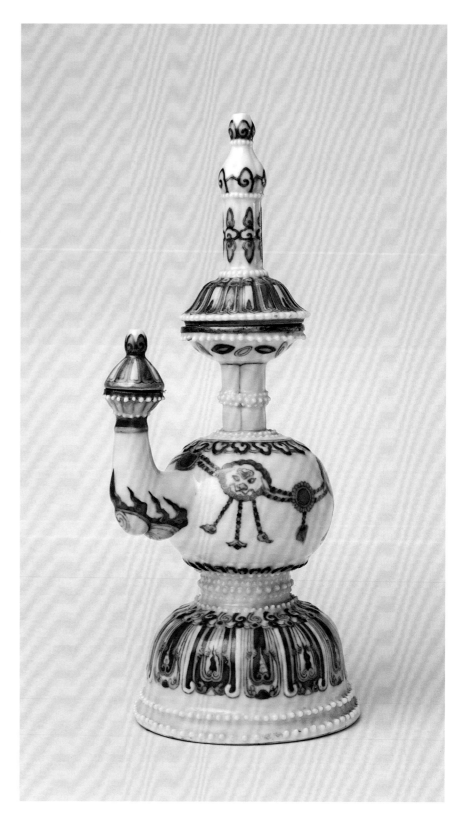

155

Flower Pot with a Foliated Everted Mouth Rim
and decorated with design of legendary immortals in *doucai* enamels

Qing Dynasty Kangxi period

Height 31.8 cm
Diameter of Mouth 59.3 × 41.5 cm
Diameter of Foot 45.5 × 26.7 cm
Qing court collection

The hexagonal flower pot has an everted foliated rim in the shape of a water chestnut flower, a curved wall, a deep belly, and a splayed high ring foot. On the base are two round holes for releasing water. The surface of the rim is decorated with brocade floral ground on which four medallions of the character *shou* (longevity) are written in seal script. The six sides of the exterior wall are decorated with auspicious scenes of immortals celebrating birthday, adding counters to bring long life, etc. The wall of the foot is decorated with eight units of *ruyi* cloud collars in relief, in which peony sprays are painted. Underneath the mouth rim is a horizontal six-character mark of Kangxi written in regular script in underglaze blue.

The legend of "adding counter to bring long life" was found in the book *Dongpo Zhilin* written by Su Shi of the Northern Song Dynasty. The legendary story tells that three immortals were comparing each other's long life on the Penglai Island where immortals reside. One of them said that he had seen all the changes in the world, and he put a counter each year in a vase for counting the number of years passed in his mansion. Now over ten mansions were already packed for storage such counters. Another said that there was a mansion in the sea, in which there was a vase which stores up the life of each man. If somebody could ask a crane to put one more counter in the vase every time, his life might increase up to more than 100 years. As such, this story is often used as a decorative motif to symbolize the blessing of longevity.

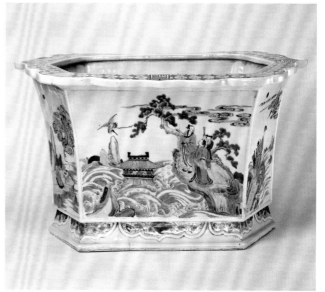

This flower pot is thickly potted with a heavy body. The auspicious decorations and the luxuriant colour scheme reveal that it was produced for the celebration of the birthday of Emperor Kangxi by the Imperial Kiln.

156

Bowl
decorated with design of pheasants and peonies in *doucai* enamels

Qing Dynasty Kangxi period

Height 7.8 cm
Diameter of Mouth 15.3 cm
Diameter of Foot 7.2 cm

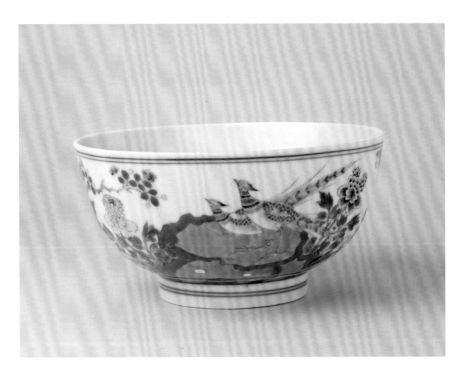

The bowl has an everted mouth, a deep curved belly, and a ring foot. One side of the exterior wall is decorated with two pheasants standing on a rock and staring at the far distance in underglaze blue and red. Beside the birds are peonies, magnolias and other flowers, which have the auspicious meaning of fortune and wealth. The other side is decorated with two magpies flying in between peonies and cydonias, which have the auspicious meaning of happiness with the coming of spring. The exterior base is written with a six-character mark of Kangxi in regular script in two columns within a double-line medallion in underglaze blue.

The decorations are painted in a delicate and meticulous manner. The intensive use of underglaze blue and red on *doucai* wares was rather unusual in the category of *doucai* wares of different periods.

157

Garlic-head Vase with a Handle in the Shape of *Ruyi* Clouds

and decorated with design of flowers in *doucai* enamels

Qing Dynasty Yongzheng period

Height 26 cm
Diameter of Mouth 5.2 cm
Diameter of Foot 11.8 cm

The vase has a garlic-head mouth, a narrow flanged neck, a slanting shoulder, a round belly, and a ring foot. On the symmetrical sides of the mouth and shoulder is a pair of handles in the shape of *ruyi* clouds. The wall of the mouth is decorated with *ruyi* cloud patterns and the upper and lower mouth rims are decorated with key-fret patterns. The neck is decorated with foliage scrolls, flowers and deformed banana leaves from the top to the bottom. The belly is decorated with six units of sprays of flowers of the four seasons and interspersed by symmetrical lotus lappets. Near the foot are decorations of deformed lotus petals. The ear is decorated with bead chains. The exterior base is written with a six-character mark of Yongzheng in regular script in two columns within a double-line medallion in underglaze blue.

The form of this vase was first produced in the Imperial Kiln in the Yongzheng period. Other than *doucai* wares, it was also found on underglaze blue, pale-celadon, sky-blue, tea-dust, and other wares, showing that it was much favoured by Emperor Yongzheng. The Yongzheng *doucai* wares are often decorated with designs in a precise and meticulous manner with rich colours. In additional to traditional enamels, *yangcai* enamels such as rouge-red, imperial yellow and water-green were also used on *doucai* wares with a subtle and lyrical colour scheme.

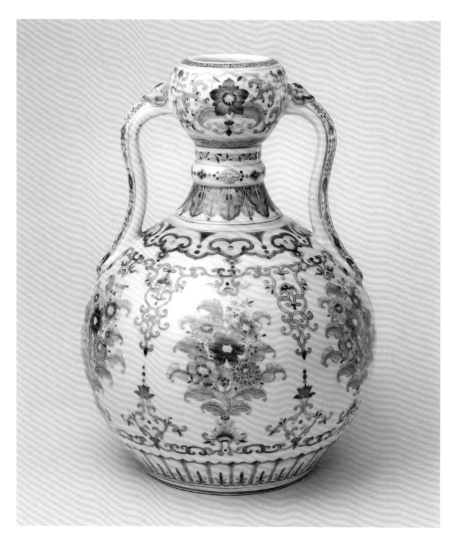

158

Zun Vase in the Shape of Lobed Chrysanthemum Petals
and decorated with design of flowers in *doucai* enamels

Qing Dynasty Yongzheng period

Diameter 25.7 cm
Diameter of Mouth 22 cm
Diameter of Foot 15.6 cm
Qing court collection

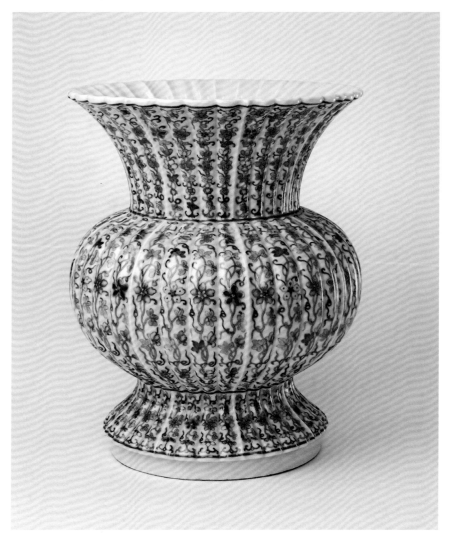

The *zun* vase is fashioned in the shape of lobed chrysanthemum petals and has a flared mouth, a long neck, a flat round belly, and a splayed high ring foot. The exterior wall is decorated with floral designs matching with the lobed chrysanthemum petals. The exterior base is written with an imitated six-character mark of Chenghua in regular script in two columns within a double-line medallion in underglaze blue.

The production of this form was rather complicated, and it was quite difficult to have the shape precisely fired without any distortion, thus showing the superb production skills of the Yongzheng Imperial Kiln. Ceramic wares with their shapes modelled after animals and plants had a long tradition in the history of Chinese ceramics, and appeared as early as the pottery wares of the Neolithic period. Yet wares with the shape of floral patterns with such a large size are quite unusual.

159

Plate with a Broad Everted Rim

and decorated with design of a dragon, a phoenix, and flowers in *doucai* enamels

Qing Dynasty Yongzheng period

Height 9.5 cm
Diameter of Mouth 44.5 cm
Diameter of Foot 25.5 cm

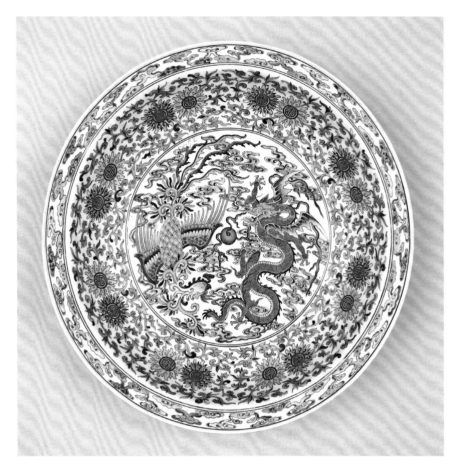

The plate has a rim everted to a flange, a curved belly and a ring foot. The interior centre is decorated with a dragon and a phoenix in pursuit of a pearl. The interior wall is decorated with eight interspersed lotus flowers with double buds in red and green respectively, and at the centre of each flower is painted with a *shou* (longevity) medallion in seal script. The everted rim is decorated with auspicious clouds, rocks, landscapes, *lingzhi* funguses, and bats. The exterior base is written with a six-character mark of Yongzheng in regular script in two columns within a double-line medallion in underglaze blue.

The plate is modelled with large size and the decorative motifs carry the auspicious meanings of "the dragon and phoenix bringing auspicious blessing" and "the mountain of longevity and sea of fortune."

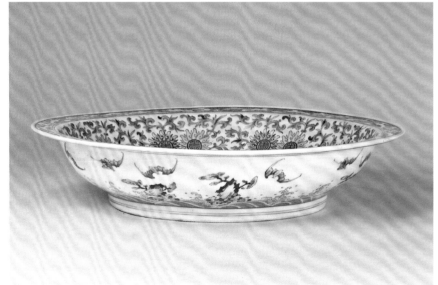

160

Large Vase with Ears in the Shape of *Chi*-dragons

and decorated with design of figures sending treasures and tributes in *doucai* enamels

Qing Dynasty Qianlong period

Height 71.5 cm
Diameter of Mouth 23.5 cm
Diameter of Foot 23 cm
Qing court collection

The vase has a flared mouth, a long neck, a slanting shoulder, and a splayed ring foot. On the symmetrical sides of the neck is a pair of ears in the shape of *chi*-dragons. The mouth rim is decorated with cloud patterns and the neck is decorated with bats holding twin-fish and *qing* chime in the mouths, representing the auspicious meaning of "abundant fortune and happiness." The belly is decorated with figures sending treasures and tributes. A number of figures, accompanied by officials, are walking in the mountains. They are either riding carts, holding plates, carrying shoulder poles, holding vases, or riding on elephants, and are carrying various treasures and tributes such as corals, precious stones, *lingzhi* funguses, etc., whereas the motif of an elephant carrying a large vase symbolizes "the elephant brings peace", and has the auspicious meaning of "the blessing for a peaceful world and an abundant harvest". The exterior base is written with a six-character mark of Qianlong in seal script in three columns in underglaze blue.

This large and heavy vase is finely potted. The decorations are painted in underglaze blue and *yangcai* enamels with a rich colour scheme in a luxuriant manner. *Doucai* wares with such a large size are very rare and unusual.

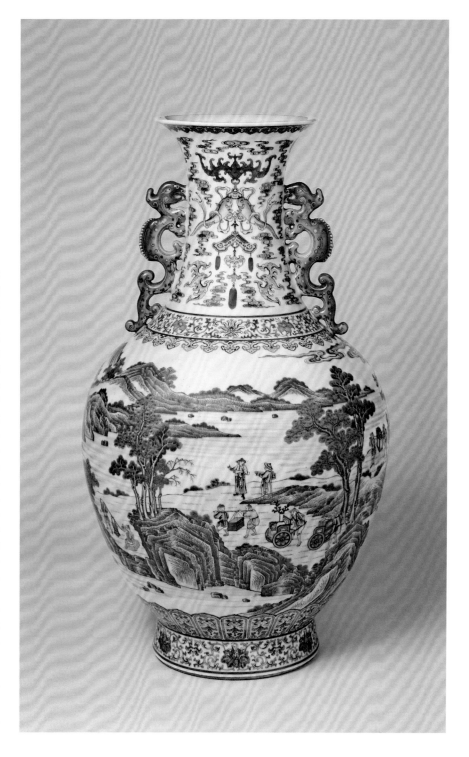

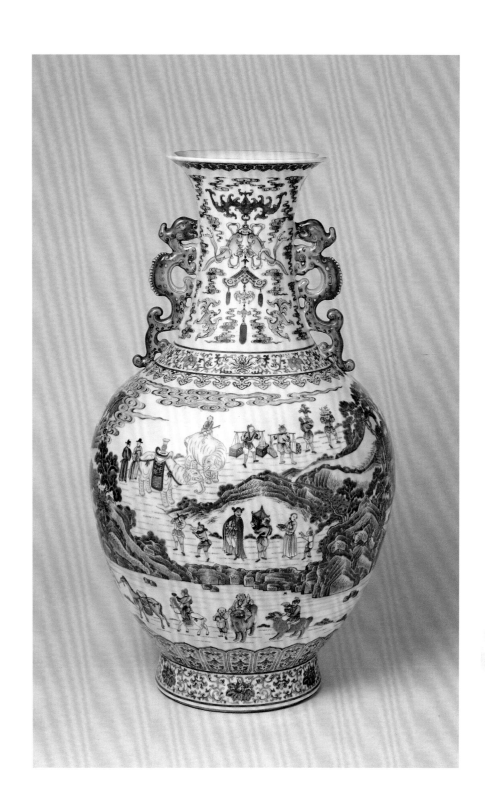

161

Flask with Ears in the Shape of *Chi*-dragons

and decorated with design of dragons in pursuit of a pearl in *doucai* enamels

Qing Dynasty Qianlong period

Height 24.3 cm
Diameter of Mouth 4 cm
Diameter of Foot 7.7 × 5.2 cm
Qing court collection

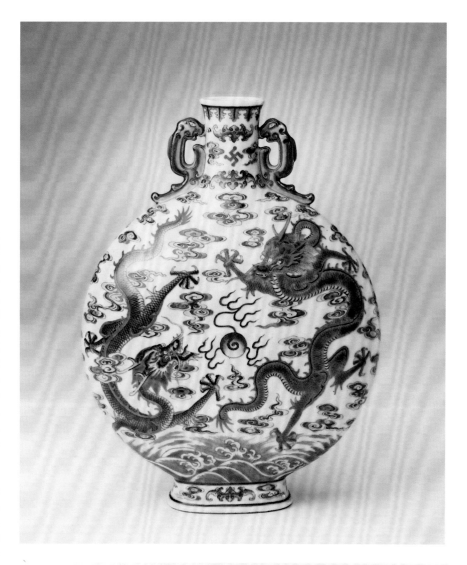

The flask has a rimmed mouth, a short neck, a slanting shoulder, a flat and round belly, and a ring foot. On the symmetrical sides of the shoulder and the neck is a pair of ears in the shape of *chi*-dragons. Each of the two sides of the belly is decorated with two dragons in pursuit of a pearl and enriched with colour cloud patterns and cresting waves. The mouth rim, neck, and the wall of the foot are decorated with banana leaves, *wan* swastika patterns, and bats amidst clouds. The exterior base is written with a six-character mark of Qianlong in seal script in three columns in underglaze blue.

There are a variety of dragon designs on Qianlong wares, including dragons amidst clouds, running dragons, single dragon, frontal dragons, dragons in pursuit of pearls, dragons amidst flowers, etc. The design of dragons with five claws on this large vase is depicted with a fierce outlook, showing a distinctive decorative style of the period.

162

Garden Stool with a Ground

in *yangcai* colour enamels
and decorated with design
of lotus flowers and
openwork cloud patterns
in *doucai* enamels
on a blue ground

Qing Dynasty Qianlong period

Height 52.9 cm
Diameter of top surface 31 cm
Qing court collection

The garden stool is modelled in the shape of a drum with diameters of the top surface and the foot similar. The centre of the upper surface of the stool is decorated with lotuses in *doucai* enamels on a sky-blue ground, and surrounded by incised floral sprays in *fencai* enamels on an aubergine ground. The body is decorated with the openwork design of four *ruyi* cloud patterns painted in gilt and lotuses in *doucai* enamels on a blue ground. The upper and lower sides of the garden stool are further decorated with a border of foliage scrolls and drum nail patterns in gilt on a black ground respectively.

The garden stool is finely modelled with elegant decorations, finely carved openwork designs and harmonious colour scheme, representing a refined ceramic furniture ware of the Qianlong period. Garden stools, which are known as sitting stools or cooling stools, are used for sitting purpose and very popularly produced with wood, stone, or ceramics. Ceramic garden stools were produced with underglaze blue, plain three colours, *doucai*, or *fencai* enamelled decorations in different periods of the previous dynasties.

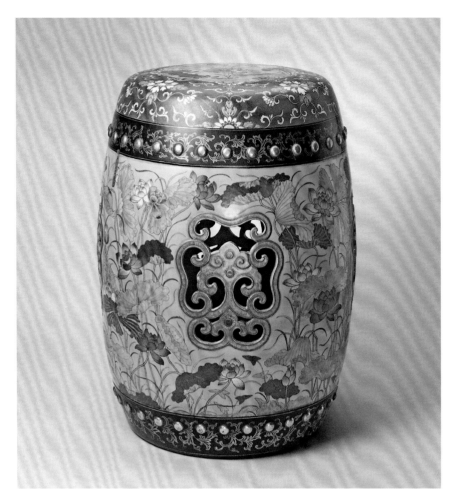

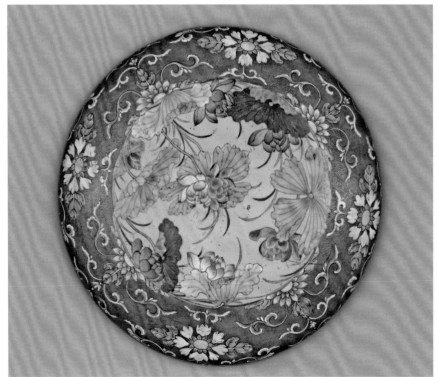

163

Vase with Two Ears
and decorated with design
of flowers and birds
in *doucai* enamels

Qing Dynasty Jiaqing period

Height 36.2 cm
Diameter of Mouth 9.7 cm
Diameter of Foot 10.2 cm

The vase has a plate-shaped mouth, a long neck, a slanting shoulder, a straight belly slimming downwards, and a ring foot. On the symmetrical sides of the neck is a pair of halberd-shaped ears holding chimes, which has the auspicious meaning of "abundant luckiness and happiness." Under the mouth rim of the exterior wall are decorations of *ruyi* cloud collars. The neck is decorated with floral sprays and the shoulder is decorated with chrysanthemum sprays, underneath are borders of floral scrolls and bats. The belly is decorated with rocks, chrysanthemums, quails, etc. Near the base are decorations of bats, lotuses, and banana leaves. The exterior base is written with a six-character mark of Jiaqing in seal script in three columns in underglaze blue.

The production of imperial wares in the Jiaqing period in the Imperial Kiln at Jingdezhen generally followed the style of Qianlong imperial wares in terms of forms, decorative styles, and colour schemes, as represented by this vase. The decorative motifs of rocks, chrysanthemums, and quails are painted in a meticulous manner with a vivid resonance.

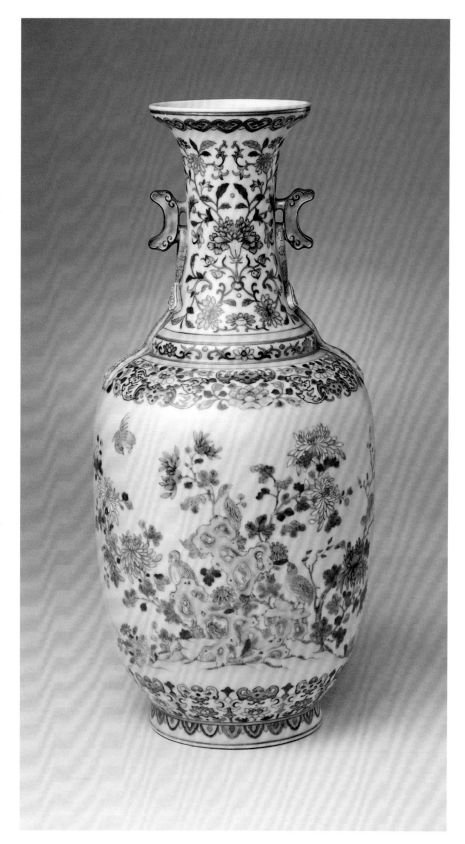

164

Covered Jar
decorated with design of eight Buddhist Emblems
and dragon medallions in *doucai* enamels

Qing Dynasty Daoguang period

Overall Height 21 cm
Diameter of Mouth 7 cm Diameter of Foot 8.5 cm
Qing court collection

The jar has an upright mouth, a short neck, a slanting shoulder, a globular belly tapering downwards, and a ring foot. It has a matching round flat cover. The shoulder is decorated with borders of *ruyi* cloud lappets and the eight Buddhist Emblems. The belly is decorated with four dragon medallions, on top and below of which are symmetrical designs of flowers and leaves. Near the foot are decorations of inverted lotus petals. The surface of the cover is decorated with a dragon amidst clouds, and the wall is decorated with *ruyi* cloud lappets.

The form and decorative style followed that of the Yongzheng and Qianlong periods. Although it has no mark, the thin glaze surface, white and coarse quality of white glaze, the rather loose painting style, and the pale colours of enamels reflect the typical features of imperial wares of the Daoguang period.

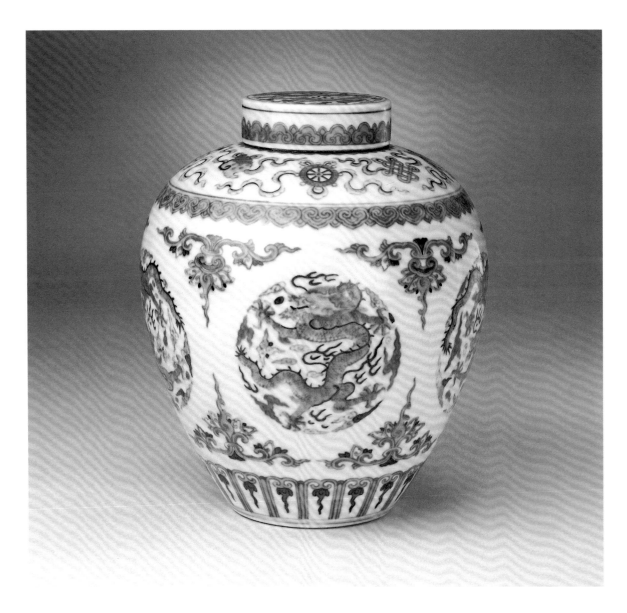

PORCELAIN WARES IN OPAQUE ENAMELS
(FALANGCAI OR CLOISONNÉ ENAMELS)

165

Vase
decorated with lotus sprays
in panels in opaque enamels
on a rouge-red ground

Qing Dynasty Kangxi period

Height 12.2 cm
Diameter of Mouth 4.4 cm
Diameter of Foot 5.4 cm
Qing court collection

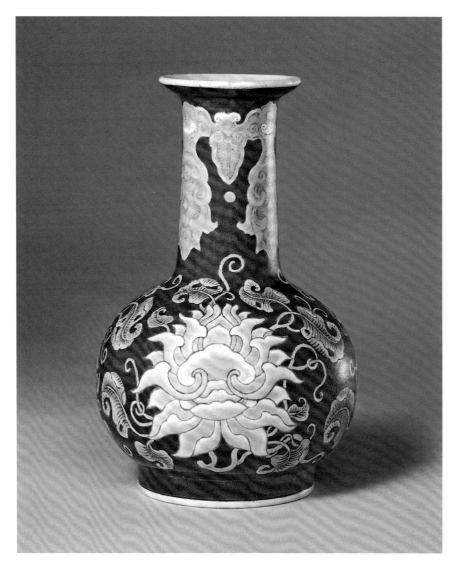

The vase has a flared mouth, a long neck, a round belly, and a cake-shaped solid base. The exterior is covered with aubergine-red enamel as the ground. The neck is decorated with three units of deformed cicada patterns in yellow enamel, imitating the designs on ancient bronze wares and jade carvings. The belly is decorated with three medallions of lotus sprays in yellow, blue, white, green, black, and other opaque colour enamels. The exterior base is incised with the imperial mark of Kangxi in regular script in intaglio style in double columns within a single-line square.

This is one of the two vases decorated in opaque enamels of the Kangxi period extant and thus very rare.

The formal term for ceramic wares decorated in opaque enamels should be "porcelain biscuit painted with opaque enamels (*falangcai*)." Influenced by the production of copper wares in opaque enamelled imported from Europe, potters at the Imperial Kiln adopted such a technique in the production of this new type of wares in colour enamels. As it was still in an initial stage of production, the style was just imitated from the copper wares in opaque enamels without a distinctive style of its own. The opaque enamels were also imported from Europe. Typeforms include vases, plates, bowls, cups, etc. The decorative designs were often painted in a delicate and precise manner, and the grounds were usually painted in rouge-red, blue, foreign yellow, and others.

166

Bowl
decorated with design of flowers in panels in opaque enamels on a rouge-red ground

Qing Dynasty Kangxi period

Height 7 cm
Diameter of Mouth 14.8 cm
Diameter of Foot 5.7 cm

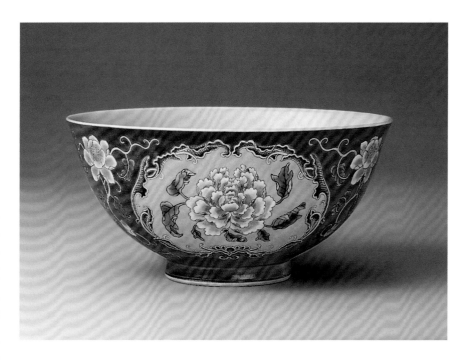

The bowl has a flared mouth, a deep curved wall, and a ring foot. The interior is covered with white glaze. The exterior wall is decorated with panels in flower shape, in which peony sprays are painted on a yellow ground. Outside the panels are decorations of floral sprays. The interior of the ring foot is covered with white glaze. The exterior base is written with the four-character imperial mark of Kangxi in regular script in two columns in a double-line square in rouge-red.

The colour scheme of the decorations of this bowl is bright and brilliant. The rough-red ground highlights the panels in bright yellow with peonies decorating the interior, and produces a superb aesthetic appeal, reflecting the early style of its type in the late Kangxi period when such wares were first produced.

Ceramic wares with decorations painted in opaque enamels were exclusively produced for the use and appreciation by the imperial family and the court had a rigid control in producing these wares. The white biscuits were produced in the Imperial Kiln at Jingdezhen and then sent to the court. With the direction of the emperor, court painters produced the exquisite decorative designs and the court calligraphers wrote the poems and the marks for the production by the opaque enamels studio of the imperial workshops of the Department of Imperial Household in the Qing Dynasty.

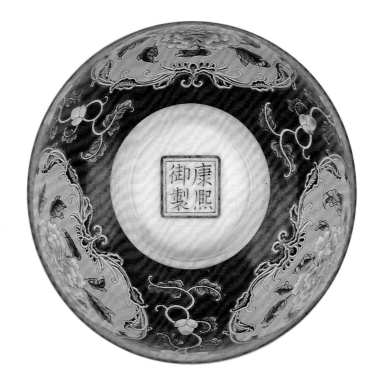

167

Bowl
decorated with design of peonies in opaque enamels on a light yellow ground

Qing Dynasty Kangxi period

Height 7.2 cm
Diameter of Mouth 15.2 cm
Diameter of Foot 5.7 cm

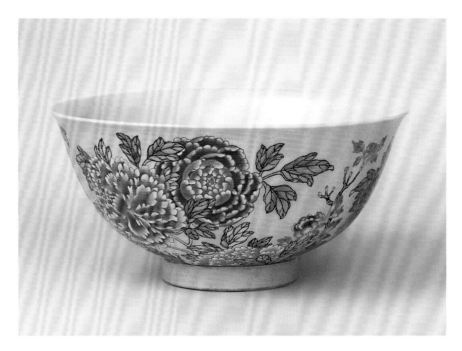

The bowl has a slightly flared mouth, a deep curved wall, and a ring foot glazed in white inside. The exterior wall is decorated with eight peonies in light red, blue, white, green, and other opaque enamels on an opaque yellow ground, with two flowers in different colours forming one group so that there are four groups of peony designs on the bowl. The interior of the ring foot is covered with white glaze. The exterior base is written with a four-character imperial mark of Kangxi in regular script within a double-line square in rouge-red.

The bowl is thinly potted and decorated with designs painted in a delicate and meticulous manner with strong dimensionality and brilliant colour scheme. Traces of the wheel scratched during the production process are barely visible under the ground in light yellow opaque enamel, showing that the glaze on the exterior wall was removed by the wheel first, and then the decorations were painted on it.

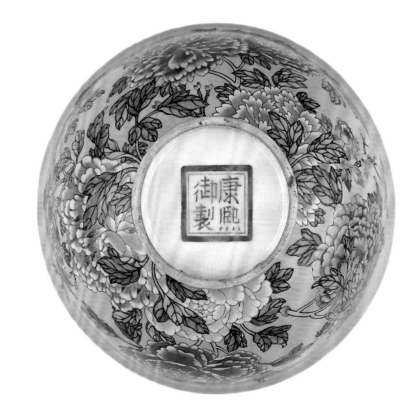

168

Bowl
decorated with design of peonies in opaque enamels on a blue ground

Qing Dynasty Kangxi period

Height 5.2 cm
Diameter of Mouth 11 cm
Diameter of Foot 4.4 cm
Qing court collection

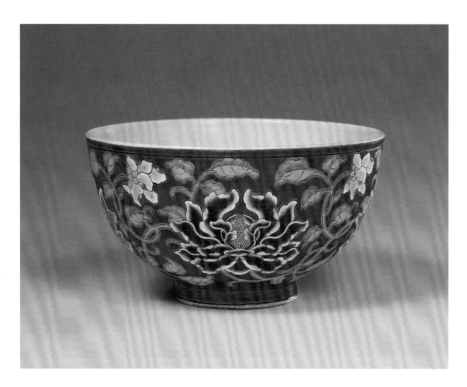

The bowl has a slightly flared mouth, a deep curved belly, and a ring foot. The interior is covered with white glaze. The exterior wall is painted in blue on the biscuit as the ground, on which are decorations of four giant peonies in rouge-red, yellow, light green, and other opaque enamels, and interspersed by four smaller peonies. The interior of the ring foot is covered with white glaze. The exterior base is written with a four-character imperial mark of Kangxi in regular script in two columns within a double-line square in rouge-red.

The bowl has a charming and graceful form and the colour schemes are skillfully treated. The peonies with naturalistic colour tones are depicted from different angles, and the whole pictorial treatment is just like a painting of peonies in *gongbi* (meticulous) brush style of Chinese painting. The grounds of Kangxi wares in opaque enamels were often painted in yellow or rouge-red, and this bowl with a blue ground instead is very rare and exceptional.

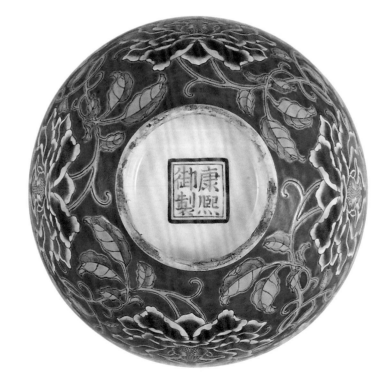

169

Bowl
decorated with design of flowers and birds in panels in opaque enamels and gilt on a rouge-red ground

Qing Dynasty Yongzheng period

Height 4.5 cm
Diameter of Mouth 9.2 cm
Diameter of Foot 3.6 cm

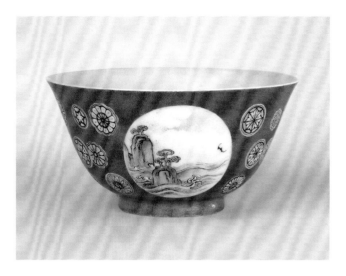

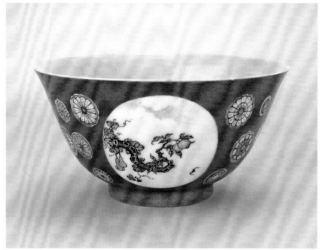

The bowl has a flared mouth, a deep curved belly, and a ring foot. The interior is covered with white glaze. The interior wall is decorated with the molded design of egrets and lotus, symbolizing the auspicious meaning of everlasting wealth and prosperity. In the centre is a molded and recess-style mark imitating the mark of Yongle period in seal script. The exterior wall is painted in rouge-red as the ground, on which are three round panels in white. Inside the panels are the designs of magpies, bamboos, and plum blossoms with the auspicious meaning of "double happiness"; peaches, gourds, and bats with the auspicious meaning of "everlasting fortune and prosperity that lasts for generations"; and *lingzhi* funguses, bats, cresting waves, and rocks with the auspicious meaning of "mountain of longevity and sea of fortune." The base is decorated with a spray of peaches, in which a four-character mark of Yongzheng is written in regular script in two columns in rouge-red.

This bowl is a rather extraordinary piece of the Yongzheng period with both molding and painting techniques employed for the decorations, as well as with two marks of the Yongzheng period and the imitated mark of the Yongle period respectively, which reflects the archaic aesthetic taste for imperial wares of the Emperor Yongzheng. Extant wares and the court archive show that various emperors had made special orders for the design and production of imperial wares, and thus revealing the different aesthetic taste of each emperor, in particular in the case of Emperor Yongzheng.

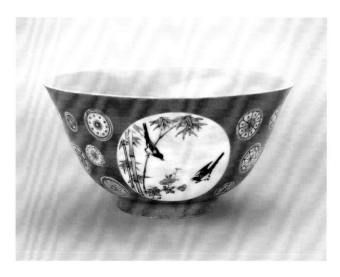

170

Bowl
decorated with orchids, rocks, and a poem in opaque enamels on a light yellow ground

Qing Dynasty Yongzheng period

Height 5.2 cm
Diameter of Mouth 10.3 cm
Diameter of Foot 4 cm
Qing court collection

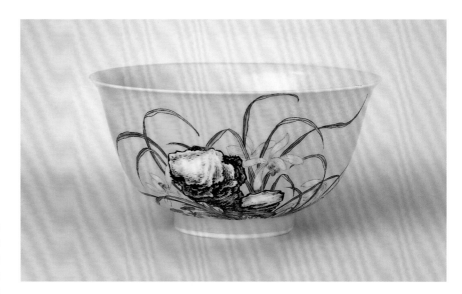

The bowl has a flared mouth, a deep curved wall, and a ring foot. The interior is covered with white glaze. The exterior is decorated with orchids and rocks with one side written with a poetic couplet "On the island with cloudy mist is a path leading to immortality, the fragrance of orchids spreads in spring time." At the beginning of the poem is a relief-style seal mark *jiali* in seal script in rouge-red, and at the end are two relief-style seal marks *jincheng* and *xuying* in seal script in rouge-red. The interior of the ring foot is covered with white glaze. The exterior base is written with a four-character mark of Yongzheng in Song regular script in two columns within a double-line square in blue.

The poetic couplet might have been derived and revised from a poem written by Ye Ziqi of the Ming Dynasty, which described that "There is nobody in the empty valley and the fragrance of orchids spreads naturally. The root of the plant cannot be seen, yet the cogon grasses around grow so high."

The bowl is finely potted with the decorations painted with a touch of delicacy. With a combination of the poem, calligraphy, and painted design, it represents a superb refined imperial ware. A number of wares in opaque enamels of the Yongzheng period inherited the style of Kangxi wares in opaque enamels, however, they were often further enriched by a combination of the poem, calligraphy, and painting, making these wares fine art works and reflecting the essence of literati painting on Yongzheng wares with decorative designs in opaque enamels.

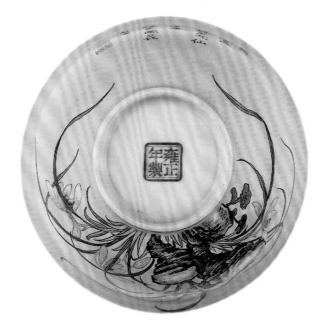

171

Bowl
decorated with design of
plum blossoms and a poem
in opaque enamels
on a light yellow ground

Qing Dynasty Yongzheng period

Height 6.2 cm
Diameter of Mouth 12 cm
Diameter of Foot 4.6 cm
Qing court collection

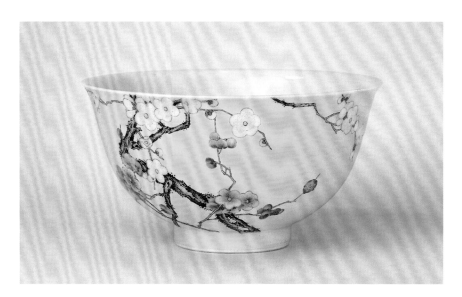

The bowl has a slightly flared mouth, a deep curved wall, and a ring foot with the interior covered with white glaze. The exterior wall is decorated with a plum tree on which red and white plum blossoms fully bloom. The empty space on the bowl is written a poetic couplet "It is said that the flowers are like snow, but the fragrance spreads around naturally." At the beginning of the poetic couplet is a relief-style seal mark *xianchun* in seal script in rouge-red, and at the end are an intaglio-style seal mark *shougu* and a relief-style seal mark *xiangqing* in seal script. The exterior base is written with a four-character mark of Yongzheng in Song regular script in two columns within a double-line square in blue.

In the book *Yuefu Shiji* of the Western Han Dynasty, there was a poem "Withering plum blossoms" which said, "It is said that the flowers are like snow, but the fragrance spreads around naturally," and the poetic couplet on this bowl should have quoted from that poem of the Western Han Dynasty.

The bowl is painted with decorations in a lyrical and delicate style, and the colour scheme is bright and charming. Most of imperial wares in opaque enamels of the Yongzheng period had white grounds, but some inherited the Kangxi style that the grounds were painted with colour enamels in a luxuriant manner.

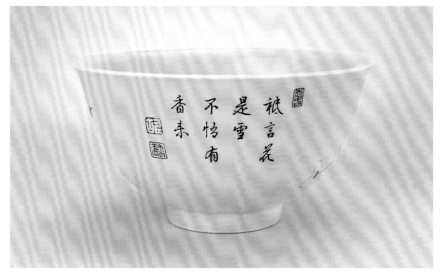

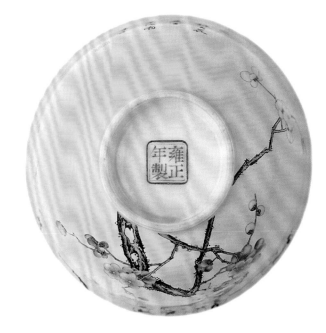

172

Cup
decorated with design of
pomegranate flowers and
a poetic inscription
in opaque enamels
on a light yellow ground

Qing Dynasty Yongzheng period

Height 4.5 cm
Diameter of Mouth 7.4 cm
Diameter of Foot 2.8 cm
Qing court collection

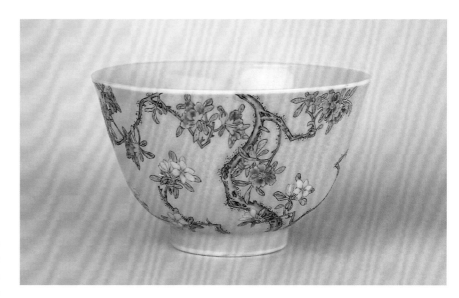

The cup has a flared mouth, a deep curved belly, and a ring foot. The interior is covered with white glaze. One side of the exterior wall is decorated with a pomegranate tree and two pear trees with blossoming flowers. Another side is written with the poetic inscription "flowers bud in clusters like pearls." At the beginning of the poem is a relief seal mark *jiali*, and at the end are two intaglio-style seal marks *jincheng* and *xuying* in seal script in rouge-red. The interior of the ring foot is covered with white glaze. The exterior base is written with a four-character mark of Yongzheng in Song regular script in two columns within a double-line square in blue.

The poetic inscription on this bowl was quoted from a poem *Pomegranate* written by Wen Tingyun of the Tang Dynasty, which said, "Flower buds cluster like pearls, colours from embroidery crowd together."

Opaque enamels are special types of colour enamels produced manually. Before the sixth year of the Yongzheng period (1728), these enamels were all imported from Europe. After the sixth year of the Yongzheng period, the imperial workshops of the court mastered the techniques and could produce over twenty types of opaque enamels, and the colour schemes even surpassed those imported from Europe, and thus led to a leap in the production of wares in opaque enamels.

173

Bowl
decorated with design of
dragons in pursuit of
the pearl amidst clouds
in opaque enamels
on a light yellow ground

Qing Dynasty Yongzheng period

Height 5 cm
Diameter of Mouth 10 cm
Diameter of Foot 4 cm
Qing court collection

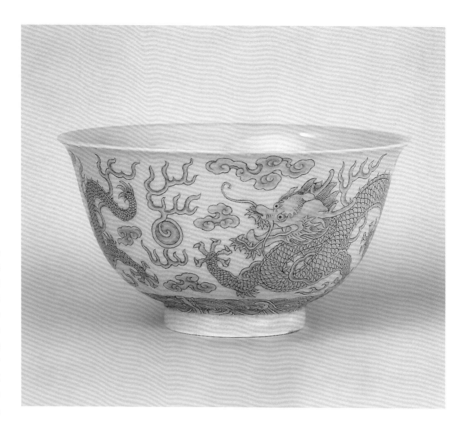

The bowl has a slightly flared mouth, a deep curved wall, a slim base, and a ring foot. The interior is covered with white glaze. The exterior wall is decorated with two dragons in pursuit of the pearl, auspicious clouds, and cresting waves in brownish-yellow. The interior of the ring foot is covered with white glaze. The exterior base is written with a four-character mark of Yongzheng in Song regular script in two columns within a double-line square in blue.

The bowl is finely fashioned, and the style of painting dragons in pursuit of the pearl amidst clouds in deep yellow opaque enamels on a light yellow ground is very rare and unusual.

The typical imperial wares in opaque enamels of the Yongzheng period represent the peak of the production of polychrome wares in the history of Chinese ceramics. These wares with common typeforms such as bowls and plates decorated with opaque enamels were no longer for functional purpose; instead they were used as decorative objects for appreciation at the time.

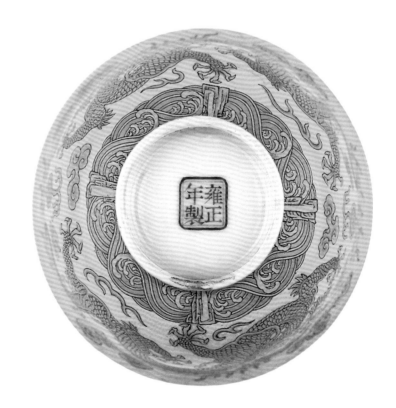

174

Olive-shaped Vase
decorated with design of pines, bamboos, plum blossoms, and a poetic inscription in opaque enamels

Qing Dynasty Yongzheng period

Height 16.9 cm
Diameter of Mouth 3.9 cm
Diameter of Foot 4.9 cm
Qing court collection

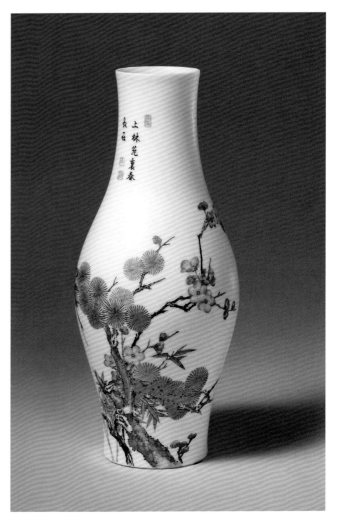

The olive-shaped vase has an upright mouth, a slanting shoulder, a globular belly tapering downwards and a ring foot. The interior and the exterior are covered with white glaze. The exterior wall is decorated with pines, bamboos, and plum blossoms, the so-called "three friends of winter" in opaque enamels. The empty space is written a poetic inscription "Springs last long at the Imperial Shanglin Garden" in running-cursive script in black with fluent brushwork. From where this sentence was quoted requires further study. At the beginning of the poetic inscription is a relief-style seal mark *xiangcai* in seal script in red. At the end are an intaglio-style seal mark *shougu* in seal script and a relief-style seal mark *xiangqinq* in rouge-red. The exterior base is written with a four-character mark of Yongzheng in regular script in two columns within a double-line medallion in underglaze blue.

The vase is thinly potted with a graceful and elegant form and covered with shiny and translucent glaze. With a combination of the poem, calligraphy, painting, and seal-carving in decorating the vase, it is a refined piece showing the superb sculptural quality of Yongzheng imperial wares in opaque enamels. In the Yongzheng period, most of the wares in opaque enamels were round objects such as plates and bowls, and objects with sculptural form like this one were rather rare. In addition, the decorations were often painted on white glaze instead of yellow, blue, and rouge-red grounds in vogue in the Kangxi period, and thus further enhanced the aesthetic appeal of the decorative designs.

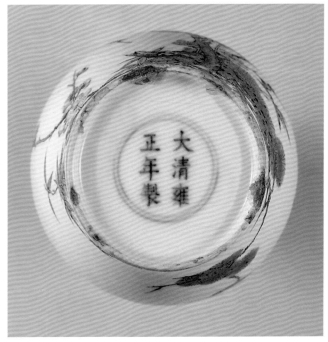

Sculptural objects refer to those wares that could not be produced by wheels, and they are objects with sculptural forms such as *zun* vases, vases, jars, etc. Round objects refer to those wares with round forms such as plates, bowls, dishes, etc.

175

Bowl
decorated with design of a pheasant amidst peonies and a poem in opaque enamels

Qing Dynasty Yongzheng period

Height 6.6 cm
Diameter of Mouth 14.5 cm
Diameter of Foot 6 cm
Qing court collection

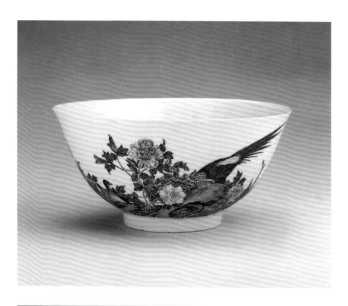

The bowl has a flared mouth, a curved wall, and a ring foot. The biscuit is thinly potted and looks semi-transparent. The interior and the exterior are covered with shiny and pure white glaze. One side of the wall is decorated with a scene of a pheasant amidst peonies painted in pink, purplish-red, pale-red, light yellow, apricot-yellow, blue, green, and brown. The other side is written with a poetic couplet "The fresh stamen is coated with gold powder, the double-flower buds look like embroidered clouds," which was quoted from a poem *Peonies* written by Han Cong, a poet of the Tang Dynasty, which said "the fresh stamen is coated with gold powder, the double-flower buds look like small embroidered bags." At the beginning of poetic couplet is a relief-style seal mark *jiali* in seal script in rouge-red. At the end are the relief-style seal marks *jincheng* and *xuying* in seal script in rouge-red. The exterior base is written with a four-character mark of Yongzheng in Song regular script in two columns within a double-line square in blue.

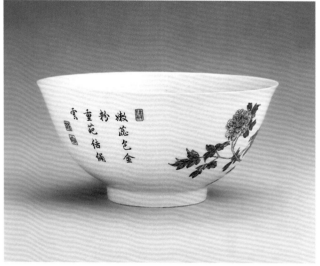

The production of wares in opaque enamels started in the late Kangxi period and came to end after the Qianlong period. In the Qianlong period, imperial wares in opaque enamels were stored at the Duanning Palace and there were over 400 pieces listed in the Court Archive. This bowl should be one of them.

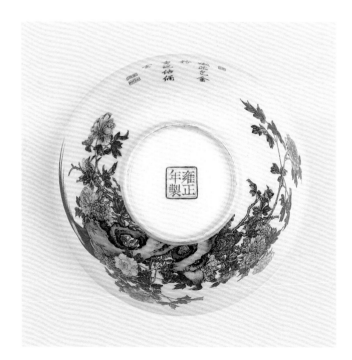

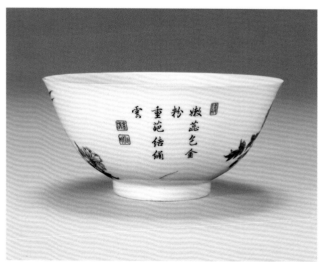

176
Bowl
decorated with design
of landscapes
in opaque enamels

Qing Dynasty Yongzheng period

H 5.2 cm
Diameter of Mouth 10.9 cm
Diameter of Foot 3.9 cm
Qing court collection

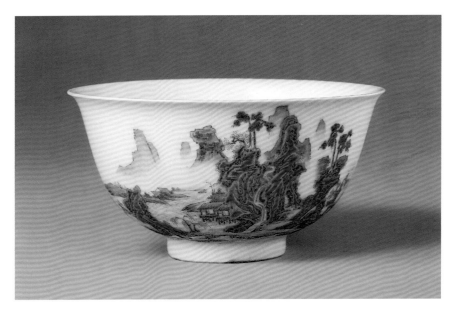

The bowl has a flared mouth, a deep curved belly, and a ring foot. The finely potted biscuit is glazed in pure white. The exterior wall is decorated with a continuous scene of landscapes in blue. The empty space is written a poetic couplet "The jade colour shades the southern mountains with the same colour, the green surrounds the vast sea with unbound green colour." At the beginning of the poetic couplet is a relief-style seal mark *shougu*, and the end are intaglio-style seal marks *shangao* and *shuichang* in seal script in rouge-red. The exterior base is written with a square mark of Yongzheng in Song regular script within a double-line square in blue.

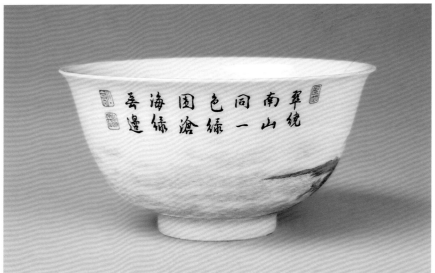

The bowl is modelled with a graceful form and the decorative designs are ingeniously rendered. The myriad peaks, pines, streams, and pavilions in the picture are painted in a precise and meticulous manner, making the designs look like a Chinese landscape painting in ink.

177

Vase
decorated with design of flowers in opaque enamels

Qing Dynasty Qianlong period

Height 20.4 cm
Diameter of Mouth 4.8 cm
Diameter of Foot 4.3 cm

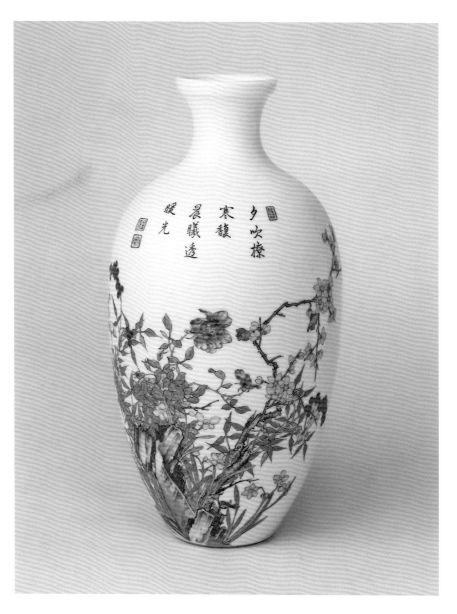

The vase has a plate-shaped mouth, a narrow neck, a slanting shoulder, a globular belly tapering downwards, and a ring foot. The body is covered with white glaze. The exterior wall is decorated with various flowers such as Chinese roses, nandinas, winter plum blossoms, narcissuses, and rocks. The empty space is written a poetic couplet "Breeze in the evening brings fragrance in the cold weather, sunshine in the morning brings warmness and brightness" which was quoted from the poem *Winter Plum Blossoms* written by Yang Wanli, a poet of the Song Dynasty. At the beginning of the poem is a relief-style seal mark *jiali* in rouge-red, and at the end are relief-style seal marks *jincheng* and *xuying* in rouge-red. The exterior base is written with a four-character mark of Qianlong in Song regular script in two columns within a double-line square in blue.

The vase is thinly potted with a graceful and elegant form. The flowers and rocks are painted in red, yellow, green, black, blue, and other enamels with a touch of brilliance and luxuriance with skillful spacious treatment. The decorative style inherited the practice of combining the poem, calligraphy, painting, and seal-carving of the Yongzheng period, and the vase represents a refined piece of wares in opaque enamels of the early Qianlong period.

178

Small Vase
decorated with design of rocks, flowers, and a poem in opaque enamels

Qing Dynasty Qianlong period

Height 9.1 cm
Diameter of Mouth 1.6 cm
Diameter of Foot 2 cm

The vase has a slim and long body, a small mouth, a straight neck, a slanting shoulder on which are three nipples, and a recessed foot. The interior and the exterior are covered with translucent white glaze. The exterior wall is decorated with flowers amidst rocks in opaque enamels. The empty space is written with a poetic inscription "Fragrant breeze blows gently in the long days" in running script in black and from where the poem is quoted needs further study. At the beginning of the poem is a relief-style seal mark *xianghe* in seal script in rouge-red, and at the end are relief-style seal marks *jincheng* and *xuying* in seal script in rouge-red. The exterior base is written with a four-character mark of Qianlong in Song regular script in two columns in blue.

The vase is decorated in a simple and refreshing manner with soft colour tones. By combining the poetry, calligraphy, painting, and seal carving, the pictorial composition reveals the essence of traditional Chinese literati painting.

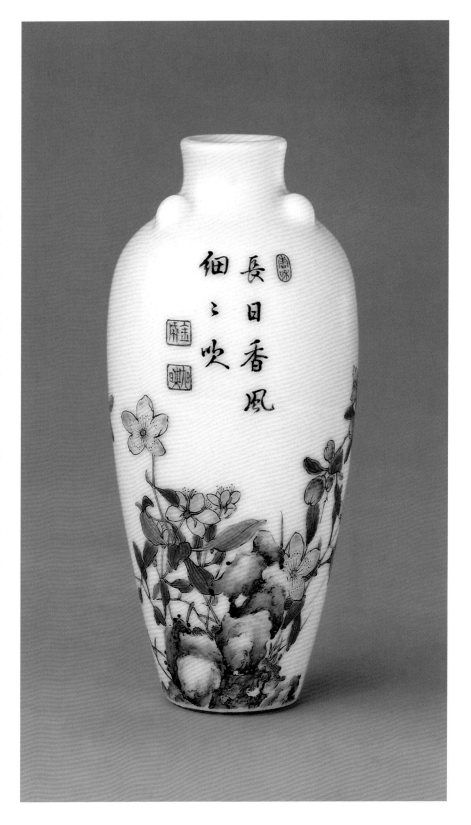

179

Small Gourd-shaped Flask with Ears

and decorated with design of foreign ladies and children in panels in opaque enamels

Qing Dynasty Qianlong period

Height 10 cm
Diameter of Mouth 0.6 cm
Diameter of Foot 2.8 × 2.1 cm
Qing court collection

The gourd-shaped vase has a small mouth, a round belly which flattens at the lower part, and a rectangular foot. On the two symmetrical sides of the body is a pair of ribbon-shaped ears. The two sides of the upper belly are decorated with oval-shaped panels in which there are landscape designs. The two sides of the lower belly are decorated with Chinese flowering crab apple-shaped panels in which there are western ladies and children depicted on a yellow ground. The figures are gorgeously dressed, the faces are painted with the western painting technique of shading, and in between the panels are foliated patterns. The exterior base is written with a four-character mark of Qianlong in Song regular script in two columns in blue.

In terms of painting style and decorative motif, this small flask reflects a prominent western painting style, showing the profound western influence on the imperial wares in opaque enamels during the Qianlong period.

180

Small Vase
decorated with design of landscapes and a poem in rouge-red and opaque enamels

Qing Dynasty Qianlong period

Height 9.6 cm
Diameter of Mouth 2.2 cm
Diameter of Foot 2.2 cm
Qing court collection

The vase has a slightly flaring mouth, a narrow neck, a slanting shoulder, a straight belly tapering downwards, and a ring foot. The interior and the exterior are covered with white glaze. The exterior wall is decorated with a scene of a garden amidst landscapes in rouge-red and accompanied by a poetic inscription "The peaks come out in evening gloom" which was quoted from the poem *A Poem for Inscribing Paintings by the Pavilion of Cultivating the Brush* written by Gao Kegong, a painter of the Yuan Dynasty. At the beginning of the poetic inscription is a relief-style oval mark *shouru* in seal script in rouge-red, and at the end are intaglio-style square seal marks *shan* and *gao* in rouge-red. The exterior base is written with a four-character mark of Qianlong in Song regular script in two columns in blue.

The decorative designs on this vase are only painted in rouge-red, which are quite rare among the wares in opaque enamels produced at the time. The colour enamels are thick and slightly in relief, and a sense of perspective and distance is created by manipulating the tonal gradations of the colours. Rouge-red is a kind of opaque enamels with gold as colourant, and thus it is also known as *jinhong* (golden-red). The terms of "wares in imitation of western aubergine wares" and "wares in western red enamel" mentioned in the book *Taocheng Jishi* refer to this type of imperial wares.

181

Small Vase
decorated with design of flowers and a poetic inscription in opaque enamels

Qing Dynasty Qianlong period

Height 7.8 cm
Diameter of Mouth 1.2 cm
Diameter of Foot 2.1 cm
Qing court collection

The vase has a slightly flared mouth, a long neck widening downwards, a hanging belly, and a ring foot. One side of the belly is decorated with rocks, peonies, and magnolias, and the other side is written with a poetic inscription "sudden light rain on a sunny day wets the flowers" and from where the inscription was quoted requires further study. At the beginning of the poetic inscription is a relief-style oval seal mark *chunqiu* in running script in iron-red and at the end are two relief-style seal marks *xu* and *ying* in seal script in iron-red. The exterior base is written with a four-character mark of Qianlong in two columns in Song regular script in blue enamel.

The vase is modelled in an elegant form which resembles that of a pear-shaped vase. The decorations are painted in the Chinese painting style with refreshing bright colours and a touch of lyricism.

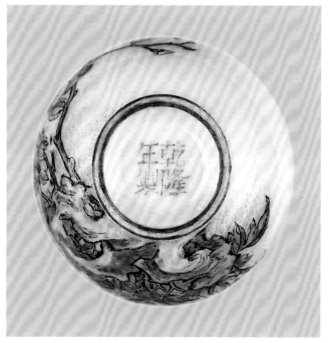

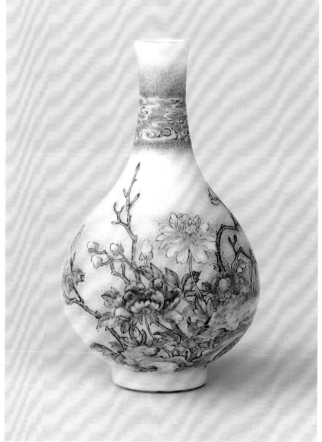

PORCELAIN WARES IN YANGCAI
(A STYLE MODELLED AFTER WESTERN PAINTING)
AND FENCAI (POWDERED) ENAMELS

182

Covered Box

decorated with openwork
design of floral scrolls and
shou (longevity) characters
in *yangcai* enamels

Qing Dynasty Yongzheng period

Overall Height 13.2 cm
Diameter of Mouth 21.7 cm
Diameter of Foot 12.9 cm
Qing court collection

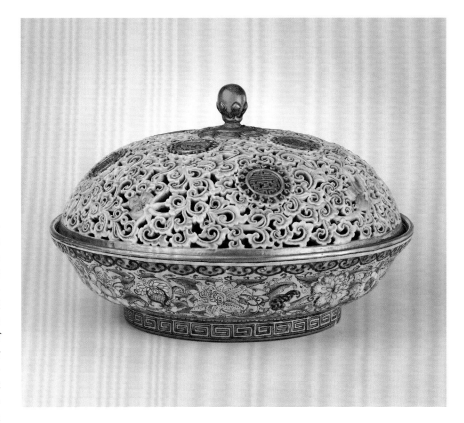

The flattened round box has interlocking mouths at the cover and the body and a ring foot. Inside the box are nine small compartments. The cover is slightly convex, and decorated with lotus scrolls supporting medallions of *shou* (longevity) characters and painted with opaque colour enamels. On the top is a tourmaline knob. The mouth rim of the box is painted in gilt, and the exterior wall is decorated with floral scrolls painted in opaque colour enamels. Near the foot are decorations of lotus petals. The exterior wall of the ring foot is decorated with key-fret patterns, and the interior of the ring foot is covered with peacock-green glaze. The exterior base is written a four-character mark of Yongzheng reserved in white in seal script in two columns within a double-line medallion in underglaze blue.

The box is decorated with combined techniques of delicate and meticulous enamel painting and skillful openwork carving. It is a very rare piece in *yangcai* enamels of the Yongzheng period. From its luxuriant and sophisticated decorative style, it should belong to the imperial wares produced in the Jingdezhen Imperial Kiln in the late Yongzheng period.

183

Vase with Ears in the Shape of Elephants Holding Rings

and decorated with design of flowers in *yangcai* enamels

Qing Dynasty Qianlong period

Height 14.1 cm
Diameter of Mouth 5.5 cm
Diameter of Foot 6.1 cm
Qing court collection

The vase has a flared mouth, a narrow neck, a globular belly, and a splayed ring foot. On the two symmetrical sides of the shoulder is a pair of ears in the shape of elephants holding rings painted in gilt. The interior of the vase is covered with turquoise-green glaze. The exterior wall is decorated with six different layers of Indian lotuses, which are separated by borders of string patterns in gilt. The empty spaces in between the designs are further decorated with foliage scrolls in gilt. The interior of the ring foot is covered with turquoise-green glaze. The exterior base is written with a four-character mark of Qianlong in seal script in two columns within a double-line square in black.

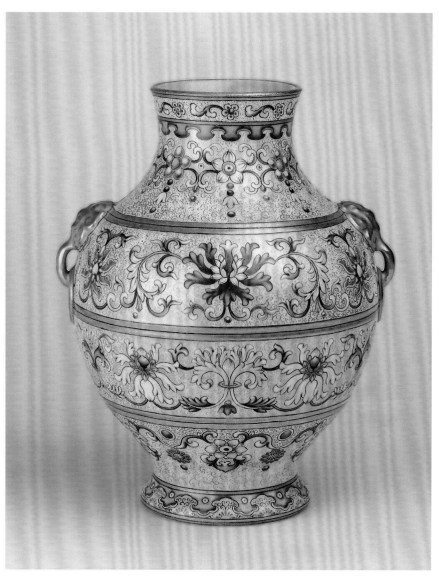

184

Conjoined Vase
decorated with design of children at play in *yangcai* enamels

Qing Dynasty Qianlong period

Overall Height 21.4 cm
Diameter of Mouth 9 × 5.2 cm
Diameter of Foot 10 × 6 cm

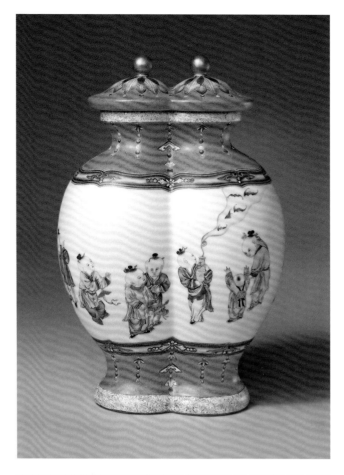

The conjoined vase has two bodies joined together. It has a washer-shaped mouth, a slanting shoulder, a globular belly tapering downwards, and a splayed ring foot. The vase has a conjoined canopy-shaped cover on which are two tourmaline knobs. The mouth rim and the wall of the foot are decorated with chrysanthemum scrolls on a light green ground. The rouge-red painted shoulder and the area near the foot are further decorated with scrolls painted in rouge-red and aubergine as the ground, on which are decorations of *qing* chimes and bead chains. The belly in white glaze is decorated with two scenes of children at play. One scene is depicted with four children playing with three goats, symbolizing the auspicious meaning of three goats bringing prosperity. Another scene is depicted with nine children at play and five bats are coming, symbolizing the auspicious meaning of bats bringing peace. The knob is painted in gilt, and the surface of the cover is decorated with a background of foliage scrolls in pinkish-aubergine on a rouge-red ground, on which are decorations of floral patterns and dot patterns. The interior of the vase and the ring foot are covered with turquoise-green glaze. The exterior base is written with a six-character horizontal mark of Qianlong in seal script in underglaze blue.

In the book *I Ching,* the *tai* trigram is made up with three *yang* trigrams on the bottom and three *yin* trigrams on the top, which symbolizes the coming of the first month in the Chinese lunar New Year calendar. The trigram signifies the end of winter and the coming of spring, when all beings will revive and restore prosperity. Therefore ancient people often used *yang (*goat) as a pun for *yang* (prosperity).

Such a conjoined vase was known as "*hehuan* vase (vase with double-happiness)" in the archive of the Qing Dynasty. It was a popular form of Qianlong imperial wares and was much favoured by Emperor Qianlong.

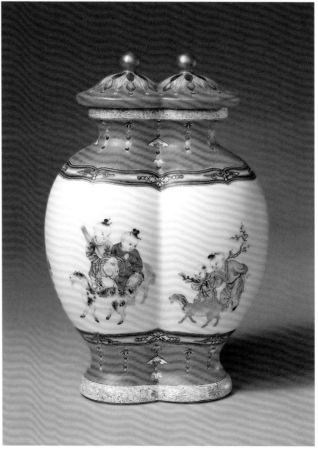

185

Vase with Three Lobes
and decorated with applique design of three children in *yangcai* enamels

Qing Dynasty Qianlong period

Height 21.1 cm
Diameter of Mouth 5.8 cm
Diameter of Foot 7.9 cm
Qing court collection

The vase is fashioned with three lobes and has a flared mouth, a long neck, a round belly, and a splayed ring foot. The exterior wall of the vase is decorated with applique design of three children playing with a ribbon hanging from the neck to the shoulder. The mouth rim is painted in red and underneath is decoration of banana leaves. The dresses of the children are painted in red, yellow, light blue, light green, light pink, and others. The interior of the vase and the ring foot is covered with turquoise-green glaze. The exterior base is written with a six-character mark of Qianlong in seal script in three columns in underglaze blue in a reserved white square.

In the archive of the Qing Dynasty, such vases were known as "vases with three children" which was designed and produced under the supervision of Tang Ying, the Director General of the Imperial Kiln. Other variations include vases with five children. In accordance with the document *Qinggong Neiwufu Zaobanchu Ge Zuocheng Zuohuo Jiqingdang* Dynasty, Emperor Qianlong had commissioned Tang Ying to produce fifty pieces of vases with three children or five children in the fourth month of the 24th year of the Qianlong period and had them sent to the Palace of Summer Resort at Chengde for bestowing to officials as gifts.

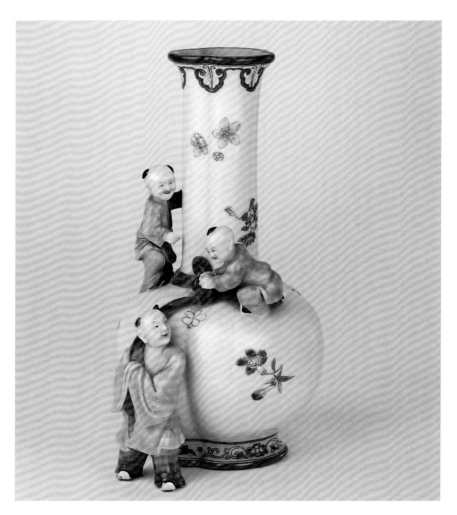

186

Zun Vase with Ears in the Shape of Goats
in imitation of archaic bronze wares and decorated in *yangcai* enamels

Qing Dynasty Qianlong period

Height 21.8 cm
Diameter of Mouth 13.2 cm
Diameter of Foot 11.7 cm
Qing court collection

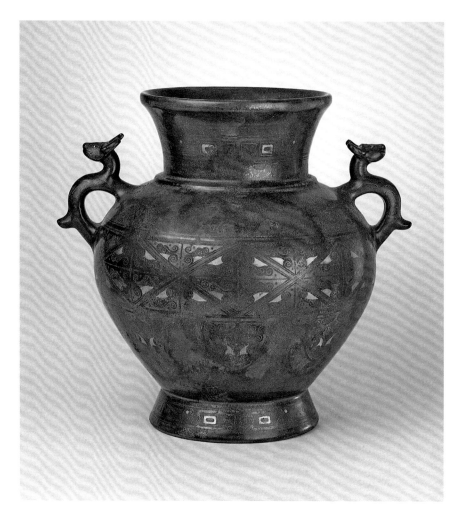

The *zun* was imitated from the form of the bronze *zun* wine-container with ears in the shape of goats and decorated with gold-and-silver inlaid designs of the Warring States period. It has a round rim, a flared mouth, a wide neck tapering downwards, a slanting shoulder, a globular belly, and a splayed ring foot. On the two symmetrical sides of the shoulder is a pair of ears in the shape of goats. The body is decorated with imitated bronze tint and gold-and-silver inlaid designs in different opaque colour enamels, which are very similar to the original. The interior of the ring foot is also enamelled in imitation of ancient bronze tint. The exterior base is written with a six-character mark of Qianlong in relief-style seal script in three columns within a double-line square, and the outlines of the square and mark are written in gilt.

Bronze *zun* wine-container was a kind of wine-container in large or middle size in the Shang and Zhou Dynasties. The form and colour of this vase is very close to its original prototype, and it is difficult to differentiate if not touched by hand, thus revealing the superb production techniques of the Imperial Kiln at Jingdezhen in the Qianlong period.

187

Square Vase
decorated with design of landscapes and imperial poems in *yangcai* enamels

Qing Dynasty Qianlong period

Height 37.5 cm
Diameter of Mouth 10.1 cm
Diameter of Foot 12 cm
Qing court collection

The square vase has a flared mouth, a narrow neck, a long belly, and a splayed square ring foot. The four sides of the exterior wall are decorated with rectangular panels with angular corners in gilt. On two panels opposite to each other are painted with designs of landscapes, terraces and mansions, trees, and streams amidst clouds with a serene and peaceful ambience. On another two panels opposite to each other are inscriptions of imperial poems written by Emperor Qianlong, including *Inscribed Poems for the Paintings by Muxi* and *Inscribed Poem for the Handscroll of Immortal Mountains and Terraces by Zhao Boju*. At the end of the poems are a intaglio-style mark *Qianlong* and a relief-style mark *zhenhan* in seal script in iron-

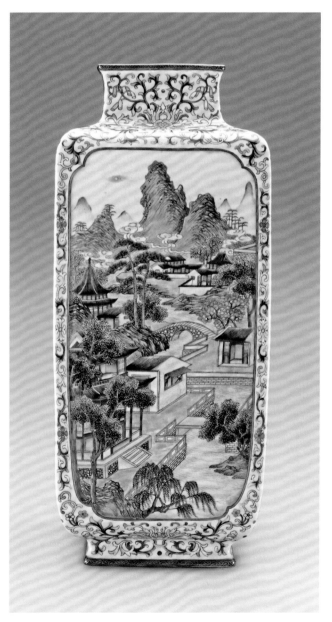

red. Outside the panels are decorations of lotuses in opaque colour enamels painted in the western style. The interior of the vase and the ring foot are covered with turquoise-green glaze. The exterior base is written with a six-character mark of Qianlong in seal script in three columns in iron red in a reserved white square.

This vase is one of the pair originally displayed at the Lijing Studio at the rear hall of the Chuxiu Palace. One of the distinctive features of the imperial *yangcai* wares of the Qianlong period are the inscriptions of the imperial poems written by Emperor Qianlong himself, showing his personal favour for this type of wares.

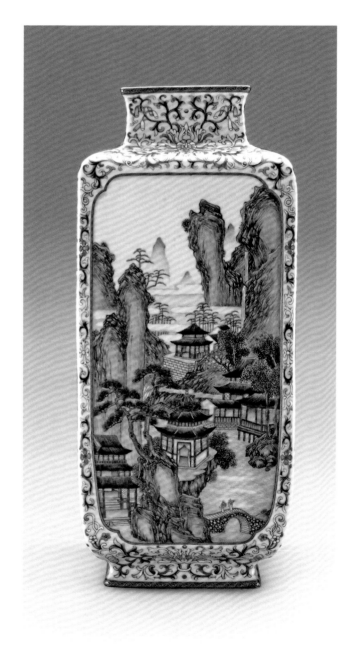

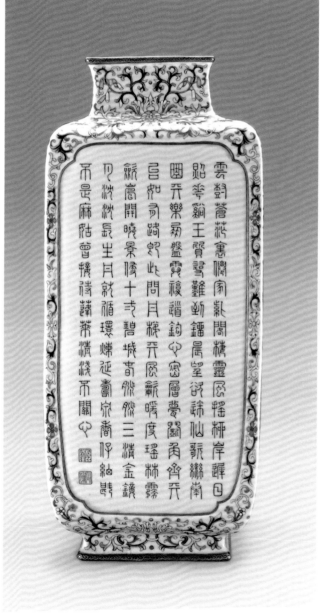

188

Zun Vase with Two Ears
and decorated with a hundred deer in *yangcai* enamels

Qing Dynasty Qianlong period

Height 45 cm
Diameter of Mouth 24.2 cm
Diameter of Foot 16 cm
Qing court collection

The *zun* vase has a slightly flared mouth widening downwards, a hanging belly, and a ring foot. On the two symmetrical sides of the shoulder is a pair of ears in the shape of *chi*-dragons. The body is decorated with a hundred deer strolling amidst landscapes. They are depicted in various postures, such as running, standing, leaning against each other, resting beside the streams, or under pines and cypresses in opaque enamels. The exterior base is written with a six-character mark of Qianlong in seal script in three columns in underglaze blue.

The decorative motifs on the imperial wares of the Qing Dynasty often carry auspicious meanings or tributes, as shown by this *zun* vase. *Lu* (deer) is a pun for *lu* (success or promotion in official career), and thus the decoration of a hundred deer carries the blessing for promotion in officialdom.

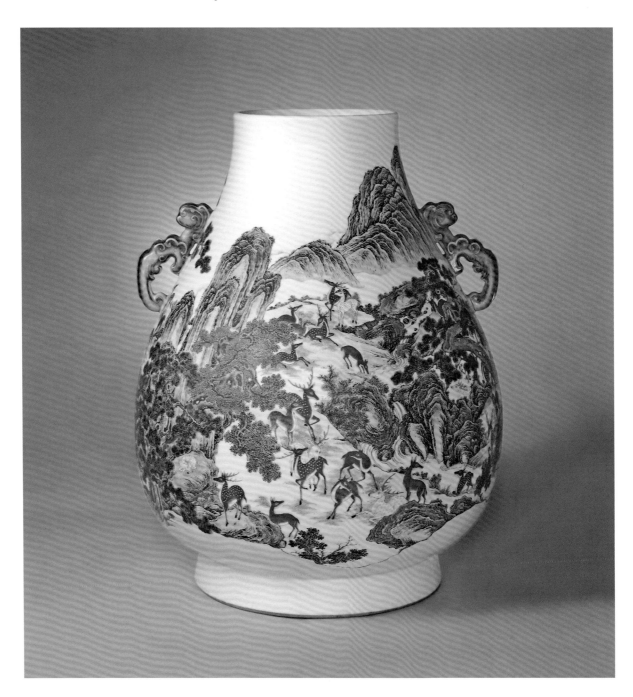

This *zun* vase was a decorative object of the Qing court. As it is decorated with a hundred deer painted in western style and has ears, it was known as "*zun* vase with two ears and a hundred deer in *yangcai* enamels" in the archive of the Qing palace. If it is inverted, the form looks like a deer's head, and thus it is also known as "*zun* vase in the shape of a deer's head." In accordance with the document *Qinggong Neiwufu Zaobanchu Ge Zuocheng Zuohuo Jiqingdang* (Jiangxi province) in the third year of the Qianlong period (1738), Emperor Qianlong had also commissioned the production of these *zun* vases without ears. Extant wares of this type reveal that there are two types, either with or without ears, but there are more produced with ears extant.

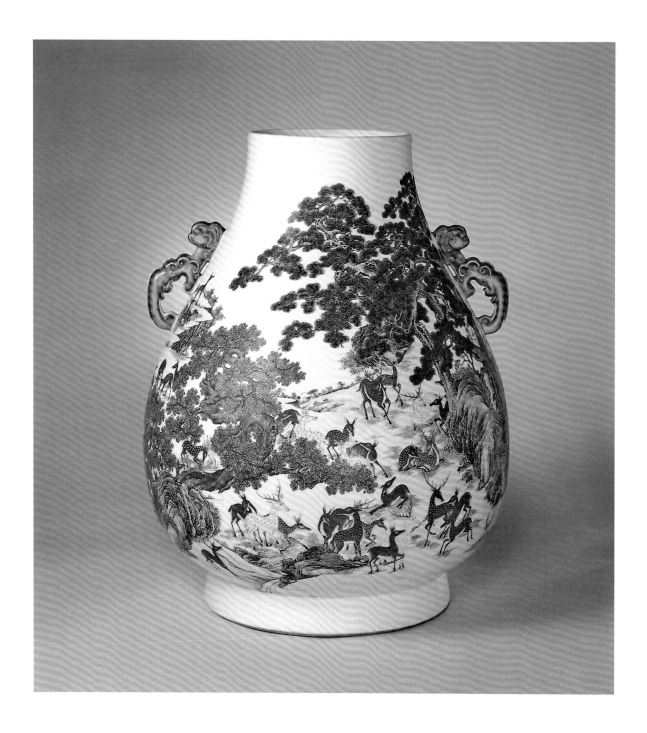

189

Duomu Pitcher
decorated with design of eight Buddhist Emblems supported by lotus scrolls in *yangcai* enamels

Qing Dynasty Qianlong period

Overall Height 47 cm
Diameter of Mouth 9.7 cm
Diameter of Foot 14 cm
Qing court collection

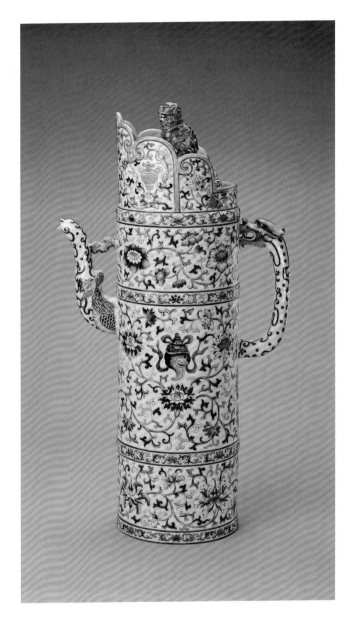

The vase is in the shape of a tube and has a mouth in the shape of a monk's cap, and a ring foot. On the two sides of the body are a dragon-shaped handle and a phoenix-shaped spout respectively. It has a matching canopy-shaped cover on which is a lion-shaped knob. The body is separated by coloured borders into four sections. The mouth and the middle belly are decorated with eight Buddhist Emblems supported by lotus scrolls, whereas the other two sections are decorated with foreign chrysanthemums and lotus scrolls. The interior of the pitcher and the interior of the ring foot are covered with turquoise-green glaze. The exterior base is written with a six-character mark of Qianlong in seal script in three columns in underglaze blue in a reserved white square.

The *duomu* pitcher is a popular drinking vessel of the Mongolian and Tibetan tribes. It appeared as early as the Yuan Dynasty and is still in use at present. *Duomu* was translated from the Mongolian and Tibetan language, and its meaning refers to "tube" or "vase." It is a utensil for drinking tea mixed with milk, or tea mixed with lamb's milk. It was originally produced with wood, but later they were also produced in cloisonné, porcelain, and other materials. In the Kangxi, Yongzheng, and Qianlong periods, these wares were massively produced for use in court banquets, ceremonies, and as gifts. In particular during banquets with Mongolian or Tibetan leaders, the vases must be used in order to show respect and enhance the friendship between the Qing court and these minority tribes.

190

Teapot

decorated with a scene of brewing tea, floral
patterns and imperial poems
in *yangcai* enamels

Qing Dynasty Qianlong period

Overall Height 12.6 cm
Diameter of Mouth 5.5 cm
Diameter of Foot 6.3 cm
Qing court collection

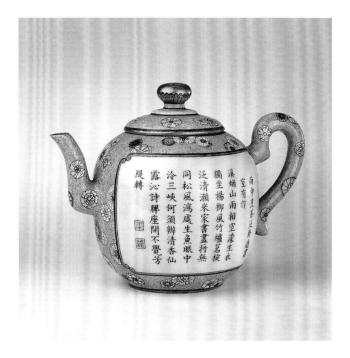

The teapot has a rimmed mouth, a short neck, a slanting shoul-
der, a globular belly, and a ring foot. On the two sides of the belly
are a curved spout and a handle. It has a matching cover on which
is a tourmaline knob. On each of the two sides of the belly is a
panel with angular corners. One panel is decorated with a scene of
Brewing Tea in Rain. In a pavilion, a scholar is sitting on the mat
and watching two attendants brewing tea. Outside the pavilion are
banana trees and rocks in misty rain. The other panel is decorated
with the imperial poem *Touring on the Boat Woyou Shushi* written
by Emperor Qianlong. At the end of the poem are an intaglio-style
seal mark *qian* in seal script and a relief-style seal mark *long* in
seal script in iron-red. Outside the panels are decorations of foliage
scrolls painted in a meticulous manner to form the ground, on which
are floral medallions. The spout, handle, and cover are also decorat-
ed with similar designs. The interior of the teapot and the ring foot
is covered with turquoise-green glaze. The exterior base is written
with a six-character mark of Qianlong in seal script in three columns
in underglaze blue in a reserved white square.

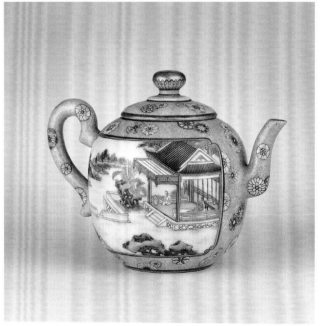

The teapot is potted in a graceful form and decorated with
elegant designs by combining poetic inscriptions and painted dec-
orations matching each other. W*oyou shushi* was the name of the
imperial touring boat. In the seventh year of the Qianlong period
(1742), Emperor Qianlong toured on this boat for viewing sceneries,
and the poem was written when he enjoyed tea during the tour. The
same poem could also be found on Yixing purple-clay tea wares
exclusively produced for the use of the court.

191

Plate
decorated with design of sculptural applique crab and fruits in *yangcai* enamels

Qing Dynasty Qianlong period

Height 6.5 cm
Diameter of Mouth 22 cm
Diameter of Foot 12.3 cm
Qing court collection

The plate has an everted rim, a shallow curved wall, and a ring foot. Inside the plate are applique decorations of fruits and a crab sculptured in naturalistic forms. Besides a crawling crab are nuts, a red date, water chestnuts, a pomegranate, peanuts, lotus seeds, melon seeds, cherries, and a water caltrop, etc. The rim is decorated with lotus scrolls in white enamel. The exterior base is written with a six-character mark of Qianlong in seal script in three columns in underglaze blue.

The decorative elements inside the plate or their groupings carry auspicious meanings. The crab with the pun *yijia* or *huangjia* symbolizes success in the Civil Services Examination. Pomegranate symbolizes progeny, and the grouping of the red date, peanuts, and melon seeds means giving birth to sons.

Naturalistic sculpturing aims to reproduce the motifs similar to their original forms and textures. The various decorative elements inside the plate look like the originals, and can hardly be differentiated by just looking, which reveal the superb ceramic production technique of the Imperial Kiln at Jingdezhen in the Qianlong period.

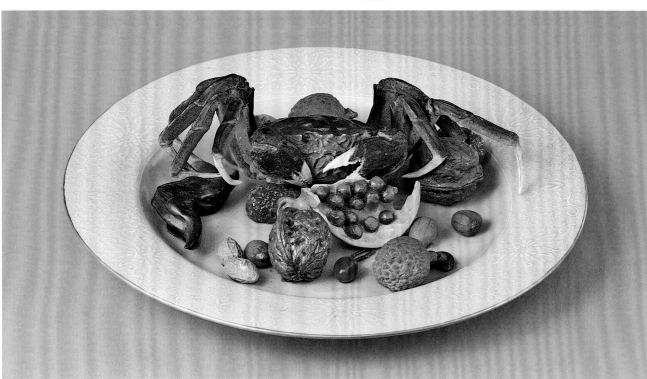

192

Square Teapot
decorated with landscapes and imperial poems in panels on an incised floral brocade ground in *yangcai* enamels on a yellow ground

Qing Dynasty Qianlong period

Overall Height 15.9 cm
Diameter of Mouth 6 cm
Diameter of Foot 6.2 cm
Qing court collection

The square teapot has a flared square ring foot, and on the symmetrical sides of the belly are a curved spout and a curved handle. It has a matching canopy-shaped cover in three tiers, on which is a tourmaline round knob. On each of the four sides at the belly is a panel. The two side panels are decorated with landscapes, terraces, and towers as well as imperial poetic couplets written by Emperor Qianlong in black enamel. At the end of the one poem are the two relief-style seal marks *Qianlong* and *chenhan* in seal script in iron-red, and at the end of another poetic couplet is a relief-style seal mark *Qianlong* in seal script in iron-red. The two front panels are decorated with sprays of plum blossoms and Chinese roses respectively. Outside the panels are incised designs of foreign flowers on a red ground. The incised ground of the cover is decorated with painted designs of chrysanthemums, lotus lappets, and deformed foliated patterns. The interior of the vase and the square ring foot is covered with turquoise-green glaze. The exterior base is written with a four-character mark of Qianlong in seal script within a double-line square in blue.

The Imperial Archive mentioned that the technique of incising foliated patterns with an awl in an extremely meticulous manner was known as "floral brocade ground," which was a new decorative technique in the Qianlong period.

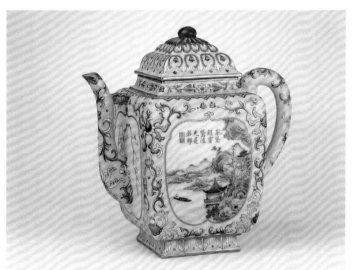

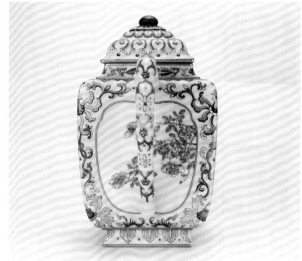

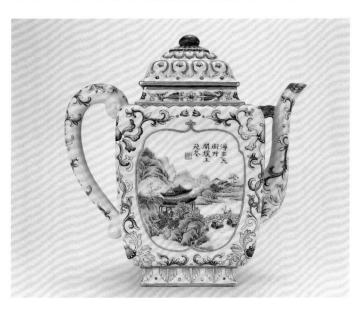

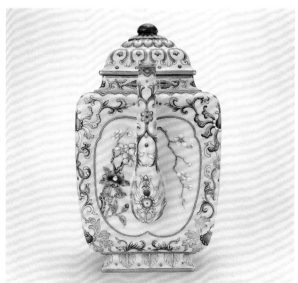

193

Openwork Lampshade
decorated with panels of
insects and a brocade
ground with red bats
in *yangcai* enamels
on a yellow ground

Qing Dynasty Qianlong period

Height 29.7 cm
Diameter of Mouth 10.8 cm
Diameter of Foot 11.2 cm
Qing court collection

The lampshade has an upright mouth, a tubular belly, and a ring foot. The size of the mouth and the foot are similar. The neck and the exterior wall of the ring foot are decorated with floral sprays in *yangcai* enamels on a yellow ground. On the shoulder and near the foot are decorations of openwork design of deformed lotus petals on an iron-red ground. The belly is decorated with four oval-shaped panels, bordered by chrysanthemum patterns in *yangcai* enamel on a blue ground. Inside the panels are designs of butterflies, insects, and flowers of the four seasons in *yangcai* enamels on a white ground. Outside the panels are openwork designs of brocade patterns on which bats are painted in iron-red.

The openwork lampshade is fashioned in an exquisite form with delicately painted decorative designs. The aesthetic effect of these designs would become more eminent when the lamp is lit.

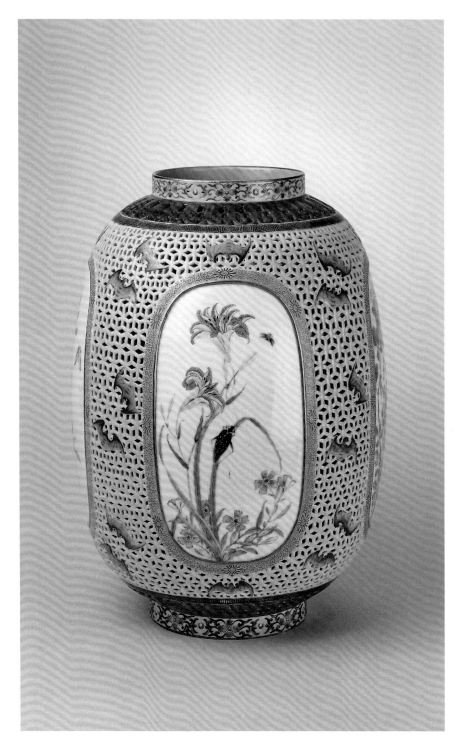

194

Food Bowl
decorated with design of landscapes in panels in *yangcai* enamels on an incised floral brocade ground in yellow

Qing Dynasty Qianlong period

Height 6.8 cm
Diameter of Mouth 15 cm
Diameter of Foot 5.4 cm

The bowl has a flared mouth, a deep curved wall, and a ring foot. The interior base is decorated with Indian lotus scrolls. The exterior wall is decorated with four round panels, in which different scenes of landscapes are painted. Outside the panels is an incised floral brocade ground in yellow, on which are decorations of foreign flowers. The interior of the ring foot is covered with white glaze. The exterior base is written with a six-character mark of Qianlong in seal script in three columns in underglaze blue.

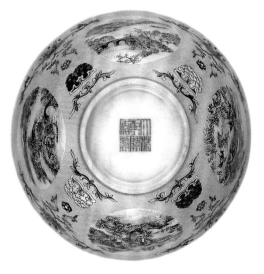

In accordance with different coloured grounds, this type of bowls with designs of landscapes in four round panels can further be classified into three sub-types: rouge-red ground, light yellow ground, and blue ground (also known as jade-coloured ground in the Qing archive). In the Qing archive, bowls with a mouth diameter at around 15 cm were known as "*shanwan*" (food bowl), and bowls with a mouth diameter of around 13 cm were known as "*tangwan*" (soup bowl). From the *Qinggong Neiwufu Zaobanchu Ge Zuocheng Zuohuo Jiqingdang*, most of these bowls were produced from the sixth year to the eighth year of the Qianlong period, and they were known as "food (or soup) bowl with incised (blue, jade-colour, or yellow) floral brocaded ground in red and landscape designs in *yangcai* enamels," or simply "food (or soup) bowl with incised red (blue, jade-colour, or yellow) floral brocaded ground and decorations in *yangcai* enamels." Emperor Qianlong had a strong interest in this type of *yangcai* wares, and had commissioned boxes specially made for keeping them for the collection of the Qianqing Palace.

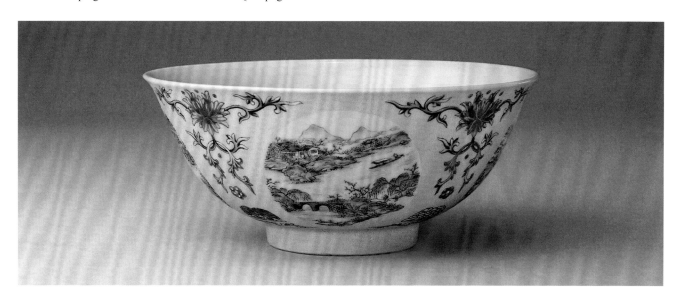

195

Jue Wine-cup on a Plate
decorated with design of unified rivers and mountains and archaic patterns on bronze wares in *yangcai* enamels on an incised floral brocade ground in rouge-red

Qing Dynasty Qianlong period

Overall Height 13.4 cm
Diameter of plate's mouth 11.6 cm
Diameter of plate's foot 6 cm
Qing court collection

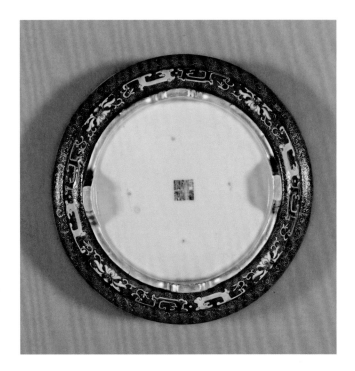

The vessel is produced in the shape of a *jue* wine-cup with a supporting plate with its form and decorations in imitation of ancient bronze wares. In addition to the mountain-shaped protruding support from the three-legged base, the interior and the exterior of the plate and the exterior wall of the *jue* wine-cup are decorated with a ground in rouge-red, which is further incised with meticulous foliage scrolls with an awl. On the ground are various decorative motifs from ancient bronze wares, such as *kui*-dragons and others. On the protruding support at the three-legged plate are decorations of cresting waves and cliff. There are fitting grooves on the plate for inserting the three legs of the *jue* wine-cup. The interior, the exterior base of the *jue* wine-cup, and the exterior base of the plate are covered with turquoise-green glaze. Both the centre of the exterior base of the *jue* wine-cup and the exterior base of the supporting plate are written with a four-character mark of Qianlong in seal script in underglaze blue inside a reserved white square.

This type of wares in the shape of *jue* wine-cup with a plate and decorated with the design of cresting waves, cliffs, and dragons amidst clouds was first produced among the underglaze blue wares of the Yongle period, Ming Dynasty. In the Qing archive of the Qianlong period, there were known as "*jue* wine-cup with a plate and decorated with design of unified rivers and mountains," and were represented in wares in *yangcai* enamels on a yellow ground, *yangcai* enamels on a red ground and underglaze blue.

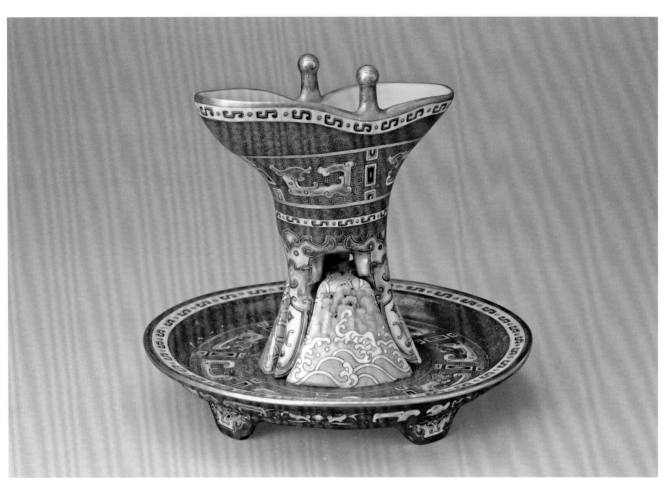

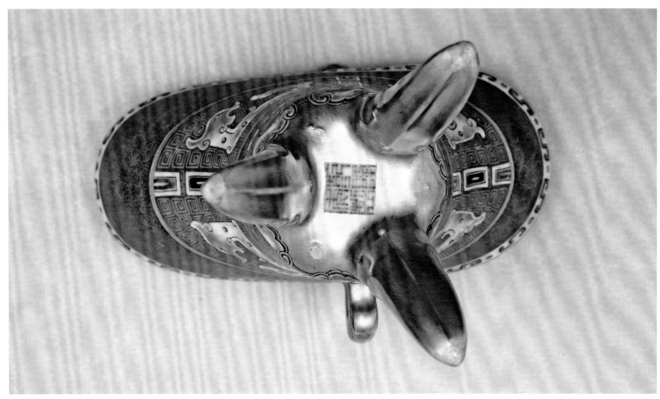

196

Bowl
decorated with design of landscapes in panels in *yangcai* enamels on an incised floral brocade ground in rouge-red

Qing Dynasty Qianlong period

Height 5 cm
Diameter of Mouth 13.5 cm
Diameter of Foot 5 cm

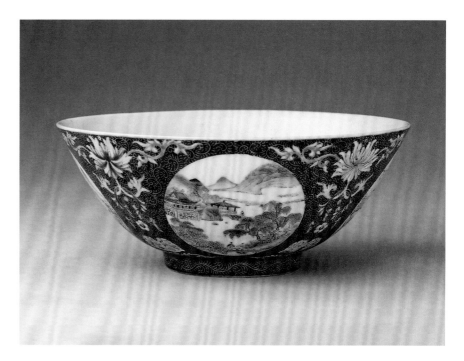

The bowl has an everted mouth, a deep curved belly and a ring foot. The interior is covered with white glaze. The exterior wall is decorated with four round panels in which different scenes of landscapes are painted. Outside the panels is a rouge-red ground with incised floral brocade patterns, on which are decorations of foreign flowers. The interior of the ring foot is covered with white glaze. The exterior base is written with a mark of Qianlong in seal script in three columns in underglaze blue.

There were various types of this kind of bowls with a red, blue, or yellow ground, and most of which were produced from the sixth to the eighth year of the Qianlong period.

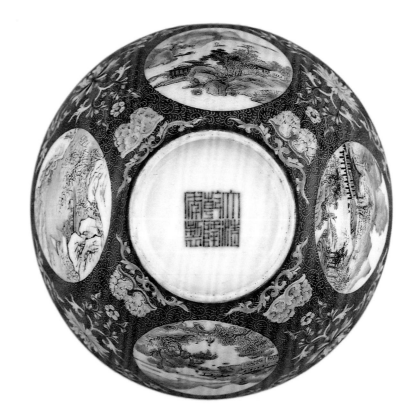

197

Cage for Gold Bell Flies in the Shape of a Book Case

and decorated with lotus scrolls in gilt and *yangcai* enamels on a coral-red ground

Qing Dynasty Qianlong period

Overall Height 14 cm
Length 20.5 cm
Width 11.7 cm
Qing court collection

The cage is in rectangular shape with a hollow interior. The form is modelled after the ancient book case for containing thread-bound books with a brocade cloth wrapping. The body is fully decorated with lotus scrolls in gilt and *yangcai* enamels on a coral-red ground. On the top left corner is an inscription "*Leshantang* (Leshan Studio)" in ink. In the middle part of the cage is a pair of porcelain seals with double convex knobs and a round porcelain seal-paste box, which can be inserted into a rectangular groove linking to the book case. After taking out the seals, the gold bell flies kept inside the cage could be fed. In the seal-paste box are various types of naturalistic porcelain fruits such as cherries, peanuts, lotus seeds, melon seeds, etc. There are five holes at the base of the case which are linked to the container's body. After the cover of the cage is removed, the crisp sound of the gold bell flies could be released and heard. The cage base is covered with turquoise-green glaze and reserved white in the centre, in which is a six-character mark of Qianlong written in seal script in red.

The form of this cage was modelled after the book case with the books *Leshantang Quanji* which collected all poems and writings by Emperor Qianlong during his young age. This piece could be used as a stationary item as well as a cage for breeding insects. The "gold bell fly," genus Gryllidae of Orthopetra, belongs to the same genus of crickets. It is a small insect with a crisp sound like gold bell chimes and was commonly bred by people in the past for amusement purpose.

198

Vase with a Reticulating Neck
and decorated with landscapes and imperial poems in panels in *yangcai* enamels on an incised floral brocade ground in blue

Qing Dynasty Qianlong period

Height 24.6 cm
Diameter of Mouth 12.6 cm
Diameter of Foot 11.9 cm
Qing court collection

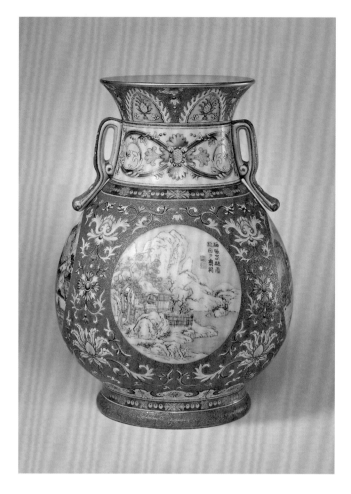

The vase has a flared mouth, a reticulating short and narrow neck, a slanting shoulder, a globular belly, and a splayed ring foot. On the two symmetrical sides of the neck are two ears in the shape of hanging ribbons. The mouth rim is painted in gilt. From the top to the bottom, the neck is decorated with deformed banana leaves on an incised floral brocade ground in blue, foreign flowers on a light yellow ground, and foreign flowers in gilt on an iron-red ground respectively. The belly is decorated with four round panels, in which scenes of landscapes of the four seasons are painted, and matched by imperial poems by Emperor Qianlong. The poem describing spring is quoted from the *Poems for Inscribing the Twelve Album Leaves of Figure Paintings by the Painter Jiao Bingzhen.* The poem describing summer is quoted from *Scenes in the Summer Garden Retreat.* From where the poem describing autumn was quoted still needs further study, and the poem describing winter is quoted from *Winter Night.* At the end of each poem are the relief-style square seal mark *Qianlong chenhan* and intaglio-style square seal mark *weimiaojingjin* in iron-red. The interior of the vase and the ring foot are covered with turquoise-green glaze. The exterior base is written with a six-character mark of Qianlong in seal script in three columns in underglaze in a reserved white square.

The most significant feature of the vase is that the neck could be reticulated. When it was displayed, people could turn the vase with the appropriate scene to the frontal side to match the current season, and then reticulate the neck so that the ears would also match the position of the vase to facilitate viewing and appreciation of the matching seasonal scene.

199

Brush Pot

decorated with the design of characters of
"tiangan, dizhi" in gourds with gourd flower
scrolls, bats, cranes and clouds
in *yangcai* enamels
on an incised floral brocade ground in blue

Qing Dynasty Qianlong period

Height 12.8 cm
Diameter of Mouth 10.7 cm
Diameter of Foot 10.7 cm
Qing court collection

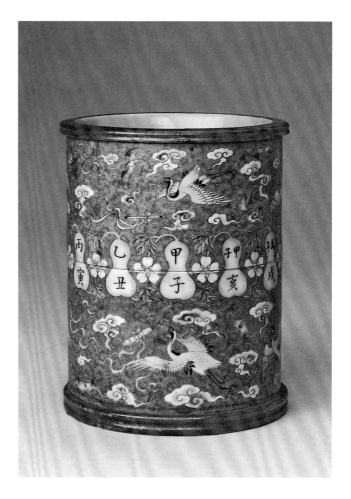

The brush pot is in the shape of a straight tube, with rims on the mouth and the foot, and a ring foot. The exterior base is in the shape of a jade *bi* disc. The rims of the mouth and foot are painted in gilt on an iron-red ground. The waist of the brush pot is decorated gourds interspersed by gourd flowers. The upper halves of the gourds are written with the characters *jia*, *yi*, *bing*, *ding*, *wu*, *ji*, *geng*, *xin*, *ren*, *gui* of the ten heavenly stems, *jiazi*, and *wannian*. The lower halves of the gourds are written with the characters *zi*, *chou*, *yin*, *mao*, *chen*, *si*, *wu*, *wei*, *shen*, *you*, *xu*, *hai* of the earthly branches. Other areas are decorated with auspicious clouds, cranes, and bats on an incised floral brocade ground in blue. The interior of the brush pot is covered with turquoise-green glaze. The interior of the ring foot is covered with white glaze. The exterior base is written with a six-character mark of Qianlong in seal script in three columns in underglaze blue.

The upper part of the brush pot could be moved so that the position of the ten heavenly stems can match the earthly stems to mark the Chinese calendar year. This system was the Chinese chronicle system, which starts with the combination of *jiazi* (jia from the heavenly stems matches with *zi* from the earthly branches) and the cycle is repeated every sixty years with different combinations in sequence. The court archive recorded that in the memorial submitted to the Emperor Qianlong by Tang Ying, Director General of the Imperial Kiln on the first day of the 12th month of the 8th year of the Qianlong period (1743), he pointed out the next year would be the "*jiazi*" year, and thus this brush pot was produced as a tributary stationary item to the emperor.

200

Vase with a Flared Mouth
and decorated with design of lotuses, peonies and imperial poems in panels in *yangcai* enamels on a green ground

Qing Dynasty Qianlong period

Height 33.5 cm
Diameter of Mouth 11.7 cm
Diameter of Foot 11.6 cm

The vase has a flared mouth, a short neck, a slanting belly, and a splayed ring foot. The mouth rim is painted in gilt and underneath is decorations of *ruyi* cloud patterns. The belly is painted with four rectangular panels with angular corners. Two panels opposite to each other are decorated with lotuses and peonies, and the other two panels are decorated with the imperial poems *Lotuses* and *Pines and Peonies* written by Emperor Qianlong to match the floral panels. The ground outside the panels is painted in green, and decorated with foreign flowers interspersed by *ruyi* cloud patterns, bats, twin-fish, *wan* swastika patterns, and other designs. Near the foot are decorations of deformed lotus petals. The interior of the vase and the ring foot is covered with turquoise-green glaze. The exterior base is written with a six-character mark of Qianlong seal script in iron-red in a reserved white square.

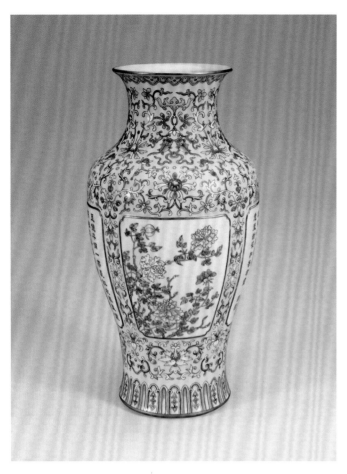
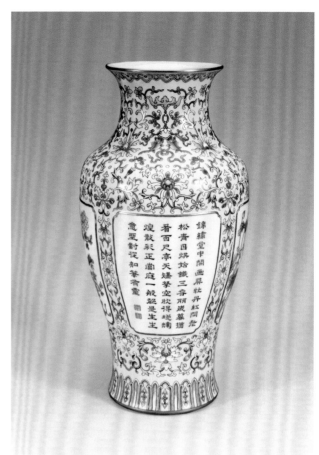
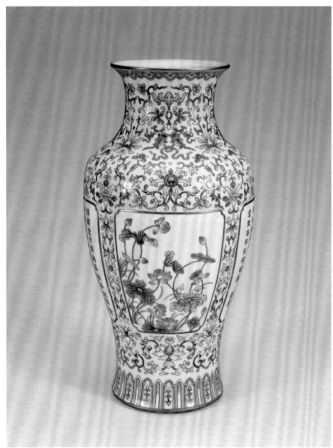
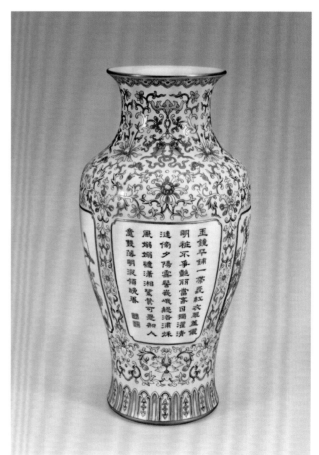

201

A Pair of Hanging Gourd-shaped Vases

decorated with design of landscapes in panels and imperial poems in *yangcai* enamels on a turquoise-green ground

Qing Dynasty Qianlong period

Height 20.4 cm
Diameter of Mouth 3.8 × 2.4 cm
Diameter of Foot 6.2 × 2.3 cm
Qing court collection

The shape and decorative designs on this pair of half-gourd-shaped vases are similar. The vases have flared mouths, semi-round flared foots with their backs flat, and three concave grooves for hanging on the wall respectively. The upper and lower belly of each vase is decorated with a panel respectively. Inside each of the upper panel is a poetic couplet "Clouds shade the phoenix tower with pines around, auspicious tributes gather at the immortal lands with grasses beside" written by Emperor Qianlong and painted in black. At the beginning of each poem is a seal mark *yuzhi* in seal script written in black, and at the end is an intaglio-style seal mark *qian* and relief-style seal mark *long* in iron-red. Inside the lower belly are the designs of landscapes, pavilions, and streams painted in a delicate manner with perspective. The interior of the vases and the interior of half-round bases are covered with turquoise-green glaze. The exterior base of each vase is written with a horizontal six-character mark of Qianlong in seal script in iron-red in a reserved white rectangle.

In the Qing archive, this type of vases was known as "vases with poetic charm for sedan chairs." They were used for hanging in sedan chairs for decorative purposes, or could also be used as flower pots to decorate the wall of a studio, and thus they were also known as "wall-hang vases."

202

Vase
decorated with design of lotus and floral medallions in *yangcai* enamels on a rice-white ground

Qing Dynasty Qianlong period

Height 20.5 cm
Diameter of Mouth 5.1 cm
Diameter of Foot 5.7 cm
Qing court collection

The vase has a flared mouth, a narrow neck, a slanting shoulder, a long and round belly, and a splayed ring foot. The body is fully decorated with various layers of bead chains, floral patterns, foliated scrolls, and cloud collars. The principal designs at the belly are four floral medallions painted in the western style, and interspersed by lotuses and bead chains. The interior of the vase and the ring foot is covered with rice-white glaze. The exterior base is written with a six-character mark of Qianlong in seal script in three columns in gilt.

According to *Qinggong Neiwufu Zaobanchu Ge Zuocheng Zuohuo Jiqingdang,* (*Qianqing Palace*), this vase was known as "*Guanyin* vase decorated with design of lotuses and floral medallions in *yangcai* enamels on a rice-white ground," which was produced in the eighth year of the Qianlong period (1743) and collected in the Qianqing Palace.

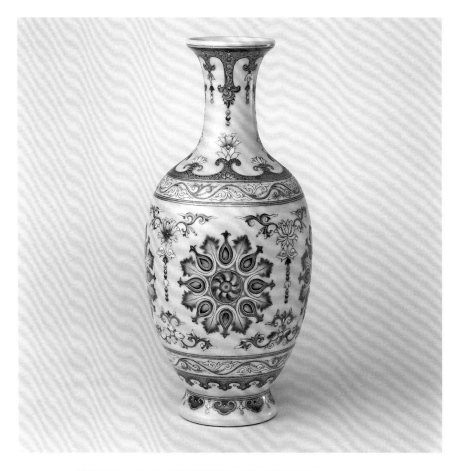

203

Vase with a Lotus-shaped Mouth
and decorated with design of landscapes
in panels and imperial poems
in *yangcai* enamels on a pea-green ground

Qing Dynasty Qianlong period

Height 26 cm
Diameter of Mouth 12.1 cm
Diameter of Foot 12.1 cm

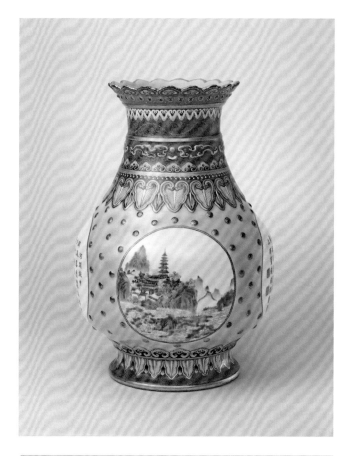

The vase has a lotus-shaped mouth, a narrow neck, a slanting shoulder, a globular belly, and a splayed ring foot. The neck and the area near the foot are decorated with incised floral brocade grounds in rouge-red and blue, on which are decorations of banana leaves, *ruyi* cloud lappets, *kui*-dragons, and drum-nails in relief. The ground of the belly is enamelled in pea-green with nipple patterns painted in gilt, on which are four round panels. Inside two panels opposite to each other are designs of the scenes of the pagoda of the Kaifu Monastery at Jingzhou. Each of the other two panels is decorated with an imperial poem in clerical script in black written by Emperor Qianlong. One of them is *Hejian Daozhong,* which praises the two celebrities in Hejian, including Mao Heng who wrote annotations for the *Classic of Poems* (*Shijing*) and Liu An (King Xian of Hejian) who submitted the ancient classics *Maoshi* and *Zuochuan* to the court in the early Western Han Dynasty. At the end of the poem are a relief-style seal mark *Qianlong yushang* and an intaglio-style seal mark *dejiaqu* in seal script in iron-red. Another poem is *Walk up to the Pagoda of the Kaifu Monasty at Jingzhou* which describes viewing of the scenery around at the pagoda. At the end are a relief-style seal mark *Qianglong chenhan* and an intaglio-style seal mark *weijingweiyi* in seal script in iron-red. The interior of the vase and the ring foot is covered with turquoise-green glaze. The exterior base is written with a six-character mark of Qianlong written in seal script in three columns in underglaze blue in a reserved-white square.

Jingzhou is the Jing county at Hebei nowadays. In the Qing Dynasty, it was under the jurisdiction of the Hejian Prefecture. The pagoda at Kaifu Monastery was built in the Northern Wei Dynasty, and renovated in the Northern Song Dynasty, which was a landmark architecture. During the possession tour to the South in the 16th year of the Qianlong period (1751) by Emperor Qianlong, he visited this pagoda, and the two poems were written at that occasion.

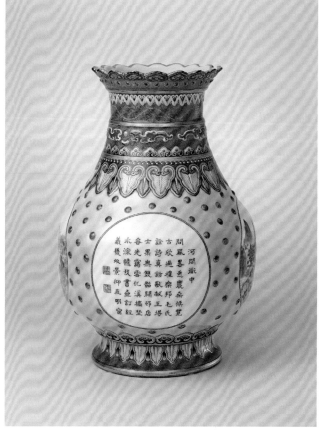

204

Vase
decorated with design of egret in a lotus pond and imperial poems in *yangcai* enamels on a gilt ground

Qing Dynasty Qianlong period

Height 28.1 cm
Diameter of Mouth 7.8 cm
Diameter of Foot 6.8 cm
Qing court collection

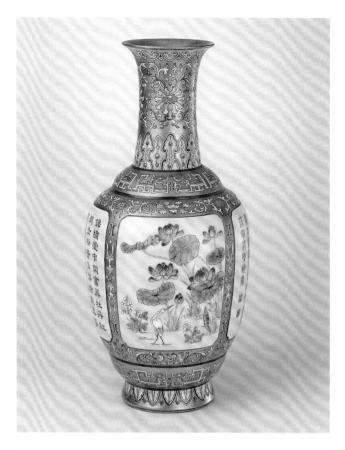

The vase has a flared mouth, a long neck, a slanting shoulder, a round hanging belly, and a splayed ring foot. The shoulder and the area near the foot are in the shape of two tiers. Underneath the mouth rim are decorations of *ruyi* cloud lappets. The middle part of the neck is decorated with lotuses, and the lower part of the neck and the exterior wall of the ring foot are decorated with upright and inverted banana leaves respectively. The shoulder and the area near the base are decorated with *kui*-dragons. The belly is decorated with four rectangular panels with angular corners. Inside two panels opposite to each other are decorations of an egret in a lotus pond, and pines and peonies respectively. The other two panels are decorated with the imperial poems written by Emperor Qianlong in clerical script in black. One poem is *Lotus*, and at the end are an intaglio-style seal mark *chen* and a relief-style seal mark *han* in seal script in iron-red. The other poem is *Pines and Peonies*, and at the end is an intaglio-style seal mark *qian* and a relief-style seal mark *long* in seal script in iron-red. Outside the panels are decorations of foreign flowers on a gilt ground. The interior of the vase and the ring foot are covered with gilt enamel. The exterior base is carved with the mark of Qianlong in seal script in three columns in relief.

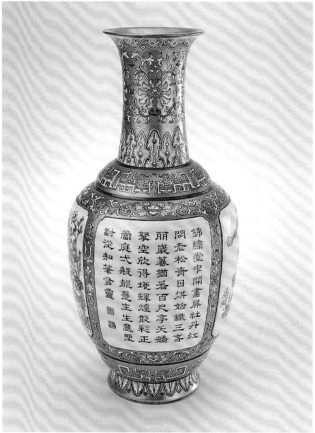

205

Large Vase

decorated with design of
flowers and imperial poems
in *yangcai* enamels
on a white ground and
designs painted in gilt
on a sky-clear blue ground

Qing Dynasty Qianlong period

Height 64.7 cm
Diameter of Mouth 22.2 cm
Diameter of Foot 20.4 cm
Qing court collection

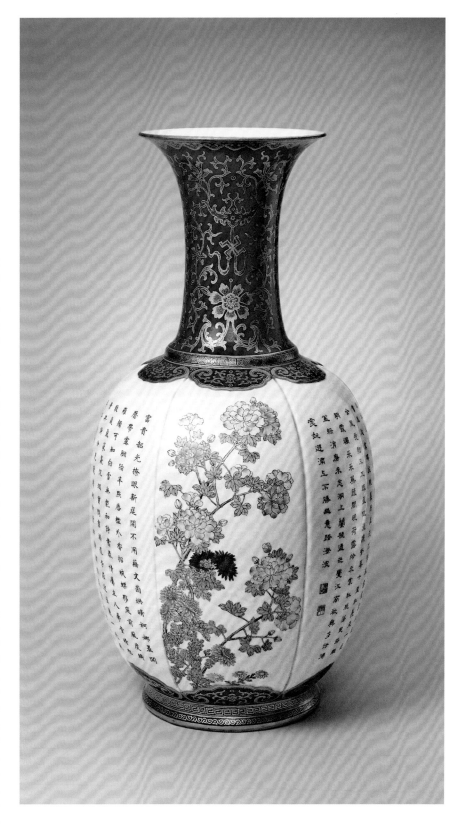

The vase has a flared mouth, a long narrow neck, a globular belly in the shape of six melon lobes, and a splayed ring foot. Near the foot and at the exterior wall of the ring foot are various designs painted in gilt on a sky-clear blue ground. Underneath the mouth are decorations of *ruyi* cloud lappets. The neck is decorated with foreign flowers and bats holding ribbons on which hang the *wan* swastika patterns. Near the foot are decorations of *ruyi* cloud lappets in which are foreign flowers. The exterior wall of the ring foot is decorated with key-fret patterns and foliated scrolls. The six lobed sides on the belly are decorated with peonies, hibiscus, and pomegranate flowers interspersed by three imperial poems by Emperor Qianlong. The poems are written in regular, seal, and clerical scripts in sepia ink respectively. The interior of the ring foot is covered with white glaze.

This is one of a pair of large vases originally displayed at the Cining Palace. The imperial poem written in regular script is *Two Poems on Peonies by Yanji of Jigu Studio,* at the end of which are an intaglio-style square seal mark *Qianlong* and a relief-style square seal mark *chenhan* in seal script in iron-red. The imperial poem written in clerical script is *Hibiscus in the Autumn Stream,* at the end of which are an intaglio-style square seal mark *bide* and a relief-style square seal mark *langrun* in seal script in iron-red. The imperial poem written in seal script is *Pomegranate Flowers,* at the end of which are an intaglio-style seal mark *weijing* and a relief-style square seal mark *weiyi* in seal script in iron-red.

206

Vase with the Reticulating Interior and Elephant-shaped Ears

and decorated with openwork design of flowers in *yangcai* enamels on an incised floral brocade ground in rouge-red and light yellow

Qing Dynasty Qianlong period

Height 40.2 cm
Diameter of Mouth 19.2 cm
Diameter of Foot 21.1 cm
Qing court collection

The vase has a flared mouth, a short neck, a globular belly, and a ring foot. The two sides of the neck are decorated with a pair of applique elephant-shaped ears. The string border in relief on the neck, the elephant-shaped ears, the border of the panels on the belly, and the foot rim are painted in gilt. The upper part of the neck is decorated with interlocking *ruyi* cloud lappets on an incised floral brocade ground in rouge-red, and the lower part is decorated with foreign chrysanthemums. The shoulder is decorated with the characters *wannian, jiazi*, and ten heavenly stems in seal script in black in a clockwise order, and underneath are the twelve characters of the earthly branches in seal script in red written in clockwise order. The belly is coloured with an incised floral brocade ground in yellow, on which are four round panels with design of rocks and the flowers of the four seasons such as peonies, magnolias, pomegranate flowers, and plum blossoms. The interior of the vase and the ring foot is covered with turquoise-green glaze. The exterior base is written with a six-character mark of Qianlong in seal script in three columns in underglaze blue in a reserved white square.

The interior is another vase linked to the neck of the exterior vase, which is decorated with foreign children at play in *yangcai* enamels and can be reticulated. Through the openwork carving on the exterior wall, the design of children at play, who is either riding on horse, beating drum, playing with lantern etc. on a white ground on the interior vase, are visible. This type of vases with openwork carvings and reticulating vases has a very sophisticated structure and technically difficult to produce, representing a new and creative type of wares designed by Tang Ying, Director General of the Imperial Kiln, with the auspicious blessing that rotating the vase would bring eternal fortune and luckiness.

207

A Pair of *Hehuan* Vases

decorated with floral sprays in *yangcai* enamels on an incised floral brocade ground in blue and rouge-red

Qing Dynasty Qianlong period

Height 16. 8 cm
Diameter of Mouth 6.8 cm
Diameter of Foot 7.5 cm

The vase is in the shape of a conjoined vase with a plate-shaped mouth, a short neck, a slanting shoulder, a globular belly, and a slightly splayed ring foot. It has a matching canopy-shaped cover on which is a tourmaline knob. The interior of the vase is covered with turquoise-green glaze. The exterior wall is decorated with sprays of foreign flowers in *yangcai* enamels on an incised floral brocade ground in both rouge-red and blue. The cover is decorated with similar designs. The interior of the ring foot is covered with white glaze. The exterior base is written with a horizontal six-character mark of Qianlong in seal script in blue.

This conjoined vase was skillfully designed and produced with a graceful shape, and was known as *hehuan* vase (conjoined vase of double happiness) in the archive of the Department of Imperial Household in the Qing Dynasty.

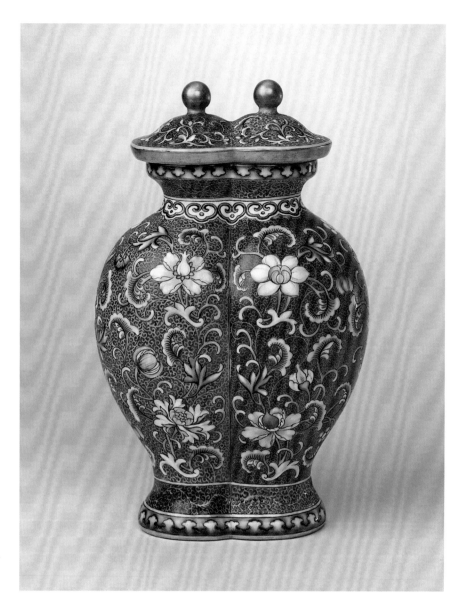

246

208

Vase with *Chi*-dragon-shaped Ears
and decorated with plum blossoms and chrysanthemums in panels, imperial poems and bats and peaches in *yangcai* enamels on a yellow ground

Qing Dynasty Jiaqing period

Height 35 cm
Diameter of Mouth 9.4 cm
Diameter of Foot 11.5 cm
Qing court collection

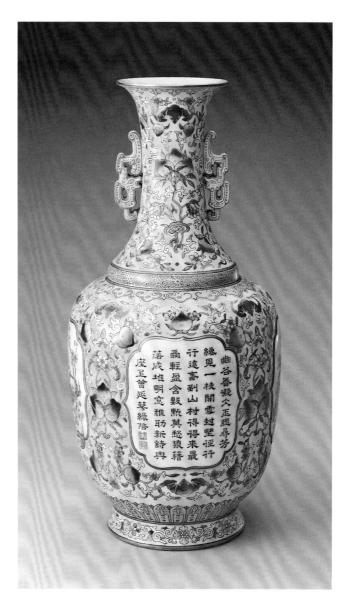

The vase has a flared mouth, a long neck, a slanting shoulder, an elongated globular belly, and a splayed ring foot. The two sides of the neck are decorated with a pair of *chi*-dragon-shaped ears. The neck is decorated with peaches, *lingzhi* funguses, and bats in *yangcai* enamels on a yellow ground. The belly is decorated with four floral-shaped panels. Two panels opposite to each other are decorated with plum blossoms and chrysanthemums, and the other two panels opposite to each other are decorated with an imperial poem written by Emperor Qianlong to describe the plum blossoms, at the end of which are an intaglio-style seal mark *chen* and a relief-style seal mark *han* in seal scripts in iron-red, and another poem to describe the chrysanthemums, at the end of which are an intaglio-style seal mark *qian* and a relief-style seal mark *long* in seal script in iron-red. Outside the panels are designs of peaches and bats in *yangcai* enamels on a yellow ground. The interior of the vase and the ring foot is covered with turquoise-green glaze. The exterior base is written with a six-character mark of Jiaqing in three columns in seal script in iron-red in a reserved white square.

The vase is written the mark of Jiaqing, but is decorated with the imperial poems by Emperor Qianlong, which shows that it should have been produced in the period from the first to the fourth year of the Jiaqing period, when Emperor Qianlong abdicated the throne in favour of his son. The Qing archive also had records that various imperial Jingdezhen wares of the Jiaqing period were inscribed with the poems written by Emperor Qianlong.

209

Hat-hanger

decorated with openwork
design of dragons in pursuit
of pearls amidst clouds
in *yangcai* enamels
on a yellow ground

Qing Dynasty Jiaqing period

Height 29.7 cm
Diameter of Mouth 12.5 cm
Diameter of Foot 12 cm
Qing court collection

The hat-hanger has a tubular body and a ring foot. The body is carved with six openwork windows in the shape of cydonias in two rows above and below, interspersing each other. Outside the openwork windows are decorations of dragons in pursuit of pearls, and surrounded by flaming-pearls and auspicious clouds. The interior of the hanger and the ring foot are covered with turquoise-green glaze. The exterior base is written with a six-character mark of Jiaqing in three columns in seal script in iron-red in a reserved white square.

This type of porcelain hat-hangers was first produced in the Jiaqing period, Qing Dynasty, and was continuously produced in subsequent periods by both the Imperial Kiln and local kilns. They were very popular during the Republican period, and were produced in pairs as wedding gifts.

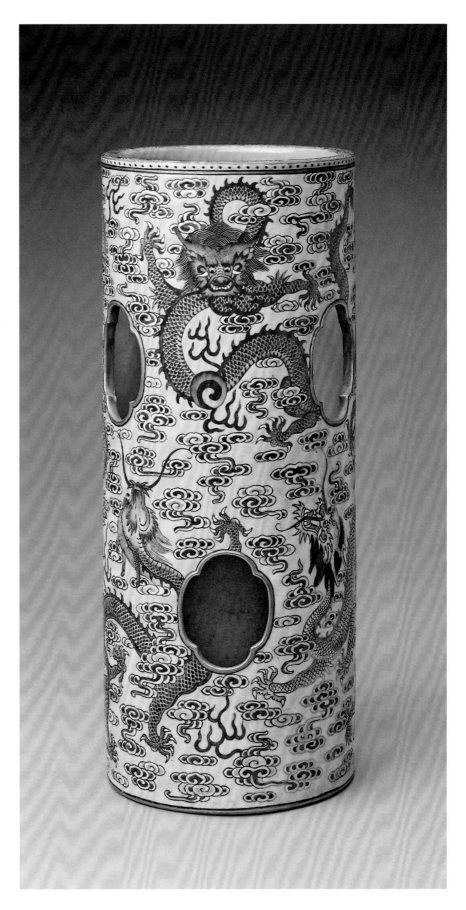

210

Vase with a Flared Mouth

and decorated with lotus scrolls, peaches, bats and *lingzhi* funguses in *yangcai* enamels on a yellow and white ground

Qing Dynasty Jiaqing period

Height 28.5 cm
Diameter of Mouth 8 cm
Diameter of Foot 10.4 cm
Qing court collection

The vase has a flared mouth, a long narrow neck, a flat globular belly, and a ring foot. The neck is decorated with Indian lotus scrolls interspersed by bats holding peaches on a sunflower-green ground. The belly is decorated with peach trees with abundant ripe peaches and interspersed by flying bats in red. At the lower part of the tree are *lingzhi* funguses. Near the mouth rim, the joint area of the neck and the shoulder, and near the foot are decorations of *ruyi* cloud patterns. The exterior wall is decorated with chrysanthemums and foliated scrolls. The decorative motifs carry the auspicious blessing of fortune and longevity. The interior of the vase and the ring foot is covered with turquoise-green glaze. The exterior base is written with a six-character mark of Jiaqing in three columns in seal script in iron-red in a reserved white square.

Many imperial wares of the Jiaqing period followed the tradition of the Qianlong wares, and they were exquisitely produced with high artistic merits. Without the mark of Jiaqing on this piece, it would be rather difficult to differentiate them from those of the Qianlong period.

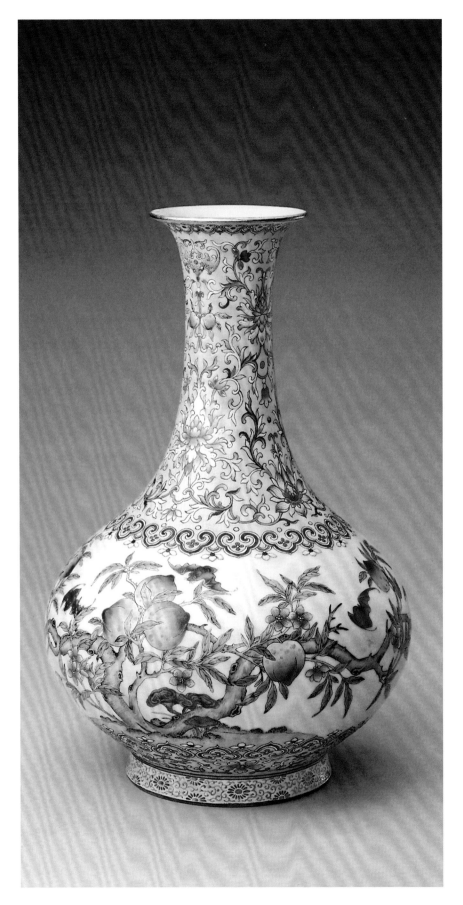

211

Vase with Two Ears

and decorated with design
of flowers in *yangcai*
enamels on a white and light
yellow ground

Qing Dynasty Daoguang period

Height 30 cm
Diameter of Mouth 8 cm
Diameter of Foot 9.4 cm

The vase has a flared mouth, a long
narrow neck, a straight belly tapering down-
wards, and a slightly splayed ring foot. On
the two sides of the neck is a pair of ears
in the shape of *chi*-dragons holding rings.
The mouth rim is painted in gilt and dec-
orated with foliage scrolls and *ruyi* cloud
patterns underneath. The neck is decorated
with foreign lotuses and lozenges on a yel-
low ground. The shoulder is decorated with
a border of key-fret patterns and a border
of *ruyi* cloud lappets. The belly is decorated
with rocks, flowers, and *lingzhi* funguses.
Near the foot are decorations of *ruyi* cloud
patterns and foreign flowers. The exterior
wall of the ring foot is decorated with key-
fret patterns. The *chi*-dragon-shape ears are
painted in blue with the two rings painted
in gilt. The interior of the vase and the ring
foot is covered with turquoise-green glaze.
The exterior base is written with a six-char-
acter mark of Daoguang in seal script in
iron-red in a reserved white square.

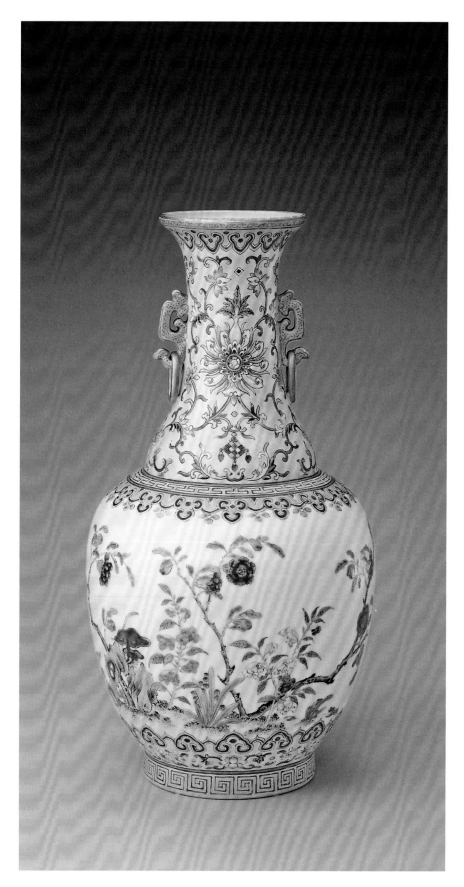

250

212

Vase with a Flared Mouth

and decorated with children at boating game during the Dragon Boat Festival in *yangcai* enamels on a white and rouge-red ground

Qing Dynasty Daoguang period

Height 26.3 cm
Diameter of Mouth 7.5 cm
Diameter of Foot 8 cm

The vase has a flared mouth, a long narrow neck, a slanting shoulder, a globular belly, and a slightly splayed ring foot. The mouth rim is painted in gilt and underneath are decorations of *ruyi* cloud patterns. The neck and the shoulder are decorated with Indian lotus scrolls interspersed by bats holding lozenges in the mouths. The belly is decorated with a continuous scene of a hundred children in boating games during the Dragon Boat Festival, within a background setting of mountains and peaks at the far distance and slopes and pavilions at the near distance. There are boating competitions on the river, and the children on the shore are holding flags and shouting with an auspicious ambience. Near the base are decorations of *ruyi* cloud patterns and floral designs. The exterior wall of the ring foot is decorated with key-fret patterns. The interior of the vase and ring foot is covered with turquoise-green glaze. The exterior base is written with a six-character mark of Daoguang in seal script in iron-red in a reserved white square.

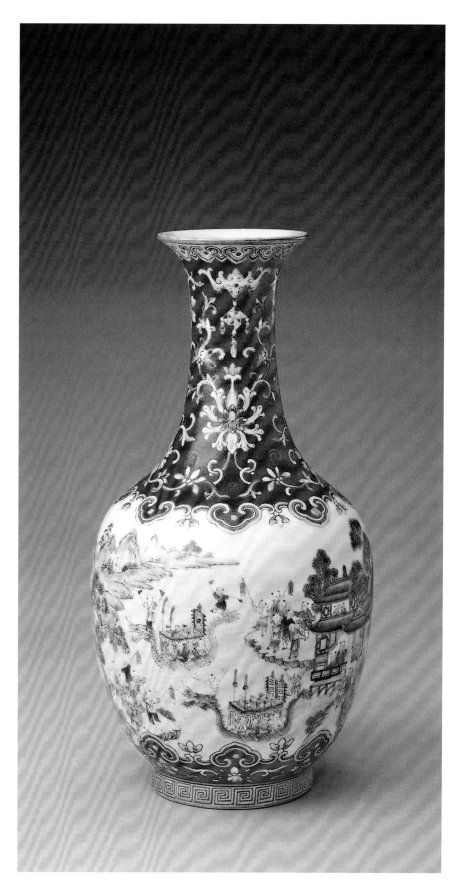

213

A Pair of Vases with Bat-shaped Ears
and decorated with design of antiques in *yangcai* enamels on a pink and white ground

Qing Dynasty Daoguang period

Height 30 cm
Diameter of Mouth 10.5 cm
Diameter of Foot 10 cm

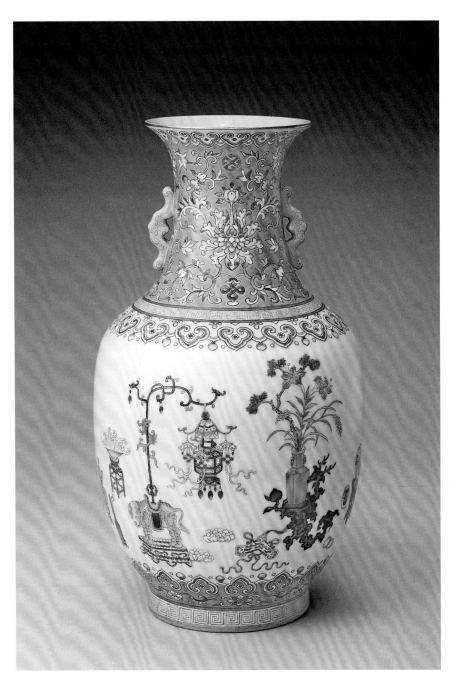

The vase has a flared mouth, a short narrow neck, a globular belly, and a slightly splayed foot. On the two sides of the neck is a pair of bat-shaped ears. The mouth rim is painted in gilt and underneath are decorations of *ruyi* cloud lappets. The neck is decorated with Indian lotuses, *wan* swastika patterns, knobs, etc. on a pink ground. The shoulder is decorated with a border of *wan* swastika patterns and a border of *ruyi* cloud lappets. On the white-glazed ground of the belly are various antique archaic designs, including flowers in a pot, *qing* chime musical instruments, elephants, lanterns, citrons, flower pots, flower vases, lozenges, lotuses, *ruyi* scepters, etc., which carry various auspicious meanings such as "the elephant brings peace to the nation", "everything lucky with the beginning of the New Year" etc. The interior of the vase and the ring foot is covered with turquoise-green glaze. The exterior base is written a four-character mark *Shendetang zhi* (produced for the Shende Studio).

The Shende Studio was located at the west of the scenery-spot *Jiuzhou Qingyan* (Blessing for peace to the country), which was a group of buildings at the Yuanmingyuan Palace Retreat (Old Summer Palace), and started to build in the tenth year of the Daoguang period (1830), and completed in the next year. It was the residence of Emperor Daoguang when he retreated in his late years and passed away there in the 30th year of the Daoguang period. Imperial wares with the mark *Shendetang zhi* were specially commissioned for use at the Studio and produced in the Jingdezhen Imperial Kiln.

214

Square Vase
decorated with design of flowers, birds and antiques in panels in *yangcai* enamels on a green ground

Qing Dynasty Xianfeng period

Height 29 cm
Length of mouth 9 cm
Diameter of foot 8.8 cm
Qing court collection

The square vase has a slightly flared mouth, a short neck, an angular shoulder, a belly tapering downwards near the foot, and a square ring foot. The neck has four round panels in which are designs of flowers and birds of the four seasons. The belly is decorated with four rectangular panels in which are designs of flowers and birds of the four seasons and various antique designs with auspicious tributes, such as "peace in four seasons", "the elephant carrying a vase" which symbolizes "the elephant brings peace to the nation," etc. The interior of the vase and the ring foot is covered with turquoise-green glaze. The exterior base is written a six-character mark of Xianfeng in two columns in regular script in iron-red.

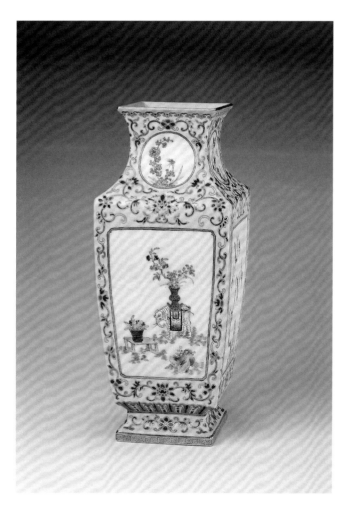

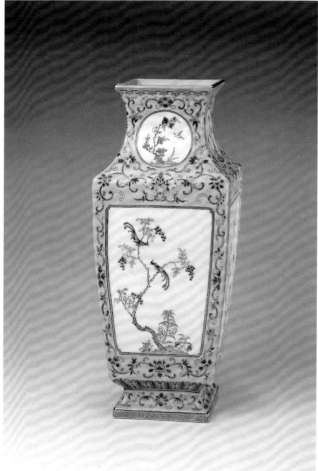

215

Statue of Zhong Kui
in *fencai* enamels

Qing Dynasty Kangxi period

Height 16.8 cm
Length of base 29 cm
Qing court collection

Zhong Kui is wearing a soft black cap on the hat, a red long robe decorated with dragons amidst waves and clouds painted in gilt, a yellow belt at the waist, and a pair of court boots. With his two eyes semi-closed, he looks like drunk. He is holding a wine-cup in one hand, and another hand is hidden inside the sleeve. On his side is a wine jar in celadon glaze imitating the imperial wares of the Song Dynasty. On top of the rock is a wine bottle decorated with bats in overglaze red on a white-glazed ground. One side of the rock is engraved with a vertical mark of Kangxi in regular script in intaglio style.

Zhong Kui was known as the demon-queller in ancient Chinese legend and was also named as "the scared lord who brings fortune and peace to a house." In the folk custom, his images were always hung with the wish to wipe off evils and disasters. This statue was originally placed in the store house of the court. When the Eight-Nation Alliance took over Beijing in the 26th year of the Guangxu period (1900), this statue was taken away from the court. Later officials of the Department of Imperial Household in the Qing Dynasty incidentally found this statue at the market, and brought it back to the palace.

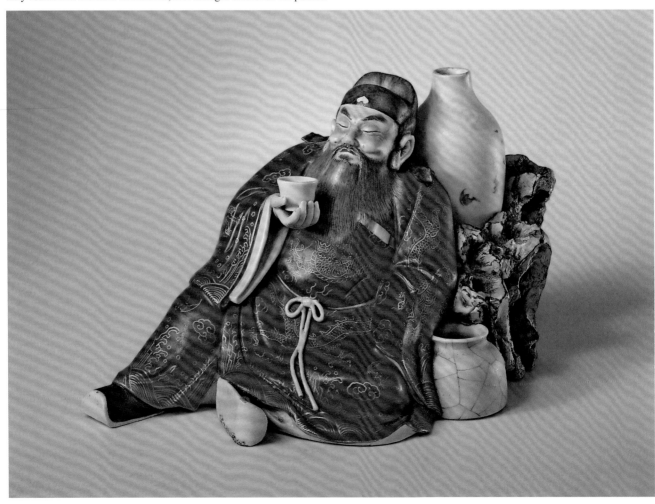

216

Celestial Sphere-shaped Vase

with design of a peach tree
with eight peaches
in *fencai* enamels

Qing Dynasty Yongzheng period

Height 50.6 cm
Diameter of Mouth 11.9 cm
Diameter of Foot 17.7 cm

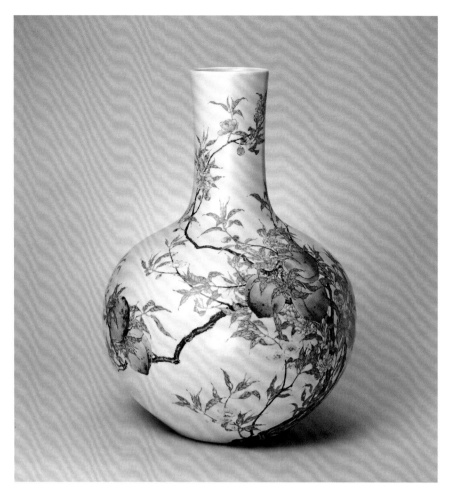

The vase has a round mouth, a straight neck, a globular belly, and a right foot, and glazed in pure white like snow. The body is decorated with a peach tree with abundant flowers and eight large peaches in *fencai* enamels. The exterior base is written with a six-character mark of Yongzheng in seal script in three columns in underglaze blue.

The decorations on the vase are well treated with spacious pictorial composition, delicate and elegant brush work, and realistic colours, representing a refined large-size imperial ware of the Yongzheng period. It is to be noted that the Yongzheng wares are often decorated with eight peaches, instead of the practice of painting nine peaches as decorations on Qianlong wares.

217

Vase with Plate-shaped Mouth

decorated with design of peonies in *fencai* enamels

Qing Dynasty Yongzheng period

Height 27.5 cm
Diameter of Mouth 6.3 cm
Diameter of Foot 8.6 cm

The vase has a plate-shaped mouth, a long narrow neck, an oval-shaped belly splaying near the foot, and a ring foot. The body is decorated with fully bloomed peonies. The exterior base is written with a six-character mark of Yongzheng in regular script in two columns within a double-line medallion in underglaze blue.

The Yongzheng imperial wares are noted for charming and graceful forms. The fluently linear shape of this vase is harmonious proportioned and decorated with designs rendered in spacious pictorial composition, meticulous brush work, and refreshing colour scheme, and the vase thus represents a refined piece with high aesthetic merits of the Yongzheng wares in *fencai* enamels.

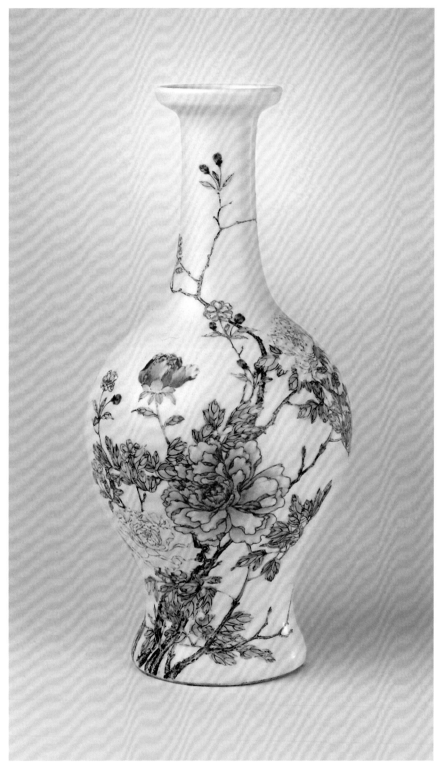

218

Pear-shaped Vase
decorated with design of lotuses and a lotus pond in *fencai* enamels

Qing Dynasty Yongzheng period

Height 27.6 cm
Diameter of Mouth 8.3 cm
Diameter of Foot 11.5 cm
Qing court collection

The vase has a flared mouth, a small neck, a hanging belly, and a splayed ring foot. The exterior is decorated with a scene of a lotus pond, in which lotuses fully bloomed with spreading leaves and ripe lotus seeds. The exterior base is written with a six-character mark of Yongzheng in regular script in two columns within a double-line medallion in underglaze blue.

The decorations on this vase are rendered with painterly brush work, lyrical resonance, and bright and elegant colour scheme. The flowers and leaves are depicted from different angles with versatile treatments, and are imbued with an exquisite aesthetic charm.

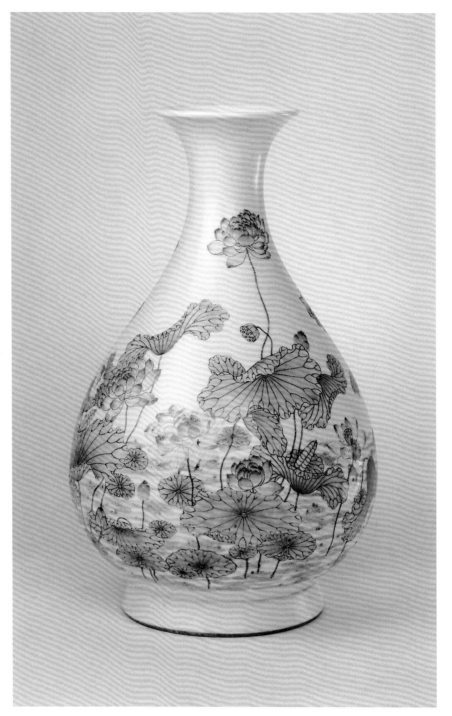

219

Meiping Vase

decorated with design of an elderly man and a deer in *fencai* enamels

Qing Dynasty Yongzheng period

Height 16.6 cm
Diameter of Mouth 3.2 cm
Diameter of Foot 6.1 cm

The vase has a small slightly flared mouth, a short neck, a wide shoulder tapering downwards, and a ring foot. The body is decorated with two scenes. The first scene is decorated with a smiling elderly man carrying a hoe on the shoulder with one hand holding a basket, in which are various herbs of immortality in different colours. On the handle of the hoe are also bundles of herbs of immortality that he had picked. A deer is accompanying him on the left side. The other scene is decorated with a red sun, rocks, flowers, and plants. The exterior base is written with a six-character mark of Yongzheng in regular script in three columns within a single-line medallion in underglaze blue.

The vase is fashioned with a graceful and charming form, as well as decorated with a refreshing and lyrical colour scheme. The decorative designs are depicted in a vivid style with auspicious tributes, reflecting the superb artistic merits of figure painting on the Yongzheng *fencai* wares.

220

Large Plate
decorated with spreading design of magnolias
and peonies
in *fencai* enamels

Qing Dynasty Yongzheng period

Height 8.8 cm
Diameter of Mouth 50.1 cm
Diameter of Foot 29 cm
Qing court collection

The plate has an everted mouth, a curved wall, and a ring foot. The exterior wall is decorated with peonies, magnolias, and begonias which spread to the interior wall of the plates, and such a decorative style was known as "spreading floral sprays." The exterior base is written with a six-character mark of Yongzheng in regular script in two columns within a double-line medallion in underglaze blue.

The decorative motifs of peonies, magnolias, and begonias have the auspicious meaning of "fortune and wealth in the jade hall." The design of peony was a very popular decoration on Qing ceramic wares, and the flowers were painted in different styles in various periods. The peonies design of the Yongzheng period is often depicted fully bloomed, and accompanied by other flowers and plants, such as chrysanthemums, magnolias, *lingzhi* funguses, etc.

221

Plate
decorated with design of a lady in *fencai* enamels

Qing Dynasty Yongzheng period

Height 2.6 cm
Diameter of Mouth 17.1 cm
Diameter of Foot 13.4 cm

The plate has a slightly flared mouth, a curved wall, a flat base, and a ring foot, and the paste is thinly potted. The interior centre of the plate is decorated with a lady standing with her hands on the rim of a jar. Next to her is a child. The figures look like watching the plants inside the jar. In the background are potted plants, and on the ground are jars, rocks, etc. The exterior base is written with a double-line medallion in underglaze blue.

The depiction of ladies on Yongzheng wares was different from that of the Kangxi period on which figures fully occupied the whole pictorial scene. The Yongzheng decorative style was to depict the figures in various backgrounds which further enrich the artistic rendering of the decorative designs.

222

Bowl
decorated with design of butterfly medallions in *fencai* enamels

Qing Dynasty Yongzheng period

Height 6. 8 cm
Diameter of Mouth 13.5 cm
Diameter of Foot 4.7 cm

The bowl has an everted mouth, a deep belly, and a ring foot. The interior of the bowl is plain. The exterior wall is decorated with five medallions of flowers and butterflies, and each medallion is decorated with two butterflies in different postures and flowers of the four seasons. The exterior base is written with a six-character mark of Yongzheng in regular script in two columns within a double-line medallion in underglaze blue.

On the Yongzheng wares in *fencai* enamels, designs of butterflies were often interspersed by flowers, which were depicted in bright and luxuriant colours.

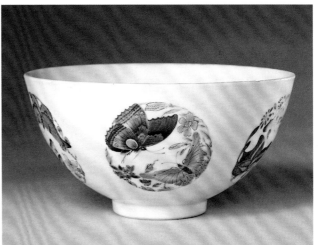

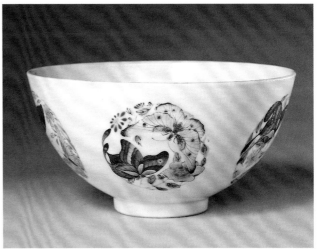

223

Olive-shaped Vase with Tubular Ears

and decorated with design of peonies in *fencai* enamels on a coral-red ground

Qing Dynasty Yongzheng period

Height 31.4 cm
Diameter of Mouth 7.1 cm
Diameter of Foot 9.6 cm

The olive-shaped vase has an upright mouth, a slanting shoulder, a round belly tapering downwards, and a ring foot. On the two symmetrical sides of the neck is a pair of tubular ears. On the foot rim are two rectangular holes for a fastening ribbon. The body is glazed with a coral-red ground, on which are clusters of peony sprays with fully bloomed flowers and abundant leaves painted in yellow, white, pink, and other *fencai* enamels. The exterior base is written with a six-character mark of Yongzheng in regular script in two columns within a double-line medallion in underglaze blue.

The technique of glazing by sufflation on refined white biscuit was used in producing coral-red glaze. After low-temperature firing, a light yellow tint would appear in the red glaze, resembling the outlook of naturalistic corals, and thus it was named coral-red glaze.

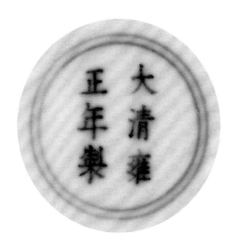

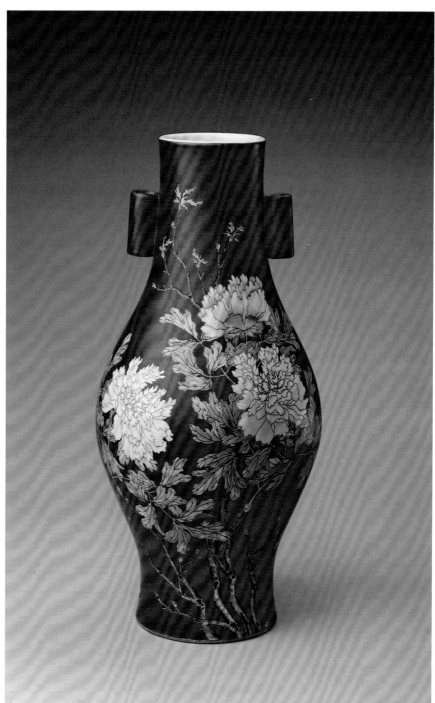

224

Bowl

decorated with design of
cranes amidst clouds and
above cresting waves
in *fencai* enamels
on a yellow ground

Qing Dynasty Yongzheng period

Height 6.5 cm
Diameter of Mouth 15.1 cm
Diameter of Foot 6 cm
Qing court collection

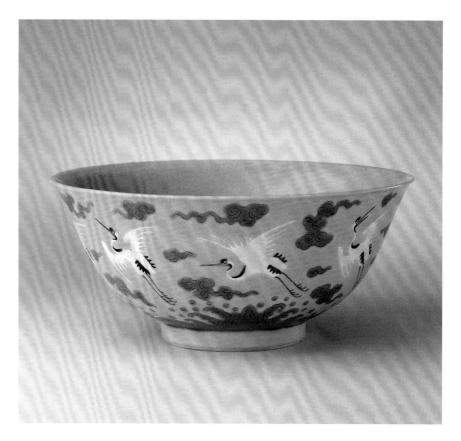

The bowl has a flared mouth, a deep curved side, and a ring foot, and is covered in yellow glaze both in the interior and the exterior. The interior is plain. The exterior wall is decorated with design of cranes amidst clouds above crested waves in white, red, black, green and other colour enamels, with the eight cranes flying amidst clouds painted in green enamel and above the cresting waves. The exterior base is written with a six-character mark of Yongzheng in regular script in two columns within a double-line medallion in underglaze blue.

Wares decorated with designs in *fencai* enamels on a yellow ground was a new typeform produced in the Yongzheng period. In his book *Taocheng Jishi* by Tang Ying, the term "wares in *wucai* enamels on a sprinkled yellow ground" actually referred to this type of new wares. On the wares with designs in *fencai* enamels of the Yongzheng period, there were a wide variety of crane designs which has an auspicious meaning, such as crane medallions, cranes amidst clouds, cranes in groups, etc.

225

Shuanglu Vase
decorated with floral sprays
and butterflies
in *fencai* enamels on
a *dongqing* celadon ground

Qing Dynasty Yongzheng period

Height 23 cm
Diameter of Mouth 3.7 cm
Diameter of Foot 10 cm

The vase has a small mouth, a long slim neck, a vertical belly, and a ring foot. The exterior is decorated with floral sprays and butterflies in *fencai* enamels on a *dongqing* celadon glazed ground. The interior of the ring foot is covered with white glaze. The exterior base is drawn with a mark composed of the brush, the *ruyi* scepter, and the silver ingot within a double-line medallion, which has the meaning "every wish would come true."

This vase was also known as *shuanglu zun* vase. In accordance with the physical standard, a utensil with the diameter of the mouth which is smaller than the diameter of belly should be called a vase. The term *zun* vase was just a common term in use at that time. *Shuanglu* was a kind of chess used in the chess game *shuanglu* (double-six game) in the ancient time, and the form of this vase is modelled after the shape of such chesses. The form was modelled in a simple and precise style, characterizing a distinctive form of imperial wares in the Yongzheng period.

226

Celestial Sphere-shaped Vase
decorated with design of nine peaches on a peach tree in *fencai* enamels

Qing Dynasty Qianlong period

Height 52.5 cm
Diameter of Mouth 11.3 cm
Diameter of Foot 17.5 cm

The vase has a slightly flared upright mouth, a long neck, a round belly, and a shallow ring foot. The interior and exterior are covered with white glaze. The exterior wall is decorated with a peach tree with a thick trunk, abundant leaves, and nine peaches on vine scrolls. Beside the tree is a cluster of Chinese roses. The exterior base is written with a six-character mark of Qianlong in seal script in three columns in underglaze blue.

This type of celestial sphere-shaped vases decorated with peach tree was produced both in the Yongzheng and Qianlong period. As a usual practice, those of the Yongzheng wares were decorated with eight peaches and those of the Qianlong period were decorated with nine peaches.

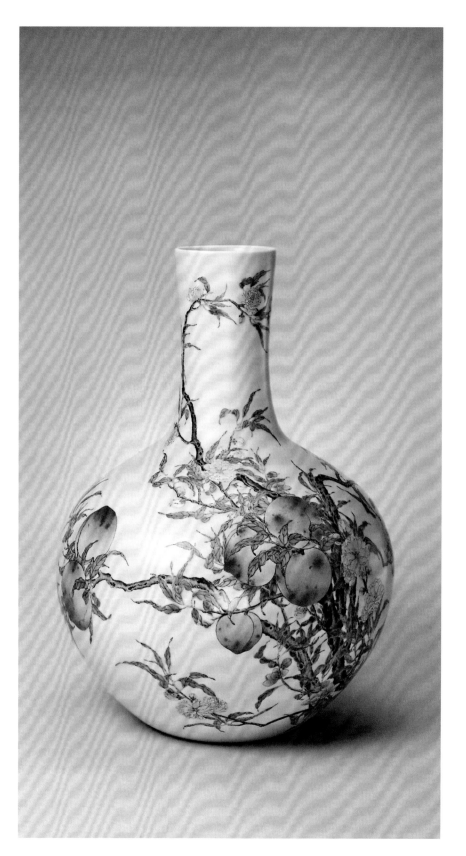

Vase with Ears in the Shape of Bats Holding *Qing* Chimes

and decorated with floral sprays with imperial poems in panels in *fencai* and *doucai* enamels

Qing Dynasty Qianlong period

Height 36.5 cm
Diameter of Mouth 11.1 cm
Diameter of Foot 11.7 cm
Qing court collection

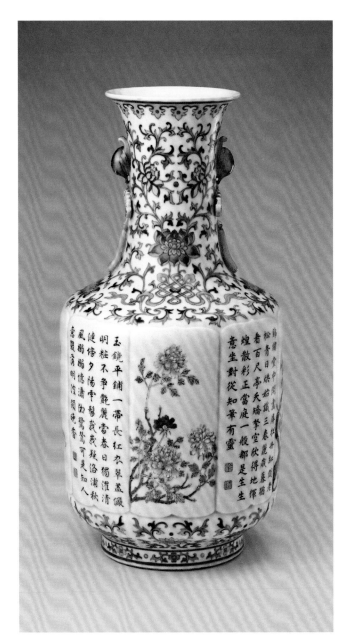

The vase has a flared mouth, a long neck, an angular shoulder, a tubular belly, and a ring foot. On the two sides of the neck is a pair of ears in the shape of bats holding *qing* chimes in the mouths painted in red. The belly is divided into eight lobed sides. Four lobed sides are decorated with flowers of the four seasons including peonies, lotuses, hibiscuses, and plum blossoms. The other four lobed sides are decorated with the imperial poem *Inscriptions for Five Panels of Painting by the Minister Jiang Nansha* written by Emperor Qianlong in regular, running, clerical, and seal scripts. The exterior base is written with a six-character mark of Qianlong in seal script in underglaze blue.

The design of peonies is matched by a poem in regular script with an intaglio-style seal mark *qian* and a relief-style seal mark *long* in seal script in iron-red. The design of lotuses is matched by a poem in running script with an intaglio-style seal mark *chen* and a relief-style seal mark *han* in seal script in iron-red. The design of hibiscuses is matched with a poem in clerical script with an intaglio-style seal mark *wei* and a relief-style seal mark *yi* in seal script in iron-red. The design of plum blossoms is matched with a poem in seal script with an intaglio-style seal mark *wei* and a relief-style seal mark *jing* in seal script in iron red. The poems and the painted designs match each other perfectly. Minister Jiang Nansha was the Prime Minister Jiang Tingxi (1669–1732) who attained the *jinshi* degree in the Civil Service Examination held at the 42nd year of the Kangxi period. He was promoted to the post of Vice-secretary of the Ministry of Rites, the Minister of the Ministry of Revenue, a Grand Secretary of the Wenhua Palace, and Principal Tutor of the Prince in the Yongzheng period, and was also a well-known court painter at the time.

This vase was originally on display at the Main Hall of the Yongshou Palace. It employed both techniques of painting in *doucai* and *fencai* enamels on the same ware. The soft colour scheme of *doucai* enamels contrasts with the luxuriant colour scheme of *fencai* enamels, representing the superb production of polychrome wares in the Qianlong period.

228

Jar
decorated with design of children at play in *fencai* enamels

Qing Dynasty Qianlong period

Height 15.3 cm
Diameter of Mouth 8.2 cm
Diameter of Foot 7.8 cm
Qing court collection

The jar has a flared mouth, a short neck, a slanting shoulder, a round belly, and a recessed ring foot. The whole body is covered with white glaze. The exterior is decorated with children at play in *fencai* enamels. The exterior base is written with a six-character mark of Qianlong in seal script in three columns in underglaze blue.

The jar is potted with perfect round body and glazed in pure white. The decorative designs are painted in a delicate and meticulous style with the facial expressions and costumes of children fully illustrated in a vivid manner, representing a refined ware of its type in the Qianlong period. In ancient China, the scene of children at play was popularly used as auspicious motifs, for abundant offspring would bring about great fortune and prosperity for the family, and such decorative designs were commonly found on Qing porcelain wares.

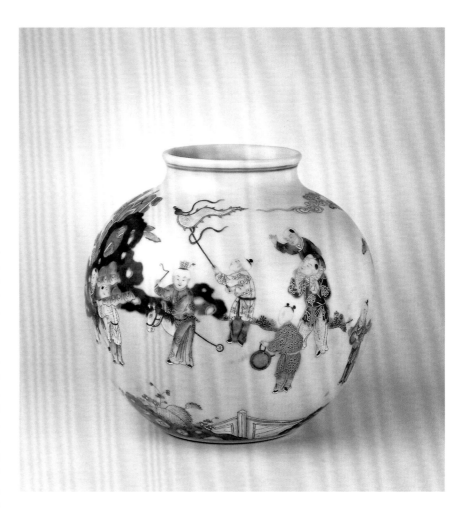

229

Gourd-shaped Vase with Three Holes
and decorated with red bats and gourd scrolls in *fencai* enamels and gilt on a turquoise-green ground

Qing Dynasty Qianlong period

Height 33 cm
Diameter of Mouth 2.1 cm
Diameter of Foot 7 cm

The vase is modelled in the shape of three conjoined gourds. It has a flared mouth, a short neck, a narrow waist, and a recessed foot. The mouth rim and the lower rim of the foot are painted in gilt. Underneath the mouth rim are decorations of *ruyi* cloud lappets. The body is decorated with bats and gourd scrolls with vines on a turquoise-green ground. The interior of the vase and the ring foot is covered with turquoise-green glaze. The exterior base is written with a six-character mark of Qianlong in seal script in three columns in gilt.

The form of the vase and the decorative motifs carry the auspicious tribute of progeny and "eternal fortune and success in the official career."

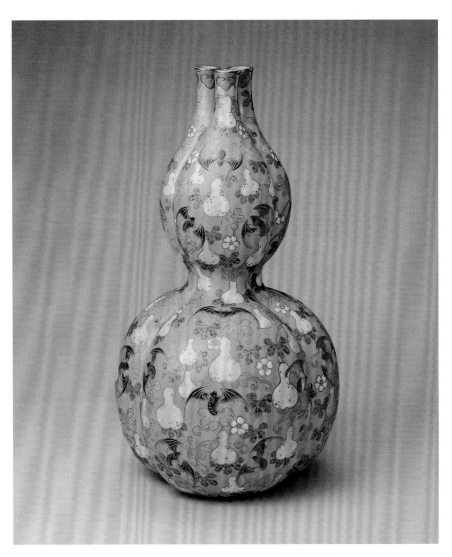

230

Flask with Three Holes

and decorated with landscapes and figures in panels in *fencai* enamels on a greenish-blue ground

Qing Dynasty Qianlong period

Height 28.5 cm
Diameter of middle mouth 3.2 cm
Diameter of Foot 6.8 × 3.8 cm
Qing court collection

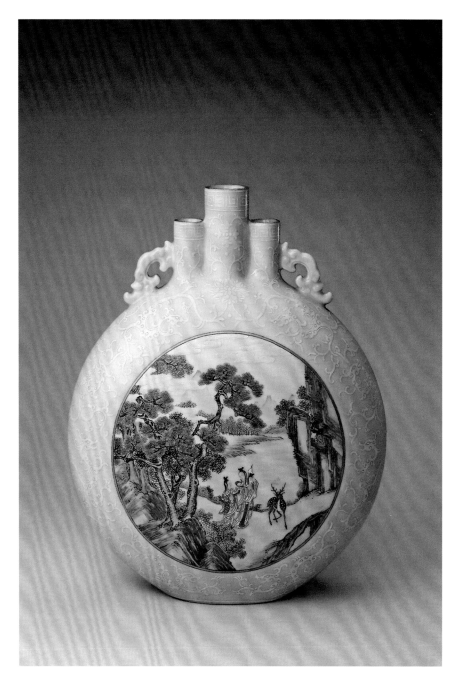

The vase has an upright mouth in the shape of the character *shan* (山, mountain), a flat round belly, and a recessed foot. On the two symmetrical sides at the mouth and the shoulder is a pair of *chi*-dragon-shaped ears. The exterior wall is covered with greenish-blue glaze and decorated with *kui*-dragons amidst flowers in white as the ground. At the front and rear side of the belly are two round panels, in which are decorations of figures in *fencai* enamels. In a setting of pines, mountains, and rocks, two fairy maidens holding a gourd and a plate are coming. Inside the plate are fruits such as citrons, pomegranates, and peaches, and beside them is a deer. The interior of the vase and of the recessed foot are covered with turquoise-green glaze. The exterior base is written with a six-character mark of Qianlong in seal script in three columns in iron-red.

The form of the vase is skillfully potted by firing two times in the kiln and decorated with designs in *fencai* enamels with a lyrical colour scheme. The decorative motifs carry auspicious meanings with the gourd and deer serving as puns for "fortune and success in officialdom" whereas citrons, pomegranates and peaches are known as the "three abundances" with the blessings for fortune, progeny, and longevity.

231

Large Vase
with decorations in various colour enamels and underglazed colours

Qing Dynasty Qianlong period

Height 86.4 cm
Diameter of Mouth 27.4 cm
Diameter of Foot 33 cm
Qing court collection

The large vase has a washer-shaped mouth, a long neck, a long round foot and a splayed ring foot. On the two symmetrical sides of the neck is a pair of *chi*-dragon-shaped ears. Altogether there are fifteen layers of decorations in various colouring techniques, such as overglaze colours of gilt, *fencai* enamels, *yangcai* enamels, and underglaze colours such as underglaze blue, as well as *doucai* colours which combined the use of both underglaze blue and overglaze enamels. In addition, a variety of colour glazes such as celadon glaze in imitation of Ge wares, turquoise-green, flambé, powder-blue, sky-clear blue, celadon glazes in imitation of Ru wares, celadon glaze in imitation of Guan wares, brown, etc. are also employed for the decorations.

The belly is principally decorated with various auspicious designs in *fencai* enamels, gilt and sky-clear blue glaze. There are altogether twelve panels, among which six are painted with designs of "three goats bringing the New Year," "surpluses of luckiness and happiness," "the phoenix facing the sun," "the elephant with a vase for

bringing peace," "mountains and mansions where immortals dwell," and "nine ancient *ding* tripods symbolizing unification of the nation." The other six panels are painted with brocade *wan* swastikas patterns, bats, *ruyi* cloud lappets, *panchi*-dragons, *lingzhi* funguses, flowers, etc., which are symbols of eternity, fortune, luckiness, wiping off evils, longevity, fortune, and wealth. The interior of the vase and the ring foot is covered with turquoise-green glaze. The exterior base is written with a six-character mark of Qianlong in seal script in three columns in underglaze blue, which turns to a blackish tint underneath the turquoise-green glaze.

In terms of firing techniques, underglaze blue, celadon glaze in imitation of Guan, Ru and Ge wares, flambé, powder-blue, and sky-clear blue glazes are all high-temperature glazes and enamels, which require high temperature firing first, whereas the *fencai, yangcai*, gold, and turquoise enamels are low temperature enamels, which require low-temperature firing in a baking atmosphere in the kiln. Therefore it was necessary to command all the specific requirements and chemical conditions in firing these glazes and enamels to assure that the wares are successfully produced.

This vase is exquisitely produced by utilizing over ten kinds of high and low temperature firing glazes and enamels for the decorations, and the colours are accurately achieved, making it esteemed as the "mother of imperial wares." The reign of

Emperor Qianlong lasted for sixty years and was regarded the most powerful High Qing period. The wealth and power of the nation enabled the court to gather the best and most competent potters and ceramic artists at the Qianlong Imperial Kiln, and as a result, the number of quality of imperial wares at the time had reached an unprecedented zenith at the time.

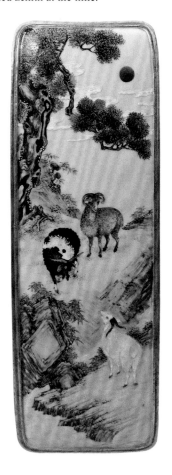

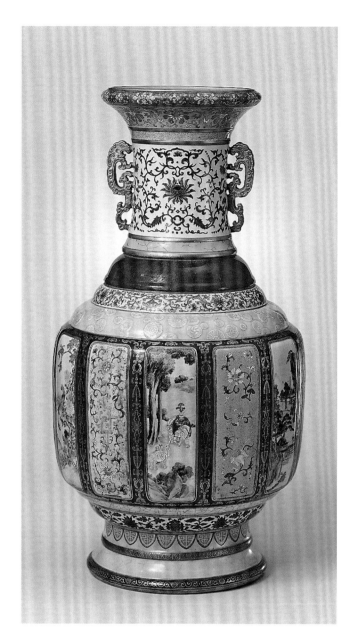

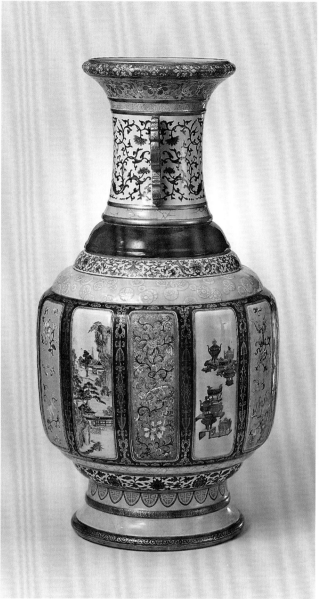

232

Large Vase with *Chi-dragon-shaped Ears*

and decorated with design of a hundred children in relief in *fencai* enamels

Qing Dynasty Jiaqing period

Height 85. 8 cm
Diameter of Mouth 31.5 cm
Diameter of Foot 29 cm

The vase has a plate-shaped mouth, a long neck, a slanting shoulder, a long round belly, a splayed ring foot, and a sandy base. On the two symmetrical sides of the neck is a pair of ears in the shape of *chi*-dragons. The interior of the vase is covered with turquoise-green glaze. The mouth rim is painted in gilt and underneath are decorations of *ruyi* cloud collars on a turquoise-green ground. The neck and the belly are decorated with a hundred children at play. In a setting with pavilions, terraces, towers, rocks, trees, and flying bats, the children are playing various games such as a dragon dance, a lion dance, fireworks, or beating drums and *gongs* with a happy and a bustling ambience. Near the foot are decorations of *ruyi* cloud collars on a turquoise-green ground.

The design of children at play was very popular on Qing porcelain wares and in particular after the Qianlong period, the number of children and the busy and happy ambience of the scenes on the wares had surpassed those of the preceding periods.

233

Vase with a Flared Mouth
and decorated with design of children at play in gilt and *fencai* enamels

Qing Dynasty Daoguang period

Height 30 cm
Diameter of Mouth 11 cm
Diameter of Foot 10 cm

The vase has a flared mouth, a short neck, a long round belly, and a ring foot. The interior and the exterior of the vase are covered with white glaze. One side of the exterior wall is decorated with children flying kites and inscribed with a character *xi* (happiness) and a swallow flying above in *fencai* enamels. The other side is decorated with magpies on a plum blossom tree in *fencai* enamels. The exterior base is written with a four-character mark *Shendetang zhi* (produced for the Shende Studio) in regular script in iron-red.

Imperial wares with the mark *Shendetang zhi* were exquisitely produced for the use by Emperor Daoguang. The reign of Daoguang (1821–1850) lasted for thirty years, and although a substantial number of imperial wares were produced in the Jingdezhen Imperial Kiln, in terms of forms and decorations, they just inherited the traditions of the preceding periods without many innovations.

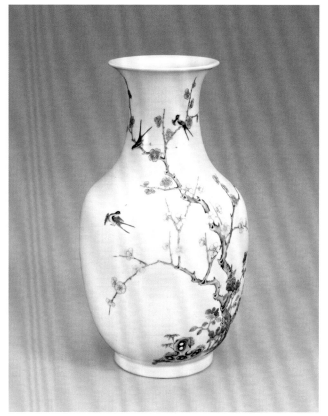

234

Large Vase with *Chi*-dragon-shaped Ears

and decorated with scenes of the Imperial Kiln in *fencai* enamels

Qing Dynasty Daoguang period

Height 63 cm
Diameter of Mouth 22 cm
Diameter of Foot 22.5 cm

The vase has a washer-shaped mouth, a wide neck, a long round belly, a ring foot, and a sandy base. On the two symmetrical sides at the neck and the shoulder is a pair of *chi*-dragon-shaped ears. The interior of the vase is covered with turquoise-green glaze. The exterior wall is decorated with various factory scenes of the Qing Imperial Kiln at Zhushan, Jingdezhen in *fencai* enamels. The "Imperial Poem Pavilion" of the Imperial Kiln is depicted at the centre, and on the east and west gates are large yellow flags on which the characters *yuyao chang* (Imperial Kiln and Factory) are inscribed. Inside the grand hall of the factory, various officials such as the managing directors and supervisors are either standing or sitting, and the potters and craftsmen are doing their jobs. The respective scenes depict grounding of materials, transportation of materials, potting the forms, fine-touching of biscuits, painting on biscuits, applying glaze, firing, moving out fired wares, packing and transportation of fired wares, etc.

Altogether sixty-one figures are depicted in different colour enamels of red, yellow, green, aubergine, blue, black, gilt, etc. The designs realistically reflect the production of wares at the Imperial Kiln, and are valuable documentation of the production mechanism, division of works, and production management of the Imperial Kiln, thus providing valuable materials for the study of the scale and the production structure of the Imperial Kiln at Jingdezhen in the Qing Dynasty.

235

Rectangular Flower Basin with Four Legs
and decorated with design of figures and landscapes in *fencai* enamels.

Qing Dynasty Xianfeng period

Height 18 cm
Diameter of Mouth 36.1 × 20 cm
Diameter of Foot 32.6 × 16.5 cm
Qing court collection

The rectangular flower basin has a slightly flared mouth, angular corners, and four legs under the base. The interior of the basin is covered with white glaze. The surface of the mouth rim is decorated with bats amidst clouds, and the rim is painted in gilt. The four sides of the belly are decorated with figures and landscapes. The legs are decorated with key-fret patterns in red on a green ground. The exterior base is written with a six-character mark of Xianfeng in regular script in iron-red.

The Qing court collection has less Xianfeng imperial wares, and thus they are quite rare and unusual. The style in writing the mark in regular script was also different from that of the Qianlong, Jiaqing, and Daoguang periods, which were often written in seal script. The Xianfeng marks were often written by holding the brush sideways, and its style was quite similar to the mark *Shendetang zhi* of the Daoguang period.

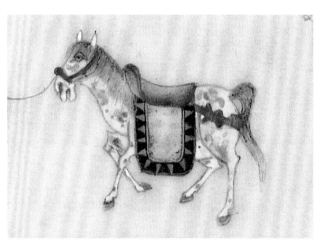

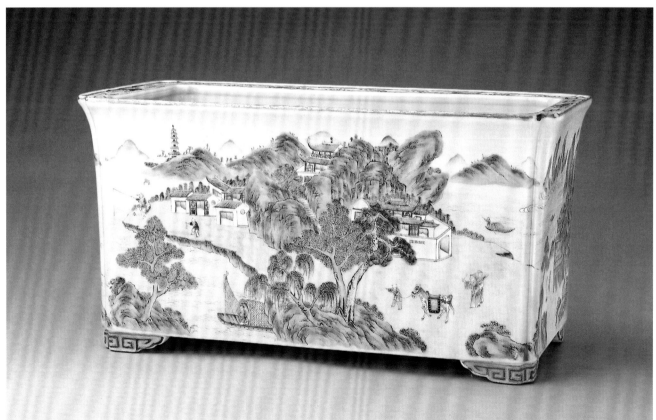

236

Vase with Two Ears
and decorated with design of landscapes and figures in *fencai* enamels on a white ground with underglaze blue designs

Qing Dynasty Xianfeng period

Height 28.4 cm
Diameter of Mouth 9.3 cm
Diameter of Foot 7.6 cm
Qing court collection

The vase has a flared mouth, a short neck, an angular shoulder, a straight belly tapering downwards, and a ring foot. On the two symmetrical sides of the neck is a pair of *chi*-dragon-shaped ears. The mouth rim is painted in gilt, and underneath are decorations of *ruyi* cloud lappets. The neck and the shoulder are decorated with lotus scrolls interspersed by auspicious designs of peaches, bats, and *qing* chimes in underglaze blue. The belly is decorated with distant mountains, towers, auspicious clouds, pines, and cypresses. In the mountain, two elders and two attendants are chatting with each other. Near the base are decorations of deformed lotus lappets in underglaze blue. The exterior wall of ring foot is decorated with key-fret patterns in underglaze blue. The interior of the vase and the ring foot is covered with white glaze. The exterior base is written with a six-character mark of Xianfeng in regular script in iron-red.

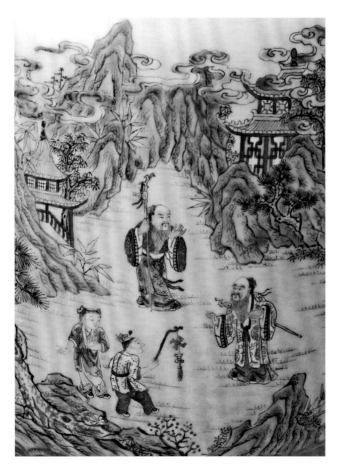

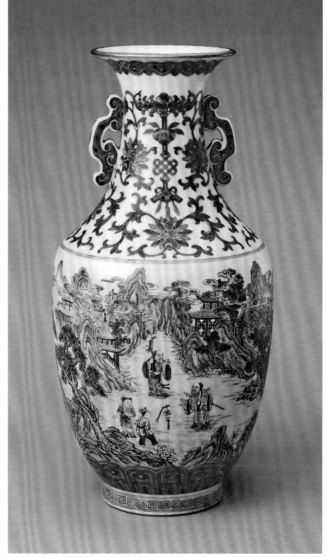

237

Cricket-containers
decorated with pines, bamboos, plum blossoms and a poem in *fencai* enamels on a rouge-red ground

Qing Dynasty Tongzhi period

Large container: Overall Height 20 cm
Diameter of Mouth 18.5 cm
Diameter of Foot 17 cm
Small container: Overall Height 11 cm
Diameter of Mouth 13 cm
Diameter of Foot 13 cm
Qing court collection

The cricket-containers are in the shape of a cylinder tube and have a ring foot. The large container has a matching round lid with a knob. The small container has a round lid without a knob. The interiors of both containers are covered with white glaze, and the forms and decorative designs are identical. The small container has porcelain chips, a cage, and a water drinking groove. The exterior wall is covered with purplish rouge-red glaze. The surface of the lid and one side of the belly are decorated with the so-called "three friends of winter," including pines, bamboos, and plum blossoms in *fencai* enamels. The other side has a floral-shaped panel, and on the white-glazed ground are decorations of a poem "Flowers wither and fall, and only the roots are left to endure the cold winter. Only green shade and fragrance could still be traced in the deep snow at Cangzhou" written in black. From where the poem was quoted needs further study. The exterior base is painted with a *yin and yang* diagram in red and black.

These two containers were representative works of similar types of cricket-containers used by the imperial family. The large container was used for the game of cricket-fight. The small container was used for keeping the cricket. Many officials and members of the imperial family of the Qing Dynasty were fond of the game of cricket-fight, and even an office was established with officials specially appointed to cater for such games. In the late Qing period, various kinds of insects such as grasshoppers, crickets, and gold bell flies were kept in cages and containers, which were put on the shelves of the rooms of the Qianqing Palace at the Chinese Lunar New Year days and the Lantern Festival on the 15th day of the first month, so that their sounds as loud as fireworks could be heard, and thus added joy to enhance the bustling ambience at these festive occasions. To cater for such needs, the Imperial Kiln at Jingdezhen had produced a large number of utensils for keeping these insects.

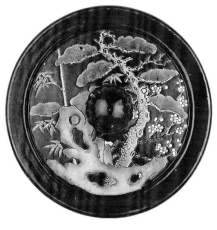

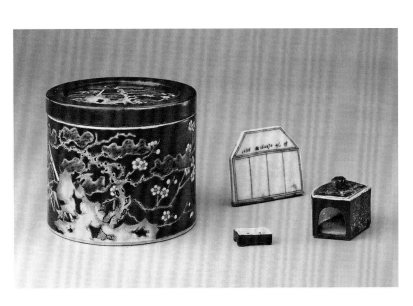
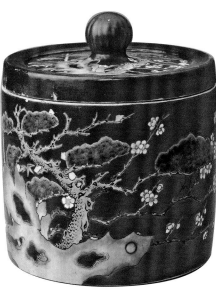

238

Spittoon

decorated with the characters *wanshou wujiang* (everlasting longevity), *wan* swastika patterns and cresting waves in *fencai* enamels on a yellow ground

Qing Dynasty Tongzhi period

Height 8.8 cm
Diameter of Mouth 8.6 cm
Diameter of Foot 5.1 cm
Qing court collection

The spittoon has a flared mouth, a wide neck, a round belly and a ring foot. The interior is covered with white glaze. The neck and the belly are respectively decorated with four round panels, in which are the characters *wan, shou, wu,* and *jiang* (collectively means everlasting longevity). Outside the panels are decorations of auspicious clouds and *wan* swastika patterns fastened with ribbons. Near the base is the decoration of cliffs and cresting waves, representing "the nation would last forever." The mouth rim, the neck, the shoulder, and the base are also decorated with borders of string designs in gilt. The exterior base is written with a four-character mark of Tongzhi in regular script in two columns in iron-red.

Spittoon was first produced in the Jin Dynasty, which was placed on the dining table for storing food residues. The spittoon with a smaller size was a kind of tea wares used for storing tea residues.

The form of this spittoon followed strictly the porcelain design diagrams (please refer to the attached diagram) issued by the Qing court, and was a commissioned piece produced in the Imperial Kiln at Jingdezhen to celebrate the birthday of Empress Dowager Cixi.

Attached Diagram: design of the bowls decorated with characters *wanshou wujiang* (everlasting longevity) and *wan* swastika patterns fastened with ribbons and waves issued by the Department of Imperial Household of the Qing Dynasty

On the right side are the inscriptions: follow this design to produce forty pieces of huge bowls, forty pieces of large bowls, forty piece of middle-sized bowls, forty pieces of soup bowls, sixty pieces of rice bowls, forty pieces of small bowls for carrying, forty-pieces of plates with nine *cuns* (Chinese inches) diameter, forty-pieces of plates with seven *cuns* diameter, forty pieces of plates with five *cuns* diameter, forty pieces of dishes with four *cuns* diameter, forty pieces of dishes with three *cuns* diameter, forty pieces of dishes with two and a half *cuns* diameter, forty pieces of wine cups, forty pieces of spoons, twenty pieces of tea bowls, twenty pieces of large tea bowls, twenty pieces of covered bowls, twenty pieces of tea containers, ten pieces of Zhadou with two and a half *cuns* diameter, ten pieces of cosmetic boxes with two *cuns* diameter, four pieces of hair-oil boxes with two and a half *cuns* diameter, and four pieces of rouge cosmetic box with one Chinese cun diameter.

Inscriptions on the middle upper side: three pairs of flower pots in cydonia-shape with one *chi* (Chinese foot) diameter, one pair of rectangular narcissus jars.

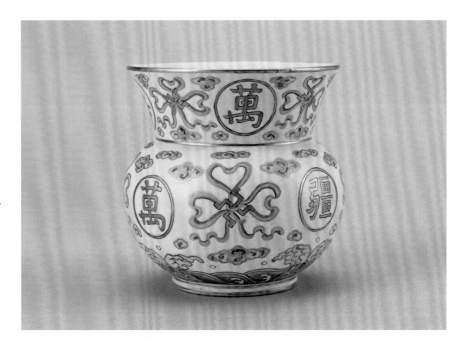

239

Covered Bowl

decorated design of five bats
holding *shou* (longevity)
characters in *fencai* enamels
on a yellow ground

Qing Dynasty Tongzhi period

Overall Height 9 cm
Diameter of Mouth 10.5 cm
Diameter of Foot 4.2 cm

Qing court collection

The bowl has a flared mouth, a deep
and curved wall, and a ring foot. It has a
matching canopy-shaped cover, on which is
a ring-shaped knob. The surface of the cov-
er and the exterior wall are in yellow glaze
ground, with four clusters of five bats en-
circling the character *shou* (longevity), in-
terspersed by four clusters of peach sprays
and a border of *wan* swastika. The interior
of the bowl, the knob, and the ring foot are
covered with white glaze. The exterior base
and the interior of the knob are written with
a four-character mark of Tongzhi in seal
script in two columns in iron-red.

This bowl with a cover was produced
in the Imperial Kiln at Jingdezhen based
on the drawing (refer to attached diagram)
issued by the court. It was one of the por-
celain vessels specially commissioned for
the celebration of Emperor Dowager Cixi's
birthday.

Diagram: the colour drawing of the huge bowl decorated with design of five bats
holding *shou* (longevity) characters in colour enamels issued by the Department of Imperial
Household.

On the right side are the inscriptions: Follow this design to produce forty pieces of
huge bowls, forty pieces of large bowls, forty piece of middle-sized bowls, forty pieces of
soup bowls, sixty pieces of rice bowls, forty pieces of small bowls for carrying, forty-pieces
of plates with nine *cuns* (Chinese inch) diameter, forty pieces of plates with seven *cuns*
diameter, forty pieces of plates with five *cuns* diameter, forty pieces of dishes with *cuns*
diameter, forty pieces of dishes with three *cuns* diameter, forty pieces of dishes with two
and a half *cuns* diameter, forty pieces of wine cups, forty pieces of spoons, twenty pieces of
tea bowls, twenty pieces of large tea bowls, twenty pieces of covered bowls, twenty pieces
of tea containers, ten pieces of Zhadou with two and a half *cun* diameter, ten pieces of
cosmetic boxes with two *cuns* diameter, four pieces of hair-oil boxes with two and a half *cuns*
diameter, and four pieces of rouge cosmetic box with one *cun* diameter.

Inscriptions on the upper side: three pairs of hexagonal flower pots with one *chi* (Chinese
foot) diameter, one pair of narcissus jars with angular corners.

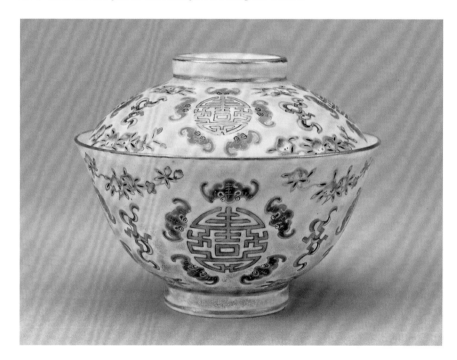

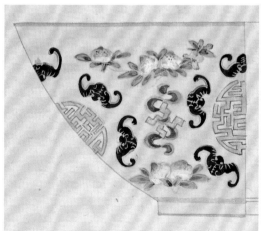

240

Huge Bowl
decorated with design of a
hundred butterflies and *xi*
(double happiness) character
in *fencai* enamels
on a yellow ground

Qing Dynasty Tongzhi period

Height 9.4 cm
Diameter of Mouth 20.6 cm
Diameter of Foot 8.1 cm
Qing court collection

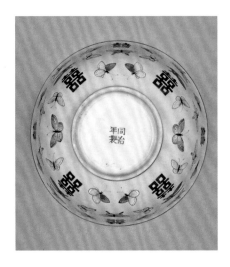

The bowl has a flared mouth, a deep and curved belly, and a ring foot. The exterior wall is painted with butterflies in *fencai* enamels and a *xi* (double happiness) character in fencai enamels on a yellow ground. The mouth rim and the exterior of the ring foot are decorated with a border of string patterns in fencai enamels respectively. The interior of the bowl and the ring foot are covered with white glaze. The exterior base is written with a four-character mark of Tongzhi in regular script in two columns in iron-red.

This decorative design of the bowl has the auspicious meaning of happiness and joy. It was specially produced in the Imperial Kiln at Jingdezhen based on the drawing (refer to attached diagram) issued by the court for the celebration of the wedding of Emperor Tongzhi.

Diagram: colour drawings of the huge bowl decorated with design of butterflies and *xi* (double happiness) character.

On the right side are the inscriptions: follow this design to produce forty pieces of huge bowls, forty pieces of large bowls, forty pieces of middle-sized bowls, forty pieces of soup bowls, sixty pieces of rice bowls, forty pieces of small bowls for carrying, forty pieces of plates with nine *cuns* diameter, forty pieces of plates with seven Chinese *cuns* diameter, forty pieces of plates with five *cuns* diameter, forty pieces of dishes with four *cuns* diameter, forty pieces of dishes with three *cuns* diameter, forty pieces of dishes with two and a half Chinese *cuns* diameter, forty pieces of

wine cups, forty pieces of spoons, twenty pieces of tea bowls, twenty pieces of large tea bowls, twenty pieces of tea containers, ten pieces of Zhadou with two and a half *cun* diameter, four pieces of cosmetic boxes with two *cuns* diameter, forty pieces of hair-oil boxes with two and a half Chinese *cuns* diameter, four pieces of rouge cosmetic box with one Chinese *cun* diameter, and twenty pieces of covered bowls.

Inscriptions on the middle-upper side: Three pairs of rectangular octagonal flower pots with one *chi* diameter, one pair of narcissus cosmetic box in the shape of plum blossoms.

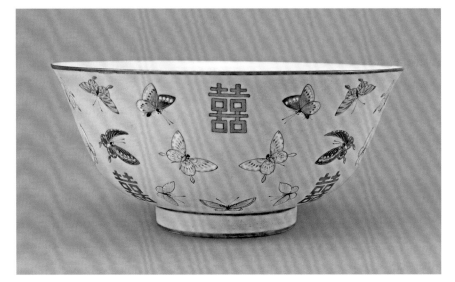

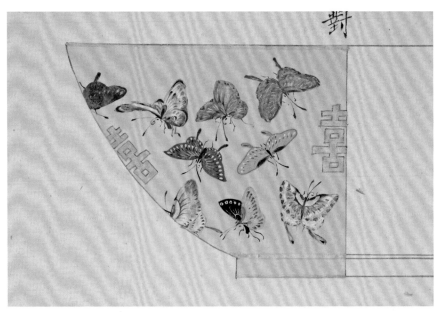

241

Vase
decorated with design of two dragons in pursuit of a pearl in *fencai* enamels and gilt

Qing Dynasty Guangxu period

Height 39 cm
Diameter of Mouth 10.5 cm
Diameter of Foot 12.7 cm

The vase has a flared mouth, a long and slanting shoulder on which are decorations of two borders of string patterns in relief, a globular belly, and a ring foot. The interior is covered with white glaze. Underneath the mouth rim of the exterior wall are borders of key-fret patterns and *ruyi* cloud patterns. The neck is decorated with a dragon in iron-red and gilt, surrounded by auspicious clouds in colour enamels. The shoulder is decorated with two borders of string patterns and *baoxiang* flowers, and the belly is decorated with two dragons in pursuit of a pearl in iron-red. The exterior base is written with a six-character mark of Guangxu in regular script in two columns in under-glaze blue.

The form of this vase is graceful with the dragons rendered in a vivid and dynamic manner, representing a refined type of imperial vases produced in the Imperial Kiln in the Guangxu period for bestowing as gifts.

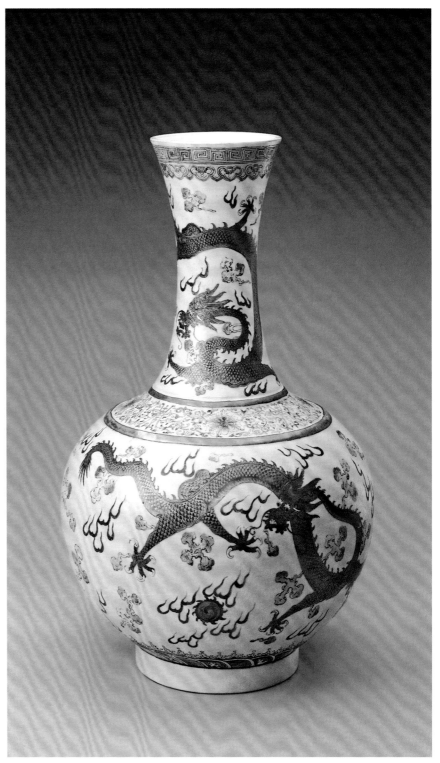

242

Vase with a High Foot and a Flared Mouth

and decorated with design of cydonias in *fencai* enamels on an aubergine ground

Qing Dynasty Guangxu period

Height 24.5 cm
Diameter of Mouth 11.5 cm
Diameter of Foot 10.3 cm
Qing court collection

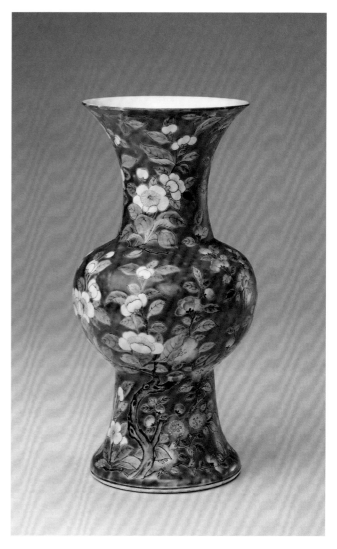

The vase has a flared mouth, a long, slanting shoulder, a globular belly tapering downwards to a tall and splayed ring foot. The interior is covered with white glaze whereas the exterior is painted with floral design in *fencai* enamels on a pink ground. The white cydonias and the pink plum blossoms are fully bloomed with butterflies flying among them. The exterior base is written with a four-character mark *yongqing changchun* in regular script in two columns in iron-red.

The colour of the ground of this vase is soft and subtle with the decorative designs painted in colour enamels in a delicate and brilliant manner. The ground glaze in pink is pure and graceful, and the decorative designs are rendered in dense and brilliant colour tone. The pronunciation of the cydonia and the vase is a pun for "peace is with the whole family."

Diagram: the design drawing of vases with a high foot and a flared mouth, decorated with design of cydonias in *fencai* enamels on a pink ground issued by the Department of Imperial Household.

Inscriptions on the upper left red slip: No. 10.

Inscriptions on the right yellow slip: based on the drawing produce two pairs of this vase in *fencai* enamels, two pairs with two *chis* in height, and four pairs with six to three *cuns* in height; based on this drawing, produce two pairs of vases with a pink ground, two pairs with two *chis* in height, and four pairs with six to three Chinese *cuns* in height.

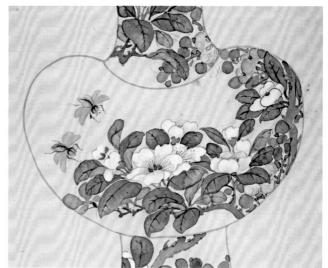

243

Round Flower Pot with a Tray

and decorated with design of pines and floral designs in *fencai* enamels on a yellow ground

Qing Dynasty Guangxu period

Flower pot Height 11.2 cm
Diameter of Mouth 17 cm
Diameter of Foot 11.8 cm
Flower pot Stand Height 3.5 cm
Diameter of Mouth 16.9 cm
Diameter of Foot 13.2 cm
Qing court collection

The round flower pot has a flared mouth everted to a flange, a deep belly, and a shallow ring foot. The base has two drainage holes. The mouth rim is decorated with bats holding a coin in the mouths interspersed by the character *shou* (longevity) in blue glaze with the auspicious meanings of fortune, longevity, and luckiness. Underneath the mouth rim are decorations of key-fret patterns and the exterior wall is decorated with two clusters of banana trees, peonies, and pine trees, symbolizing wealth and longevity. The interior of the pot and the ring foot are covered with white glaze. The exterior base is written with a four-character mark of *Tihedian zhi* (commissioned for the Tihe Hall) in seal script in two columns in iron-red.

The matching tray (*lian*) for the flower is in round shape. It has a flared mouth, a shallow wall, and a flat base supported by four legs. The interior is covered with white glaze. The mouth rim and the flanged rim are decorated with lozenge and key-fret patterns. The exterior wall is painted with five clusters of peonies. The exterior base is written with a four-character mark of *Tihedian zhi* (commissioned for the Tihe Palace) in seal script in two columns in iron-red.

This vase was produced in the Imperial Kiln at Jingdezhen in the Guangxu period based on the drawing issued by the court, representing a type of wares commissioned for the exclusive use of Empress Dowager Cixi.

Diagram: the colour design drawing of a round flower pot with a tray decorated with design of pines and floral designs in *fencai* enamels on a yellow ground issued by the Department of Imperial Household.

Inscriptions on the top right yellow slip: based on this drawings produce a pair of four *cuns* small round flower pots in fencai enamels on a yellow ground, with a matching tray (*lian*); based on the drawing, produce a pair of four *cuns* small round flower pots with floral designs painted in sepia ink on a yellow ground, with a matching tray.

Inscriptions on the lower right yellow slip: based on this drawing, produce a pair of five *cuns* small round flower pots in *fencai* enamels on a yellow ground, with a matching tray (*lian*); based on the drawing, produce a pair of five *cuns* small round flower pots with floral designs painted in sepia ink on a yellow ground, with a matching tray (*lian*).

Inscriptions on the upper left yellow slip: based on the drawing, produce a pair of four *cuns* small round flower pots with enamelled ground and underglaze blue designs, with a matching tray (*lian*).

Inscriptions on the lower left yellow slip: based on the drawing, produce a pair of five *cuns* small round-flower pots with enamelled ground and underglaze blue designs, with a matching tray (*lian*).

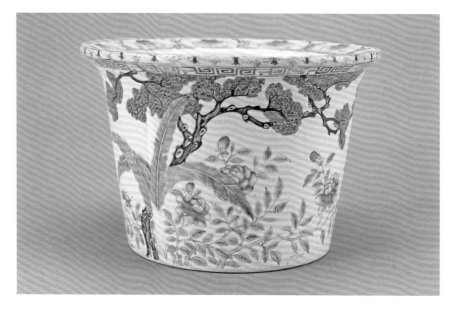

244

Round Box
decorated with design of flowers in *fencai* enamels on a yellow ground

Qing Dynasty Guangxu period

Overall Height 14.6 cm
Diameter of Mouth 21.3 cm
Diameter of Foot 13.5 cm
Qing court collection

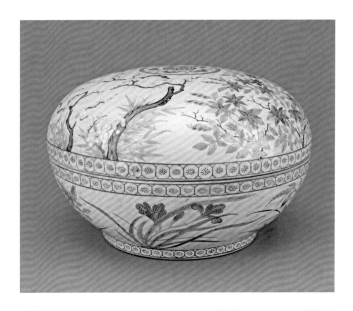

The round box has a fitting flat cover and a ring foot. The whole body is decorated with designs in *fencai* enamels on a yellow ground. The top of the cover is decorated with a round panel in which are decorations of five bats in blue enclosing the character *shou* (longevity) in seal script in a medallion, and complemented by flowers of the four seasons, symbolizing five bats bringing fortune and longevity. The upper and lower mouth rim is decorated with floral patterns in blue. The exterior is painted with flowers of the four seasons, including plum blossoms, orchids, peonies, and peach flowers, and the interior of the ring foot is covered with white glaze. The exterior base is written with a four-character mark of *Tihedian Zhi* (commissioned for the Tihe Hall) in seal script in two columns in iron-red.

Tihe Hall was the rear hall of the Yikun Palace in the Forbidden City. In the tenth year of the Guangxu period (1884), in celebration of Empress Dowager Cixi's 50th birthday, the Chuxiu Palace had undergone a major renovation by demolishing the old rear hall at Yikun Palace and the Chuxiu Gate, and replaced with the new Tihe Hall.

Diagram: the colour design drawing of the round box decorated with design of flowers in *fencai* enamels on a yellow ground issued by the Department of Imperial Household.

Inscriptions on the right yellow slip: based on the design drawing, produce a pair of seven *cuns* round boxes in *fencai* enamels on a yellow ground; based on the drawing, produce a pair of seven *cuns* round boxes with designs painted in sepia ink on a yellow ground.

Inscriptions the left yellow slip: based on the design drawing, produce a pair of seven Chinese *cuns* round boxes in with enamelled ground and underglaze blue designs.

245

Jar with Elephant-shaped Handles

and decorated with flowers and birds in *fencai* enamels on a green ground

Qing Dynasty Guangxu period

Height 14 cm
Diameter of Mouth 5.4 cm
Diameter of Foot 5.2 cm
Qing court collection

The jar has a flared mouth, a long neck and a globular belly that tapering downwards to a splayed ring foot. A pair of elephant-shaped handles is on the symmetrical sides of the neck and the shoulder. The shoulder is decorated with *ruyi* cloud lappets in relief and outlined in black. The neck and belly are painted with peonies. The exterior of the ring foot is painted with lotus lappets. The interior of the jar and the ring foot is covered with white glaze. The exterior base is written with a four-character mark of *yongqing changchun* in regular script in two columns in iron-red.

Diagram: the colour design drawing of the jar with elephant-shaped handles decorated with flowers and birds in *fencai* enamels on a green ground issued by the Department of Imperial Household.

Inscriptions on the red slip: No. 12.

Inscriptions on the yellow slip: based on the design drawing, produce two pairs of flower pots with jade-green ground, two pairs with one *chi* five *cuns* in height, and four pairs with six to three *cuns* in height. Based on the design drawing, produce two pairs of flower pots with pea-green ground, two pairs with one *chi* five *cuns* in height, four pairs with six to three *cuns* in height.

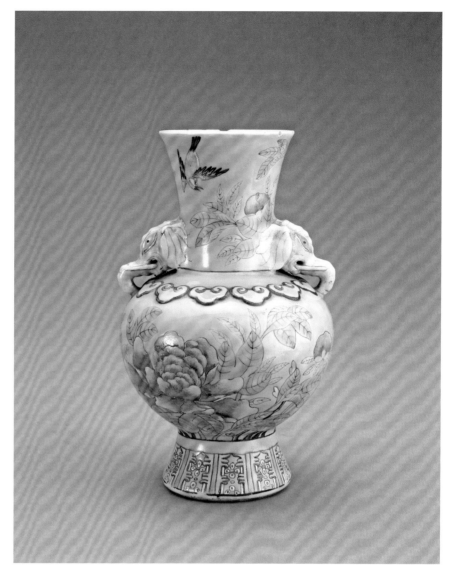

246

Fish Bowl
decorated with design of wisteria, Chinese roses and birds in *fencai* enamels on a green ground

Qing Dynasty Guangxu period

Height 30 cm
Diameter of Mouth 34.2 cm
Diameter of the bottom 23 cm
Qing court collection

The fish bowl has a mouth curved inward, a curved belly tapering downwards to the base with a ring foot recessed in the interior. The mouth rim is painted with wisteria flowers in aubergine whereas the belly is painted with Chinese roses in pink. The leaves are painted in yellow and green. A thrush is perking on a branch. The interior of the ring foot is covered with white glaze. Underneath the mouth rim is a horizontal five-character mark *Daya zhai* (Daya Studio) written in regular script in two columns in iron-red in reserved white, along with an oval-shaped seal mark *tiandi yijiachun* written in seal script in iron-red. The exterior base is written with a four-character mark of *yongqing changchun* in regular script in two columns in iron-red.

This fish bowl is produced in the Imperial Kiln at Jingdezhen based on design drawings issued by the Department of Imperial Household and it was for the exclusive use of Empress Dowager Cixi.

Diagram: the colour design drawing of the fish bowl decorated with design of wisteria, China roses and birds in *fencai* enamels on a green ground issued by the Department of Imperial Household.

Inscriptions on the upper right yellow slip: based on the design drawing, produce two pairs of two *chis* six *cuns* large fish bowls with wisteria flowers on a pale green ground, four pairs of round (four characters missing), and two pairs of round fish bowls with nine *cuns* diameter.

Inscriptions on the upper right yellow slip: based on the design drawing, produce one set of bowl and plate. Based on the drawing, produce twenty huge bowls with wisteria flowers on a pea green ground, thirty large bowls, forty medium-size bowls, sixty bowls for carrying, twenty-nine *cuns* plates, thirty-seven Chinese *cuns* plates, forty-five *cuns* plates, forty-three *cuns* plates, forty long spoons, four pairs of one *chi* round boxes, four pairs of five *cuns* round boxes, forty covered-bowls with covers, forty spittoon, and forty tea bowls.

Diagram: paper box with the inscription *Daya zhai* (Daya Studio).

Overall height 66 cm, width 135.5 cm, with wooden frame, it is decorated with two brocade borders. On the greenish-blue paper with gilt sprinkles is the ink inscription *Daya zhai* (Daya Studio) in regular script. Above the character *ya* is a seal mark *Daya zhai* in relief style, on top of which is another seal mark *haihan chunyu*.

Daya zhai (Daya Studio) was a studio name bestowed by the Emperor Xianfeng to Empress Dowager Cixi (at the time she was still a concubine). There were two wooden tablets with this name inscribed with one hung at the *Ping'an shi* (Room of Peace), a side chamber at the rear hall of the Yangxin Palace, Forbidden City and another at the Hall of *Tiandi yijiachun* (Hall of Spring in union the Heaven and Earth) at Yuanmingyuan Imperial Retreat, both of which were residences of Empress Dowager Cixi. With the fire which demolished the Yuanmingyuan Imperial Retreat, the wooden tablet hung at Yuanmingyuan Imperial Retreat also disappeared. With the move of the residence of the Empress Dowager, the wooden table hung at the Ping'an shi was also moved to other locations, and finally hung at the Changchun Palace in the late Qing period. With the pass away of the Empress Dowager Cixi, the tablet was moved and stored at the storages of the Imperial Workshops in the Qing Palace.

The tablet with the inscription *haihan chunyu* (The sea is vast and the spring nurtures all beings) was inscribed in the eighth year of the Xianfeng period (1858), and hung inside the Changchun Palace. The seal mark *haihan chunyu* on the *Daya zhai* paper box should have been stamped on it after the tablet was removed for hanging at the Changchun Palace.

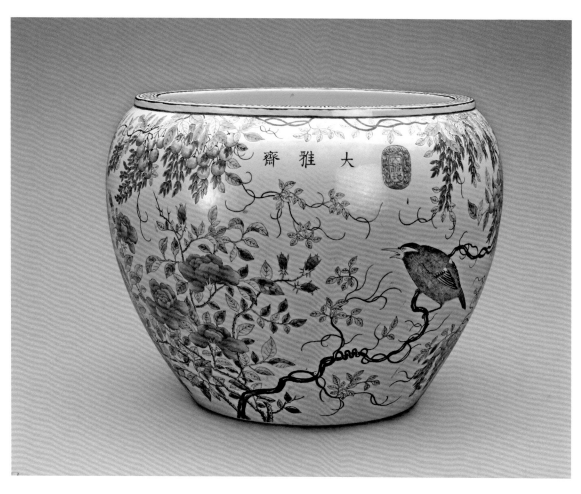

247

Pear-shaped Vase
decorated with design of flowers and butterflies in *fencai* enamels

Qing Dynasty Xuantong period

Height 30 cm
Diameter of Mouth 8.7 cm
Diameter of Foot 12 cm
Qing court collection

The vase has a flared mouth, a narrow neck, a hanging belly, and a ring foot. The interior and the exterior of the vase is covered with white glaze. The mouth rim is painted in gilt and the exterior of the belly is painted with peonies, magnolias, and butterflies. The exterior base is written with a six-character mark of Xuantong in regular script in two columns in iron-red.

The vase is thickly potted with an elegant form. The decorative designs are skillfully rendered, showing the quality of imperial wares of the Xuantong period. The Xuantong period (1909-1911) was short, but the Imperial Kiln at Jingdezhen still produced imperial wares continuously, though both the quantity and quality of which could not match that of the preceding dynasties.

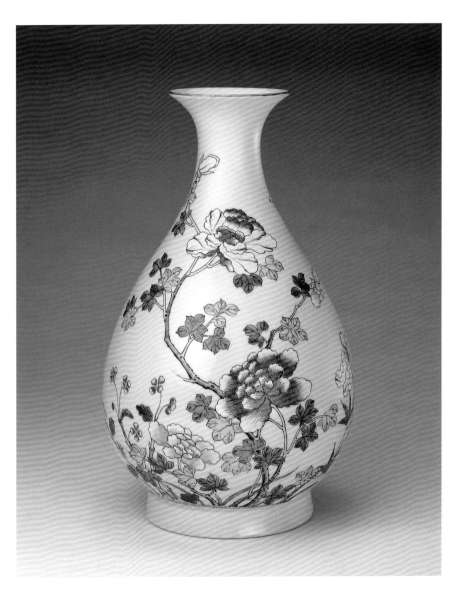

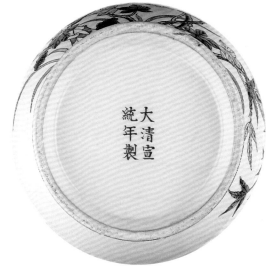

PORCELAIN WARES IN MIXED GLAZES AND ENAMELS

248

Pottery Jar with a Plate-shaped Mouth

and decorated with green-glazed designs under yellow glaze

Western Han Dynasty

Height 33.5 cm
Diameter of Mouth 15 cm
Diameter of Foot 14 cm

The jar has a plate-shaped mouth, a long neck, a globular belly, and a high ring foot. The paste is greyish in colour and covered with yellow glaze. The belly is painted with cloud patterns in green glaze.

Cloud design is the most representative decorative design in the Han Dynasty. In the Qin and Han Dynasties, the beliefs of deities and immortals were popular; and from common folks to the rich and powerful, all wished immortality and eternal life. Such a desire was also reflected by the decorative motifs in vogue in these periods, thus come a lot of designs of deities and mythical beasts amidst clouds among majestic mountains and islands where immortals dwell.

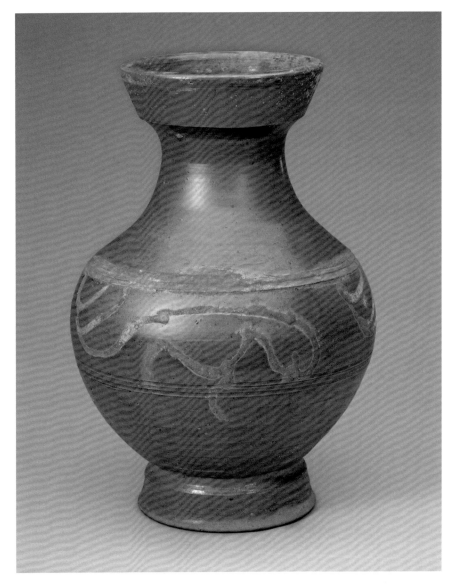

249

Ewer
decorated with green glazed designs under white glaze

Tang Dynasty

Height 16.7 cm
Diameter of Mouth 7.3 cm
Diameter of Base 5.8 cm

The ewer has a flared mouth, a round rim, a narrow neck, and an oval shoulder tapering downwards to a slightly flared and flat base. On the symmetrical sides of the shoulder and the neck is a short spout and curved handle. The paste is greyish in colour and coarse. The exterior is covered with white glaze and decorated with green patches and splashes.

The exterior wall is covered with white glaze which stops above the base and decorated with green patches and splashes. The decorative method of this ewer is to spray and pour green glazed patches and splashes over the white glaze so that green glaze would drip naturally and mixed with white glaze to create splashed aesthetic effects. Such wares in green and white glaze of the Tang Dynasty were developed from ceramic production in the Northern Dynasties. Kilns in Changsha, Hunan, kilns in the Gong county and Mi county, Henan, and the kilns in Huangbao county, Shaanxi are noted for producing this type of wares.

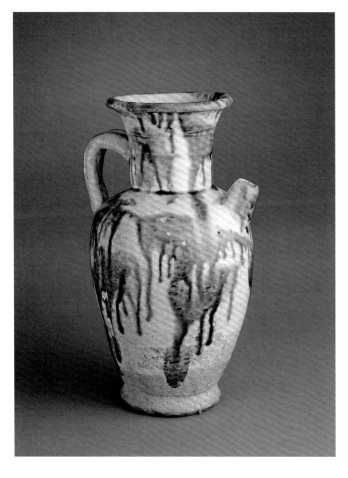

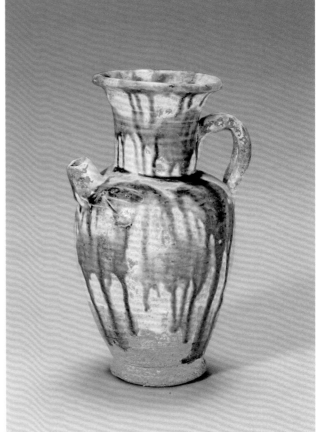

250

Vase
with Six Tubes
and decorated with design of foliage scrolls in green and sgraffito in white glaze, Dengfeng ware

Northern Song Dynasty

Height 22.9 cm
Diameter of Mouth 2 cm
Diameter of Foot 9 cm

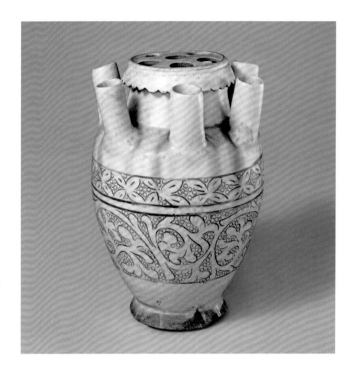

The ewer has six holes on the top mouth rim turning downwards and decorated with a floral border, a wide shoulder with six tubes, and a deep belly tapering downwards to a flared ring foot. The grey paste is covered with transparent glaze which stops above the foot. The six tubes on the shoulder are decorated with splashes of green glaze dripping downwards. The belly is decorated with two layers of sgraffito and craved designs, with the upper and narrower layer carved with four-petal floral design and the lower and wider layer with foliage scrolls.

Such wares with a number of tubes were popular burial objects in the Song Dynasty. The form is often potted in round shape or in the shape of pagoda, with five or six tubes. The interior of the tubes is hollow and blocked from the body of the vase. Such vases are often found together with vases with plate-shaped mouths, and remains of grains and wine paste are sometimes found, showing that they are the burial objects known as *shao* and *ying* urns, as recorded in historical documents. Some of these vases were found with epitaph inscriptions on them, and provide valuable information to conduct further researches.

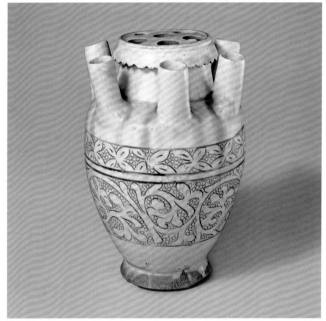

The historical site of Dengfeng kiln is located at Dengfeng City, Henan, which started production of ceramic wares in the Tang Dynasty, developed rapidly in the Northern Song Dynasty, but ceased production in the Yuan Dynasty. The kiln primarily produced stoneware in white glaze along with wares in black and *sancai* glaze. White glazed wares include wares painted in green glaze on a white ground, wares with incised designs on a white ground, wares with cut decorations on a white ground, wares with sgraffito designs on a white ground, and wares with decorations in black glaze on a white ground. The most unique technique is sgraffito design on a white ground. Such a technique is modelled after the gold and silver wares with chiseled decorations which began to be produced in the Tang Dynasty and subsequently has become a trendy decorative style adopted by kilns in North China since the late tenth century.

251

Bowl
with a Fitted Cover
and decorated with dragons
in iron-red enamel amidst
clouds on a white ground

Ming Dynasty Xuande period

Height 7.5 cm
Diameter of Mouth 17.1 cm
Diameter of Foot 10 cm

The bowl has a flared mouth, an angular belly, and a ring foot. The lower belly is decorated with a string border in relief. The whole body is covered with white glaze, whereas the interior is plain. The wall of the belly is decorated with a dragon amidst clouds and lotus lappets near the base which turns inwards. The exterior base is written with a six-character mark of Xuande in regular script in two columns within a double-line medallion in underglaze blue.

The form of the bowl is finely potted and there should have been a matching cover, which fits perfectly with the bowl and gives it the name *hewan* (fitting bowl). It was first produced in the Xuande period. The paste of this bowl is delicately fashioned and the white glaze is shinny and translucent. The dragon is depicted in a vivid manner with the accurate red colour tone harmoniously matching the pictorial treatment, reflecting the superb skills in producing wares with designs in iron-red in the early Ming Dynasty.

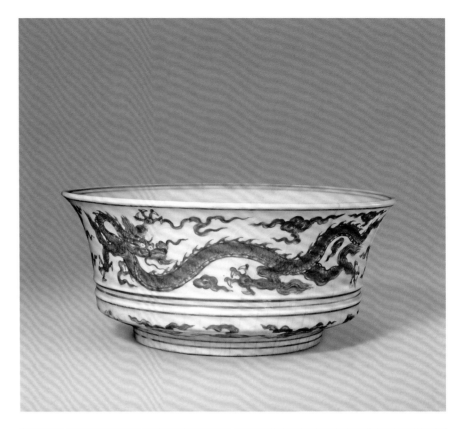

252

Plate
decorated with five fishes in iron-red enamel on a white ground

Ming Dynasty Hongzhi period

Height 4 cm
Diameter of Mouth 17.8 cm
Diameter of Foot 10.8 cm

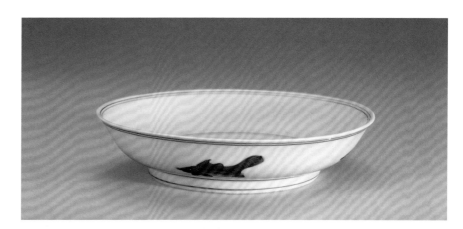

The plate has a slightly flared mouth, a curved wall, and a ring foot. The interior centre is decorated with a fish design, whereas the exterior is painted with *li* (carp), *gui* (mandarin fish), *qing* (mackerel), and *bo* (white fish), which are puns for *li gui qing bai* (courtesy, noble, clean and honest). The interior of the ring foot is covered with white glaze.

The fish designs are painted in a meticulous manner with details such as the gills and fins vividly rendered. The contrasting effect of iron-red enamel on a white ground has a strong visual aesthetic appeal.

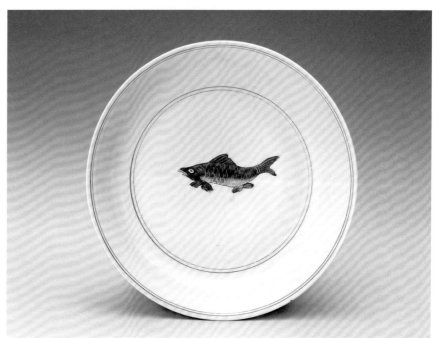

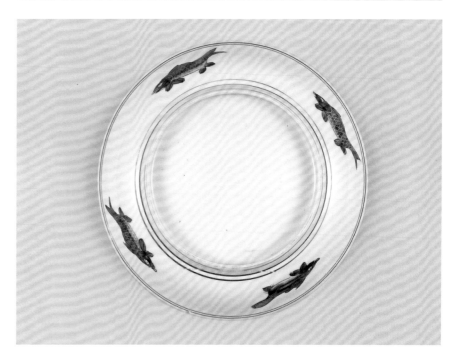

253

Bowl
decorated with incised design of dragons amidst clouds and cresting waves in green enamel on a white ground

Ming Dynasty Hongzhi period

Height 7 cm
Diameter of Mouth 16.3 cm
Diameter of Foot 6.7 cm
Qing court collection

The bowl has a flared mouth, a deep and curved wall, and a ring foot. The body is covered with white glaze. The exterior wall is incised with cresting waves and dragons amidst clouds in green enamel. The interior of the base, the mouth rim, and the exterior of the ring foot are decorated with string borders in green enamel. The exterior base is written with a six-character mark of Hongzhi in regular script in two columns within a double-line medallion in underglaze blue.

Wares with designs in green enamel on a white ground was first produced at Jingdezhen Kiln in the Yongle period in the Ming Dynasty, and continued in the Chenghua, Hongzhi, Zhengde, Jiajing, and Wanli periods. There are two techniques of production. The first is to paint designs in colour enamels directly on the body. The second is to incise designs on the biscuit first and then cover with transparent glaze. Afterwards other designs would be painted on the appropriate void spaces, and then the already applied transparent glaze be cut away for incising these designs on the exposed paste, to be followed by another round of high-temperature firing in the kiln. When firing was completed, potters would fill green enamel into the exposed areas, and fired again in low-temperature firing. This bowl is decorated with the second method which requires high technical mastery of production. Its refined form and pure colour of green enamel reveal the superb standard in the production of this type of imperial wares in the Hongzhi period.

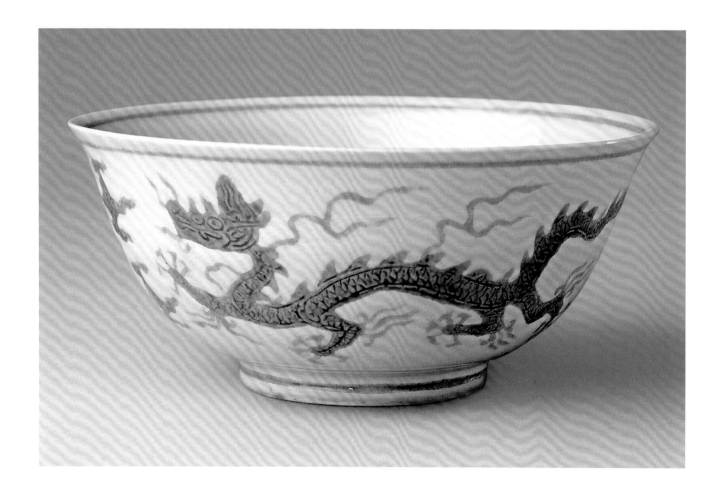

254

Plate
decorated with design of
flower and fruit sprays
in brown enamel
on a white ground

Ming Dynasty Hongzhi period

Height 5 cm
Diameter of Mouth 26 cm
Diameter of Foot 16 cm
Qing court collection

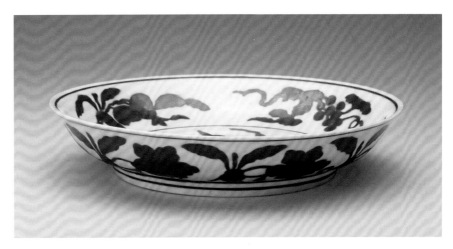

The plate has a flared mouth, a curved
wall, and a ring foot. The interior centre is
decorated with floral sprays and the interior
wall is painted with grapes, pomegranates,
and other flower and fruit sprays. The exte-
rior wall is decorated with sprays of flowers
and leaves. All the decorative designs are
incised first before application of glazes.
The interior base, the mouth rim, and the
exterior wall of the ring are decorated with
string borders in brown enamel. The exteri-
or base is written with a six-character mark
of Hongzhi in regular script in two columns
within a double-line medallion in under-
glaze blue.

Brown enamel is applied on the finely
incised designs, which creates a harmoni-
ous contrast with the pure white glaze with
high aesthetic appeal. The form and design
carry on the legacy of similar wares of the
Xuande and Chenghua periods.

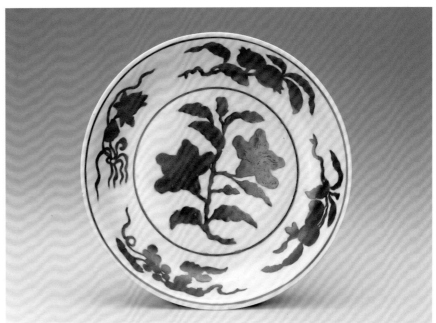

255

Plate
decorated with design of
Arabic and Persian scripts in
iron-red enamel
on a white ground

Ming Dynasty Zhengde period

Height 3.9 cm
Diameter of Mouth 17.9 cm
Diameter of Foot 11.9 cm

The plate has a flared mouth, a curved wall, and a ring foot. The body is covered in white glaze with Arabic and Persian script designs painted in iron-red. The four Arabic characters on the sides of the interior centre means "the supreme Allah says." The Arabian script in the centre of the plate is extracted from Koran, which means, "do not open your hands fully, or you will be the one blamed for regrets." The Arabic script on the exterior wall means "the supreme Allah says: those do good deeds that are only as big as dust will have their rewards; those who do evil things that are as only big as dust will be blamed, and this reveals the rewarding result of doing good deeds." The middle line among the three lines of scripts on the exterior base is written in Arabic script whereas the other two lines are in Persian script. The collective meaning of the three lines is "Ming Khan is Aman Sulaimansha."

Islamic religion was much favoured in the Zhengde period in the Ming Dynasty. Such a fashionable trend inspired the Imperial Kiln to use Arabic and Persian scripts in decorating porcelain wares. Most of the scripts were extracts of Koran, which became a distinctive decorative feature on Zhengde wares. Some scholars also believe that Emperor Zhengde was in fact is a Muslim, thus the three lines of inscriptions on the base can be alternatively interpreted as a reign mark with the connotation "The Great Emperor of the Ming court is Sulaiman, who commissioned the production of this ware."

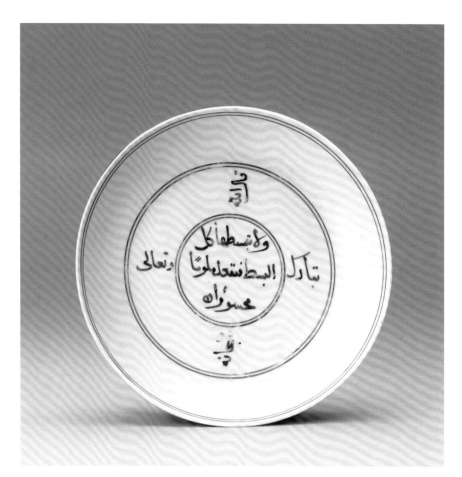

256

Plate

decorated with design of dragons amidst clouds in green enamel and incised cresting waves on a white ground

Ming Dynasty Zhengde period

Height 4.3 cm
Diameter of Mouth 17.7 cm
Diameter of Foot 10.5 cm

The plate has a flared mouth, a shallow and curved wall, and a ring foot. The body is covered with white glaze. The exterior wall incised with cresting waves under the glaze and painted with design of dragons amidst clouds in green enamel over the glaze. At the interior base, the area underneath the mouth rim and on the exterior wall of the ring foot are decorations of string borders painted in green enamel. The exterior base is written with a six-character mark of Zhengde in regular script in double columns within a double-line medallion in underglaze blue.

The decorative style of this plate is similar to the one illustrated at Plate 254. The green enamel has a slight yellowish tint and enhances the translucent effect. With the eyes wide-open and staring sideways, it looks as if the dragon is wearing a pair of spectacles, so this dragon design is commonly known as "the dragon with spectacles." The decorative style carries on the legacy of similar wares of the Chenghua period, with distinctive period characteristics. Dragon design had become a legitimate symbol of the emperor since the Yuan Dynasty, and the design has variations in different dynasties, which pose a standard in authenticating and dating of imperial wares of different dynasties.

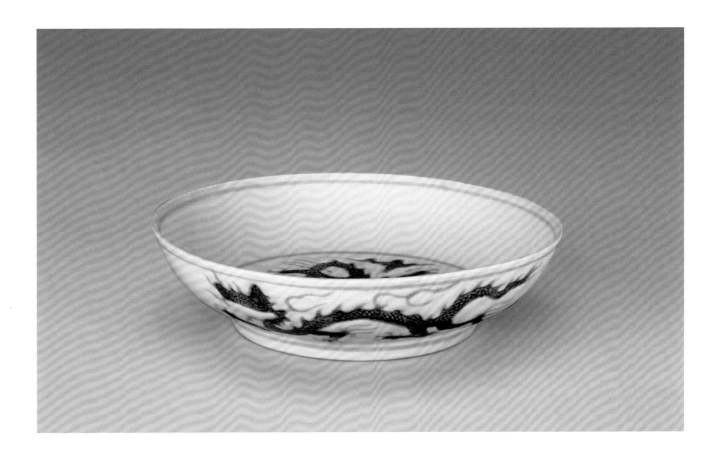

257

Zun Vase
decorated with incised
design of dragons amidst
clouds in green enamel
on a yellow ground

Ming Dynasty Zhengde period

Height 11.2 cm
Diameter of Mouth 14.6 cm
Diameter of Foot 8.4 cm
Qing court collection

The *zun* vase has a flared mouth, a
round belly, and a ring foot. The interior is
covered with white glaze whereas the exte-
rior wall is decorated with a dragon amidst
clouds in green enamel on a yellow ground.
Near the base are decorations of lotus lap-
pets. The interior of the ring foot is covered
with white glaze. The exterior base is writ-
ten with a four-character mark of Zhengde
in regular script in two columns within a
double-line medallion in underglaze blue.

The form of this *zun* vase is elegantly
potted with pure glaze and with the
colour tones of yellow and green enamels
harmoniously matched, representing a
refined imperial ware of the Zhengde
period.

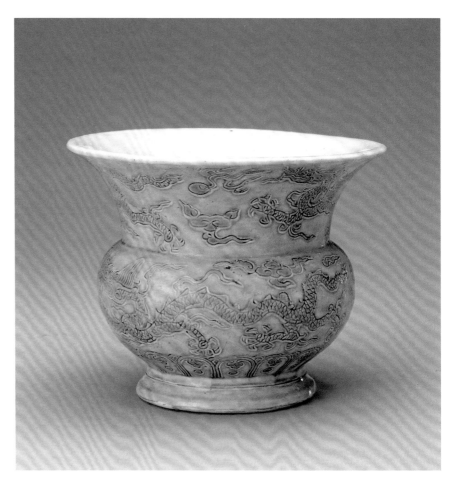

258

Gourd-shaped Vase
decorated with design of
lotus scrolls
in iron-red enamel
on a yellow ground

Ming Dynasty Jiajing period

Height 45.1 cm
Diameter of Mouth 5.1 cm
Diameter of Foot 13.4 cm
Qing court collection

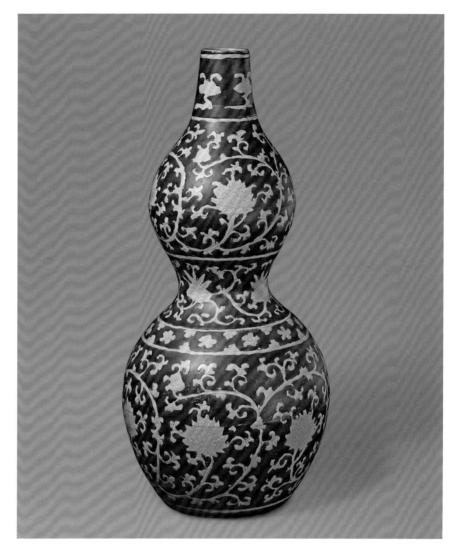

The gourd-shaped vase has an upright mouth, a narrow waist, and a ring foot. The body is decorated with six string borders in iron-red enamel on a yellow ground. The neck is decorated with *lingzhi* fungus sprays whereas the upper and lower belly is decorated with lotus scrolls and the waist with *lingzhi* fungus scrolls. The interior of the vase and the ring foot is covered with white glaze. The exterior base is written with a six-character mark of Jiajing in regular script in two columns within a double-line medallion in underglaze blue.

Emperor Jiajing was devoted to Daoism, resulting in the building of many Daoist temples and presentation of ceremonial functions and events. The Imperial Kiln at Jingdezhen fired a large number of Daoist wares including incense burners, *jue* wine cups, *zun* vases with flanges, and gourd-shaped vases. Decorative motifs associated with Daoism, such as cranes flying amidst clouds, the eight divinatory trigrams, the eight immortals, etc. were popular decorative designs of the period.

259

Box
decorated with dragons amidst clouds
in yellow enamel
on a green ground

Ming Dynasty Jiajing period

Overall Height 18 cm
Diameter of Mouth 31 cm
Diameter of foot 19.8 cm
Qing court collection

The round-shaped box has a cover fitting perfectly with the body and the ring foot. The body is decorated with dragons amidst clouds in yellow enamel on a green ground. The ring foot is covered with white glaze. The exterior base is written with a six-character mark of Jiajing in regular script in two columns within a double-line medallion in underglaze blue.

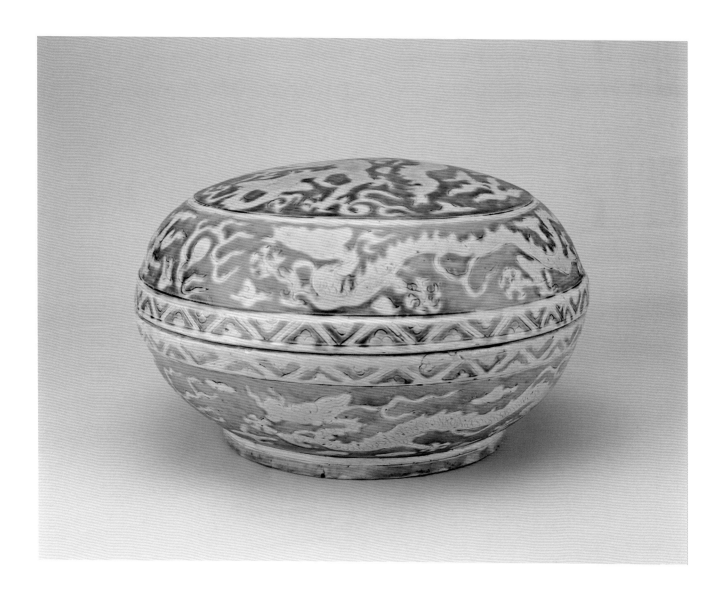

260

Covered Jar
decorated with design of incised lozenge-shaped panels and
dragons amidst clouds and cresting waves
in yellow enamel on a green ground

Ming Dynasty Wanli period

Height 19.1 cm
Diameter of Mouth 9.4 cm
Diameter of Foot 11.3 cm
Qing court collection

The covered jar has a straight mouth, a short neck, a slanting shoulder, a globular belly, and a ring foot. It has a matching round and a flat cover. The shoulder is decorated with deformed lotus lappets whereas the belly is decorated with four panels in lozenge shape, in which are decorations of dragons amidst clouds. Outside the panels are decorations of eight Buddhist auspicious emblems including the wheel, the conch shell, the umbrella, the canopy, the lotus, the jar, the twin-fish, and the endless knot. Near the base are decorations of floral patterns. The surface of the cover is painted with dragon medallions whereas the side of the cover is painted with floral patterns. The interior of the ring foot is covered with white glaze. The exterior base is written with a six-character mark of Wanli in regular script in two columns within a double-line medallion in underglaze blue.

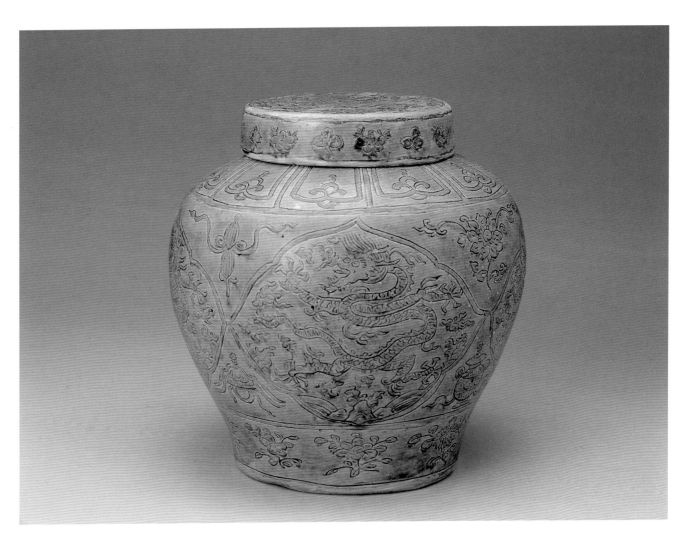

261

Lantern-shaped *Zun* Vase
decorated with design of legendary figures in panels in gilt and iron-red enamel on a white ground

Qing Dynasty Kangxi period

Height 38.5 cm
Diameter of Mouth 12.5 cm
Diameter of Foot 14 cm

The *zun* vase has a washer-shaped mouth, a short neck, a slanting shoulder, and a round belly tapering downwards to a splayed base and a ring foot. The interior and the exterior are covered with white glaze. The exterior is decorated with designs in gilt and iron-red. The belly is decorated with floral scrolls as the ground on which are square-shaped, fan-shaped, flower-and-leaf-shaped, and lozenge-shaped panels in which are designs of antiques, landscapes, and figures. Among them, the legendary figure design of "Zhong Kui, the demon-quellor in possession" and "Immortal of Longevity in the South Pole" are further written with the poetic couplets "There are unbound amusement in the painting hall, a lady is drunk before a painting in the book room," and "The Immortal of Longevity in South Pole is worshipping the Big Dipper, amidst five coloured clouds are the three terraces" written in black respectively. The mouth rim, the neck, the shoulder and the exterior wall are decorated with string borders, bead chains, a brocade ground, and floral medallions in panels. Near the foot is decorations of *chi*-dragons. The interior of the ring foot is covered with white glaze.

The vase is elaborately decorated with over ten layers of different designs, mostly in panels in various shapes, and thus the complicated designs are rendered systematically. The use of gold enamel further gives the vase a luxuriant and lustrous resonance. The use of iron-red enamel in the Kangxi period had reached a fully matured stage, and the iron-red could be rendered in light washes with tonal gradations and strong expressiveness.

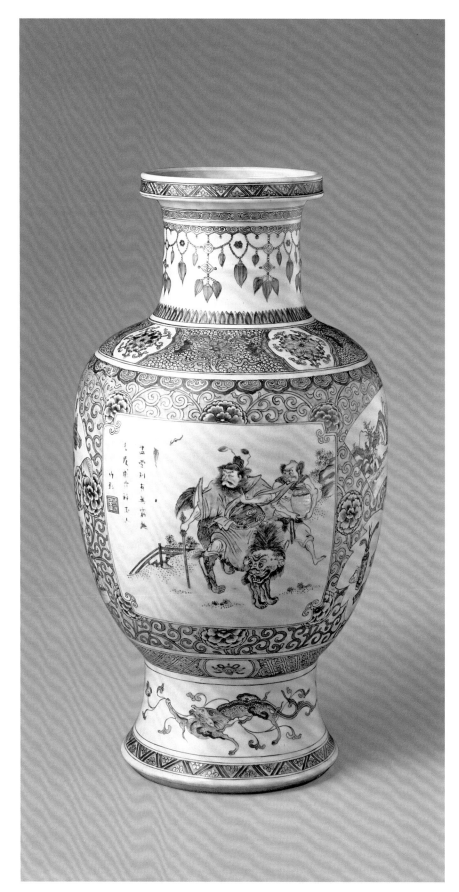

262

Bowl
decorated with design of two dragons in pursuit of a pearl in iron-red enamel on a yellow ground

Qing Dynasty Kangxi period

Height 7.4 cm
Diameter of Mouth 15 cm
Diameter of Foot 6.4 cm
Qing court collection

The bowl has a flared mouth, a deep and curved wall and a ring foot. The exterior is decorated with two dragons in pursuit of a ball in iron-red enamel on a yellow ground. The red glaze is tinted with date-red colour, and the interior of the bowl and foot are covered with white glaze. The interior of the ring foot is also covered with white glaze. The exterior base is written with a six-character mark of Kangxi in regular script in two columns within a double-line medallion in underglaze blue.

Both yellow and iron-red enamels utilized oxidized iron as colourant, but with different contents of PbO and Fe_2O_3. The yellow enamel contains over 40% of PbO and 3% of Fe_2O_3. Thus the latter could be melt in the glaze and turned to ferric iron, giving the enamel yellow colour. The red enamel contains less PbO, but the content of Fe_2O_3 is high, ranging from 30% to 50%, and the oxidized iron would not melt in the enamel, but it becomes pellets floating on the surface of lead glaze, making the enamel turns to red colour.

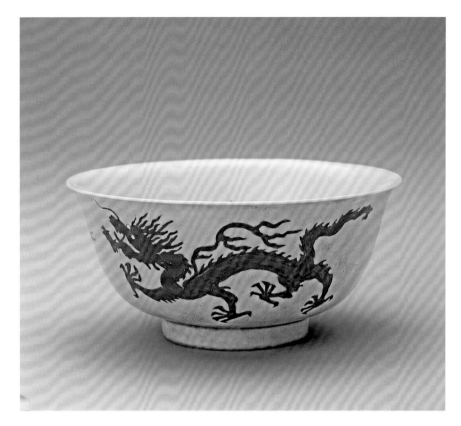

263

Plate
decorated with design of dragons in pursuit of a flaming pearl in iron-red enamel on a green ground

Qing Dynasty Kanxi period

Height 4.7 cm
Diameter of Mouth 21.7 cm
Diameter of Foot 14.2 cm
Qing court collection

The plate has a flared mouth, a shallow and curved wall, and a ring foot. The body is decorated with dragons in pursuit of a flaming pearl in iron-red enamel on a green ground with a sharp contrasting tonal effect. The interior of the ring foot is covered with white glaze. The exterior base is written with a six-character mark of Kangxi in regular script in two columns within a double-line medallion in underglaze blue.

In the Ming and Qing Dynasties, the Imperial Kiln at Jingdezhen had produced a large number of wares with monochrome grounds with decorations in single enamel colour, such as wares with green enamelled designs on a white ground, red enamelled designs on a white ground, green enamelled designs on a yellow ground, aubergine enamelled designs on a yellow ground, red enamelled design on a yellow ground, red enamelled designs on a yellow ground, yellow enamelled designs on a green ground, etc. However, wares with red enamelled designs on a green ground were very rare, as represented by this refined piece decorated with dragon designs in red enamel on a green ground.

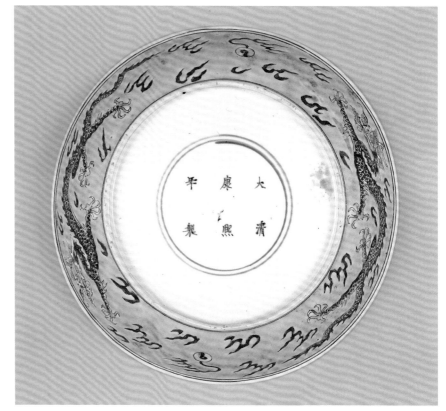

264

Bowl
decorated with design of dragons in green enamel on an underglaze blue ground

Qing Dynasty Kangxi period

Height 7 cm
Diameter of Mouth 14 cm
Diameter of Foot 5.8 cm
Qing court collection

The bowl has a flared mouth, a deep and curved wall, and a ring foot. The interior and the exterior are painted with designs in green enamel in reserved white on an underglaze blue ground. The interior centre and the exterior wall are decorated with dragons amidst clouds whereas near the base of the exterior wall are decorations of lotus lappets. The interior of the bowl and the foot are covered with white glaze. The exterior base is written with a six-character mark of Kangxi in regular script in two columns within a double-line medallion in underglaze blue.

Kangxi imperial wares with designs in green enamel are often rendered on a white ground or yellow ground, and less are rendered on an underglaze blue ground. The underglaze blue turns to bluish-black and the green is also in darker tone on this plate.

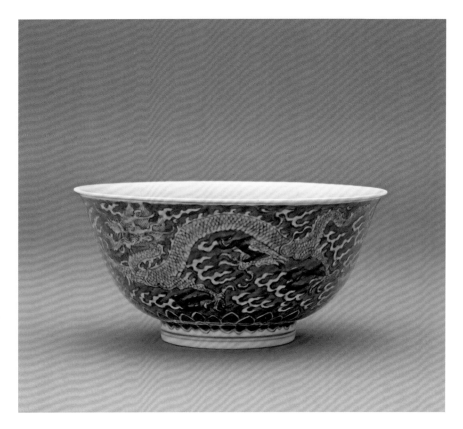

265

Bowl
decorated with incised design of dragons amidst clouds and cresting waves in aubergine enamel on a green ground

Qing Dynasty Kangxi period

Height 6.7 cm
Diameter of Mouth 13.3 cm
Diameter of Foot 6.7 cm
Qing court collection

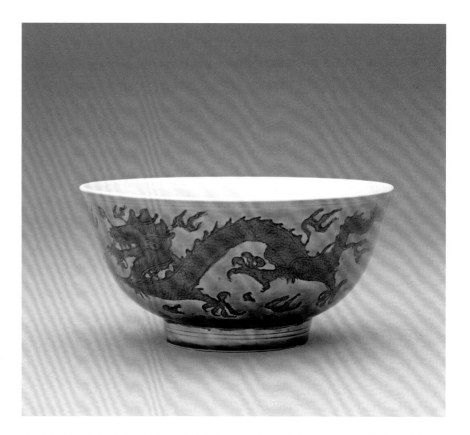

The bowl has a flared mouth, a deep and curved wall, and a ring foot. The exterior is decorated with two dragons in pursuit of a pearl in aubergine enamel on a green ground. All designs are incised on the biscuit first. The interior of the bowl and the ring foot are covered with white glaze. The exterior base is written with a six-character mark of Kangxi in regular script in two columns within a double-line medallion in underglaze blue.

The incised design on this bowl is also known as "awl-incised design," which is one of the techniques for decorating porcelain wares, and originated in the Yongle period in the Ming Dynasty. The technique is to use a sharp-pointed tool or an awl to incise designs of dragons and phoenixes, floral and foliated scrolls, and others on the biscuit first, and then covered with transparent glaze for firing.

266

Bowl
decorated with incised
design of dragons amidst
clouds and cresting waves
in aubergine enamel
on a yellow ground

Qing Dynasty Kangxi period

Height 6.4 cm
Diameter of Mouth 13 cm
Diameter of Foot 5.9 cm
Qing court collection

The bowl has a slightly flared mouth, a
deep and curved wall, and a ring foot. The
exterior wall is decorated with two dragons
in pursuit of a pearl in aubergine enamel
on a yellow ground, and complemented by
cloud patterns. Cliffs and cresting wave de-
signs are painted near the base. The exterior
wall is incised with two string borders. All
the designs are first incised on the biscuit
with a sharp-pointed tool or an awl. The in-
terior of the bowl and the ring foot is cov-
ered with white glaze. The exterior base is
written with a six-character mark of Kangxi
in regular script in two columns within a
double-line medallion in underglaze blue.

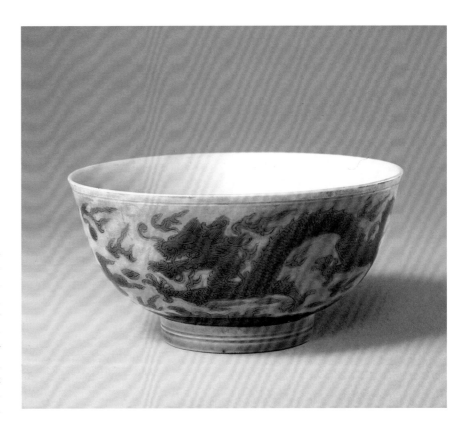

267

Bowl
decorated with design of phoenix medallions in iron-red enamel on a *dongqing* celadon ground

Qing Dynasty Yongzheng period

Height 6.9 cm
Diameter of Mouth 14 cm
Diameter of Foot 6 cm
Qing court collection

The bowl has a flared mouth, a deep and curved wall, and a ring foot. The interior and the exterior of the bowl are covered with *dongqing* celadon glaze. The interior of the base and the exterior wall are decorated with phoenix medallions in iron-red with delicate and meticulous brush work. The interior of the ring foot is covered with white glaze. The exterior base is written with a six-character mark of Yongzheng in regular script in two columns within a double-line medallion in underglaze blue.

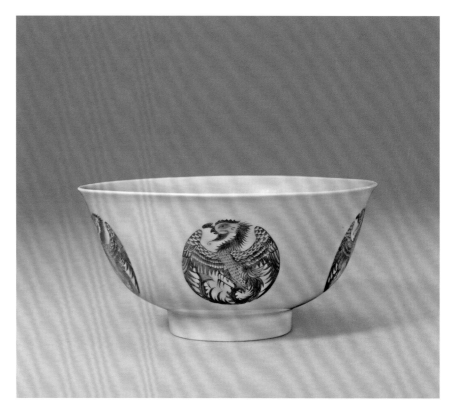

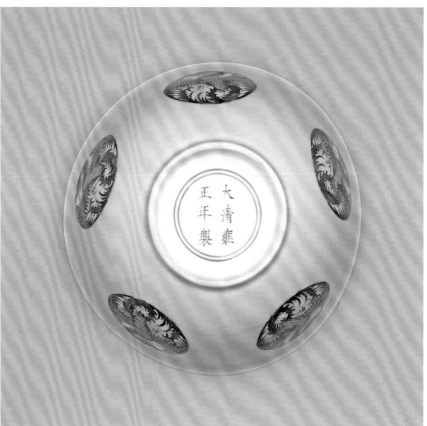

268

Brush Pot
decorated with design of landscapes in sepia ink enamel
on a white ground with simulated wood texture

Qing Dynasty Yongzheng period

Height 14.2 cm
Diameter of Mouth 18.4 cm
Diameter of Base 18.6 cm
Qing court collection

The brush pot is in cylindrical shape, and the base and the mouth are in similar size. The base is in the shape of a jade *bi* disc, whereas the interior, the mouth, and the foot are covered with glazed patterns simulating wood texture. The belly is painted with a continuous landscape scene in sepia ink enamel on a white ground. The landscape scenes depicting the sceneries of the Jiangnan region with myriad mountains and peaks, bushes, stream, and boating on a lake, as well as terraces and pavilions, pagoda, and figures on the lower part with a background of slope and river bank with delicate brush work, a touch of gracefulness, and lyrical resonance. The exterior base is covered with glaze simulating wood texture and decorated with a border of key-fret patterns in black on a green ground.

In terms of painting style, application of colours, and pictorial composition, the Yongzheng wares decorated with designs in sepia ink are in reminiscence of the traditional Chinese ink painting style. The pictorial plane is skillfully treated with delicate brush work, ink tonal gradations, spacious composition, and perspectives with a touch of loftiness and literati resonance, revealing the artistic cultivations of potters and ceramic artists.

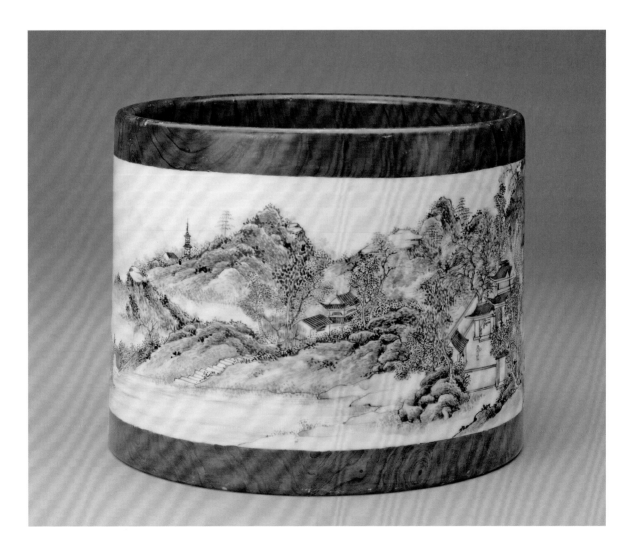

269

Plate
decorated with incised
design of floral sprays
in yellow enamel
on an underglaze blue
ground

Qing Dynasty Yongzheng period

Height 6.8 cm
Diameter of Mouth 33.3 cm
Diameter of Foot 21 cm
Qing court collection

The plate has an everted mouth, a curved wall, and a ring foot. The centre of the plate and the exterior are painted with floral sprays with the veins and textures of flowers and leaves finely incised like molded decorations. The interior of the ring foot is covered with white glaze with a reddish tint at the rim of the foot. The exterior base is written with a six-character mark of Yongzheng in regular script within a double-line medallion in underglaze.

The form and decorative designs of the plate are modelled after the plate decorated with design of flowers in yellow enamel on a blue ground of the Jiajing period, Ming Dynasty.

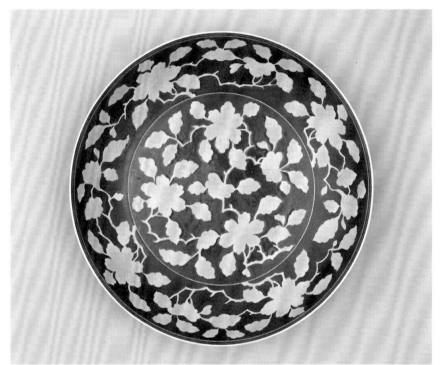

270

Plate

decorated with incised
design of two dragons
in pursuit of a pearl amidst
cresting waves in green
enamel on a white ground

Qing Dynasty Yongzheng period

Height 4.3 cm
Diameter of Mouth 17.5 cm
Diameter of Foot 10 cm
Qing court collection

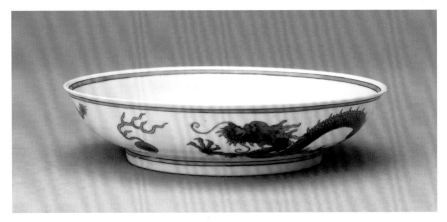

The plate has a flared mouth, a shallow and curved wall, and a ring foot. The interior centre is decorated with dragons amidst clouds whereas the exterior wall is decorated with two dragons in pursuit of a pearl amidst incised waves design. Underneath the mouth rim and exterior ring foot are decorations of string borders. The interior of the ring foot is covered with white glaze. The exterior base is written with a six-character mark of Yongzheng in regular script in two columns within a double-line medallion in underglaze blue.

The colour of green enamel on this plate is soft and brilliant. The dragons are painted in a meticulous and delicate manner whereas the cresting waves are precisely and clearly incised. The plate is modelled after the plate decorated with design of dragons amidst *anhua* incised cresting waves in green enamel in white glaze of the Hongzhi period in the Ming Dynasty (Plate 297).

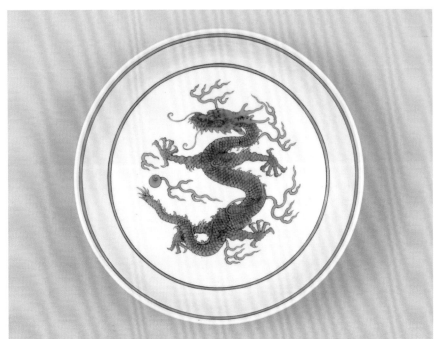

312

271

Olive-shaped Vase
with incised design of
auspicious clouds,
sprays of peonies and
chrysanthemums in green
enamel on a yellow ground

Qing Dynasty Yongzheng period

Height 30 cm
Diameter of Mouth 7.5 cm
Diameter of Foot 8.3cm
Qing court collection

The olive-shaped vase has a flared
mouth, a small neck, a round belly tapering
downwards to a slightly splayed base, and a
high ring foot. The interior is covered with
yellow glaze. The mouth rim is decorated
with two string borders. The neck is paint-
ed with banana leaves and floral designs.
The belly is decorated with peony sprays
interspersed by chrysanthemum sprays and
cloud design. Near the foot are decorated
with deformed lotus lappets, in which are
floral designs. The exterior base is written
with a six-character mark of Yongzheng
in regular script in two columns within a
double-line medallion in underglaze blue.

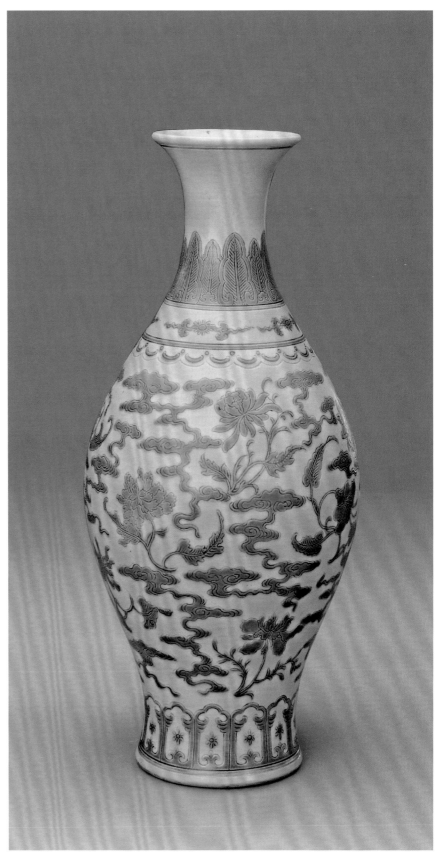

272

Ganlu Vase
decorated with design of lotuses in iron-red enamel on a white ground

Qing Dynasty Qianlong period

Height 22 cm
Diameter of Mouth 3.4 cm
Diameter of Foot 12 cm
Qing court collection

The vase has an everted mouth, a long neck with lower part in relief, and a globular belly tapering downwards to a splayed flared base. The body is covered with white glaze and the exterior wall is decorated with designs in iron-red enamels. The neck is decorated with key-fret patterns, floral patterns, and lotus lappets, whereas the upper and lower parts of the belly are painted with lotus lappets and banana-leaf designs, and the middle part is decorated with lotus flowers. Near the base is decorations of lotus lappets.

This vase is also known as "*ganlu* (pure water) vase", which was a Buddhist ceremonial vessel that the Qing court bestowed to Tibetan monks. The Qing court archive records that Tang Ying, the Director General of the Imperial Kiln, had been commissioned by the imperial court to produce this type of pure-water vase with decorative designs in iron-red enamel on a white ground. On the other hand, in his book *Yinliuzhai Shuoci*, Xu Zhiheng mentioned that, "Such vases were exclusively produced in the Qianlong period. Later Tibetan monks seldom visited the court, and production of such wares was suspended."

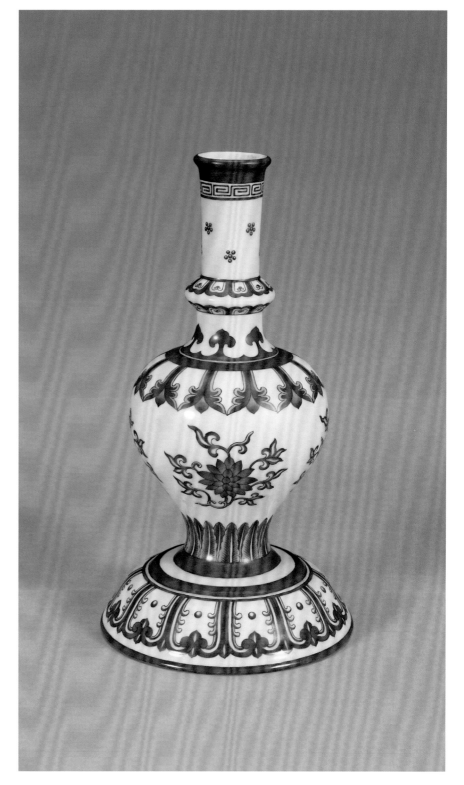

273

Vase with Tubular Handles

and decorated with incised design of dragons amidst clouds in green enamel on a yellow ground

Qing Dynasty Qianlong period

Height 30.8 cm
Diameter of Mouth 7.5 cm
Diameter of Foot 8.5 cm
Qing court collection

The vase has a flared mouth, a long neck, a slanting shoulder, a globular belly tapering downwards to a slightly splayed base, and a ring foot. On the symmetrical sides of the neck is a pair of tubular handles, and the wall of the ring foot also has two holes for fashioning the vase to facilitate carrying. The body is covered with yellow glaze and the exterior wall is decorated with designs in green enamel. The neck is decorated with cloud patterns and the belly is painted with dragons amidst clouds, with wave design painted near the foot and key-fret patterns on the tubular ears. The exterior base is engraved with a six-character mark of Qianlong in seal script in intaglio style in three columns.

Wares with decorative designs in green enamel on a yellow ground were commonly produced in the Imperial Kiln in the Qing Dynasty. In the Qianlong period, such wares produced were mostly vases, covered jars, large plates, and bowls.

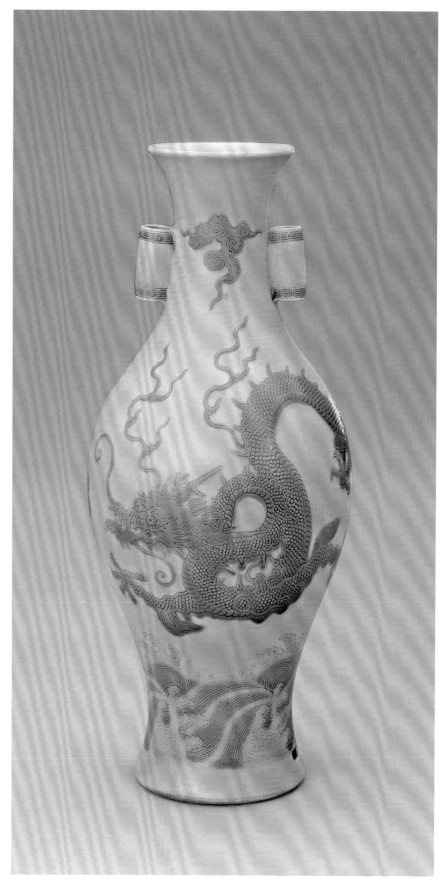

274

Meiping Vase
decorated with design of
lotus scrolls in green enamel
on a black ground

Qing Dynasty Qianlong period

Height 17 cm
Diameter of Mouth 3.3 cm
Diameter of Foot 6.2 cm
Qing court collection

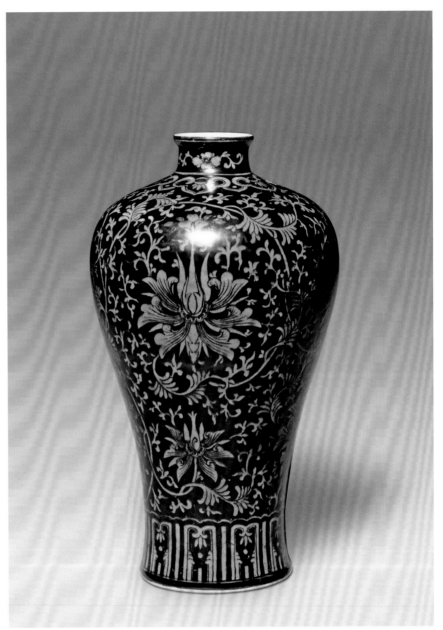

The vase has an everted mouth, a short neck, a wide shoulder, a belly curved inwards, and a ring foot. The exterior wall is decorated with designs in green enamel on a black ground. The neck is decorated with floral patterns, and the shoulder is painted with *ruyi* cloud patterns, whereas the upper and lower belly is decorated with lotus scrolls. Lotus lappets are painted near the base. The interior of the vase and the ring foot are covered with turquoise-green glaze. The exterior base is written with a six-character mark of Qianlong in regular script in three columns within reserved square in underglaze blue.

The decorative technique in producing wares with designs in green enamel on a black ground is to paint the decorative designs in "lifted white" in underglaze blue on the fashioned biscuit first. After covering with transparent glaze and fired in high temperature in the kiln, then cucumber green enamel would be applied and fired a second time in low temperature baking atmosphere again. The underglaze blue turns to black under the cucumber green enamel.

275

Covered-bowl
decorated with an imperial
poem in iron-red enamel
on a white ground

Qing Dynasty Jiaqing period

Height 8.1 cm
Diameter of Mouth 15.7 cm
Diameter of Foot 4.7 cm
Qing court collection

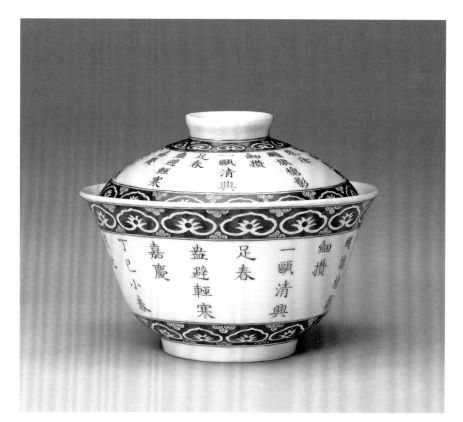

The bowl has a flared mouth, a deep
and curved belly and a ring foot. It has a
matching canopy-shaped cover, on which
is a knob. The body is covered with white
glaze. The exterior wall is decorated with
designs in iron-red enamel. The cover is
painted with *ruyi* cloud patterns, and in
between is an imperial poem of Jiaqing,
Brewing Tea, written in regular script.
Underneath the poem is the inscription "*Ji-
aqing dingsi xiaochunyue zhi zhonghuan
yuzhi*" (made in the middle small spring
month of the year *dingsi* of the Jiaqing
period) with a relief-style round seal mark
jia in seal script and a relief-style square
seal mark *qing* in seal script in iron-red.
The interior of the knob and the ring foot
are six-character marks of Jiaqing written in
seal script in three columns in iron-red.

The year *dingsi* corresponds to the
second year of the Jiaqing period (1797). The
"small spring month" actually refers to the
tenth month of the Chinese lunar year, and
zhonghuan refers to the middle ten days of a
month. In ancient China, there was a practice
that officials could take a formal day off in
every ten days, and on this day, they often
took baths and laundry works, thus a month
is divided in three parts, *shanghuan, zhong-
huan*, and *xiahuan*, referring to the division of
a month in three periods, each with ten days.

This covered-bowl is modelled af-
ter the type of bowls with design of three
purities of the Qianlong period. The dec-
orative designs are rendered meticulously
with a touch of delicacy, and the poem is
written in a graceful manner. Wares with
these imperial poems are mostly tea wares
such as teapots, tea-bowls, tea-cup stands,
etc. with underglaze blue and painted wares
with coloured grounds produced.

PORCELAIN WARES IN PLAIN THREE-COLOUR ENAMELS

276

Covered Jar
in *sancai* glaze
(three-colour glazes)

Tang Dynasty

Overall Height 23.5 cm
Diameter of Mouth 12.8 cm
Diameter of Foot 12.8 cm

The covered jar has a slightly flared mouth, a short neck, and a swelling shoulder tapering downwards to a wide ring foot. It has a matching canopy-shaped cover with the pointed knob on the top. The cover is everted to a flat flange and a straight mouth. The jar is potted with greyish-white paste, and covered with *sancai* glazes dripping downwards but stop at the over belly. The mouth of the jar is in yellow glaze, and below the mouth is glazed in green enamel, with spots of white and yellow lines dissected into a number of lozenge patterns, inside which are five-petal flowers formed by white spots. The cover is glazed in green and dissected into four petals by yellow lines and decorated with white spots, inside which are five-petal flowers formed by white spots. Such glazing and decorative technique is likely derived from the fashionable decorative style on the wares in marble glaze of the Tang Dynasty.

Wares in *sancai* glazes are low-temperature fired earthenwares. The paste is mostly porcelain clay, but there are also pottery wares. The first step is to fire the biscuit (plain firing) first, then apply glaze and fire again. The major characteristic is that the glaze is in rich and bright colour tones including green, yellow, brown, reddish brown, red blue, white, etc., with the glaze shiny and generating a free splashing aesthetic appeal. Another characteristic is that the wares are potted in a wide variety of forms, which could be divided into two types of sculptural objects and vessels. Sculptural objects include burial figures, burial animals and beasts, tomb guardian beasts, burial objects in architectural, cart forms, etc. Vessels and utensils include vases, jars, covered jars, censers, bottles, cups, bowls, plates, cups, spittoons, boxes, pillows, candle stands, etc. The sculptural objects are produced for burial purposes with the deceased, whereas vessels and utensils are for daily use, but some are also for burial purpose.

Tang *sancai* ware was first produced in the period of Emperor Gaozong. It reached a height in the period of Emperor Xuanzong, then declined gradually afterwards. Kilns for producing these wares spread over wide districts and regions, with large numbers produced in Xi'an and Luoyang with higher standards and achievements. Xi'an and Luoyang were the two capitals in the Tang Dynasty, and the massive production of *sancai* wares was closely associated with the extravagant practices in funerals by putting a lot of burial objects with the deceased in their tombs. A possible reason for the decline of these wares was that Emperor Xuanzong in his 29th year of reign (741) ordered to stop extravagant practices in burials, or it was also due to the decline of the Tang court and social upheavals after the Rebellions of An Lushan and Shi Siming in the late Tang period.

277

Pillow in the Shape of Waist

and decorated with carved design of potted flowers in *sancai* glazes

Northern Song Dynasty

Height 10 cm
Diameter of surface 40 × 25 cm
Diameter of Base 39 × 24 cm

The pillow is shaped like a waist with the surface in a slope form, higher in the front part and lower at the rear part. The paste is coarse with brownish-red tint and mainly glazed in green, whereas the designs are rendered in yellow and white glazes. The centre of the pillow is decorated with design of waist-shaped panel in which are decorations of pots of flowers. In the centre of the surface, two pots of flowers in green and bordered by yellow are painted on a white ground. Each pot has a plant with yellow flowers and green leaves, interspersed by rocks and green bamboos in between. The decorations are bordered with two lines in yellow. The border of the pillow surface and the sides are glazed in green and decorated with foliage scrolls. The base is unglazed and inscribed "*Xuxinlengqi, dushizicuo*" (It is all my faults and I should keep a humble heart and calm temper).

Wares in *sancai* glazes of the Song and Jin Dynasties were earthenware fired in low temperature with the production techniques inherited from by Tang Dynasty. Glazes commonly used include yellow, green, white, brown, bright red, black, and the newly created peacock green. Wares produced are mostly pillows, lamps, boxes, and other functional utensils and vessels. Others include tributary wares and vessels. These two types of wares are mostly decorated with carved and incised designs, and they are widely found at the kiln sites in Yu county, Henan, Lushan, Neixiang, and Yiyang districts.

278

Long Plate in a Floral shape
and decorated with design of lotuses and waves in *sancai* glazes

Liao Dynasty

Height 2.5 cm
Diameter of Mouth 30 × 17 cm
Diameter of Base 26 × 12 cm

The plate foliated in the shape of cydonia with a mouth rim everted to a flange, a shallow body, and a flat base. The form is modelled after gold and silver wares. It is decorated with molded designs, and glazed in green, white, and yellow. The mouth rim is covered with green glaze and decorated with a border of foliated scrolls. The interior is decorated with molded wave designs on a white ground, and with three flowers in green petals and yellow stamen, which looks like three lotuses fully bloomed on the water surface.

Sancai wares produced in the Liao Dynasty were fired in low temperature with the production techniques inherited from the Tang *sancai* wares, and became popular in late middle and late period of the Liao Dynasty. The biscuit is mostly potted with porcelain clay, but with various ingredients and the quality is soft and coarse with a reddish tint. To enhance aesthetic effect, a layer of slip was applied on the paste and then fired to have the form completed, and applied again with glazes for firing a second time. Most of the colour glazes are confined to yellow, green, white, and brownish-red and without blue. Decorations are often rendered with the molded designs of stamped techniques. As compare with the Tang prototypes, other than the differences in the use of clay (porcelain clay for Liao wares) and colour (without blue), the fluidity of colour glazes is not so smooth and glazes usually do not mix, thus without the splashed and naturally dripping effects of the Tang *sancai* wares. Kilns that produced *sancai* wares in the Liao Dynasty include Gangwa kiln, Chifeng, Inner Mongolia, Jiangguantun kiln, Liaoyang, Liaoning, Longquanwu kiln, Mentougou, Beijing, etc., with the best produced in the Gangwa kiln, which are noted for refined forms and delicate decorative style.

279

Three-legged Washer
decorated with incised design of toads in waves in plain three-colour enamels on a green ground

Ming Dynasty Zhengde period

Height 10.8 cm
Diameter of Mouth 23.7 cm
Distance between legs 17 cm
Qing court collection

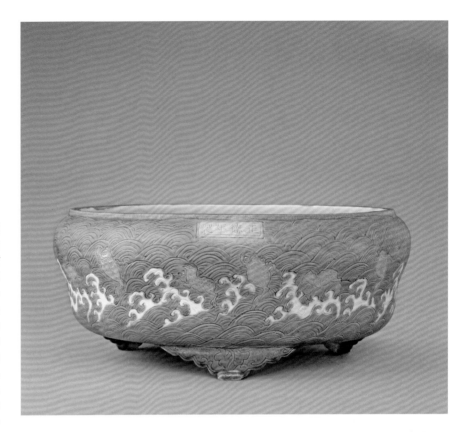

The washer has a wide mouth curved inwards, a narrow waist, and a flattened base supported by three legs in the shape of *ruyi* cloud patterns. The interior is covered with greenish-white glaze, whereas the exterior decorated in three-colour enamels of yellow, green, and white. The body is decorated with toads in the sea. Sixteen toads are rendered with different postures swimming amidst waves in yellow enamel. All the decorations are incised with a pointed tool or an awl first. The mouth rim and the foot are covered with aubergine enamel. Underneath the mouth rim is an incised rectangular frame with the interior covered in yellow enamel, in which a horizontal four-character mark of Zhengde is written in regular script.

The form of this washer is finely fashioned in a distinctive shape. Decorative designs are concisely and vividly rendered with harmonious and charming colour tones and fluent brush work with a touch of gracefulness and delicacy. Plain three-colour glazed wares started to take shape in the Chenghua period in the Ming Dynasty, but few were produced at the time. It was not until the Zhengde period that more were produced with refined quality and attained high esteem.

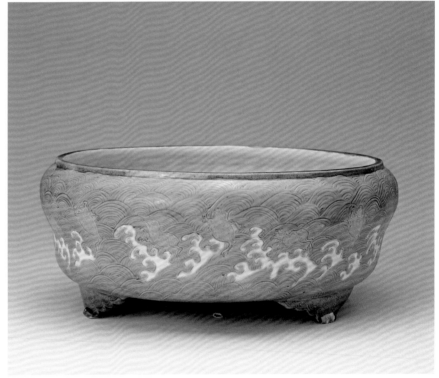

280

Stem-bowl
decorated with incised design of lotus scrolls in plain three-colour enamels on a green ground

Ming Dynasty Zhengde period

Height 12 cm
Diameter of Mouth 15.9 cm
Diameter of Foot 4.6 cm
Qing court collection

The bowl has a flared mouth, a deep and curved belly, and a slim base supported on a hollow stem-foot. It is covered with greenish-white glaze in the interior of the bowl and the ring foot first, and then incised with design of lotus scrolls, cloud patterns on the exterior wall before firing in high temperature. After first firing, low temperature green glaze was then applied with the incised design filled with aubergine, peacock green, yellow enamels, and translucent glaze before firing it again in low temperature baking atmosphere for a second time. Five lotus flowers scrolls are depicted with one in yellow, two in white, and two in peacock green harmoniously with a touch of subtleness and tranquility.

281

Stool
decorated with incised
design of dragons in a lotus
pond in plain three-colour
and red enamels
on a white ground

Ming Dynasty Jiajing period

Height 36.9 cm
Diameter of Surface 24 cm
Diameter of Base 24 cm
Qing court collection

The stool is in drum-shaped, hollow inside with a slightly concave surface. The interior is plain and unglazed. The surface is painted with a dragon facing the front in a lotus pond. The upper and lower exterior walls are painted with a border of drum nails and key-fret patterns respectively. Between the upper and lower border with drum-nail patterns are decorations of two dragons swimming in a lotus pond. The decorations are incised with a pointed tool or an awl on the paste first, and then decorated in red, green, yellow and blue enamels.

The form of the stool is fashioned in a new and creative shape with elaborate decorative designs, representing a refined piece produced in Imperial Kiln in the Jiajing period. The stool is actually a seat which was a popular type of wares in the Ming and Qing Dynasties. The distinctive feature of stools produced in the Ming Dynasty is the surface, which is usually convex whereas those produced in the Qing Dynasty is flat.

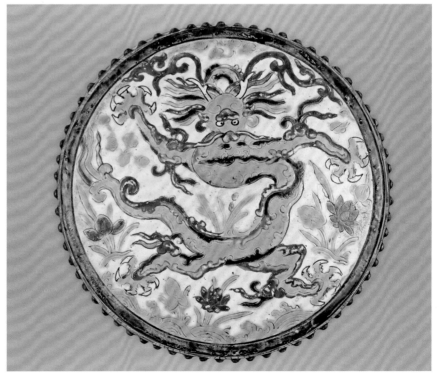

282

A Pair of Plates
decorated with incised
design of dragons amidst clouds, flowers,
and fruits sprays in plain three-colour
enamels on an aubergine ground

Ming Dynasty Wanli period

Left: Height 2.9 cm
Diameter of Mouth 14 cm
Diameter of Foot 8 cm

Right: Height 2.7 cm
Diameter of Mouth 14 cm
Diameter of Foot 8.5 cm

The plate has a slightly flared mouth, a shallow and curved wall, and a shallow ring foot. The two plates are same in form and design. Dragons amidst clouds are painted within a medallion in yellow in the interior centre of the plate. The interior and the exterior walls are decorated with floral sprays with flowers in yellow and leaves in green enamels. All the decorations are incised on the paste first. The interior of the ring foot is glazed in aubergine enamel. The exterior base is incised with a six-character mark of Wanli in regular script in green enamel in two columns within a double-line medallion in yellow.

325

283

Plate with a Foliated Everted Rim
and decorated with incised design of dragons amidst clouds and flowers in plain three-colour enamels on a yellow ground

Qing Dynasty Kangxi period

Height 8 cm
Diameter of Mouth 40.8 cm
Diameter of Foot 25.6 cm
Qing court collection

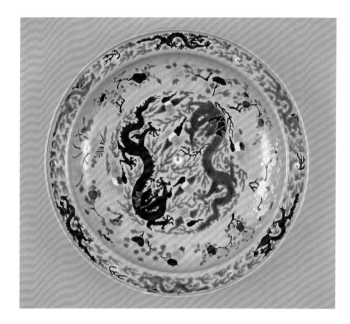

The plate has a flared mouth, a foliated edge everted to a flange, a shallow and curved wall, and a ring foot. Two dragons in pursuit of a pearl are painted in the interior centre of the plate whereas the interior wall is painted decorated with floral sprays. The upper side of the everted flange is decorated with dragons in pursuit of a pearl whereas the lower side is decorated with cranes amidst clouds. The exterior wall is also decorated with dragons in pursuit of a pearl. All the decorations are incised with a pointed tool or an awl on the paste first. The interior of the ring foot is covered with white glaze. The exterior base is written with a six-character mark of Kangxi in regular script in two columns within a double-line medallion in underglaze blue.

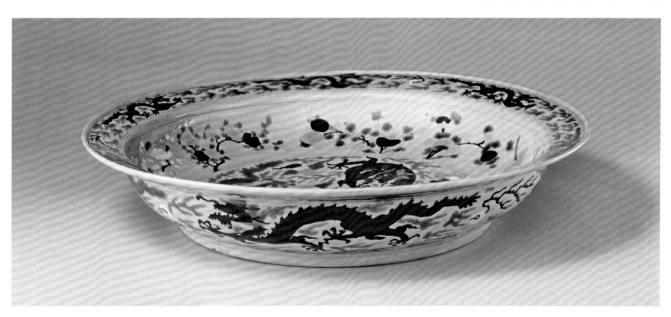

284

Octagonal Censer

decorated with openwork design of *wan* swastikas in plain three-colour enamels on a white ground

Qing Dynasty Kangxi period

Height 17.1 cm
Diameter of Mouth 19.6 cm
Diameter of Foot 20.3 cm
Qing court collection

The censer is in octagon shape supported by an octagon base that can be dismantled. The top of the censer has a round panel in which openwork design of *wan* swastika patterns is framed within square, and further enriched by designs of floral scrolls around. The body is glazed in a green ground with pearl patterns, and the eight sides of the censer are decorated with openwork design of coin-shaped panels with a *chi*-dragon on the top side of each panel.

This censer is decorated with designs in yellow, green, and aubergine enamels, and supplemented by blue designs on a white ground, exuding a sense of subtleness and tranquility.

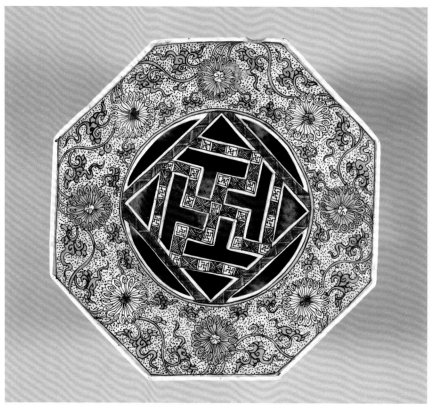

285

Plate
decorated with incised design of dragons amidst clouds, flowers and fruits in plain three-colour enamels on a white ground

Qing Dynasty Kangxi period

Height 4.7 cm
Diameter of Mouth 25.1 cm
Diameter of Foot 16.7 cm
Qing court collection

The plate has a slightly flared mouth, a shallow and curved wall, and a ring foot. The interior and the exterior of the plate are decorated with incised design of dragons amidst clouds. The interior is painted with fruit sprays such as pomegranates and others on the incised designs. The exterior is painted with peony sprays with the flowers in green, purple, yellow, and black. The fruits are outlined in black to highlight the fully ripe fruits in a vigorous manner. The interior of the ring foot is unglazed. The exterior base is written with a six-character mark of Kangxi in regular script in two columns within a double-line medallion in underglaze blue.

The colour tone of the designs on the plate is graceful and subtle, and the incised design of dragons amidst clouds is visible under the painted designs of flowers and fruits, showing the consummate manipulation of the pictorial plane by the ceramic artists.

286

Duomu Pitcher

decorated with tiger-skin patterns in three-colour enamels

Qing Dynasty Kangxi period

Height 40.5 cm
Diameter of Mouth 13.8 cm
Diameter of Foot 12.6 cm

The pitcher is in cylindrical shape, and has a mouth in the shape of a monk's cap and ring foot. On one side is a curved spout, and on the other side is a pair of animal-masked handles. The belly is decorated with string borders in relief. The interior is unglazed whereas the exterior is in yellow, green, white, and brown enamels. The interior of the ring foot is covered with white glaze.

The pitcher was a utensil used by Mongolian and Tibetan tribes in daily life. This type of wares was first produced in the Jingdezhen Kilns in the Yuan Dynasty, and produced in a large number in the Imperial Kiln at Jingdezhen in the Kangxi and Qianlong periods.

287

Vase
decorated with incised design of lotus sprays in plain three-colour enamels on a yellow ground

Qing Dynasty Qianlong period

Height 32.4 cm
Diameter of Mouth 10 cm
Diameter of Foot 8 cm

The vase has a flared mouth, a long neck, a slanting shoulder tapering downwards to the flat base, and a ring foot. The exterior is decorated in aubergine and green enamels on a yellow ground. Underneath the mouth rim are decorations of *ruyi* cloud lappets in aubergine, and the neck is decorated with lotus designs in aubergine and green enamels. The joint area of the shoulder and the neck is decorated with floral designs in aubergine and green enamels. The shoulder is painted with *ruyi* cloud lappets whereas the belly is decorated simultaneously with four lotus sprays in aubergine and green enamels. Near the base are decorations of lotus lappets. All the decorations are incised with a pointed tool or an awl on the paste first. The interior of the vase and the ring foot are covered with yellow glaze. The base is incised with a six-character mark of Qianlong in seal script in three columns.

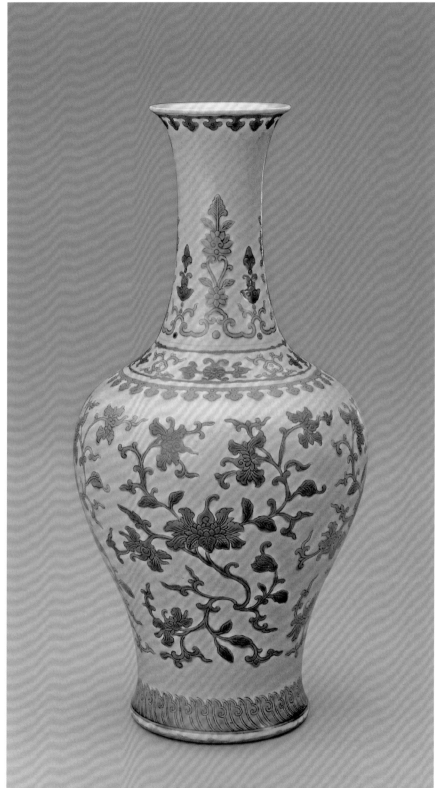

FAHUA POTTERY AND PORCELAIN WARES

288

Drum-shaped Stool
decorated with carved and
openwork design of
a peacock and peonies
in *fahua* enamels

Ming Dynasty Zhengtong period

Height 32.5 cm
Diameter of Surface 24.5 cm
Diameter of Foot 24.5 cm

The drum-shaped stool is hollow in-
side and the surface is slightly convex. The
body is decorated with incised, engraved,
carved designs in openwork or in relief,
and in *fahua* enamels of aubergine, yellow,
white, peacock green, and others. The cen-
tre surface of the stool is painted with moon
and flowers surrounded by four lotus leaves
which is only painted partially in half. The
upper and lower parts of the exterior wall
are decorated with two borders of drum-nail
patterns respectively with the six nail-drum
patterns depicted rather spaciously on the
exterior side. In between the nail-drum pat-
terns are decorations of auspicious clouds
in the shape of a character *ren*. The exterior
wall is carved with openwork design of pea-
cock, rocks, and peonies.

Porcelain wares with *fahua* decoration
were first produced in the Yuan Dynasty
and developed rapidly in the Ming Dynasty,
but gradually declined in the Qing Dynasty.
These wares were produced mainly in the
kilns in the Southern Shanxi province. *Fa-
hua* wares produced are mainly coloured
in yellow, green, blue, and aubergine. This
stool is decorated with peacock and peonies
and the decorative style is very similar to
those painted on wares in underglaze blue
produced in the Jingdezhen Kiln in the
Zhengtong period in the Ming Dynasty,
thus this stool should also be dated to the
period as well.

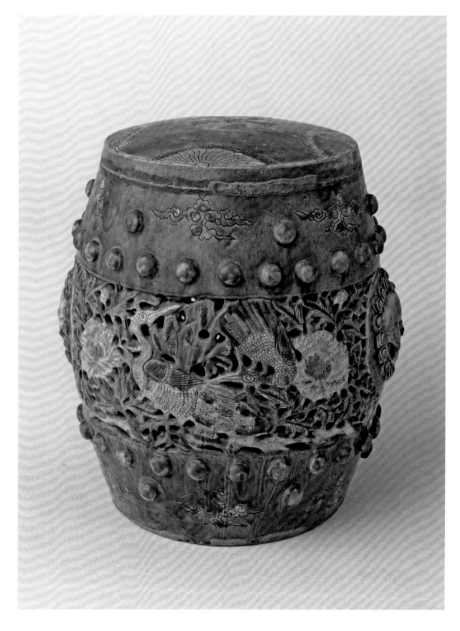

289

Drum-shaped Stool
decorated with carved and openwork design of a phoenix in *fahua* enamels

Ming Dynasty Chenghua period

Height 35 cm
Diameter of Surface 22.3 cm
Diameter of Foot 23.5 cm

The drum-shaped stool is hollow inside and the surface is slightly convex. On the two symmetrical sides of the belly is a pair of animal masked handles. The body is decorated with designs in white, blue, aubergine, and peacock green glazes. The centre of the surface is carved with peony design. The upper and lower sides of the belly are decorated with a border of drum-nail patterns respectively, whereas the middle part of the belly is carved with a dancing phoenix among blooming peonies, floral sprays, rocks, and mountains.

Fahua wares are originally pottery wares. The Jingdezhen Kiln in the Ming Dynasty successfully imitated the techniques, and wares of this type were produced with better skills and quality. This stool is a product of the Jingdezhen Kiln dated to the Chenghua period of the Ming Dynasty. The chemical components of both the *fahua* glazes and glass glaze are basically the same and the difference is that glass glaze utilizes oxidized lead as flux, whereas *fahua* glaze utilizes potassium nitrate as flux.

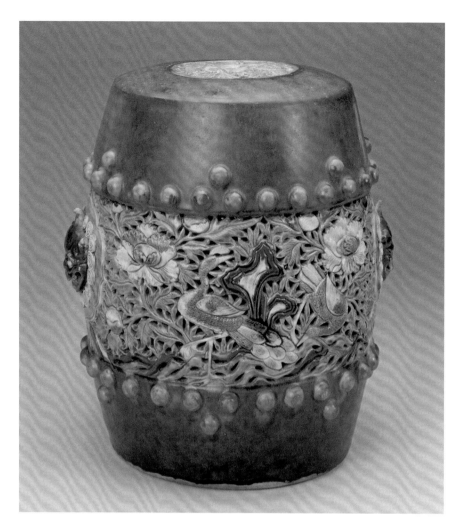

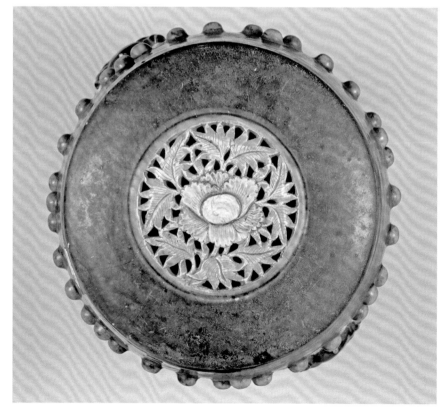

Dynastic Chronology of Chinese History

Xia Dynasty	Around 2070 B.C.—1600 B.C.
Shang Dynasty	1600 B.C.—1046 B.C.
Zhou Dynasty	
Western Zhou Dynasty	1046 B.C.—771 B.C.
Eastern Zhou Dynasty	770 B.C.—256 B.C.
Spring and Autumn Period	770 B.C.—476 B.C.
Warring States Period	475 B.C.—221 B.C.
Qin Dynasty	221 B.C.—206 B.C.
Han Dynasty	
Western Han Dynasty	206 B.C.—23A.D.
Eastern Han Dynasty	25—220
Three Kingdoms	
Kingdom of Wei	220—265
Kingdom of Shu	221—263
Kingdom of Wu	222—280
Western Jin Dynasty	265—316
Eastern Jin Dynasty Sixteen States	
Eastern Jin Dynasty	317—420
Sixteen States Periods	304—439
Southern and Northern Dynasties	
Southern Dynasties	
Song Dynasty	420—479
Qi Dynasty	479—502
Liang Dynasty	502—557
Chen Dynasty	557—589
Northern Dynasties	
Northern Wei Dynasty	386—534
Eastern Wei Dynasty	534—550
Northern Qi Dynasty	550—577
Western Wei Dynasty	535—556
Northern Zhou Dynasty	557—581
Sui Dynasty	581—618
Tang Dynasty	618—907
Five Dynasties Ten States Periods	
Later Liang Dynasty	907—923
Later Tang Dynasty	923—936
Later Jin Dynasty	936—947
Later Han Dynasty	947—950
Later Zhou Dynasty	951—960
Ten States Periods	902—979
Song Dynasty	
Northern Song Dynasty	960—1127
Southern Song Dynasty	1127—1279
Liao Dynasty	907—1125
Western Xia Dynasty	1038—1227
Jin Dynasty	1115—1234
Yuan Dynasty	1206—1368
Ming Dynasty	1368—1644
Qing Dynasty	1616—1911
Republic of China	1912—1949
Founding of the People's Republic of China on October 1, 1949	